JEFF DUNAS

AMERICAN PICTURES

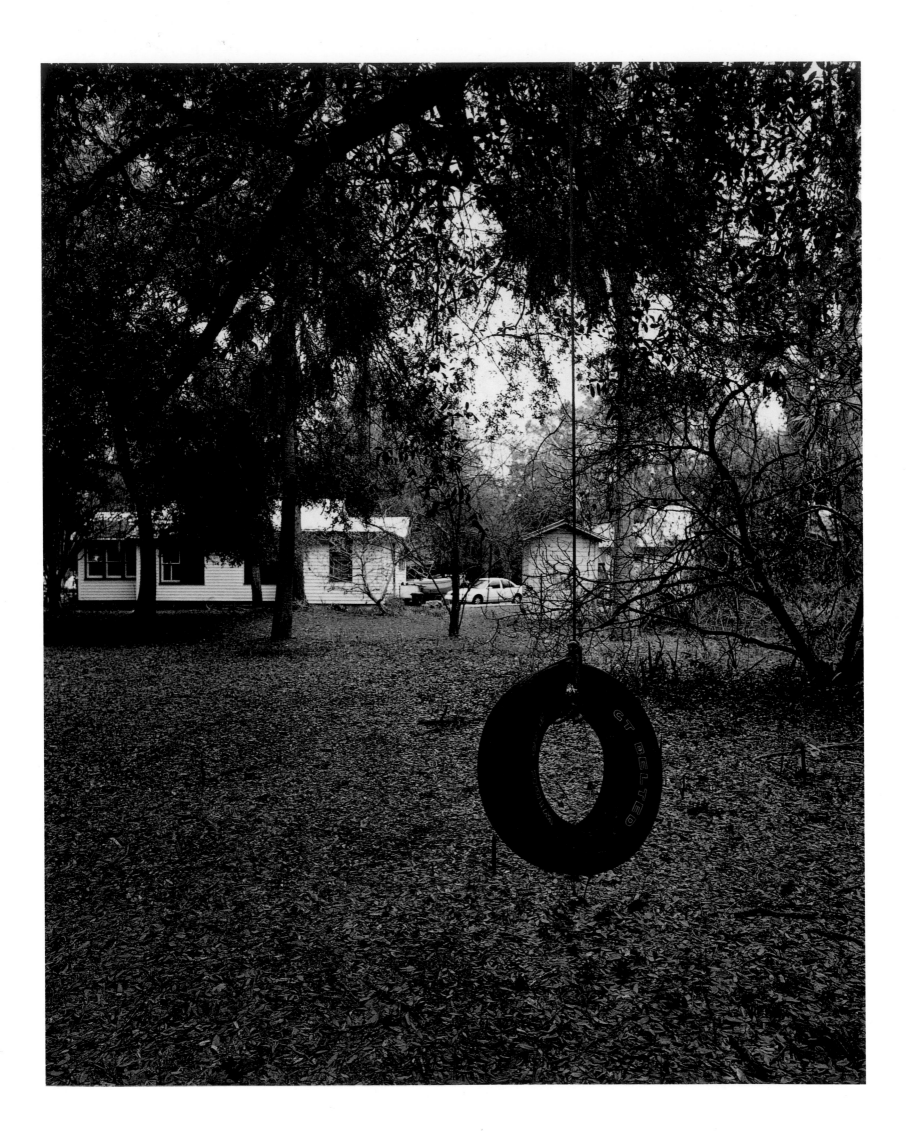

JEFF DUNAS

AMERICAN PICTURES

A Reflection on Mid-Twentieth Century America

Amerika Mitte des 20. Jahrhunderts in Bildern

Un reflet de l'Amérique du milieu du XXe siècle

KÖNEMANN

INTRODUCTION
Jeff Dunas: American Pictures

Memories are considered ephemeral, but they are holistic; they encompass all experience including vision. So why do we confuse photographs with memories? Photographs only contain visual evidence, with all the elasticity of fiction. Why do we trust photographs even more than memory when they are highly selective and notoriously impeachable, even though they might be clearly straight and unmanipulated? Our best critical writers on photography have been breaking down this question into manageable divisions for the last three decades: mirror and window, document and expression, form and context, semiotics and structure.

But even after we appreciate all of these critical positions, it is hard to deny that it is the factual information that photographs apparently represent that holds our fascination. The knowledge that they are not reliable objective documents fails to prevent us from accepting them as subjective evidence. We let them comfort us and confirm our experience and even our memories: this thing existed; I was there and saw it exactly this way. Or perhaps more importantly: I can imagine I experienced this thing in just this way. Better these flat reminders be an inventory of our lives than a lot of other things we can't choose to forget.

If we can't help ourselves and confuse the act of seeing with the act of seeing a photograph, then photographs obligate us, either consciously or not, to examine perception itself. And, of course, this leads us to question our own beings, which is built on our memories and perceptions. But if we keep our balance on this medium that teeters between experience and fiction, between standing in front of events or objects and standing in front of a piece of photographic paper, then all photographs become didactic in a constructive way. Those of us immersed in photography and photo-theory can take the further step of questioning the mythologies of our discipline. How much do we really know about the America we assume Walker Evans and Robert Frank gave us full scale? According to Jeff Dunas, his motive for making the images in *American Pictures* was to revisit the iconography of his youth on numerous road trips across the continent. In the expanded documentary tradition of Evans and Frank, Dunas sought an America in which he grew up. But unlike Robert Frank who portrayed a dark psychology of a postwar American society, or Evans, whose art was informed by a fundamental skepticism, Dunas shows us relics that for him are much less troublesome. Growing up in the 1950s and 1960s, Dunas associates the chronological layers of roadside America with an optimistic sense of America's economic and social triumph, and perhaps his own youthful self-construction.

We see in these pages an intrinsically American cultural fabric. Frozen-in-time Midwestern store fronts; junk yard wrecks of legendary 1940s and 1950s automobiles; children at play in what could be any American town between now and 1930; images that reflect Dunas' and his generation's memories of their cultural heritage. New cars in what have become old photographs in the work of Evans and Frank, are for Dunas old cars in new photographs. What he grew up loving to see was already living memories of an earlier era.

Dunas consciously connects with Walker Evans' *American Photographs,* first published in 1938 in conjunction with Evans' one-man exhibition at the Museum of Modern Art. But in Dunas' vision, late twentieth century America seems much friendlier than it did in the mid-1930s when Evans made his various road trips in the southern and eastern United States. Part of Evans' motivation was similar, however, in that he inventoried icons of American culture, specifically cars, road signs and both commercial and vernacular outdoor advertising. Dunas' love of typography echoes Evans' preoccupation with the narration of America, and use of signs for seamlessly combining text with image. Many of the signs Dunas found could almost be the same ones photographed by Evans 60 years before. While Evans' vision of 1930s America is rather cold, hard-edged, and precise, Dunas' later view of the same social landscape is lyrical and even dreamlike.

When Italian automobile designer, Giorgietto Giugiaro was commissioned to create the never released Aetna car for Lotus in

the late 1980s, essentially a square lozenge, he explained in an interview that this commission was to him 'like a walk in the park.' When we see Dunas' photographs of cars from the wildest period in American automobile design, the 1950s, one can't help but think that these designers' idea of what they were doing must have been a quick climb of the Half Dome at Yosemite. Not only are we drawn to Dunas' love of sculptural form, but we also are reminded that these essentially Baroque vehicles embodied 1950s American industrial and economic culture, taking the road culture of the 1930s into an aesthetic realm.

Authenticity is another issue in the work of Jeff Dunas, one which is related to the gap between perception and photographic image. For many growing up in fifties America, with all the darkness we now understand, the icons along the highway, including cars on the road and junked beside it, backed up the stories of parents and grandparents and gave credibility to the mutually dependent American fictions of individuality and progress. Dunas builds on two important real illusions: the 1930s hope that the Midwestern or Southern road ended in the cool salvation of a California orange grove; and the 1950s conviction that any car on any road anywhere led to pure personal freedom.

Graham Howe
Pasadena, June 2001

Graham Howe has curated over 100 graphic art exhibitions, including: John Swope: Camera Over Hollywood; Two Views of Manzanar: Ansel Adams & Toyo Miyatake; Paul Outerbridge Jr.; Tracings of Light: Sir John Herschel and the Camera Lucida; The Graham Nash Collection *and* Eikoh Hosoe: META. *His critical writing has been published in numerous art journals.*
Howe received his Master of Fine Arts Degree in Painting, Sculpture and Graphic Arts, majoring in photography at the University of California, Los Angeles, in 1979. He was the founding Director for the Australian Centre for Photography, Sydney from 1973 to 1975 and curator of the Graham Nash Collection from 1976 to 1988. From 1984 to 1985 he was curator at the Museum of Contemporary Art, Los Angeles. Howe founded the museum services organization Curatorial Assistance in 1987 and is president of Curatorial Assistance Traveling Exhibitions, a non-profit organization for the circulation of art exhibitions.

Jeff Dunas: American Pictures

Erinnerungen gelten als kurzlebig, sind aber allumfassend; sie beinhalten alle Erfahrungen einschließlich des Sehvermögens. Also, warum verwechseln wir die Fotos mit den Erinnerungen, wenn sie lediglich visuelle Beweise mit der Dehnbarkeit der Fiktion beinhalten? Warum vertrauen wir Fotografien sogar mehr als der Erinnerung, wenn sie hochgradig selektiv und notorisch anfechtbar sind – selbst dann, wenn sie vollkommen ehrlich und unmanipuliert sind? Die besten Kritiker der Fotografie zerlegen nun schon seit 30 Jahren diese Frage in überschaubare Abschnitte: Spiegel und Fenster, Dokument und Ausdruck, Form und Kontext, Semiotik und Struktur.

Aber selbst nachdem wir all diese kritischen Positionen würdigen, ist es nur schwer zu leugnen, dass uns gerade die Tatsachen faszinieren, die die Fotos offenbar ausmachen. Das Wissen, dass Fotos keine verlässlichen objektiven Dokumente sind, hindert uns nicht daran, sie als subjektive Beweise zu sehen. Wir lassen uns von ihnen trösten und uns unsere Erfahrungen und sogar unsere Erinnerungen von ihnen bestätigen: Das hier existierte; ich war da und habe es genau so gesehen. Oder vielleicht noch wichtiger: Ich kann mir vorstellen, diese Sache genau in dieser Weise erlebt zu haben. Dann sollen doch besser diese Andenken das Inventar unseres Lebens bilden als eine Menge anderer Dinge, die wir einfach nicht vergessen können.

Da wir nichts dafür können und den Akt des Sehens mit dem Akt des Anschauens einer Fotografie verwechseln, zwingt uns die Fotografie, bewusst oder unbewusst die Wahrnehmung als solche zu überprüfen. Das führt uns natürlich dazu, unsere eigene Existenz in Frage zu stellen, da wir sie auf unseren Erinnerungen und Wahrnehmungen aufgebaut haben. Falls wir uns aber im Gleichgewicht halten auf diesem Medium, das zwischen Erfahrung und Fiktion schwankt – zwischen der Konfrontation mit Ereignissen oder Gegenständen und der Konfrontation mit einem Stück Papier –, dann werden alle Fotografien auf konstruktive Weise lehrreich. Für diejenigen unter uns, die tiefer in die Fotografie und Foto-Theorie eingetaucht sind, kann das zu dem weiteren Schritt führen, die Mythologien unserer Disziplin zu hinterfragen. Wie viel wissen wir wirklich über das Amerika, von dem wir annehmen, dass es uns von Walker Evans und Robert Frank in vollem Umfang geliefert wurde?

Laut Jeff Dunas war sein Motiv für das Fotografieren der Bilder in *American Pictures,* die »Bilder« seiner Jugend auf zahlreichen Fahrten quer über den Kontinent wieder aufzusuchen. In der erweiterten dokumentarischen Tradition von Evans und Frank suchte Dunas das Amerika, in dem er aufgewachsen war. Anders als Robert Frank, der die düstere Seite einer amerikanischen Nachkriegsgesellschaft porträtierte, oder als Evans, dessen Kunst von einem grundlegenden Skeptizismus durchdrungen war, zeigt Dunas uns Relikte, die für ihn weitaus weniger problematisch sind. Dunas, der in den 1950er und 1960er Jahren groß wurde, verbindet die chronologischen Schichten des gewöhnlichen Amerika mit einem positiven Gespür von Amerikas wirtschaftlichem und sozialem Triumph, vielleicht auch mit der Entwicklung seines eigenen jugendlichen Selbstverständnisses.

Auf diesen Seiten begegnen wir Amerikas ureigenstem kulturellen Gewebe: in der Zeit eingefrorene Ladenfronten im Mittelwesten; die Wracks legendärer Automobile aus den 1940er und 1950er Jahren auf Schrottplätzen; spielende Kinder in einer Umgebung, die jede beliebige amerikanische Stadt zwischen heute und 1930 sein könnte – Bilder, die die Erinnerungen von Dunas und seiner Generation an ihr kulturelles Erbe reflektieren. Neue Autos in heute alt gewordenen Fotografien im Werk von Evans und Frank sind für Dunas alte Autos in neuen Fotografien. Was ihm in seiner Kindheit gefiel, war jetzt bereits die lebendige Erinnerung an eine frühere Ära.

Dunas knüpft bewusst Verbindungen zu Walker Evans' *American Photographs,* die 1938 zum ersten Mal im Rahmen seiner Einzelausstellung im Museum of Modern Art veröffentlicht wurden. Allerdings erscheint das Amerika des späten 20. Jahrhunderts in Dunas' Sicht viel freundlicher als das Amerika Mitte der 1930er Jahre, als Evans seine diversen Reisen über die Straßen der südlichen und östlichen Vereinigten Staaten unternahm. Evans' Motivation war aber teilweise ähnlich, da auch er eine Bestandsaufnahme von Ikonen amerikanischer Kultur machte – insbesondere von Autos, Straßenschildern und sowohl kommerzieller als auch volkstümlicher Außenwerbung. In Dunas' Liebe zur Typographie klingt Evans' Erzählen der amerikanischen Geschichte nach, ebenso seine Verwendung von Schildern zur nahtlosen Kombination von Text und

Bild. Viele Schilder, die Dunas fand, könnten beinahe dieselben sein, die Evans 60 Jahre zuvor fotografiert hatte. Evans' Vision des Amerika der 1930er Jahre ist eher kalt, scharf umrissen und präzise, Dunas' spätere Sicht der gleichen sozialen Landschaft dagegen lyrisch, sogar traumartig.

Als der italienische Automobildesigner Giorgietto Giugiaro Ende der 1980er Jahre damit beauftragt wurde, für Lotus das nie herausgebrachte Modell Aetna zu entwerfen – im Wesentlichen ein eckiger Rhombus –, erklärte er in einem Interview, dieser Auftrag sei für ihn »wie ein Spaziergang im Park«. Beim Anblick von Dunas' Fotos von Autos aus der wildesten Epoche des amerikanischen Automobildesigns, den 1950ern, kommt einem unwillkürlich der Gedanke, diese Designer müssten bei dem, was sie taten, eine Schnellbesteigung des Half Dome im Yosemite Nationalpark im Sinn gehabt haben. Wir fühlen uns nicht nur von Dunas' Liebe zur plastischen Form angezogen, sondern werden auch daran erinnert, dass diese im Grunde genommen barocken Fahrzeuge die industrielle und wirtschaftliche Kultur Amerikas in den 1950ern verkörperten und die Straßenkultur der 1930er Jahre zur ästhetischen Domäne werden ließen.

Neben den Unterschieden zwischen Fotografie und Wahrnehmung – diese aber auch berücksichtigend – steht im Werk von Jeff Dunas die Frage der Authentizität. Für viele, die im Amerika der 1950er Jahre mit all seinen uns heute bekannten Schattenseiten heranwuchsen, unterstützten die Ikonen entlang der Landstraße – einschließlich der Autos auf der Straße und ihrer Wracks am Straßenrand – die Erzählungen der Eltern und Großeltern und verliehen den voneinander abhängigen amerikanischen Fiktionen von Individualität und Fortschritt ihre Glaubwürdigkeit. Dunas stützt sich auf zwei entscheidende reale Illusionen: die Hoffnung der 1930er Jahre, dass die Straße durch den Mittelwesten oder Süden in der kühlen Erlösung eines kalifornischen Orangenhains endete, und die Überzeugung der 1950er Jahre, dass jedes Auto auf jeder Straße überall zu ungetrübter persönlicher Freiheit führte.

Graham Howe
Pasadena, Juni 2001

Graham Howe hat als Kurator über 100 Ausstellungen betreut und mehrere Bücher über die Kunst der Fotografie verfasst, unter anderem John Swope: Camera Over Hollywood, Two Views of Manzanar: Ansel Adams & Toyo Miyatake, Paul Outerbridge Jr., Tracings of Light: Sir John Herschel and the Camera Lucida, The Graham Nash Collection *und* Eikoh Hosoe: META. *Seine Kritiken wurden in zahlreichen Kunstzeitschriften veröffentlicht.*

Howe erwarb 1979 seinen Magister-Artium-Titel in den Fachbereichen Malerei, Bildhauerei und Grafische Kunst an der University of California (UCLA) in Los Angeles; der Schwerpunkt seiner Studien lag im Bereich Fotografie. Er war von 1973 bis 1975 Gründungsdirektor des Australian Centre for Photography in Sydney und von 1976 bis 1988 Kurator der Graham Nash Collection. Von 1984 bis 1985 arbeitete er außerdem als Kurator am Museum of Contemporary Art in Los Angeles. Howe gründete 1987 die Organisation für Curatorial Assistance und ist Präsident der Curatorial Assistance Traveling Exhibitions, einer gemeinnützigen Organisation für die Zirkulation von Kunstausstellungen.

INTRODUCTION

Jeff Dunas : American Pictures

On dit les souvenirs éphémères mais ils sont surtout holistiques et dépassent toute expérience, vision comprise. Mais aussi, pourquoi confondons-nous photographies et souvenirs puisqu'ils ne contiennent qu'une évidence visuelle ayant l'élasticité de la fiction ? Pourquoi faisons-nous moins confiance aux souvenirs qu'à des photographies alors qu'elles sont plutôt sélectives et évidemment hypothétiques, même en étant sans ambiguïté ni manipulées ? Nos meilleurs critiques des trois dernières décennies ont scindé cette problématique en éléments plus facilement gérables : miroir et fenêtre, document et expression, forme et contexte, sémiotique et structure.

Mais, même après avoir apprécié à leur juste valeur toutes ces positions critiques, il est difficile de nier que les photographies sont ce qui emporte notre fascination. Le fait de savoir qu'il ne s'agit pas de documents objectivement fiables ne nous empêche pas de les accepter comme une preuve subjective. Nous leur permettons de nous conforter et de confirmer notre expérience, voire nos souvenirs même : cette chose existait, j'étais là et je l'ai vue exactement de cette manière. Ou, plus grave encore peut-être : je peux imaginer que j'ai vécu cette chose précisément de cette manière. Mieux vaudrait que ces banals rappels soient un inventaire de nos vies plutôt qu'un fatras d'autres choses que nous ne pouvons pas nous décider à oublier.

Comme nous n'y pouvons rien et que nous confondons l'acte de voir avec celui de voir une photographie, les photographies nous obligent, consciemment ou non, à étudier la perception en soi. Cela nous conduit naturellement à questionner cet être propre que nous avons construit sur nos souvenirs et nos perceptions. Mais si nous parvenons à faire la part des choses concernant ce médium qui nous fait toujours hésiter entre réalité et fiction – être face à des événements ou des objets et être devant un carré de papier sensible – alors toute photographie devient didactique de manière constructive. Pour ceux d'entre nous qui sont immergés dans la pratique photographique et sa théorie, nous sommes invités à questionner les mythologies de notre discipline. Que savons-nous vraiment de l'Amérique dont nous supposons que Walker Evans et Robert Frank nous donnent toute l'échelle ? Le motif qui a poussé Jeff Dunas à créer les images de *American Pictures* fut, avoue-t-il lui-même, de revisiter l'iconographie de sa jeunesse au cours de plusieurs voyages à travers le continent nord-américain. Suivant la longue tradition documentaire de Evans et Frank, Dunas est parti en quête de cette Amérique dans laquelle il avait grandi mais, contrairement à Robert Frank qui dresse le sombre portrait psychologique de la société américaine d'après-guerre, ou à Walker Evans, dont l'art est imprégné d'un scepticisme fondamental, Dunas nous présente des reliques qui lui sont moins pénibles. Ayant grandi dans les années 1950 et 1960, Dunas associe aux couches chronologiques de l'Amérique des bas-côtés de la route l'optimisme du triomphe économique et social des États-Unis et, peut-être, de sa propre éducation.

Ces pages nous présentent un tissu culturel éminemment américain : devantures de boutiques du Midwest confites par le temps ; épaves de voitures légendaires des années 1940 et 1950 dans des casses automobiles ; enfants jouant dans ce qui pourrait être n'importe quelle ville américaine entre 1930 et aujourd'hui – des images qui reflètent les souvenirs et le patrimoine culturel de Dunas et de sa génération. Les rutilantes automobiles que l'on voit dans les (désormais anciennes) photographies de Evans et Frank sont désormais de vieilles voitures pour Dunas. Et ce qu'il connaissait lui-même dans sa jeunesse était déjà le souvenir vivant d'une époque antérieure.

L'ouvrage de Dunas se rattache consciemment à *American Photographs* de Walker Evans, publié pour la première fois en 1938 à l'occasion de son exposition au musée d'Art moderne. Mais, dans la vision de Dunas, l'Amérique de cette fin du XXᵉ siècle semble plus amicale que l'Amérique du milieu des années 1930, à l'époque des voyages d'Evans dans le sud et l'est des États-Unis. Leurs motivations sont toutefois comparables en ce qu'Evans aussi inventoriait les icônes de la culture américaine que sont notamment les voitures, les panonceaux et les enseignes à la fois commerciales et vernaculaires. L'amour de la typographie de Dunas rappelle aussi l'obsession de narration de l'Amérique par Evans et son utilisation

des panneaux pour associer plus étroitement encore le texte à l'illustration. Parmi ceux que Dunas a (re)découvert figurent peut-être aussi ceux photographiés par Evans 60 ans auparavant. En revanche, alors que le regard d'Evans sur l'Amérique des années 1930 est plutôt froid, aigu et précis, celui que porte Dunas sur le même paysage social semble lyrique voire onirique.

Le designer automobile italien Giorgietto Giugiaro a expliqué dans une interview que sa création de la Lotus Etna (un prototype aux lignes cunéiformes jamais entré en production) à la fin des années 1980 avait été pour lui « comme une promenade dans le parc ». En revoyant les voitures des années 1950, la période la plus folle du design automobile américain, photographiées par Dunas, on ne peut que penser que les concepteurs avaient une très haute idée de ce qu'ils faisaient. Si l'amour de Dunas pour ces formes sculpturales nous transporte, il nous rappelle également que ces véhicules baroques, en symbolisant la culture industrielle et économique américaine des années 1950, renvoient le « culte de la route » des années 1930 au royaume de l'esthétique.

La déconnexion entre photographie et perception dans l'œuvre de Jeff Dunas est une question d'authenticité. Pour la plupart de ceux qui étaient adolescents dans une Amérique des années cinquante dont nous comprenons maintenant la neurasthénie, toutes ces icônes d'une époque le long des autoroutes – et leurs carcasses sur le bas-côté – évoquent les histoires des parents et des grands-parents et rendent crédible la fiction américaine à laquelle seraient liés individualisme et progrès. Dunas s'appuie sur deux grandes illusions vraies : l'espoir des années 1930 que les routes du Midwest ou du sud des États-Unis conduisent enfin au salut des accueillantes orangeraies californiennes et la conviction des années 1950 que toute voiture procure la liberté absolue.

Graham Howe
Pasadena, Juin 2001

Graham Howe, qui s'est occupé de plus d'une centaine d'expositions, est l'auteur de nombreux livres sur la photographie (John Swope : Camera Over Hollywood ; Two Views of Manzanar : Ansel Adams & Toyo Miyatake ; Paul Outerbridge Jr. ; Tracings of Light : Sir John Herschel et la Camera Lucida ; The Graham Nash Collection et Eikoh Hosoe : META).

Ses critiques sont publiées dans de nombreuses revues d'art. Howe a obtenu en 1979 une maîtrise en Peinture, Sculpture et Arts graphiques, avec spécialisation en photographie, à l'université de Californie à Los Angeles. Directeur fondateur de l'Australian Centre for Photography de Sydney de 1973 à 1975, il fut successivement le conservateur de la Graham Nash Collection de 1976 à 1988 puis, de 1984 à 1985, du musée d'Art contemporain de Los Angeles. Howe a créé en 1987 la Curatorial Assistance, un organisme des services aux musées, et préside les Curatorial Assistance Traveling Exhibitions, une organisation à but non lucratif pour la promotion des expositions artistiques.

The tire hangs suspended, abandoned by its children; a car is parked, itself no doubt abandoned; a building carries the sign of a former hotel, but it is likewise abandoned; a group of children stare at the camera, abandoned by hope.

This sense of abandonment haunts Jeff Dunas' portraits of a forgotten America, as if the camera had in some way resonated with the photographer's own sense of history and memory. In these evocative images, Dunas creates a veritable landscape of abandonment, one that, despite the obvious presence of the living, nevertheless coheres and supports the myth of an America escaping from its past, yet leaving uncomfortable traces scattered everywhere, as if preserved in aspic. Dunas' subjects are living in the past, in an environment created in the 1950s and 1960s and still littered (the word is advisable) with objects, buildings, and sites that seem to have resisted all but the outward marks of decay. Abandoned then, but not uninhabited, or rather, having a sense of being jettisoned, being only recently left alone, its populace, perhaps like that of Pompeii or Herculaneum, was interrupted in their daily lives and forced by some unknown emergency to leave in a hurry.

Here, in these depictions of shattered and isolated buildings, rusting and unoccupied cars, empty churches and stoops, broken and faded signs, another America is figured. Above all, it is the signs, indicating what once was there, traces of a modest but real consumerism of the immediate postwar period, that are the most redolent. They symbolize the temporal displacement of the photographer, documenting a voyage into an inner space of a realm once vibrant and experienced, but now empty and subject only to the photographer's gaze, sometimes sympathetic, sometimes ironic, sometimes coldly analytic, sometimes refusing empathy, always in sharp focus. This gaze frames and stabilizes what in experience is fluid and fragmented; it monumentalizes the fleeting moment, isolates and scrutinizes the face until expression is rendered mute and uncomplaining to enigmatic effect. A museum is then created of nostalgic moments in everyday American life and space; and yet there is no trace of nostalgia or sentiment, only a reverie on the physicality of things. And if the buildings and the machines share this substantiality—their frames and surfaces scarred by use and natural erosion—people as well find their bodily presence transformed into icons of social roles, of individual psyches, of aspirations long forgotten.

In this process of materialization and framing, the photograph plays a special part. For it is a natural characteristic of the photograph to transform movement into stillness, fleeting expression into frozen gesture, and most importantly for Dunas' collection, space into place. For where in myth and much reality the American landscape has been seen as infinite, home of mobility and extension, of expansion and endless restlessness, it is the photograph that, from Ansel Adams to Robert Frank, has fixed in place what it constructs as image. The photograph has created a sense of place where experience would have ruled it out; has situated the flux of goods new and old so as to put them in place, set them down at rest, drawn boundaries around them, and with or without captions, endowed old forms with new functions.

Of course, this sense of place is, on the surface, entirely at odds with the myth of the American landscape, which has been forever imaged as the site of the sublime, the absolutely natural: the sublime of extension, of distance, of depth, and of atmosphere. These are the characteristics of the Hudson River School and of the Abstract Expressionists. Such images resist colonization, forbid settling, and refuse roots, preferring to lose all limits to space in misty haze, distant mountains, blinding light, and deepening gloom. The space is horizontal. It is the space of Frank Lloyd Wright's prairie, and as Wright understood, it demanded horizontal dwellings open to the horizon and expanding under extended roofs. The *Little House on the Prairie* only tenuously, like Dorothy's, held to the ground, ready to be leveled or swept up by the next natural force to soar across the plain.

In his study of the myths of the United States created by British authors in the nineteenth and early twentieth centuries, under the evocative title *Imagining America,* the British writer and photographer Peter Conrad speaks of the creation of at least nine mythic Americas: the Institutional America found in the travel journals of Charles Dickens, the Aesthetic America of Oscar Wilde and Rupert Brooke, the Epic (and even Chivalric) America of Rudyard Kipling and Robert Louis Stevenson, the Futuristic America of H. G. Wells and so many others, the Primitive America of D. H. Lawrence's imagination, the Theological America dear to the heart of W. H. Auden, the Psychedelic America of Aldous Huxley and countless others, and finally, the Mystical America sought in California by Christopher Isherwood. All of these mythic Americas, and many

more, have found their place at one time or another. We have only to add the more dystopian worlds of writers from Sinclair Lewis to William Gibson to bring the catalogue up to date. It is significant that Kevin Starr, certainly a historian of the "real," felt impelled to follow mythic tradition by entitling his series of Southern Californian histories *Americans and the California Dream, Inventing the Dream,* and *Material Dreams.*

In Conrad's list of imaginary Americas, "space" does not figure on its own, but it certainly pervades almost every utopian or dystopian reading of the United States, an omnipresent flux, a spectacular phenomenon, a vehicle for vision and hallucination, and more tellingly, perhaps the most non-European of all non-European phenomena observed by visitors. Skyscrapers and metropolitan crowds, elevated highways and freeways, theological millennialisms and crackpot cults—these Europe too could boast, although perhaps not in double-digit glory. But it was American space—from the Romantics, starting with Chateaubriand, to the modernists, from Erich Mendelsohn, to the postmodernists, starting with Jean Baudrillard—that caught the imaginations of generations of tourists.

Perhaps the single most characteristic quality of American space for the European, from de Tocqueville to Baudrillard, was its apparently non-historical aspect, whether rural or urban. The wilderness, apparently untouched by human hand, was, as Ruskin had already noted, at once melancholy and terrifying. Similarly, the metropolis, still marked by the recent traces of its foundation, represented all that George Beard characterized as "topophobic." More recent critical theorists have echoed this view. Theodor Adorno, for example, while correcting the "romantic" fallacy of America's lack of history, nevertheless continued the myth of the "untouched" landscape. Writing in *Minima Moralia* after a flight from Europe, he noted: "Paysage. The shortcoming of the American landscape is not so much the absence of historical memories, as romantic illusion would have it, but that it bears no traces of the human hand. This applies to the lack of arable land, the uncultivated woods often no higher than scrub, and above all to the roads. These roads are always inserted directly into the landscape, and the more impressively smooth and broad they are, the more unrelated and violent their gleaming tracks appear against their wild, overgrown surroundings. They are expressionless. Just as they know no marks of

foot or wheel, no soft paths along their edges as a transition to the vegetation, no trails leading off into the valley, so they are without the mild, soothing, un-angular quality of things that have felt the touch of hands or their immediate implements. It is as if no one had ever passed a hand over the landscape's hair. It is uncomforted and comfortless, and it is perceived in a corresponding way. For what the hurrying eye has seen merely from the car it cannot retain, and the vanishing landscape leaves no more traces behind than it bears upon itself. "[1]

But if, from Ruskin to Adorno, the problem with American space has been its lack of human traces, this very absence of history or cultivation has been, from the viewpoint of British architectural critic Reyner Banham to French postmodern media theorist Baudrillard, its principle virtue. In both cases, when judged by the standards of the awe-full or terrifyingly sublime, of the disturbingly empty or excitingly infinite, the spatial characteristics of America have represented a kind of absolute point of reference to romantic and modernist thought alike. Indeed, beyond any capacity for evoking emotions or inspiring reveries, American space has often taken on the role of a metaphysical category for the European imaginary, a complex figure that incorporates every level of aesthetic appreciation and social occupation. Where Adorno dreamed a nightmare of an America in which all would end up sleeping in their cars in asphalt parking lots, Banham unfolded his raveling bicycle and pedaled across the desert as if no one had ever before touched the arid sand of "America Deserta," and Baudrillard tooled across the country to Las Vegas with hardly a stop, save to note down his smooth *Cool Memories* on the fly. Inevitably, of course, the reality is more complex. These mythic landscapes in a sense form so many "magic geographies"—akin to the "magic realism" of contemporary Latin American literature and cinema—that they construct what the literary critic Fredric Jameson has termed "histories with holes in them": incomplete, merging and collaging reality and myth, dream and reality. In a moment when even murder can be "dreamed," we can understand once again the power of such mythic constructions that, in short, have the effect of creating layer upon layer of magic geography that supersedes and blocks real geography.

And although Jeff Dunas is American, and it is his personal view of the land and its people that is figured here, in another sense he is

also an exile, like a visitor from another country, finding its scenes strange through his own capacity for estrangement. Estrangement was for the critic Walter Benjamin that quality of things that made them visible for the first time, a framing of the commonplace and the already known scene in such a way as to give it a startling freshness, a sharp, evocative character that pierced the routine and shattered the banal. It is with this sense of framing and in the overlapping zones of these different geographies that Dunas works. Against these myths of emptiness, he has succeeded in capturing another geography, another America, one struggling to make a place for itself in the midst of nothingness, a place that even when forgotten and left by economic and social drift to peel and rust amid the weeds, still retains its humanness, its air of workaday ordinariness, and finally, its presence. Against the urban myth of "nothing beyond the cities," he has documented a portrait of a land and a people whose only monument is their context, ragged and rundown as it is. This is not a land of monuments, nor of great architecture, streets and cityscapes, but a land that is monumental all the same, one that through its faded signs designates the majesty of human occupation, one that arrests the traveler who looks and, even now, causes him to draw up his trailer and frame it in his lens.

Anthony Vidler
Los Angeles and Barcelona, June 2001

Anthony Vidler was trained as an architect and art historian in Cambridge, England. He taught for thirty years at Princeton University as Professor of Architecture and European Cultural Studies and has served as dean of the College of Architecture, Art and Planning, Cornell University. He now teaches at UCLA, where he chairs the Department of Art History and is Professor of Architecture. He has published widely on art and architecture; his books include The Architectural Uncanny *and* Warped Space, *both from MIT Press.*

1. Theodor Adorno, *Minima Moralia: Reflections from Damaged Life,* translated from the German by E. F. N. Jephcott (London: New Left Books, 1974), p. 48.

Vorwort

Magische Geographien: Jeff Dunas in Amerika

Der Autoreifen hängt herunter, von den Kindern verlassen; ein abgestelltes Auto, ohne Zweifel ebenfalls verlassen; ein Gebäude trägt zwar das Schild eines früheren Hotels, ist jedoch auch verlassen; eine Gruppe von Kindern starrt in die Kamera, von der Hoffnung verlassen.

Dieses Gefühl von Verlassenheit geistert durch Jeff Dunas' Porträts eines vergessenen Amerika, als würde die Kamera in gewisser Weise das Gespür des Fotografen für Geschichte und Erinnerung wiedergeben. In diesen evokativen Bildern kreiert Dunas eine regelrechte Landschaft der Verlassenheit, die trotz der offensichtlichen Anwesenheit der Lebenden mit dem Mythos eines Amerika zusammenhängt und diesen stützt – eines Amerika, das seiner Vergangenheit entflieht, jedoch überall verstreut unbequeme Spuren hinterlässt, als wäre es in Aspik konserviert. Dunas' Motive leben in der Vergangenheit, in einer Umwelt, die in den 1950ern und 1960ern geschaffen wurde und übersät ist von Gegenständen, Gebäuden und Orten, die offenbar allem außer den äußeren Anzeichen des Verfalls widerstanden haben. Verlassen und verkommen, aber gewiss nicht unbewohnt, oder eher mit einem Gefühl behaftet, als wäre sie aufgegeben, erst kürzlich allein gelassen worden, als wäre ihre Bevölkerung, vielleicht ähnlich der von Pompeji oder Herculaneum, in ihrem alltäglichen Leben unterbrochen und von irgendeinem unbekannten Notfall gezwungen worden, in aller Eile fortzugehen.

In den vorliegenden Abbildungen verfallener und einsamer Gebäude, rostender und ausgedienter Autos, leerer Kirchen und Treppen, zerbrochener und verblasster Schilder wird ein anderes Amerika vorgestellt. Vor allem die Schilder, die noch immer anzeigen, was einmal da war, die Spuren eines bescheidenen, aber realen Konsumbewusstseins der unmittelbaren Nachkriegszeit, sind am erinnerungsträchtigsten. Sie symbolisieren die zeitliche Verschiebung des Fotografen, indem sie eine Reise in den inneren Raum eines Reiches dokumentieren, das einst voller Leben und erfahrbar war, heute jedoch leer und nur dem Auge des Fotografen zugänglich ist. Dieser Blick des Fotografen ist manchmal wohlwollend, manchmal ironisch, manchmal kühl analysierend, manchmal jedes Mitgefühl verweigernd, aber immer gestochen scharf. Dieser Blick rahmt und verfestigt, was als fließend und fragmentarisch erlebt wird; er monumentalisiert den flüchtigen Augenblick, isoliert und prüft das Gesicht, bis der Ausdruck stumm und geduldig wird bis zur Rätselhaftigkeit. So wird ein Museum aus nostalgischen Augenblicken des amerikanischen

Alltagslebens und -raumes geschaffen; dabei fehlt jede Spur von Sentimentalität, es ist nur eine Träumerei über die Solidität von Gegenständen. Wenn schon Gebäude und Maschinen diese Eigenschaft teilen – ihre Umrisse und Oberflächen voller Narben von Abnutzung und natürlicher Erosion –, dann werden auch die Menschen in ihrer körperlichen Präsenz transformiert zu Ikonen von gesellschaftlichen Rollen, individuellen Psychen, längst vergessenen Hoffnungen.

In diesem Prozess der Materialisierung und des Festschreibens spielt das Foto eine besondere Rolle. Ist es doch ein Wesensmerkmal des Fotos, Bewegung in Stillstand zu transformieren, den flüchtigen Ausdruck in gefrorene Geste, und was für Dunas' Sammlung am wichtigsten ist, Raum in Örtlichkeit. Während im Mythos und oft auch in der Wirklichkeit die amerikanische Landschaft als unendlich, als Heimat der Mobilität und Ausdehnung, der Expansion und der endlosen Ruhelosigkeit gesehen wurde, hat das Foto – von Ansel Adams bis zu Robert Frank – örtlich fixiert, was es als Bild konstruiert. Das Foto kreierte ein Gefühl von Örtlichkeit, wo die Erfahrung diese ausschließen würde; es hat dem Strom neuer und alter Waren einen Platz zugewiesen, sie beruhigt, Grenzen gezogen und, ausdrücklich oder nicht, alten Formen neue Funktionen verliehen.

Dieses Gefühl von Örtlichkeit ist an der Oberfläche selbstverständlich vollkommen unvereinbar mit dem Mythos der amerikanischen Landschaft, die von jeher als Ort des Erhabenen, des absolut Natürlichen vorgestellt wurde – einer Erhabenheit der Ausdehnung, der Entfernung, der Tiefe und der Atmosphäre. Das sind die Charakteristika der Hudson River School und der Abstrakten Expressionisten. Derartige Bilder widerstehen der Kolonisierung, verbieten die Besiedlung und verweigern die Verwurzelung – sie ziehen es vor, alle dem Raum gesetzten Grenzen in nebligem Dunst, entfernten Bergen, blendendem Licht und zunehmender Finsternis zu verlieren. Die Räumlichkeit ist horizontal. Es ist die Räumlichkeit von Frank Lloyd Wrights Prärie, und wie Wright wohl verstand, verlangte sie waagerechte, zum Horizont offene und unter gestreckten Dächern sich ausdehnende Wohnstätten. *Unsere kleine Farm* hielt sich genau wie Dorothys Haus nur schwach am Boden, bereit, von der nächsten Naturgewalt angehoben oder mitgerissen zu werden und über der Ebene davonzufliegen.

Der britische Schriftsteller und Fotograf Peter Conrad gab seiner Studie über die Mythen der Vereinigten Staaten, wie sie von briti-

schen Autoren im 19. und Anfang des 20. Jahrhunderts geschaffen wurden, den atmosphärischen Titel *Imagining America*. In ihr unterscheidet er mindestens neun mythische Amerika: das institutionelle Amerika der Reisetagebücher von Charles Dickens, das ästhetische Amerika von Oscar Wilde und Rupert Brooke, das epische (sogar höfisch-ritterliche) Amerika von Rudyard Kipling und Robert Louis Stevenson, das futuristische Amerika von H.G. Wells und vielen anderen, das naturverbundene Amerika aus D.H. Lawrences Phantasie, das W.H. Auden am Herzen liegende theologische Amerika, das psychedelische Amerika von Aldous Huxley und zahllosen anderen, und schließlich das mystische Amerika, das Christopher Isherwood in Kalifornien suchte. All diese mythischen Amerika, und ebenso viele andere, haben zu irgendeinem Zeitpunkt ihre Berechtigung gehabt. Wir müssen nur noch die eher dystopischen Welten von Schriftstellern von Sinclair Lewis bis William Gibson hinzufügen, um die Liste auf den neuesten Stand zu bringen. Selbst Kevin Starr, mit Sicherheit ein Chronist des »Realen«, fühlte sich bezeichnenderweise genötigt, der mythischen Tradition zu folgen und seine Serie über die Geschichte Südkaliforniens mit den Titeln *Americans and the California Dream, Inventing the Dream* und *Material Dreams* zu versehen.

In Conrads Auflistung der imaginären Amerika taucht Raum als solcher nicht auf, aber er durchzieht ohne Zweifel nahezu jede utopische oder dystopische Literatur über die Vereinigten Staaten – als allgegenwärtiger Strom, spektakuläres Phänomen, Vehikel für Vision und Halluzination und, noch aufschlussreicher, als das von ausländischen Besuchern beobachtete, vielleicht am wenigsten europäische aller nicht-europäischen Phänomene. Wolkenkratzer und Menschenmassen der Großstädte, Hochstraßen und auf Pfeilern gebaute Autobahnen, theologische Millennialismen und Spinnerkulte – all dessen kann Europa sich auch rühmen, wenn auch nicht in zweistelligem Glanz. Vielmehr war es die amerikanische Weite, die die Vorstellungskraft von Generationen von Touristen gefangen nahm – von den Romantikern, angefangen mit Chateaubriand, über die Modernisten, angefangen mit Erich Mendelsohn, bis zu den Postmodernisten, angefangen mit Jean Baudrillard.

Die für den Europäer – von de Tocqueville bis Baudrillard – am meisten hervortretende Eigenart der amerikanischen Weite war ihr offenbar nicht-historischer Aspekt, ob nun auf dem Lande oder in der Stadt. Die scheinbar von Menschen unberührte Wildnis war,

wie Ruskin bereits bemerkt hatte, zugleich melancholisch und Furcht erregend. Auf ähnliche Weise verkörperte die noch von frischen Spuren ihrer Gründung gezeichnete Metropole all das, was George Beard als »topophobisch« charakterisierte. Jüngere Vertreter der Kritischen Theorie haben diese Ansicht aufgegriffen. So korrigierte etwa Theodor Adorno zwar den »romantischen« Irrtum über Amerikas Geschichtslosigkeit, führte jedoch ungeachtet dessen den Mythos der »unberührten« Landschaft fort. In *Minima Moralia* notierte er nach einem Flug von Europa: »Paysage. – Der Mangel der amerikanischen Landschaft ist nicht sowohl, wie die romantische Illusion es möchte, die Absenz historischer Erinnerungen, als daß in ihr die Hand keine Spur hinterlassen hat. Das bezieht sich nicht bloß auf das Fehlen von Äckern, die ungerodeten und oft buschwerkhaft niedrigen Wälder, sondern vor allem auf die Straßen. Diese sind allemal unvermittelt in die Landschaft gesprengt, und je glatter und breiter sie gelungen sind, um so beziehungsloser und gewalttätiger steht ihre schimmernde Bahn gegen die allzu wild verwachsene Umgebung. Sie tragen keinen Ausdruck. Wie sie keine Geh- und Räderspuren kennen, keine weichen Fußwege an ihrem Rand entlang als Übergang zur Vegetation, keine Seitenpfade ins Tal hinunter, so entraten sie des Milden, Sänftigenden, Uneckigen von Dingen, an denen Hände oder deren unmittelbare Werkzeuge das ihre getan haben. Es ist, als wäre niemand der Landschaft übers Haar gefahren. Sie ist ungetröstet und trostlos. Dem entspricht die Weise ihrer Wahrnehmung. Denn was das eilende Auge bloß im Auto gesehen hat, kann es nicht behalten, und es versinkt so spurlos, wie ihm selber die Spuren abgehen.«[1]

Wenn aber, von Ruskin bis Adorno, das Problem mit der amerikanischen Weite das Fehlen menschlicher Spuren gewesen ist, so ist vom Standpunkt des britischen Architekturkritikers Reyner Banham bis hin zu dem des französischen postmodernen Medientheoretikers Baudrillard gerade diese Abwesenheit von Geschichte oder Kultivierung ihr größter Vorzug. Am Maßstab des Ehrfurcht gebietenden oder Furcht erregend Erhabenen, dem beunruhigend Leeren oder aufregend Endlosen gemessen, haben in beiden Fällen die räumlichen Charakteristika Amerikas eine Art absoluten Bezugspunkt sowohl für das romantische als auch für das modernistische Denken dargestellt. Über jede Fähigkeit des Hervorrufens von Emotionen oder des Anregens von Träumereien hinaus, hat die amerikanische Weite für die europäische Vorstellung tatsächlich häufig die Rolle einer metaphysischen Kategorie angenommen –

eine komplexe Figur, die jede Ebene ästhetischer Wertschätzung und gesellschaftlicher Tätigkeit umfasst. Während Adorno vom Alptraum eines Amerika heimgesucht wurde, in dem alle in ihren Autos schlafend auf Asphalt-Parkplätzen endeten, klappte Banham sein Tourenfahrrad auseinander und radelte quer durch die Wüste, gerade so, als hätte niemand zuvor den öden Sand von »America Deserta« berührt, und Baudrillard jagte quer durch das Land nach Las Vegas, fast ohne Zwischenstopp, es sei denn, um unterwegs seine gefälligen *Cool Memories* niederzuschreiben. Zwangsläufig ist die Wirklichkeit natürlich komplexer. Diese mythischen Landschaften bilden in gewissem Sinne so viele »magische Geographien« – ganz ähnlich dem »magischen Realismus« in Literatur und Film des zeitgenössischen Lateinamerika –, dass sie konstruieren, was der Literaturkritiker Fredric Jameson als »Geschichten mit Löchern« bezeichnet hat: Realität und Mythos, Traum und Wirklichkeit – unvollständig, miteinander verschmelzend und Collagen bildend. In dem Moment, in dem selbst Mord »geträumt« werden kann, können wir erneut die Macht solch mythischer Konstrukte verstehen, die, kurz gesagt, Schicht für Schicht eine magische Geographie erschaffen, die die reale Geographie ersetzt und blockiert.

Und obwohl Jeff Dunas Amerikaner ist und hier seine persönliche Sicht des Landes und seiner Menschen vorlegt, ist er in anderer Hinsicht auch ein Exilant, wie ein Besucher aus einem anderen Land, der die Schauplätze als fremd empfindet aufgrund seiner eigenen Fähigkeit zur Entfremdung. Die Entfremdung war für den Theoretiker Walter Benjamin jene Eigenschaft der Dinge, die sie zum ersten Mal sichtbar werden lässt, ein Erfassen der alltäglichen und bereits bekannten Schauplätze auf eine Weise, dass diese eine überraschende Frische, einen klar umrissenen, atmosphärischen Charakter erhält, der die Routine durchbricht und das Banale erschüttert. Mit dieser Art von Wahrnehmung und in den sich überlappenden Zonen dieser unterschiedlichen Geographien arbeitet Dunas. Im Gegensatz zu diesen Mythen der Leere ist ihm das Einfangen einer anderen Geographie gelungen, eines anderen Amerika, das darum kämpft, sich einen Platz inmitten des Nichts zu erobern – einen Platz, der selbst, wenn er vergessen ist und von ökonomischen und gesellschaftlichen Strömungen dem Abblättern und Verrosten im Unkraut überlassen wird, trotzdem seine Menschlichkeit, seinen Flair von Alltäglichkeit und letztendlich seine Präsenz bewahrt. Dem städtischen Mythos des »nichts geht über das Großstadtleben« hat er dokumentarisch das Porträt eines

Landes und eines Volkes entgegengestellt, deren einziges Zeugnis ihr Kontext ist, so zerlumpt und heruntergekommen er auch sein mag. Dies ist weder ein Land der Monumente, noch eines der großartigen Architektur, Straßen- oder Stadtlandschaften, und doch ist es ein monumentales Land – ein Land, das mittels seiner verblichenen Zeichen die Würde menschlichen Handelns kenntlich macht, ein Land, das den betrachtenden Reisenden aufmerksam werden lässt und ihn selbst heute noch zum Anhalten seines Wohnwagens bewegt und ihn dazu veranlasst, es mit seinem Objektiv zu erfassen.

Anthony Vidler
Los Angeles und Barcelona, Juni 2001

1. Theodor Adorno, *Minima Moralia: Reflexionen aus dem beschädigten Leben,* Frankfurt/Main 1951 (zitiert nach Neuauflage 1973, S. 54 f.)

Anthony Vidler studierte in Cambridge, England, Architektur und Kunstgeschichte. 30 Jahre lang lehrte er als Professor für Architektur und European Cultural Studies an der Princeton University, USA, und war Dekan des College of Architecture, Art and Planning der Cornell University. Heute lehrt er an der University of California (UCLA) in Los Angeles, er ist dort Direktor der Abteilung für Kunstgeschichte und Professor für Architektur. Zu seinen zahlreichen Publikationen über Kunst und Architektur zählen seine Bücher The Architectural Uncanny *und* Warped Space, *beide erschienen bei MIT Press.*

Préface
Géographies magiques : Jeff Dunas en Amérique

Un pneu suspendu, délaissé par les enfants ; une voiture, elle-même aussi à l'abandon ; un immeuble portant l'enseigne d'un ancien hôtel, mais tout aussi déserté ; un groupe d'enfants fixant la caméra, abandonnés par l'espoir.

Cette impression d'abandon hante les portraits de Jeff Dunas d'une Amérique oubliée, comme si son appareil était entré en résonance avec le sens de l'histoire et les souvenirs propres du photographe. Par ses images, Dunas évoque et crée un véritable paysage de l'abandon qui, malgré la présence évidente de la vie, conforte et rend alors cohérent le mythe d'une Amérique désireuse d'échapper à un passé dont elle laisse toutefois partout des traces désagréables, comme conservées en gelée. Les sujets de Dunas vivent dans le passé, dans un environnement produit par les années 1950 et 1960 et toujours encombré (le mot est ici délibérément choisi) d'objets, d'immeubles et de sites qui semblent avoir résisté à tout sauf aux marques extérieures de décrépitude. Des lieux abandonnés donc mais pas tout à fait inhabités ou, plutôt, donnant l'impression que sa population, à l'exemple de celles de Pompéi et d'Herculanum, interrompue dans sa vie quotidienne et forcée par quelque urgence inconnue de partir en toute hâte, s'en est délestée et ne les a délaissés que récemment.

Ces illustrations de bâtiments ruinés et isolés, de voitures rouillées et vides, d'églises et de vérandas vides, de panneaux cassés et effacés, nous proposent une autre Amérique. Les enseignes surtout, attestant de ce qui existait là autrefois et traces d'un modeste mais véritable consumérisme de l'immédiat après-guerre, sont sans doute les témoignages les plus évocateurs. Elles symbolisent le déplacement temporel du photographe documentant son voyage dans l'espace intérieur d'un royaume autrefois vibrant et vivant mais désormais vide, dans un territoire devenu un sujet uniquement pour l'œil du photographe, dont le regard tantôt sympathique, ironique, froidement analytique ou s'interdisant l'empathie le conserve toujours en étroit point de mire. Ce regard cadre et fixe ce qui est en réalité fluide et fragmenté ; il « monumentalise » un moment flottant, isole et scrute le visage jusqu'à ce que son expression soit rendue muette et résignée à tout effet énigmatique. Il se crée alors un musée des instants nostalgiques de la vie et de l'espace quotidien américain ; et il n'y a cependant aucune trace de nostalgie ou de sentiment, seulement une rêverie sur la matérialité des choses. Et si bâtiments et machines partagent cette substantialité – leurs carcasses et leurs surfaces égratignées par l'usage et l'usure

naturels – les gens voient aussi leur présence corporelle transformée en icônes du rôle social, de la psyché individuelle, des aspirations longtemps oubliées.

Le photographe joue évidemment un rôle particulier dans ce processus de matérialisation et de cadrage car c'est un de ses attributs naturels que de transformer un mouvement en immobilité, une expression fugace en un geste figé et, plus important encore pour cette livraison iconographique de Jeff Dunas, un espace en un lieu. Car si le paysage américain est considéré – dans le mythe et certainement aussi la réalité – comme infini, tout de mobilité et d'expansion, d'étendue et d'agitation permanente, ce sont ses photographes qui, de Ansel Adams à Robert Frank, ont fixé l'image qu'il a construite. Ces photographes ont créé une impression de lieu alors que l'expérience l'aurait exclue, ont agencé la multitude des objets nouveaux et anciens pour les mettre en place, les déposer, les cerner de limites et investir, avec ou sans légende, les anciennes formes de nouvelles fonctions.

Évidemment, cette impression de lieu est, dans l'apparence, en totale contradiction avec le mythe du paysage américain, considéré à jamais comme site du sublime et du naturel absolu : sublimes de la proportion, de la distance, de la profondeur et de l'atmosphère, caractéristiques de la Hudson River School et des expressionnistes abstraits. De telles images résistent à la colonisation, interdisent le peuplement et refusent les racines, préférant perdre toutes limites de l'espace dans un brouillard diffus, de lointaines montagnes, une aveuglante clarté et une intense mélancolie. L'espace est horizontal. C'est celui de la prairie de Frank Lloyd Wright et, comme il l'a lui-même compris, il nécessite des habitations horizontales ouvertes sur l'horizon et prolongées par de vastes toitures. Cette « Petite maison dans la prairie » ne tient au sol, comme celle de Dorothy, que de manière précaire, prête à être soulevée ou balayée par les forces du prochain élément naturel à s'élancer dans la plaine.

Dans son étude des mythes américains créés par les auteurs britanniques du XIXᵉ et du début du XXᵉ siècle, l'écrivain et photographe anglais Peter Conrad raconte, sous le titre évocateur de *Imagining America,* la création d'au moins neuf Amériques mythiques : l'Amérique institutionnelle du journal de voyage de Charles Dickens ; l'Amérique esthétique d'Oscar Wilde et de Rupert Brooke ; l'Amérique épique (voire chevaleresque) de Rudyard Kipling et

Robert Louis Stevenson ; l'Amérique futuriste de H.G. Wells et bien d'autres ; l'Amérique primitive imaginée par D.H. Lawrence ; l'Amérique théologique chère au cœur de W.H. Auden ; l'Amérique psychédélique d'Aldous Huxley et d'innombrables auteurs ; enfin, l'Amérique mystique recherchée en Californie par Christopher Isherwood. Toutes ces Amériques, et bien d'autres encore, ont existé à un moment ou un autre. Il ne reste qu'à y ajouter les mondes dystopiques d'écrivains allant de Sinclair Lewis à William Gibson pour mettre le catalogue à jour. Il est significatif que Kevin Starr, certainement un historien du «réel», se soit senti obligé de suivre la tradition mythique en intitulant sa série d'histoires culturelles de la Californie du Sud *Americans and the California Dream, Inventing the Dream* et *Material Dreams.*

Dans la liste des Amériques imaginaires établie par Conrad, «l'espace» ne figure pas en soi mais transparaît certainement dans presque toutes les lectures utopiques ou dystopiques des États-Unis comme un flux omniprésent, un phénomène spectaculaire, un véhicule de vision et d'hallucination et, plus parlant encore, comme le plus non-européen de tous les phénomènes non-européens observés par les visiteurs. Gratte-ciel et foules métropolites, autoroutes et voies rapides surélevées, millénarisme théologique et cultes cinglés – certes l'Europe peut aussi se vanter d'en posséder mais à une échelle bien moindre. C'est bien l'idée de l'Espace américain – celle des romantiques à commencer par Chateaubriand, des modernistes avec Erich Mendelsohn et jusqu'aux postmodernistes et Jean Baudrillard – qui a enflammé l'imagination de générations de touristes.

La qualité première et caractéristique la plus unique de l'espace américain pour les Européens, de Tocqueville à Baudrillard, est sans doute son aspect – rural ou urbain – apparemment non-historique. Ses vastes étendues, apparemment inviolées par l'homme, étaient, comme le notait déjà Ruskin, autant mélancoliques que terrifiantes. De la même manière, les métropoles, encore marquées par les traces d'une fondation récente, symbolisaient tout ce que George Beard définissait comme «topophobique». Les tenants modernes de la théorie critique ont repris cette vision. Theodor Adorno, par exemple, tout en corrigeant le sophisme «romantique» du manque d'histoire de l'Amérique, prolonge néanmoins ce mythe du paysage «inviolé». En 1944, il écrit, à son retour d'Europe dans *Minima moralia, Réflexions sur la vie mutilée* : «Paysage. Ce qui manque aux paysages américains, ce n'est pas tant, comme le voudrait une

illusion romantique, qu'on n'y retrouve point de réminiscences historiques, mais plutôt le fait que sur eux la main de l'homme n'a pas laissé de traces. Ce n'est pas seulement qu'il n'y a guère de champs labourés et que les bois n'y sont souvent que des taillis non défrichés ; ce sont surtout les routes qui donnent cette impression. Elles coupent le paysage sans jamais aucune transition. Plus on les a tracées larges et plates – moins leur chaussée luisante semble à sa place dans cet environnement d'une végétation trop sauvage et plus elle semble lui faire violence. Ces routes n'ont pas d'expression. On n'y voit nulle trace de pas ni de roues, entre elles et la végétation il manque la transition d'un chemin de terre meuble qui les longe et il n'y a pas non plus de sentiers partant latéralement vers le fond de la vallée : il leur manque aussi cette douceur apaisante et ce poli qu'ont les choses où la main et les outils qui la prolongent directement ont fait leur œuvre. De ces paysages, on serait tenté de dire que personne ne leur a passé la main dans les cheveux. Ils sont inconsolés et désolants. À cela répond aussi la façon dont on les perçoit. Car, à la vitesse de la voiture, l'œil ne peut conserver ce qu'il ne fait qu'apercevoir au passage et qui disparaît ainsi sans laisser de traces, tout comme il ne laisse lui-même aucune trace[1].»

Mais, si le problème de l'espace américain a été, de Ruskin à Adorno, l'absence de traces humaines, son manque véritable d'histoire ou de culture fut cependant sa principale vertu, tant du point de vue du critique britannique en architecture Reyner Banham que du théoricien français postmoderne des médias Jean Baudrillard. Dans les deux cas, jugé à l'aune d'un sublime terrifiant ou craint, d'un vide inquiétant ou d'un infini passionné, les caractéristiques spatiales de l'Amérique ont représenté une sorte de point de référence absolu à la pensée aussi bien romantique que moderniste. En fait, au-delà de toute capacité à susciter une émotion ou à inspirer la rêverie, l'espace américain a souvent accepté le rôle de catégorie métaphysique dans l'imaginaire européen, une figure complexe qui intègre tous les niveaux d'appréciation esthétique et d'occupation sociale. Lorsque Adorno avait ce cauchemar d'une Amérique dans laquelle chacun se retrouvera endormi dans sa voiture sur des parkings d'asphalte, Banham dépliait sa bicyclette de voyage et pédalait dans le désert comme si personne n'avait jamais mis auparavant le pied dans les sables arides de l' «America Deserta» et Baudrillard traversait le pays jusqu'à Las Vegas en s'arrêtant à peine, sauf pour noter au vol ses doucereux *Cool Memories.* Inévitablement, naturellement, la réalité est plus complexe. Ces paysages mythiques

forment en un sens tant de « géographies magiques » – par analogie au « réalisme magique » de la littérature et du cinéma latino-américains contemporains – qu'ils construisent ce que le critique littéraire Fredric Jameson a défini comme « des histoires avec des trous » : incomplètes, fusionnant réalité et mythe, rêve et réalité. À une époque où l'on peut même « rêver » le meurtre, on peut comprendre une fois encore la puissance de telles constructions mythiques qui ont pour effet de créer couche après couche une géographie magique qui supplante et neutralise la géographie réelle.

Bien que Jeff Dunas soit Américain et que soit présentée ici sa vision personnelle de ce pays et de son peuple, il est en un sens également un exilé, un visiteur venu d'un autre pays qui trouve ces scènes étranges en raison de sa propre capacité au détachement. Pour le critique Walter Benjamin, le détachement était cette qualité des choses qui les rend visibles pour la première fois, un cadrage de la banalité et de la scène déjà connue réalisé de manière à lui rendre une surprenante fraîcheur, un caractère aigu et évocateur capable de dépasser la routine et d'anéantir le cliché. C'est avec son sens du cadrage et dans les zones de recouvrement de ces différentes géographies que travaille Dunas. S'opposant à ces mythes de vacuité, il a réussi à saisir une autre géographie et une autre Amérique, celle qui lutte pour se faire une place au milieu du néant ; une place qui, même oubliée et abandonnée à la rouille au milieu des mauvaises herbes par les puissances économiques et sociales, conserve toute son humanité, toute son apparence de quotidienneté ordinaire et, finalement, toute sa présence. Contre le mythe urbain du « rien au-delà de la cité », il offre le portrait documenté d'un pays et d'un peuple dont le seul monument est leur contexte vital, aussi miséreux et réduit qu'il soit. S'il ne s'agit pas d'un pays aux monuments, à l'architecture ou à l'urbanisme imposants, il en devient tout aussi grandiose par ses enseignes effacées témoignant de la majesté d'une occupation humaine ou par ce voyageur qui l'observe et arrête sa caravane pour le cadrer dans son objectif.

Anthony Vidler
Los Angeles et Barcelone, Juin 2001

Après avoir suivi une formation en architecture et en histoire de l'art à Cambridge (Angleterre), Anthony Vidler a enseigné pendant trente ans l'architecture et la culture européenne à l'université de Princeton et exercé les fonctions de directeur du collège d'Architecture, d'Art et d'Urbanisme de l'université Cornell. Il enseigne aujourd'hui à l'UCLA, où il occupe la chaire du département d'histoire de l'Art et d'Architecture. Il a publié de nombreux ouvrages sur l'art et l'architecture, notamment The Architectural Uncanny *et* Warped Space, *aux éditions MIT Press.*

1. Theodor Adorno, *Minima Moralia : Réflexions sur la vie mutilée,* traduit de l'allemand par Eliane Kaufholz et Jean-René Ladmiral (Paris, Payot, 1980, p. 50).

AMERICAN PICTURES

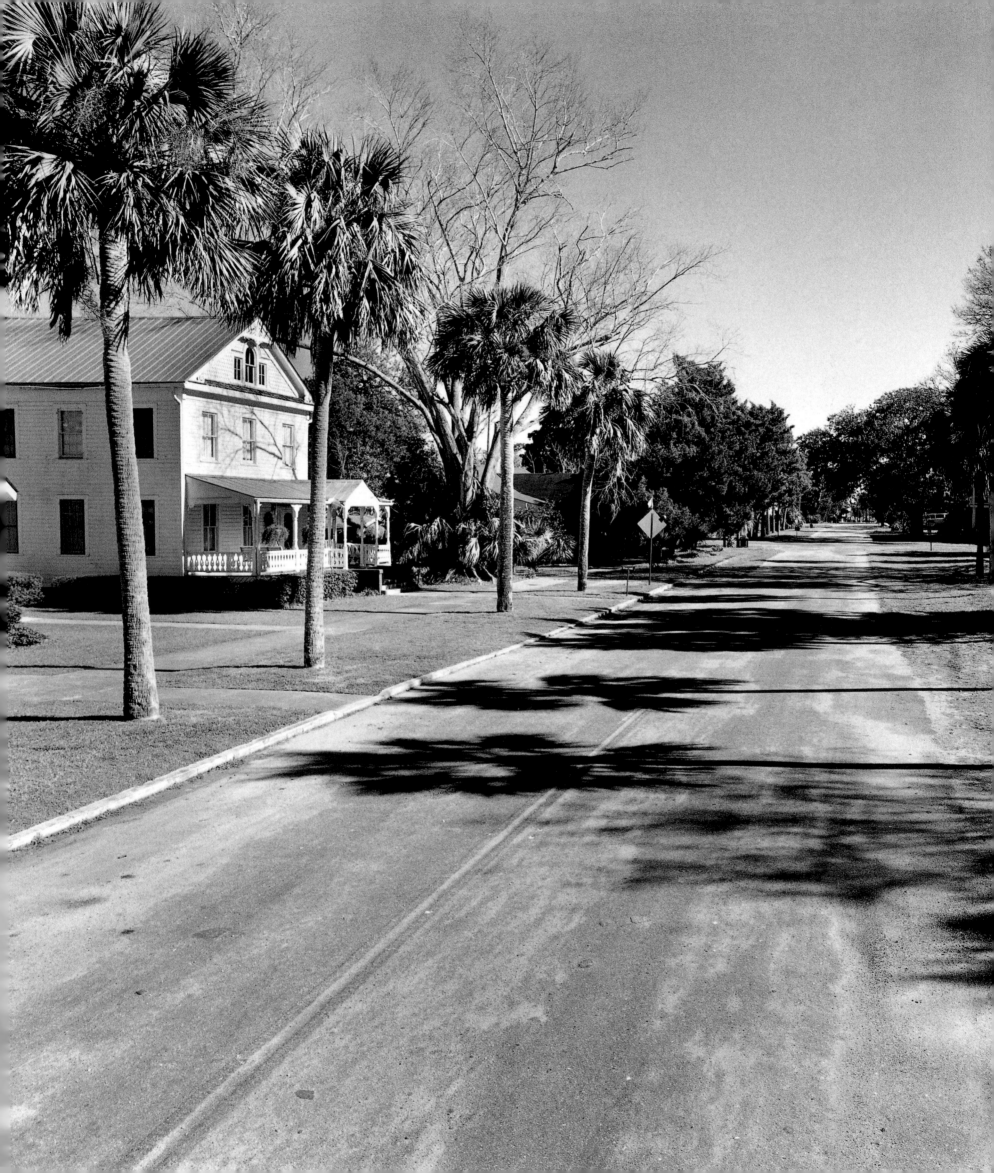

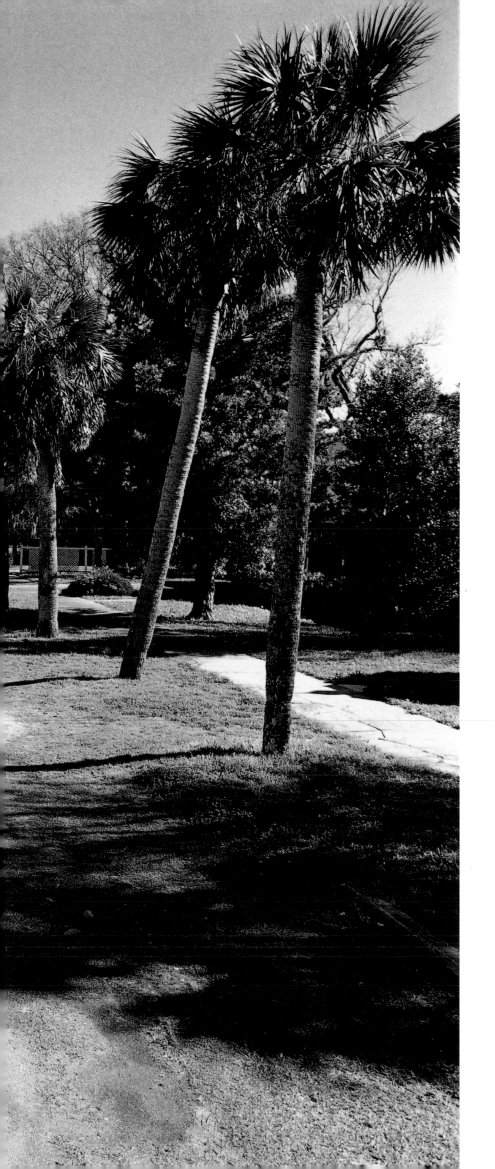

UNTITLED 2
Apalachicola, Florida 1999

3 PORCH DETAIL
Vicksburg, Mississippi 1996

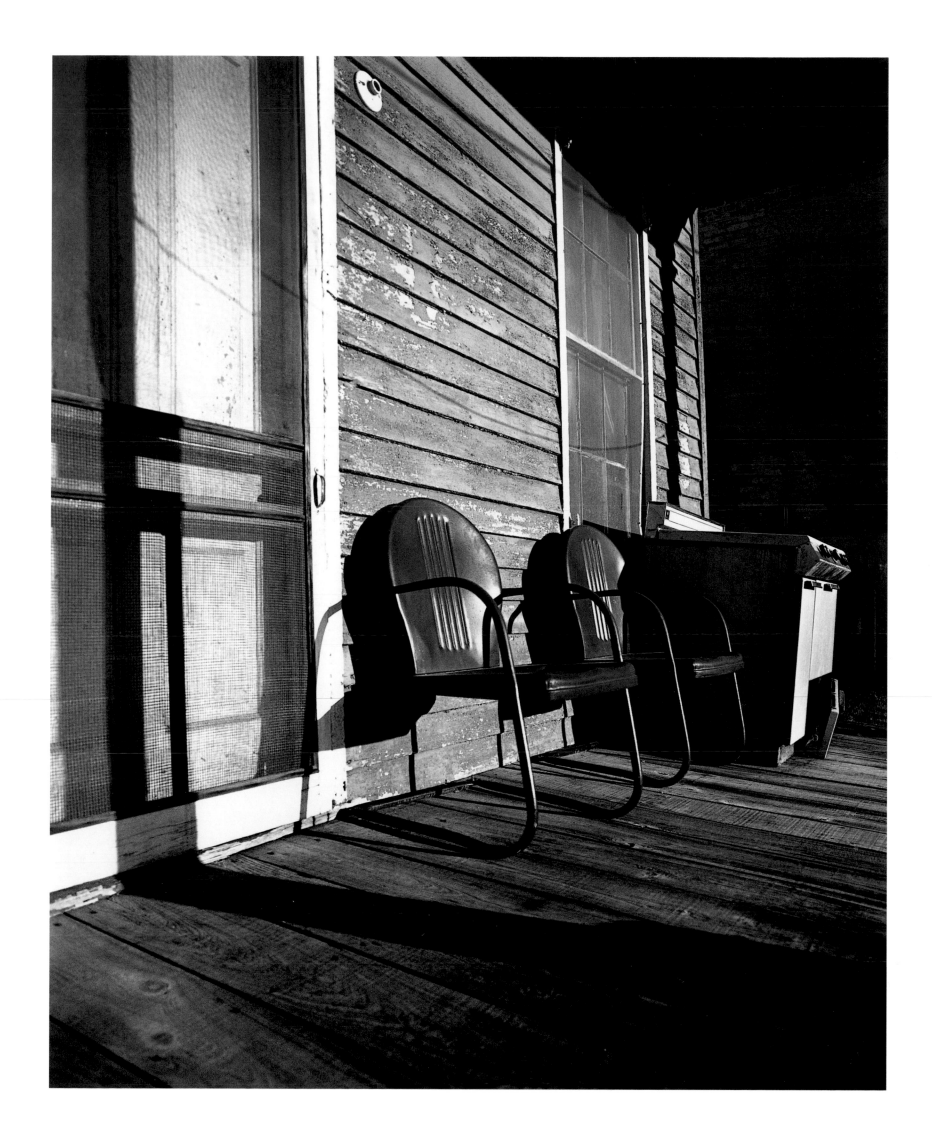

4 LINGER LONGER R.V. PARK
Anclote Harbor, Florida 1999

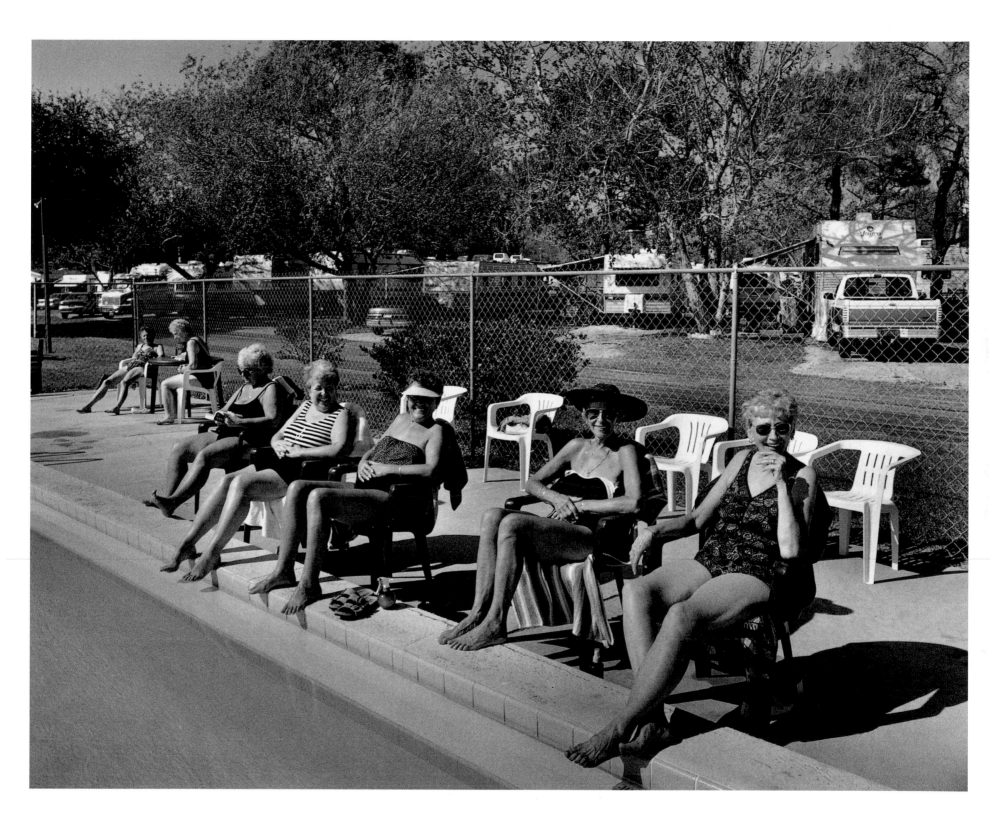

5 JAMES BRANNON
Panama City, Florida 1999

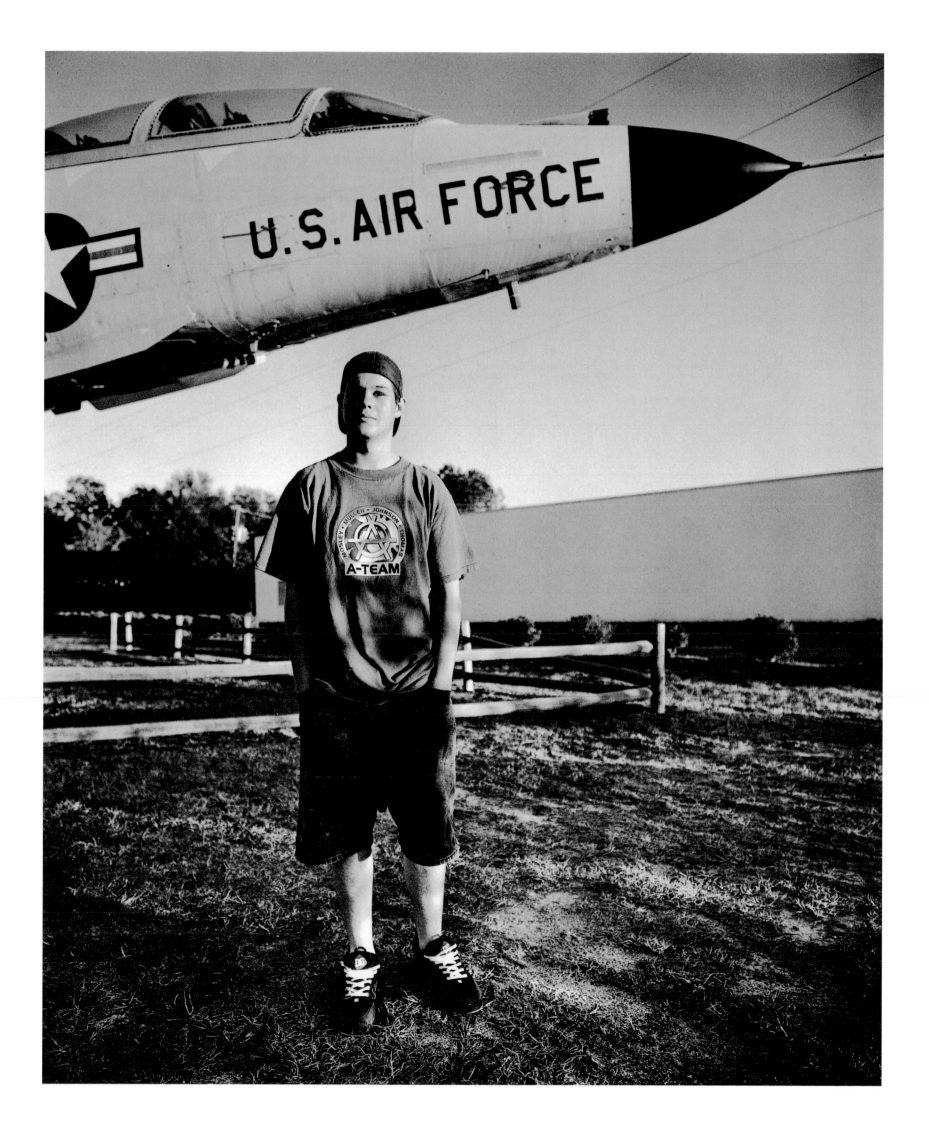

6 UNTITLED
Lewelen, Nebraska 1993

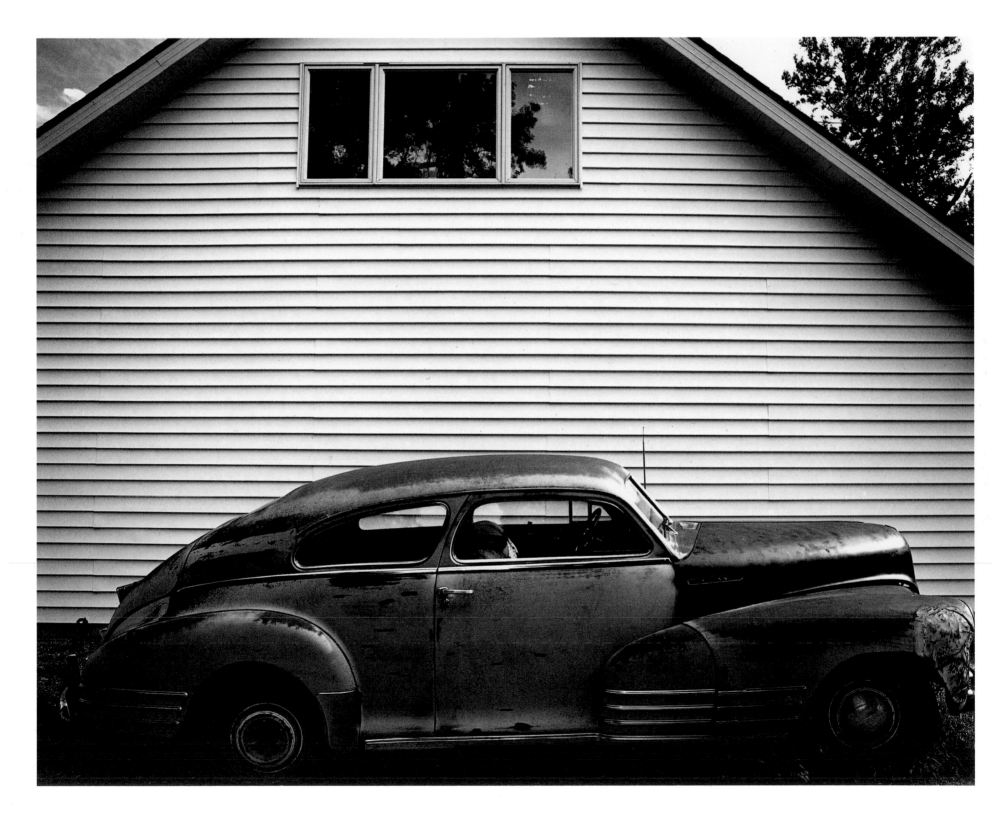

7 HIGHWAY 90

Orleans Parish, Louisiana 1999

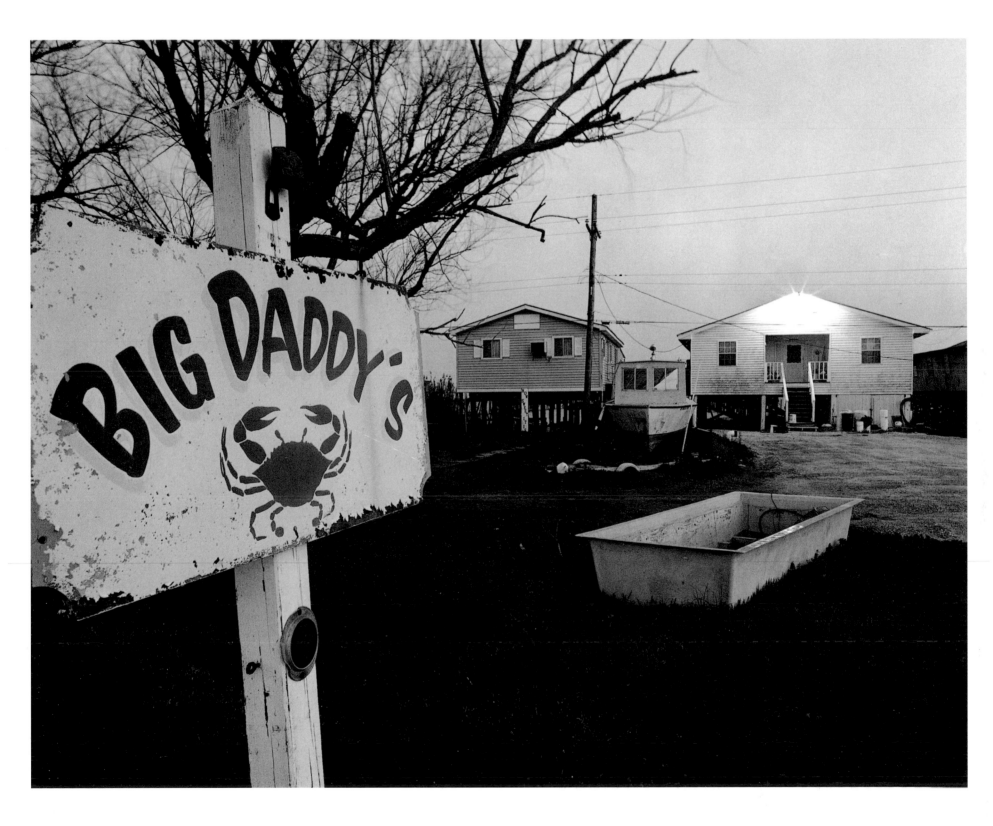

8 UNTITLED
Palacios, Texas 1999

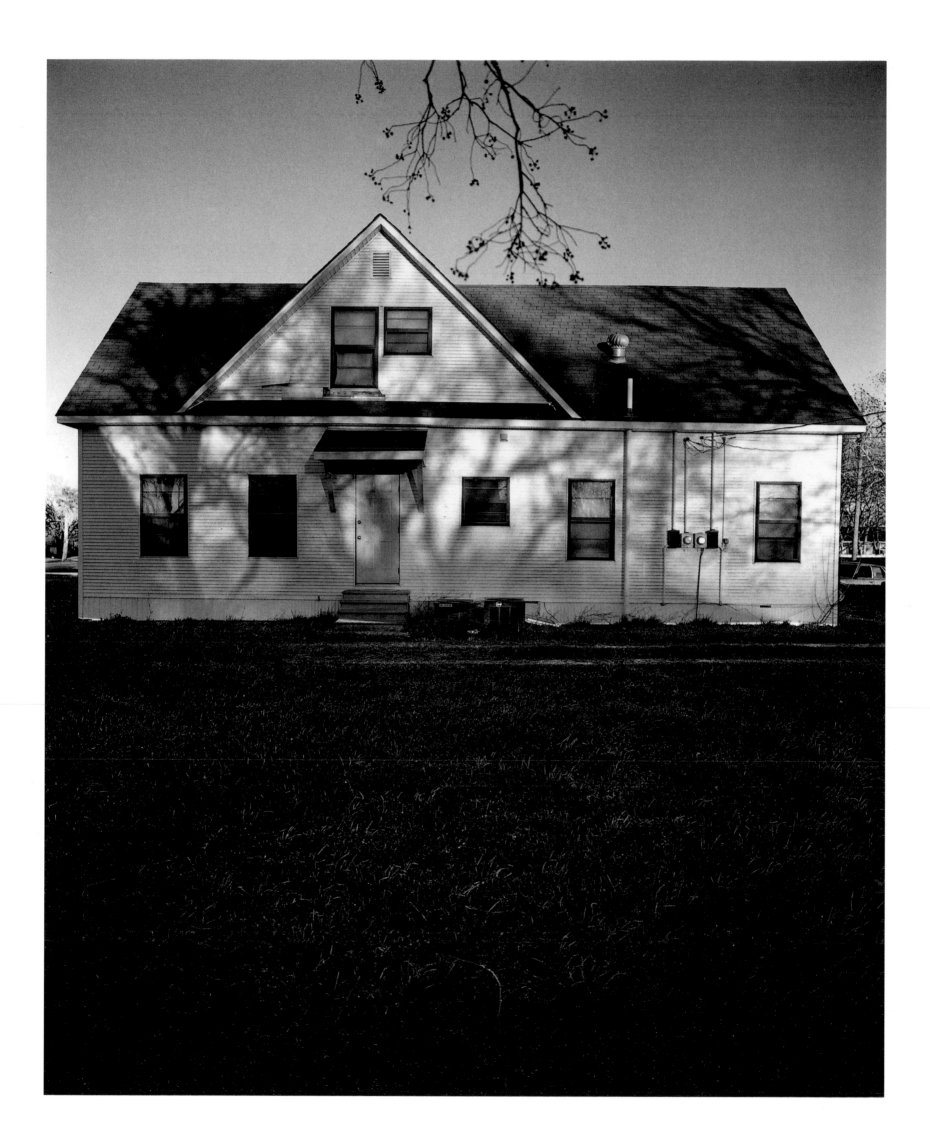

9 AUTO ARTIFACTS
Golden Meadows, Louisiana 1999

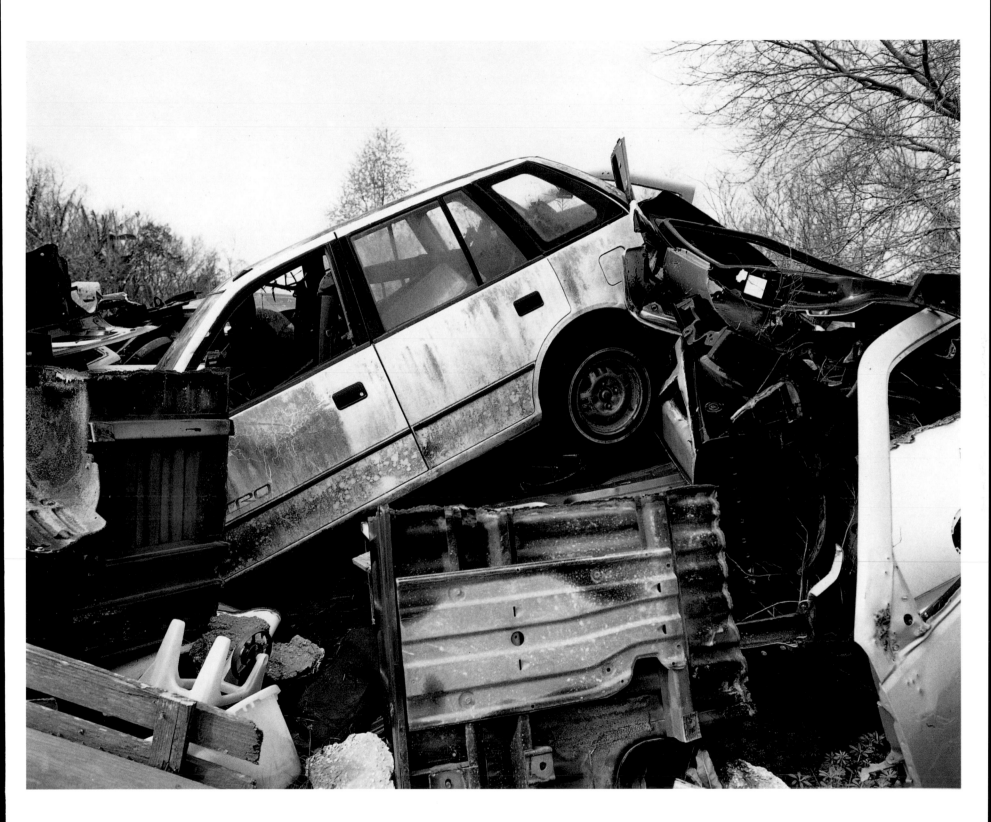

10 FUN IN THE SUN

Lava Hot Springs, Idaho 1993

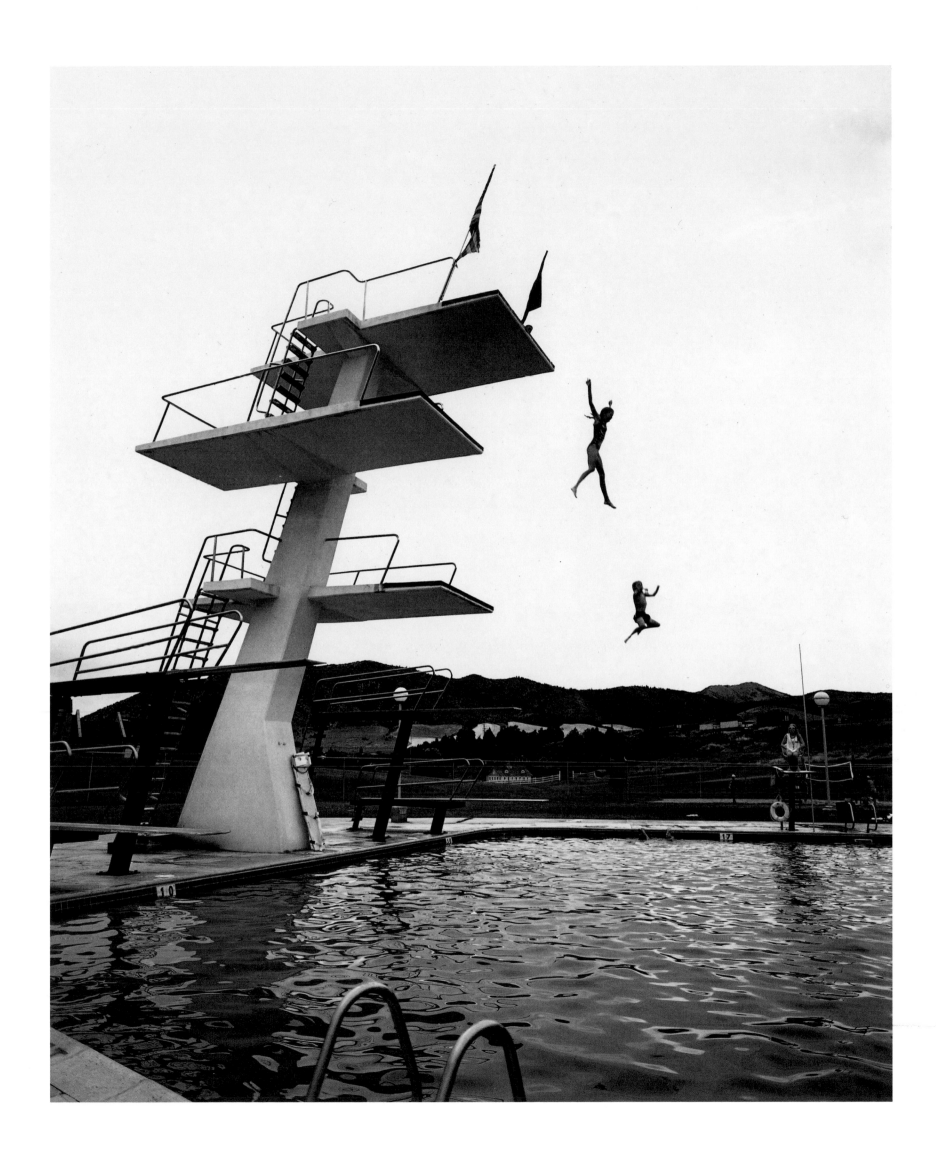

11 CRYSTAL BEACH

Bolivar Penninsula, Texas 1999

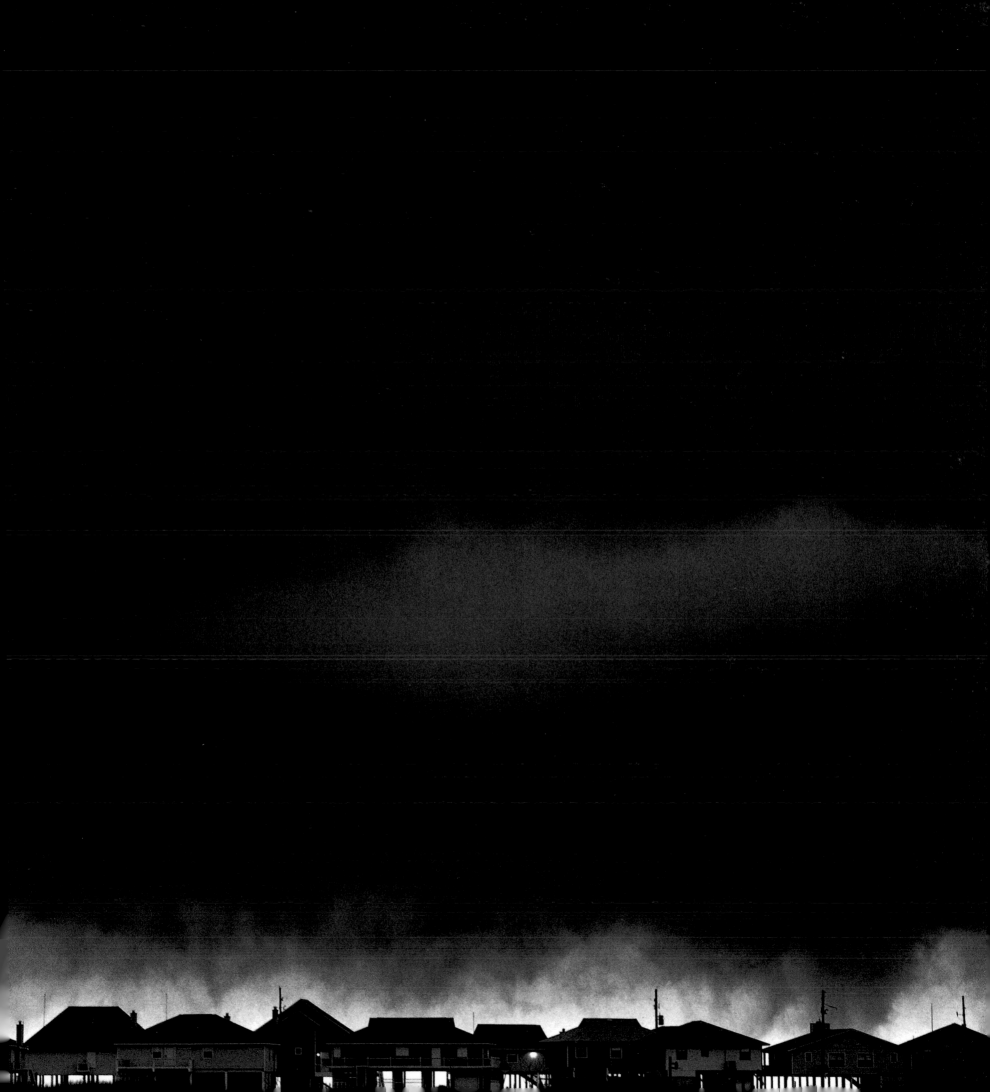

12 THE TREICHELS

The Dalles, Oregon 1993

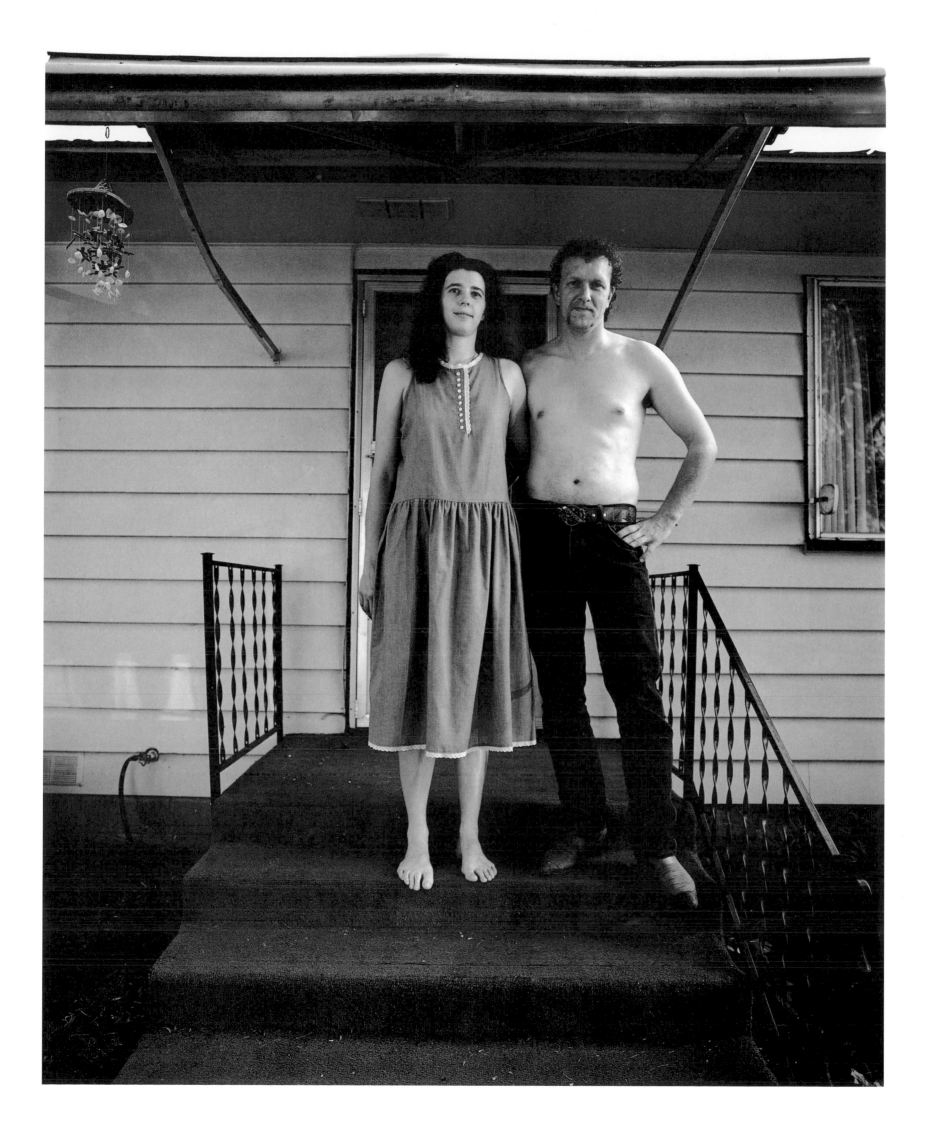

13 OLD FRIEND

Green River, Wyoming 1993

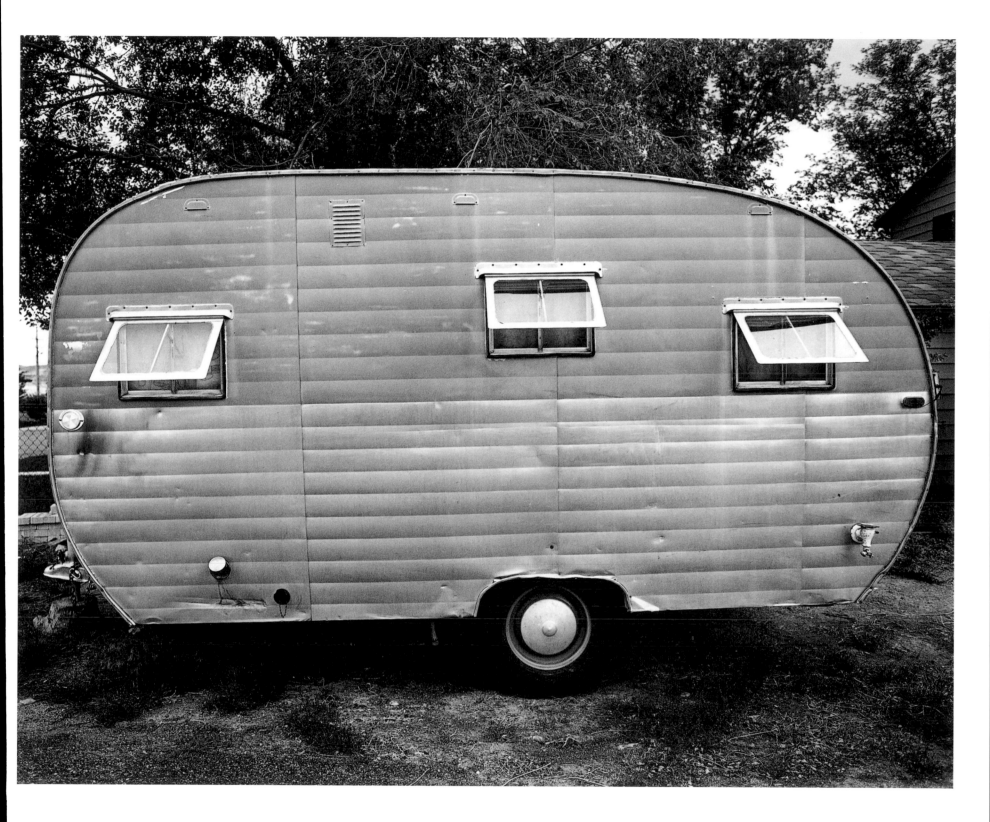

14　CRYSTAL BEACH CITY LIMIT

High Island, Texas 1999

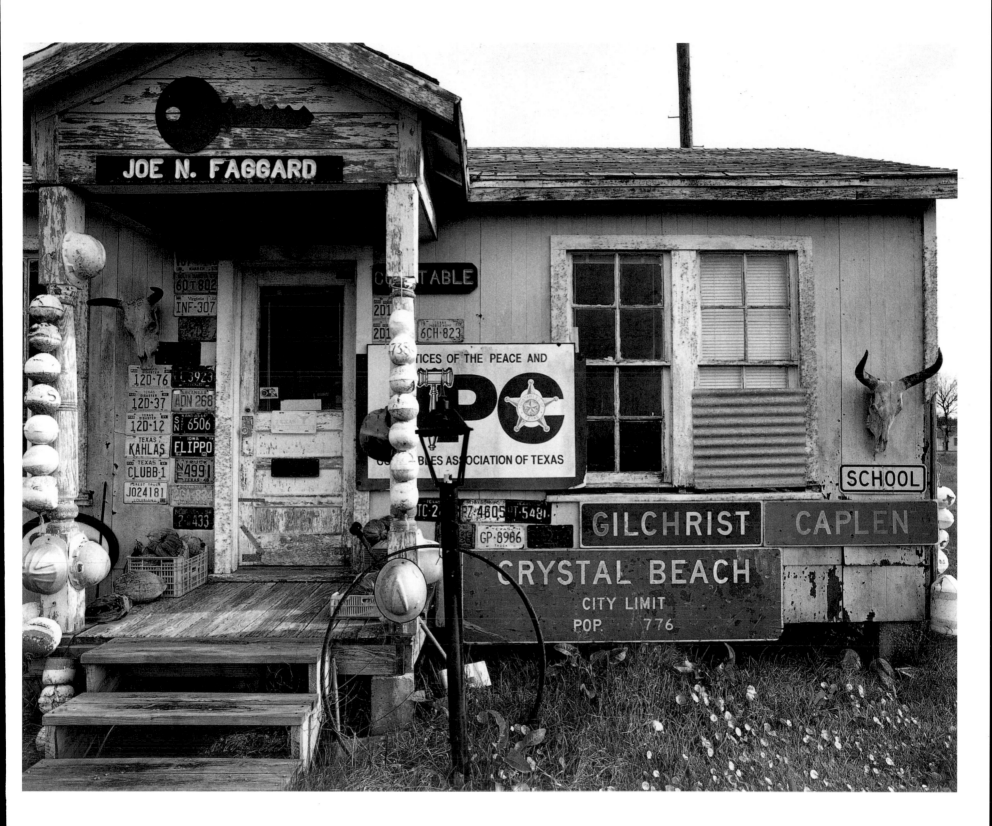

15 UNTITLED
Galveston, Texas 1999

16 HI-WAY BAR

Wamsutter, Wyoming 1993

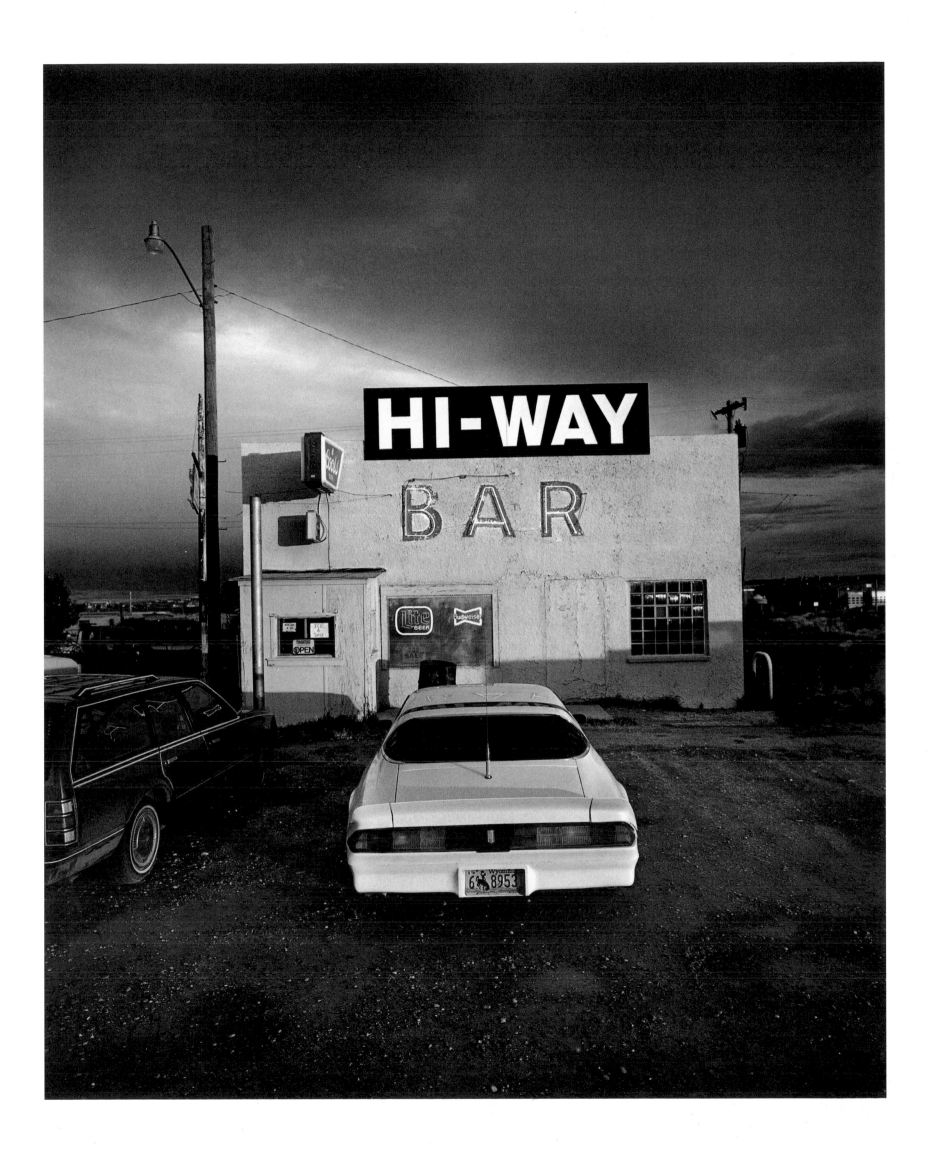

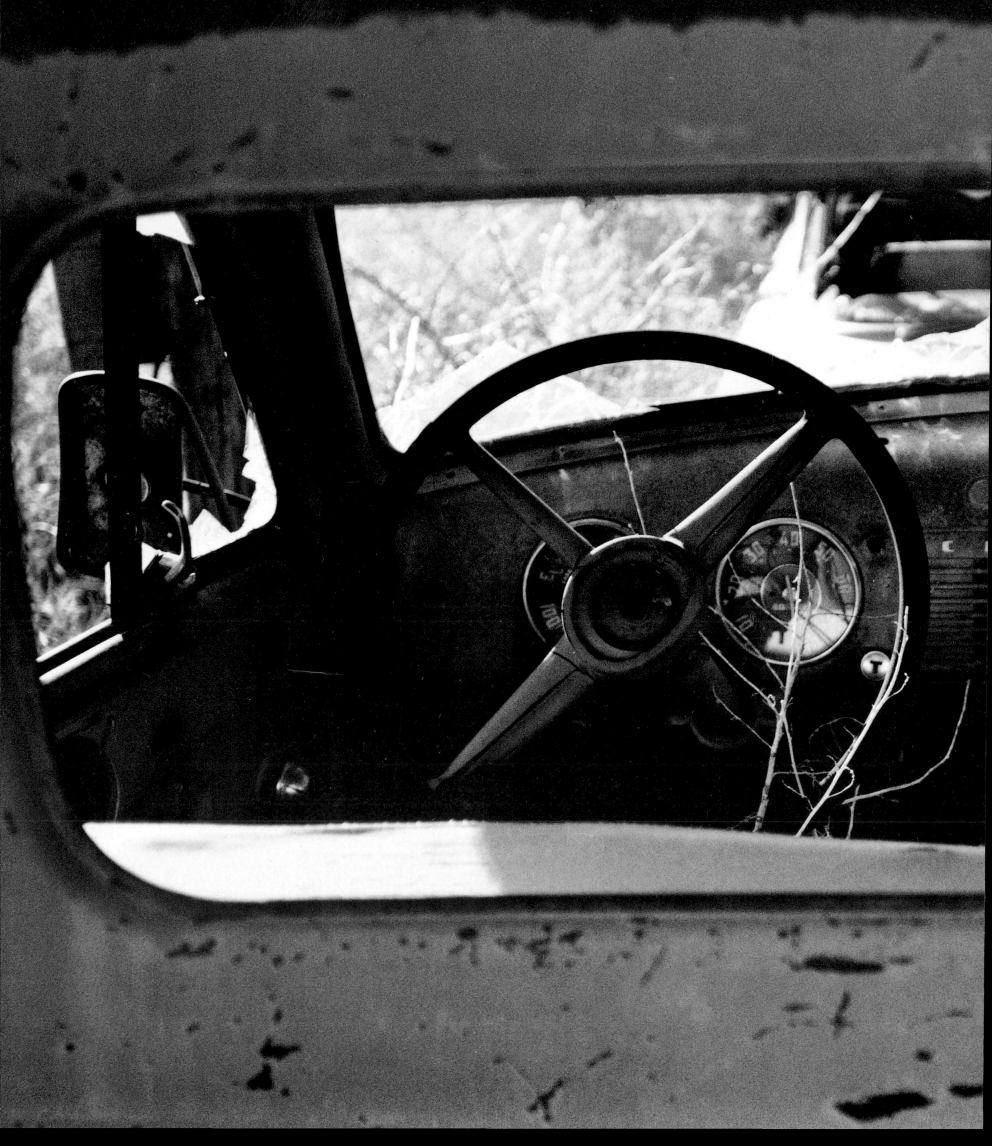

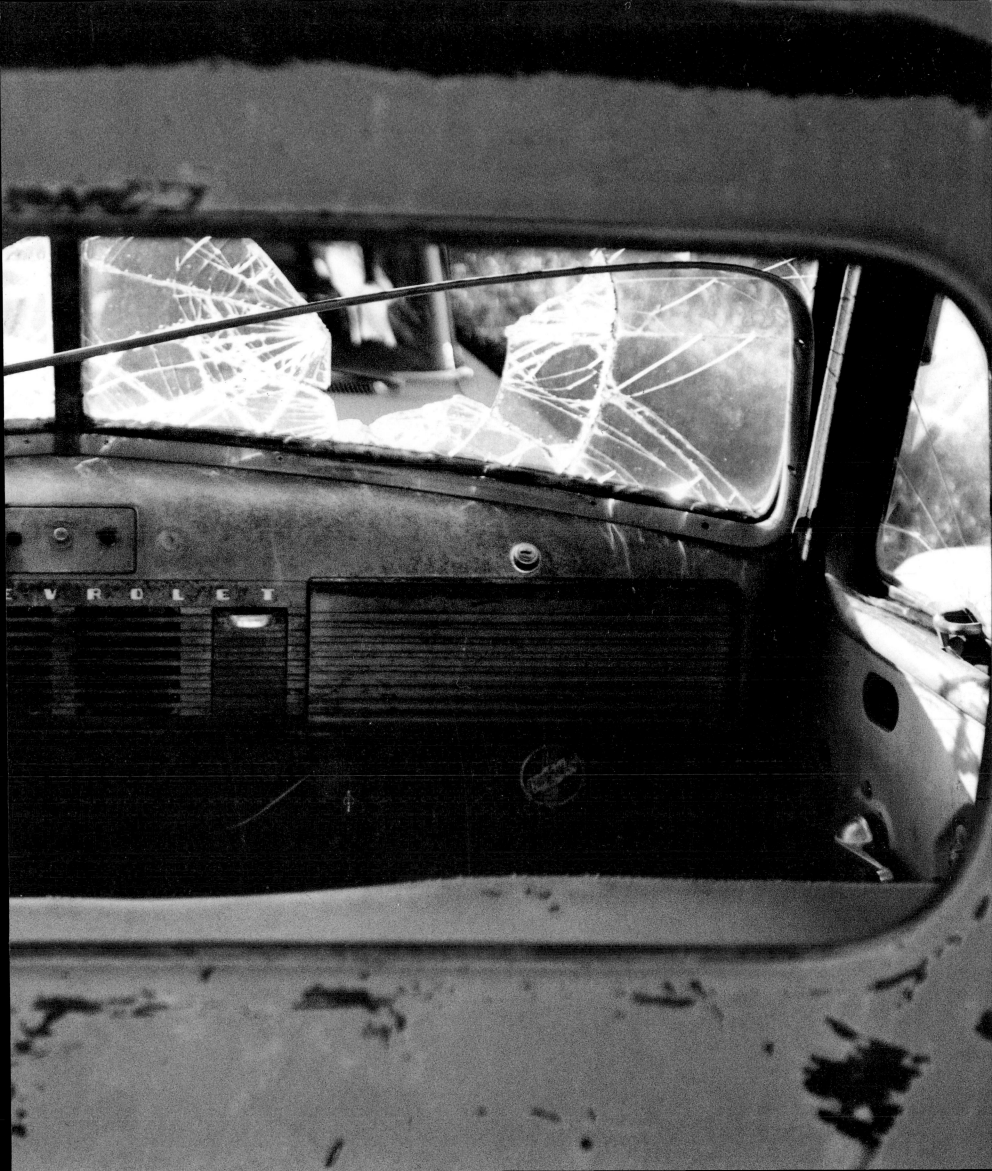

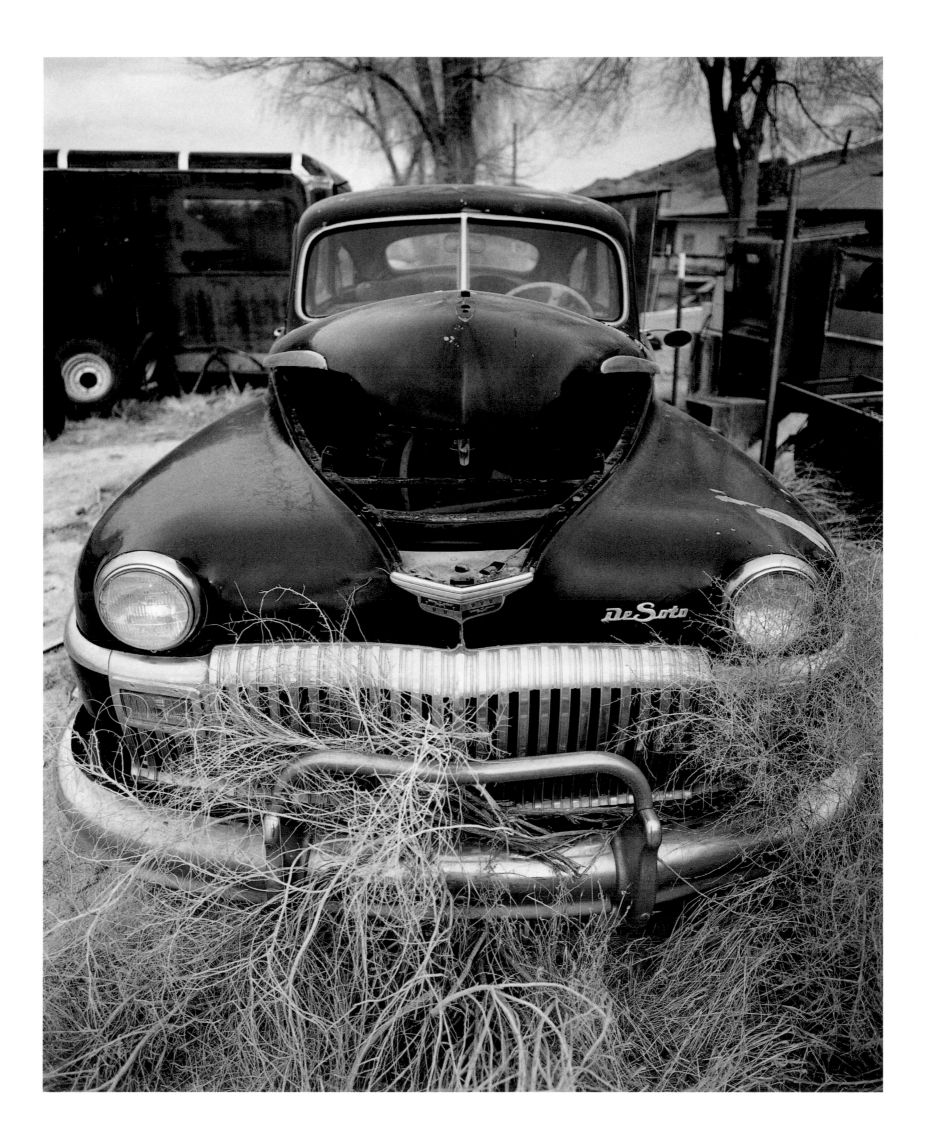

19 HANGING OUT IN FRANKLIN

Franklin, Louisiana 1999

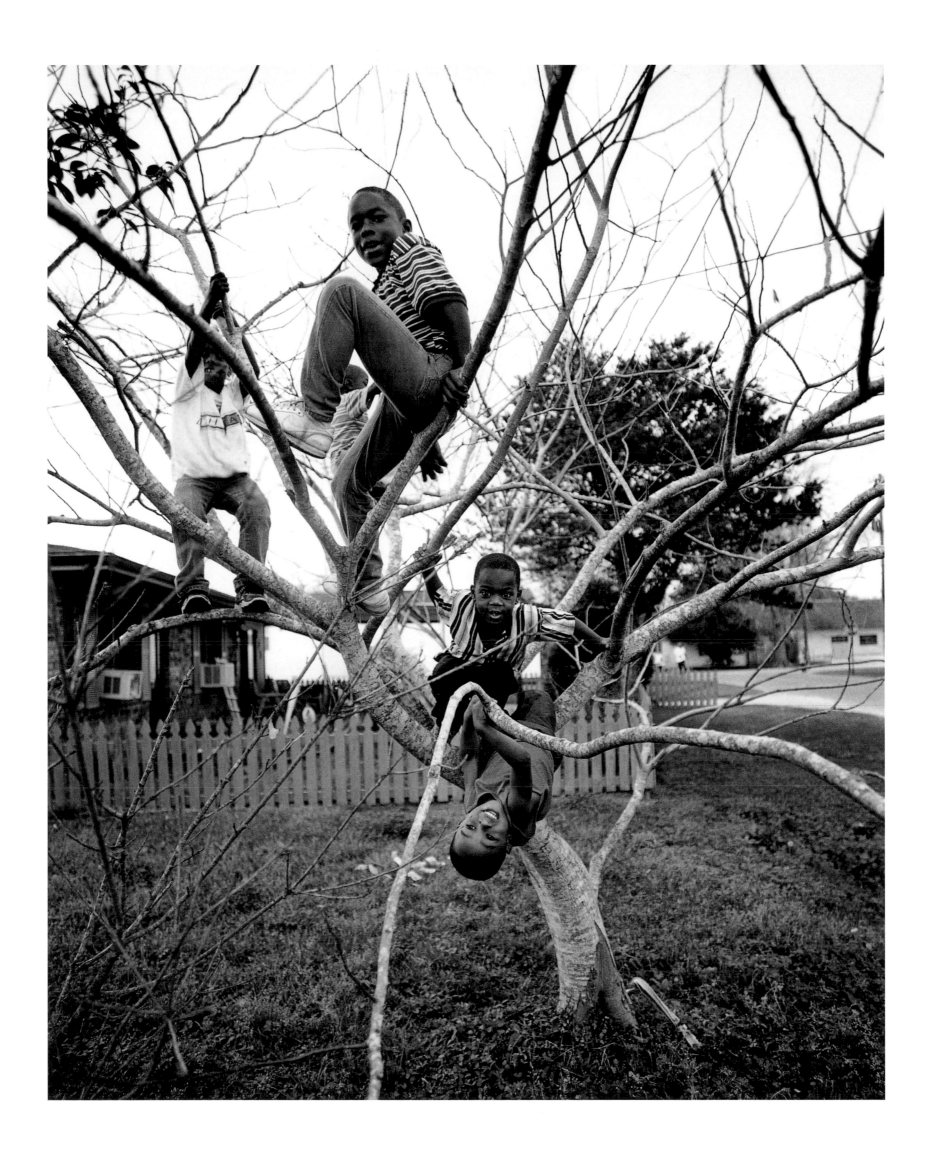

20 ED KALENDA

Quartzside, Arizona 1994

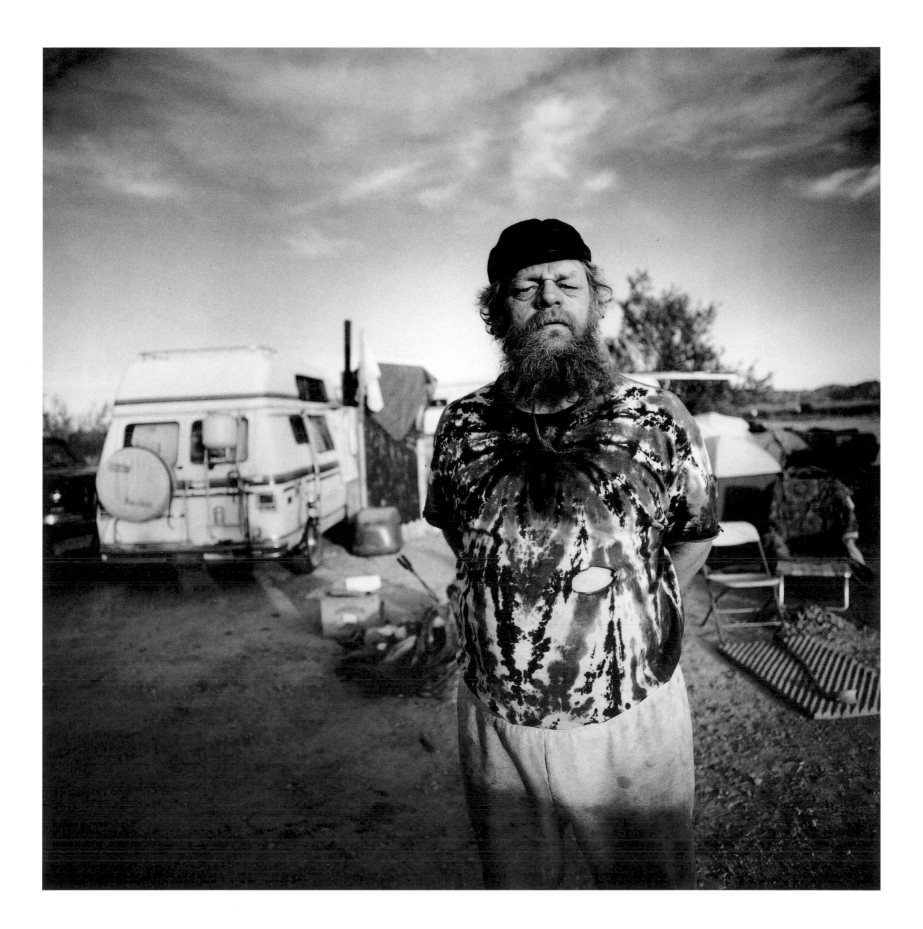

21 UNTITLED

High Island, Texas 1999

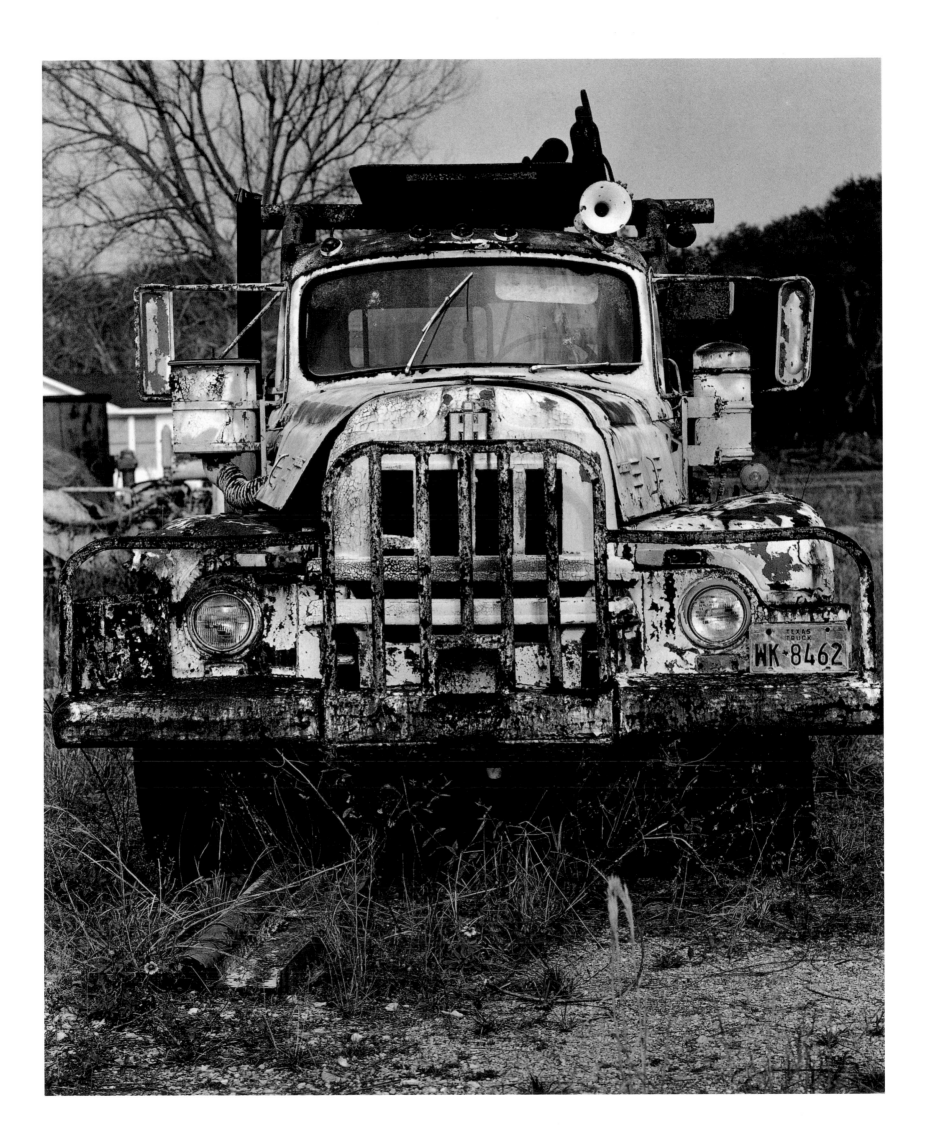

22 UNTITLED

Harlingen, Texas 1999

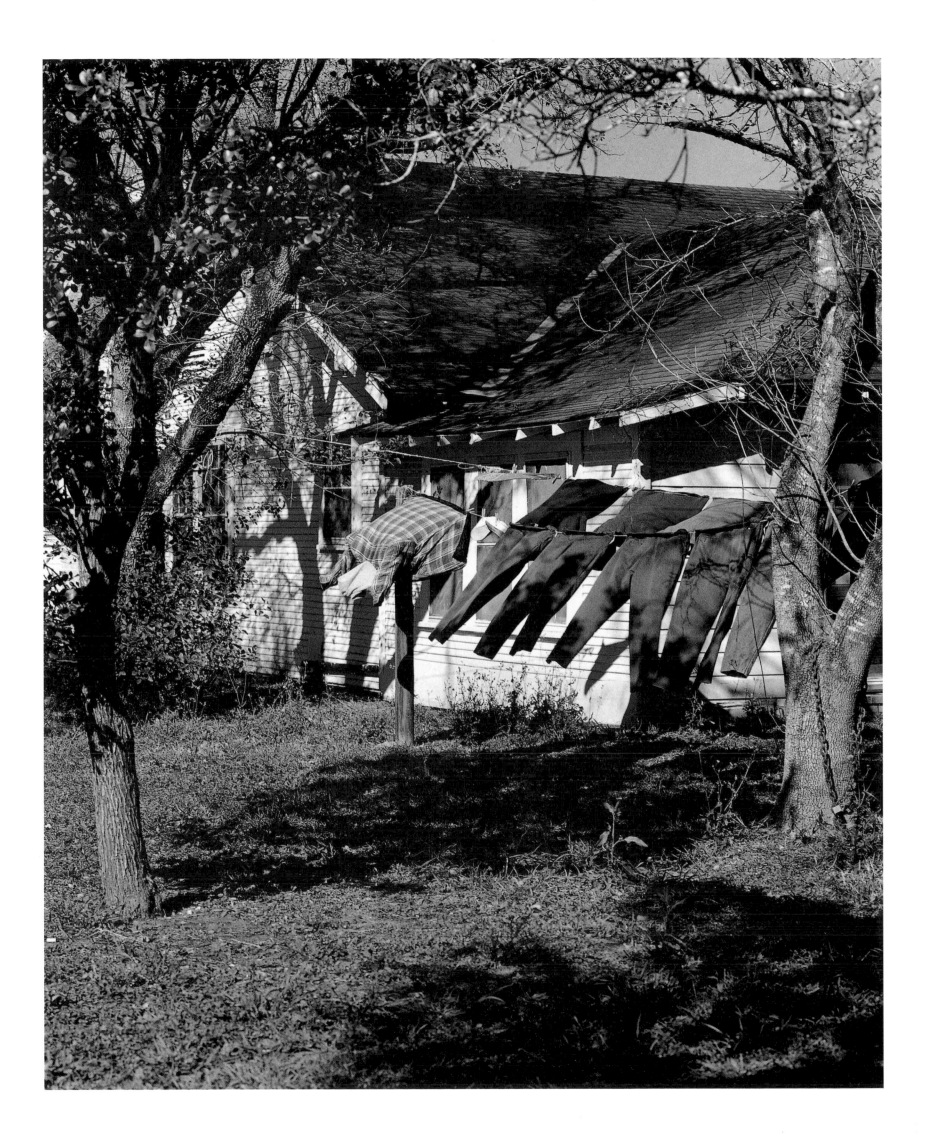

23 EL RANCHO VERDE MOTEL

Blythe, California 1995

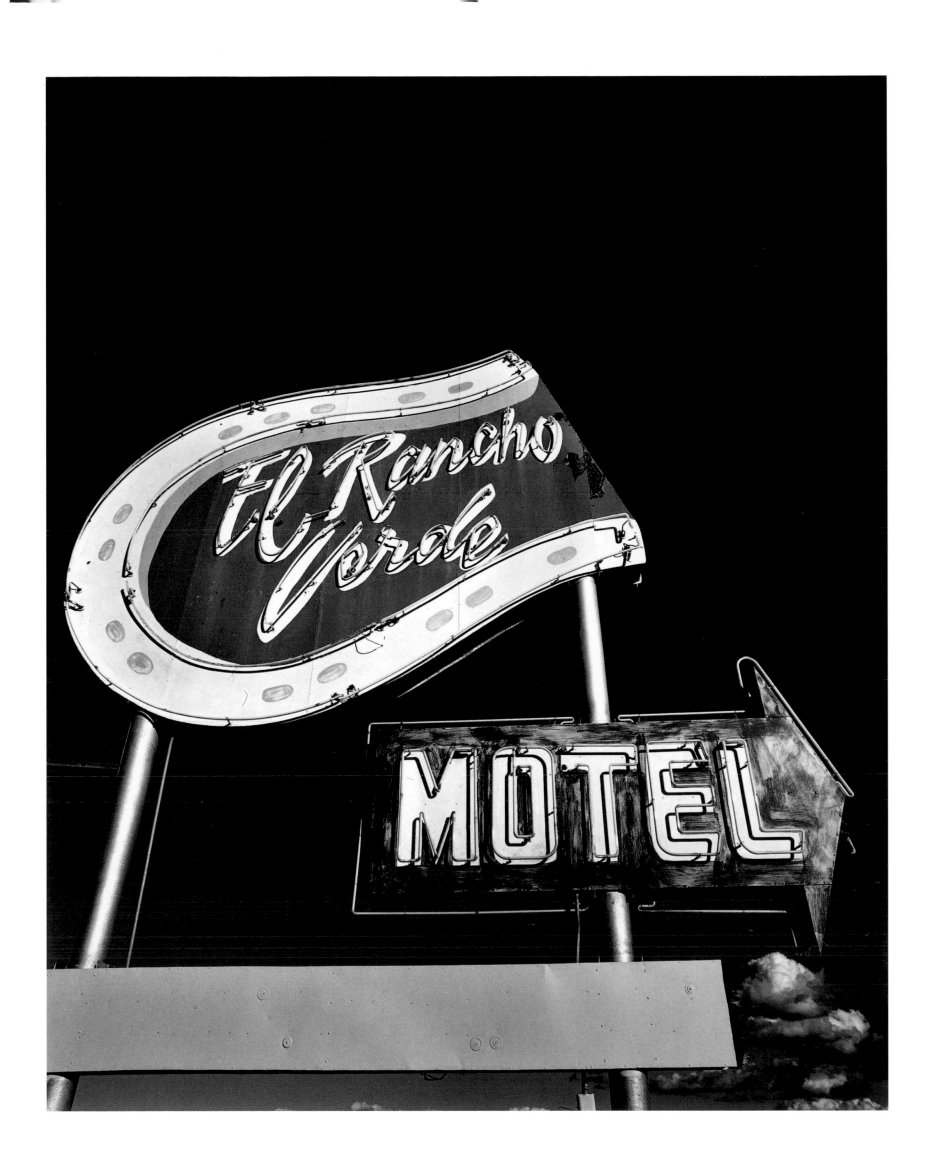

24 UNITED METHODIST CHURCH

Heppner, Oregon 1993

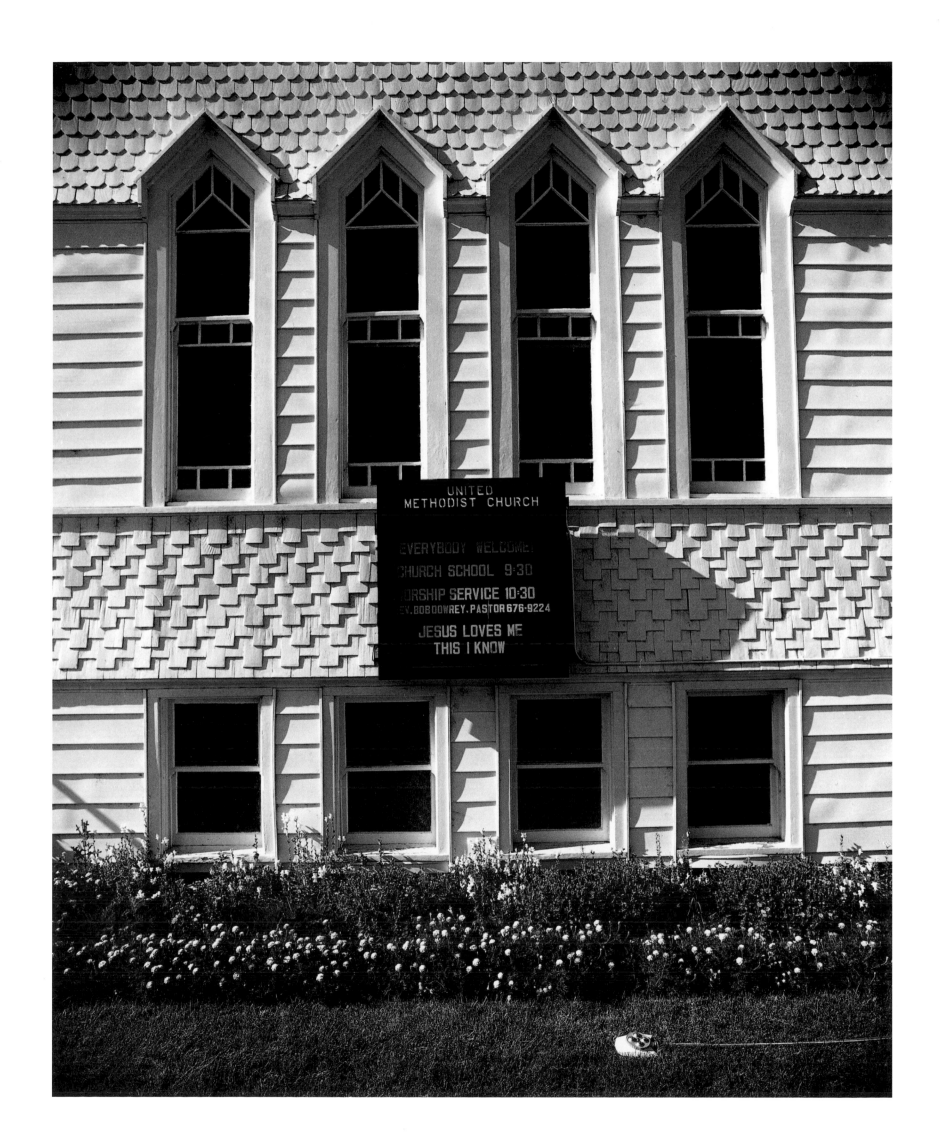

25 RAILROAD AVENUE

Franklin, Louisiana 1999

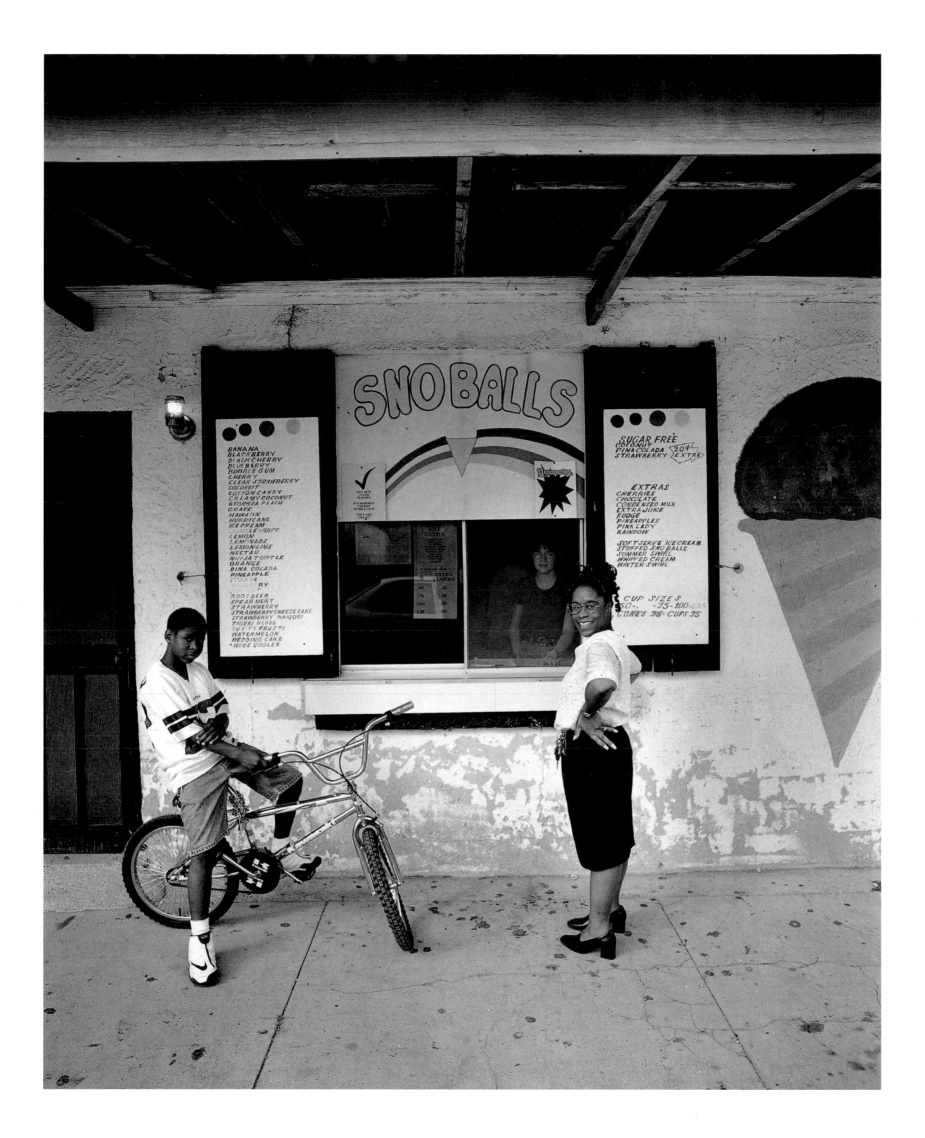

26 UNTITLED

Beatty, Nevada 1995

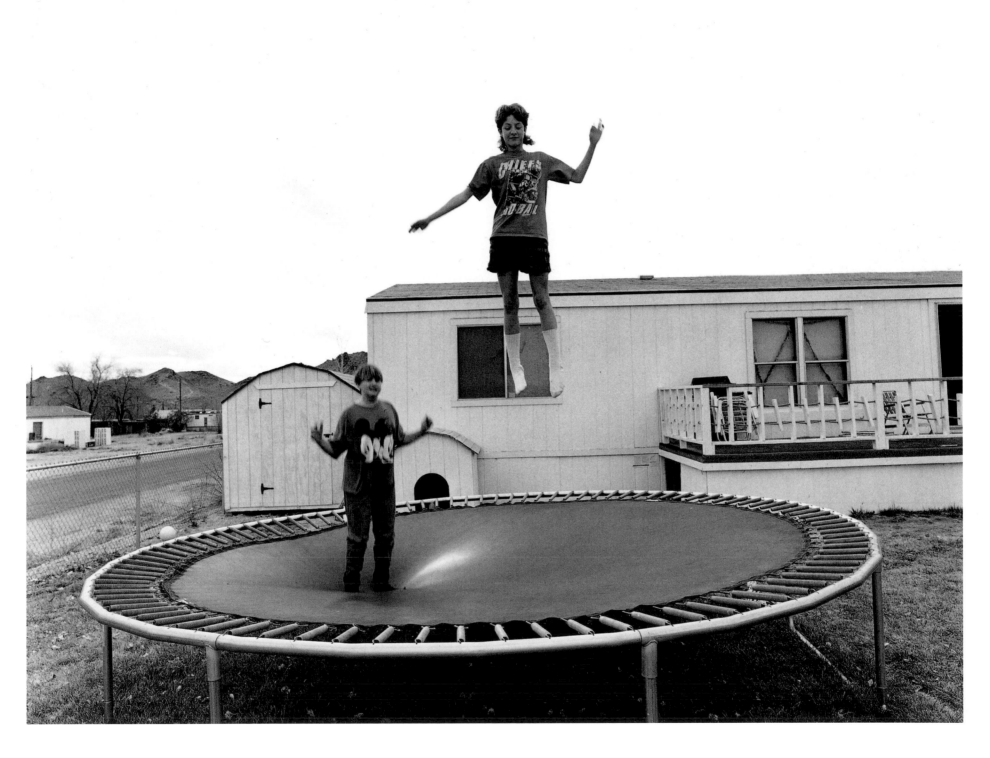

27 UNTITLED
Maxwell, Nebraska 1993

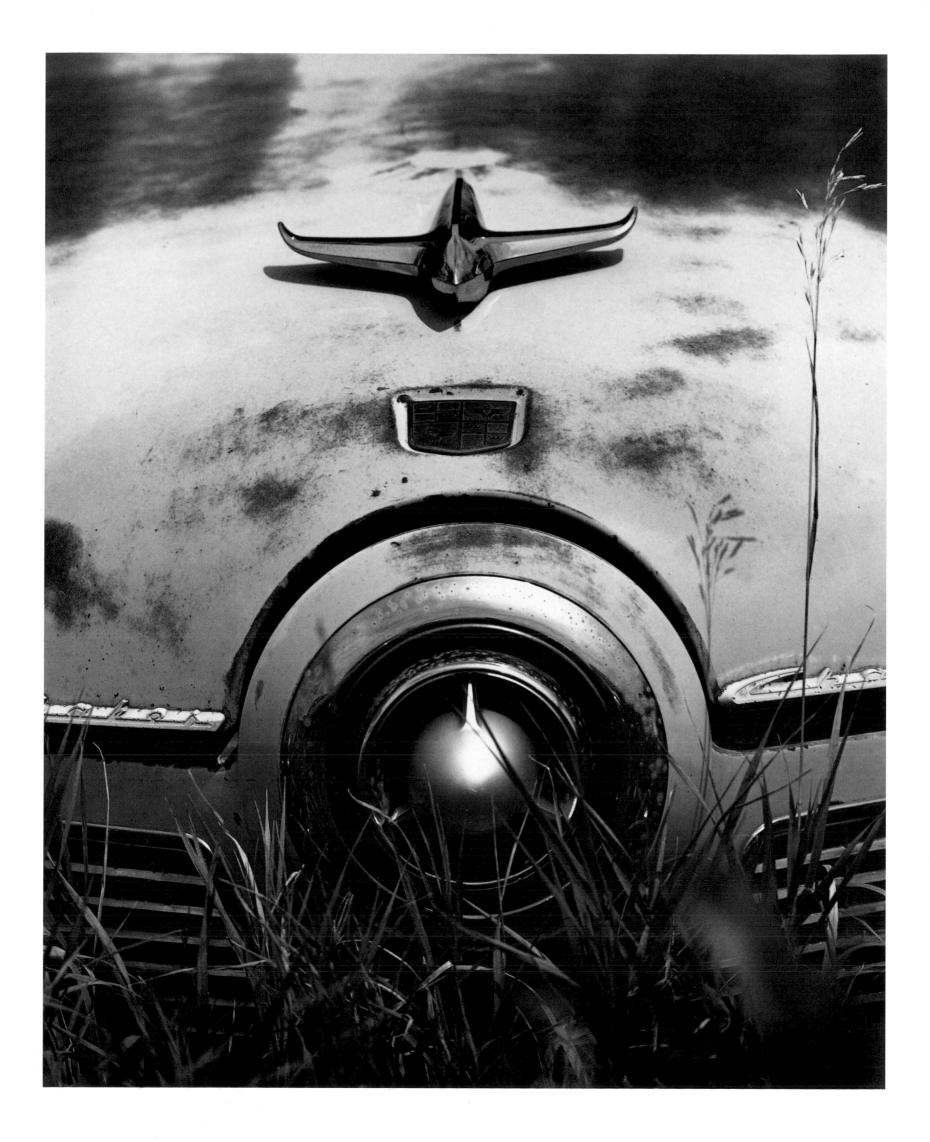

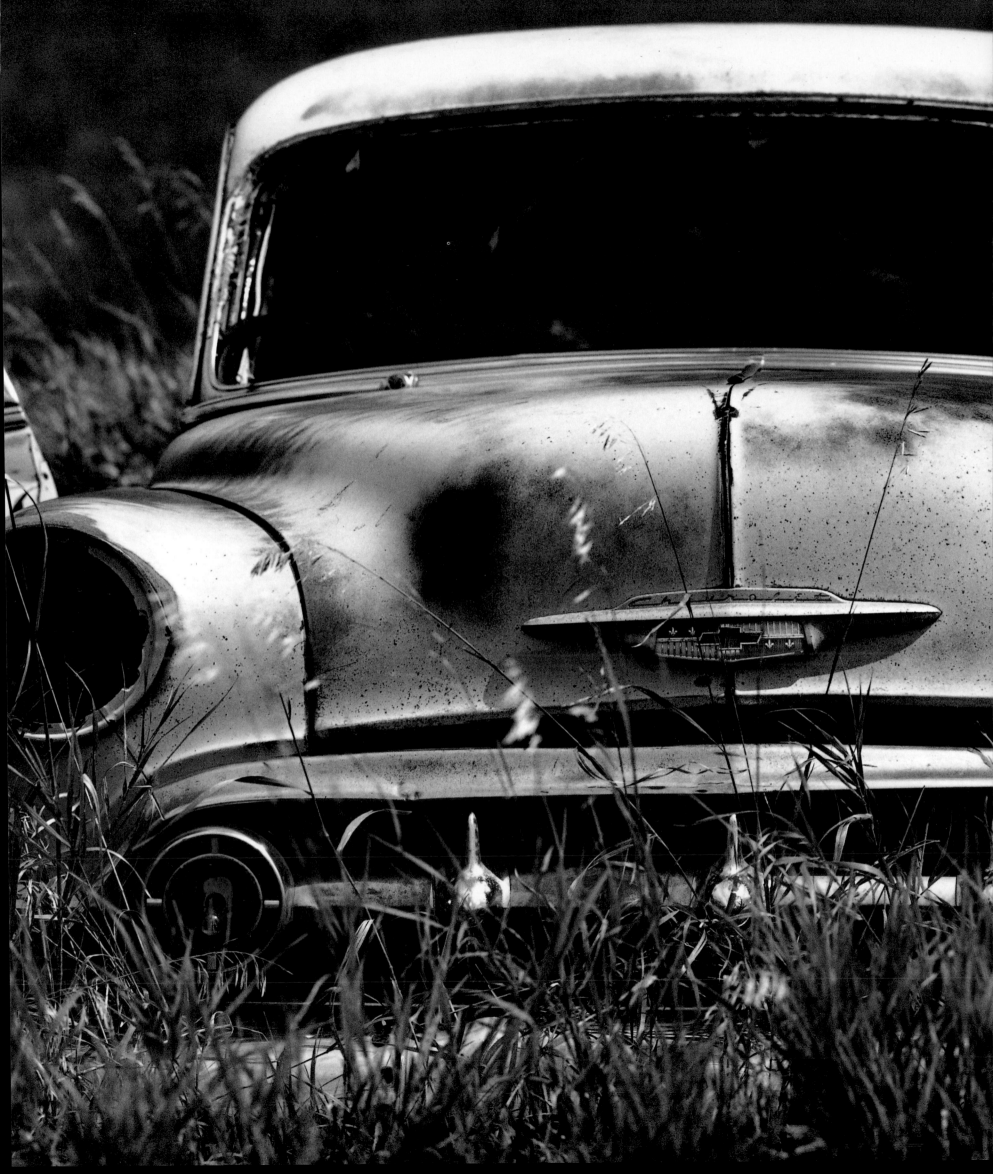

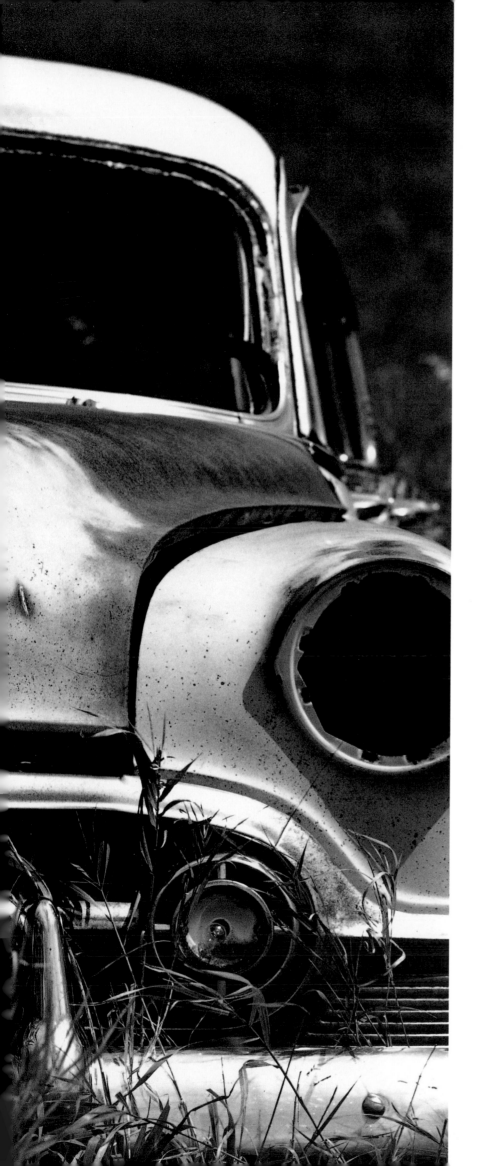

UNTITLED II 28

Maxwell, Nebraska 1993

29 OAK STREET

La Grande, Oregon 1993

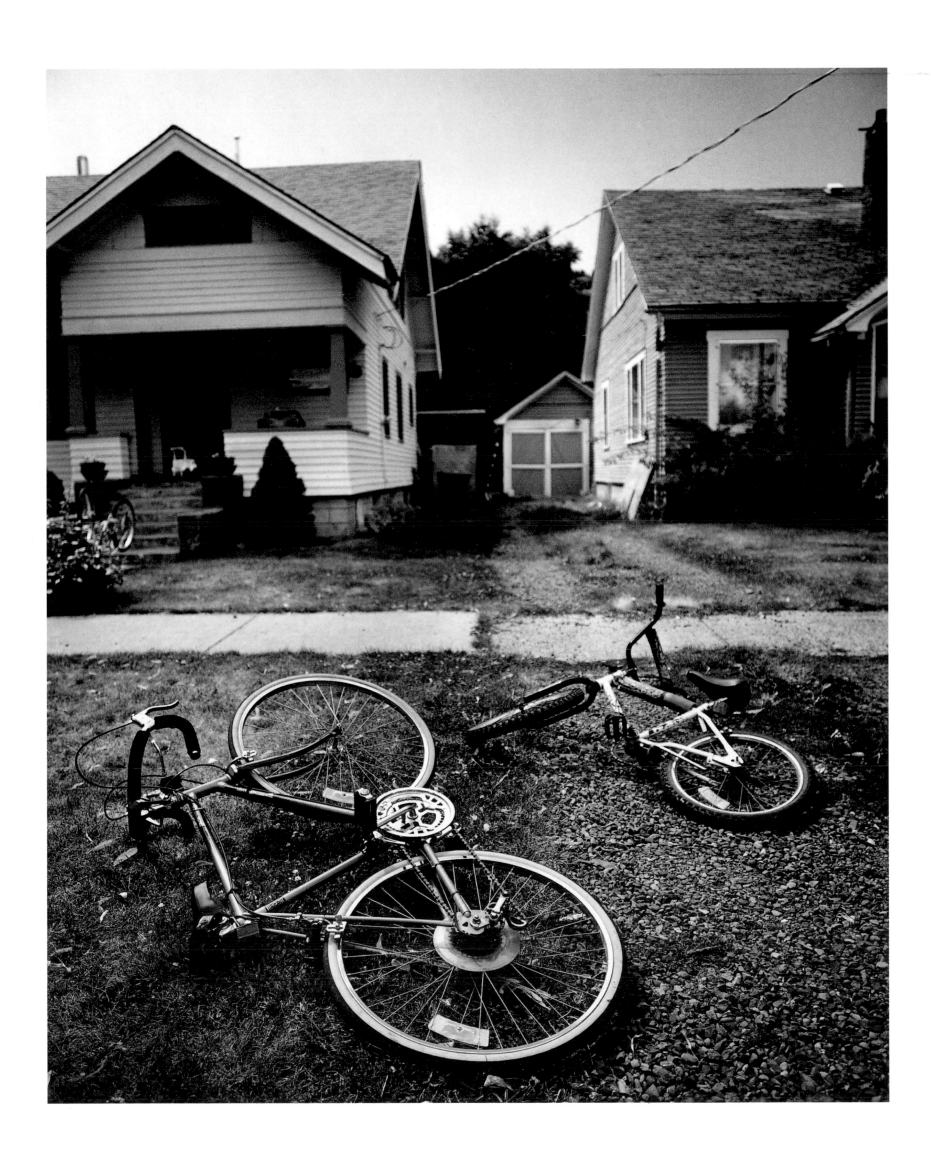

30 UNTITLED

Tunica, Mississippi 1997

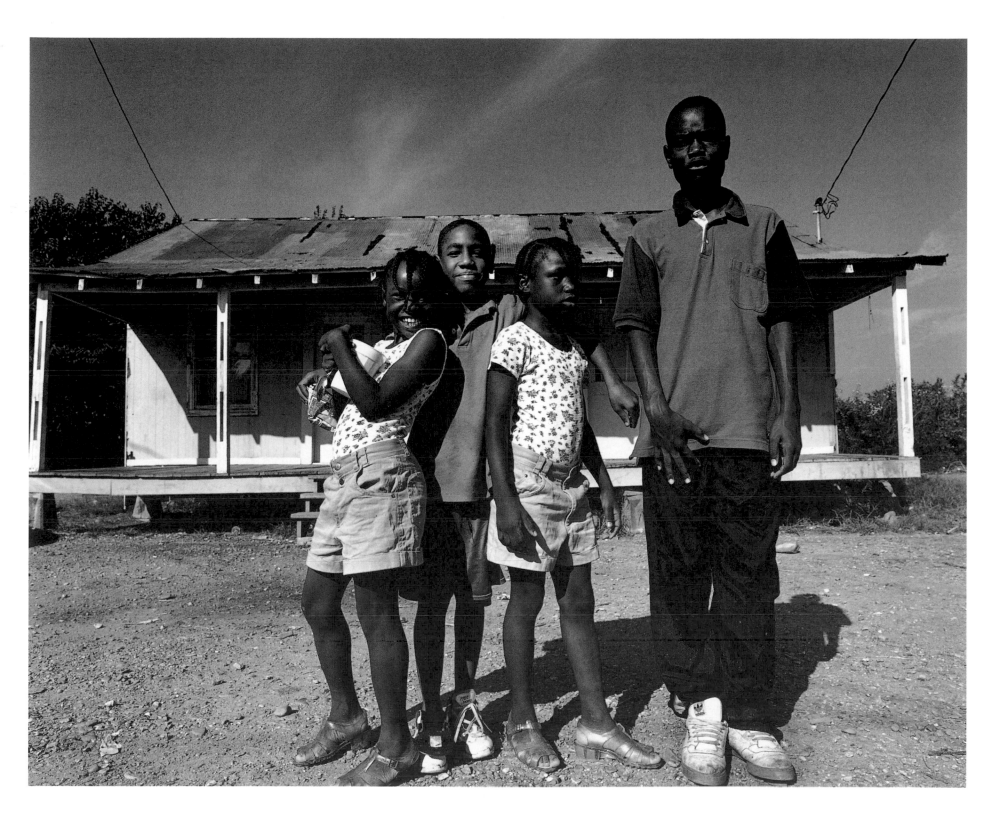

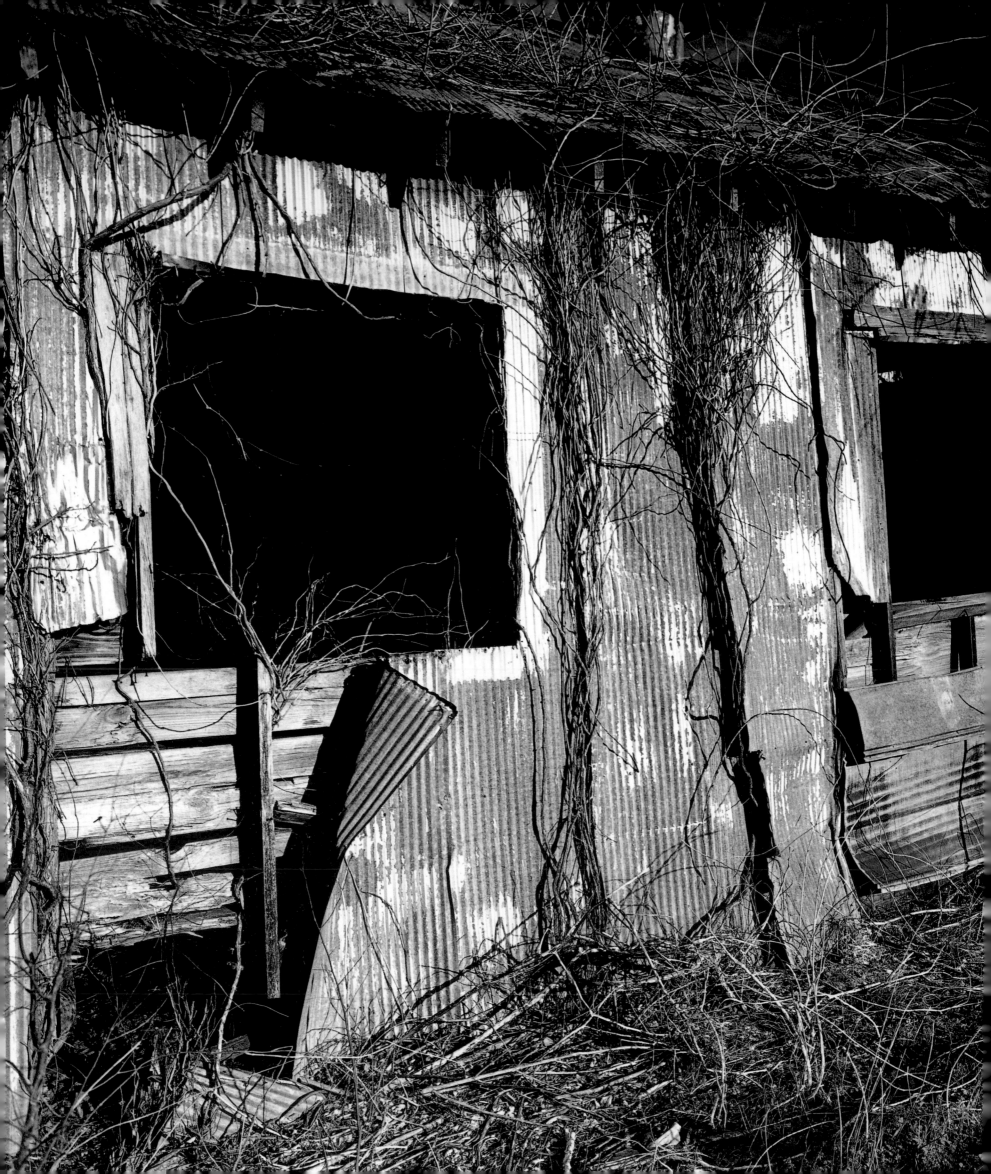

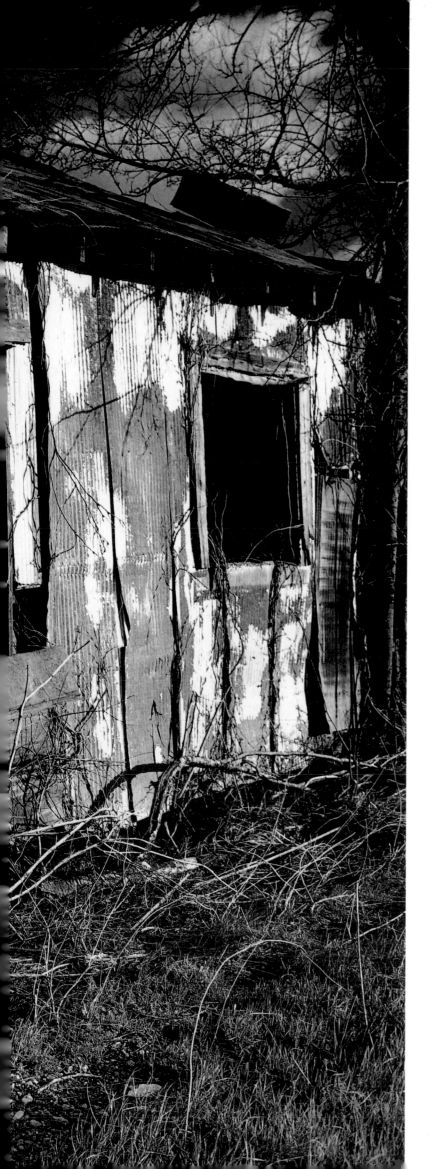

BETWEEN BUELA AND SCOTT 31
Bolivar County, Mississippi 1996

32 OTIS WINNARD

Bay St. Louis, Mississippi 1999

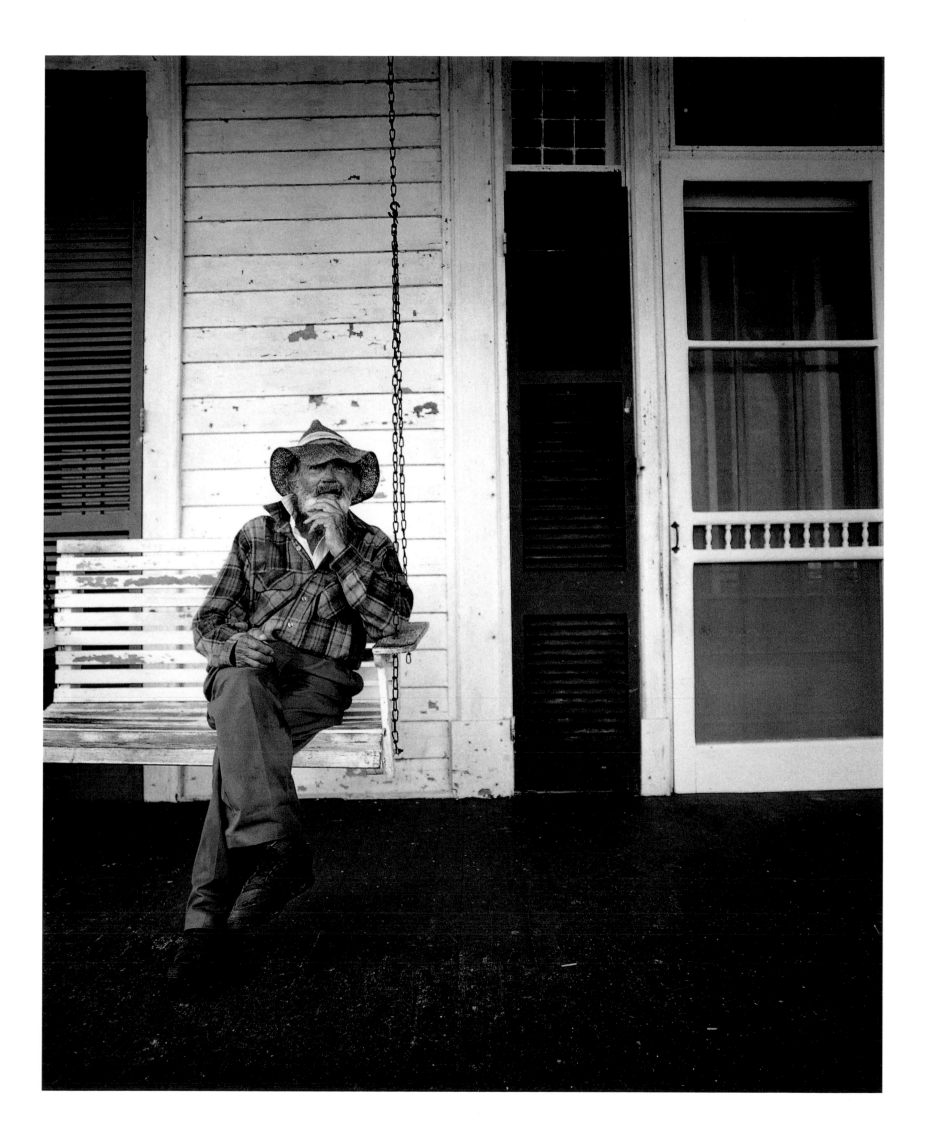

33 UNTITLED

Palacios, Texas 1999

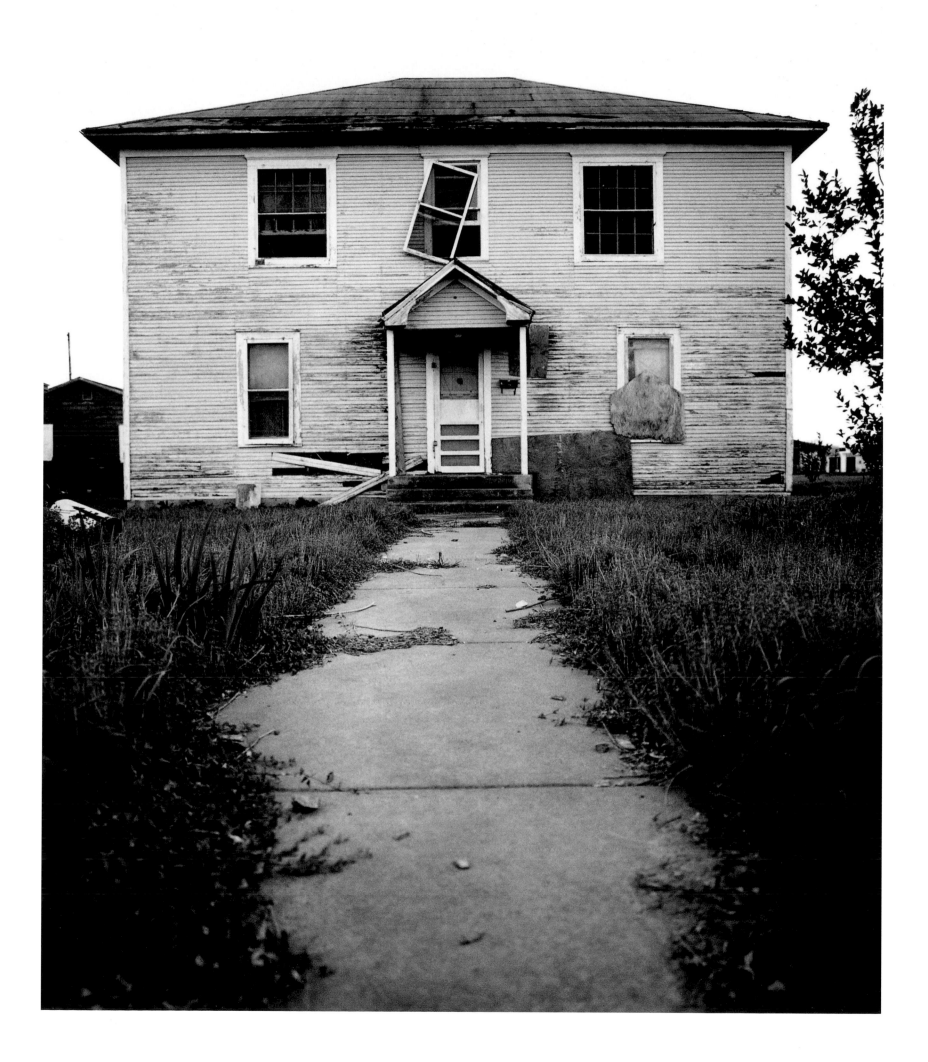

34 BEER * ICE * POP
Chadron, Nebraska 1993

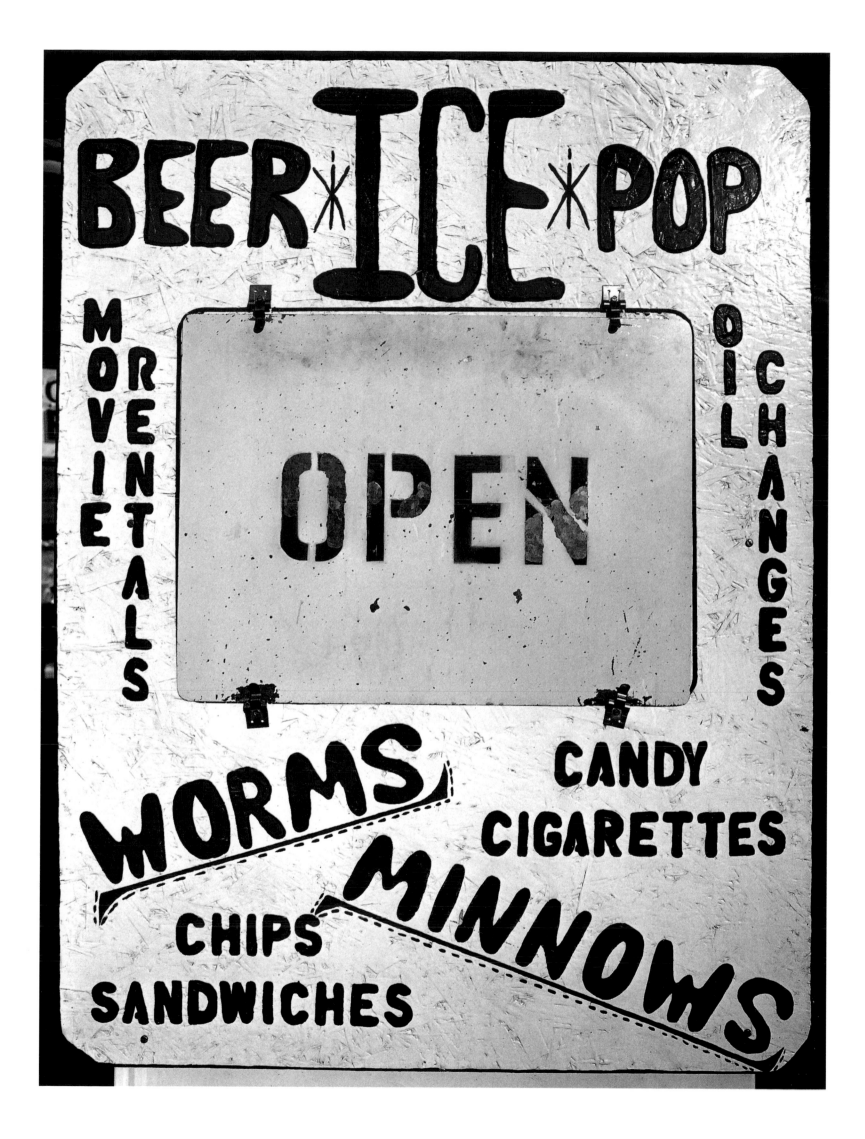

35 MICHAEL BARNES & JOSH FAYARD

Bay St. Louis, Mississippi 1999

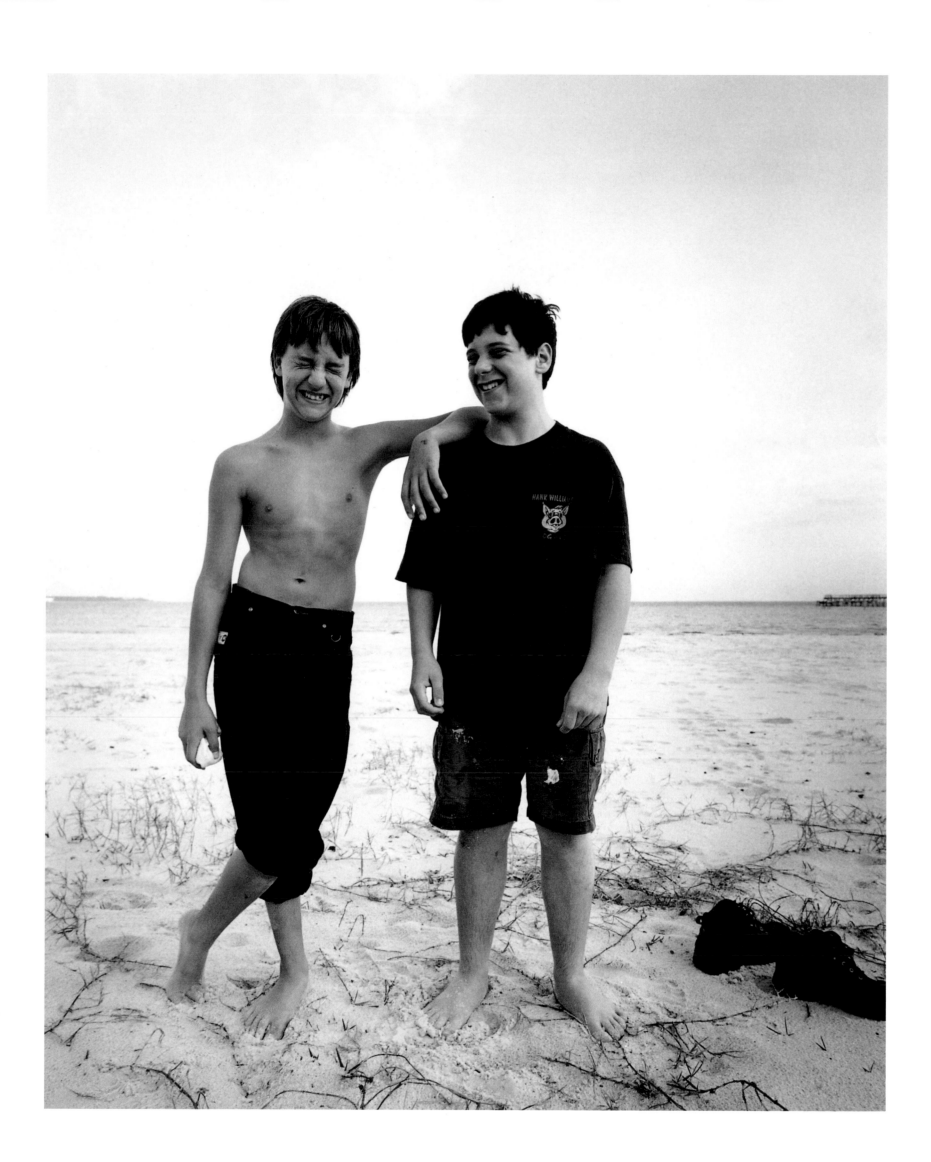

36 ARIZONA PLAYGROUND

Salome, Arizona 1995

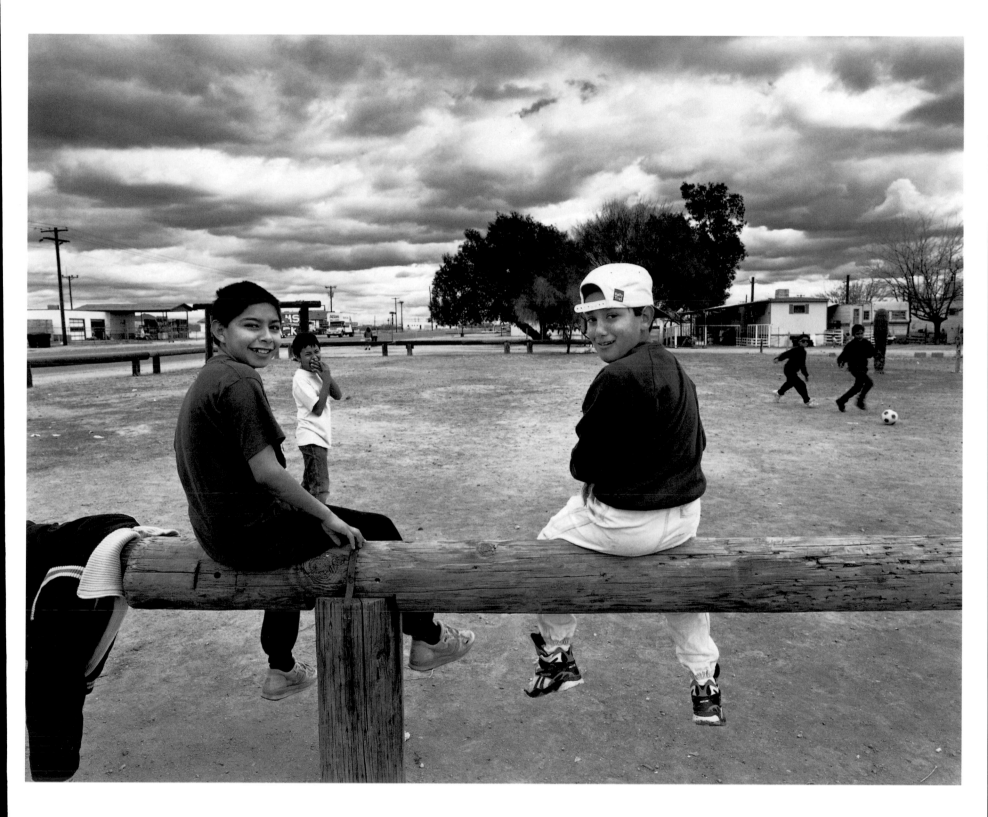

37 SPARKY'S CAFE

Bridgeport, Nebraska 1993

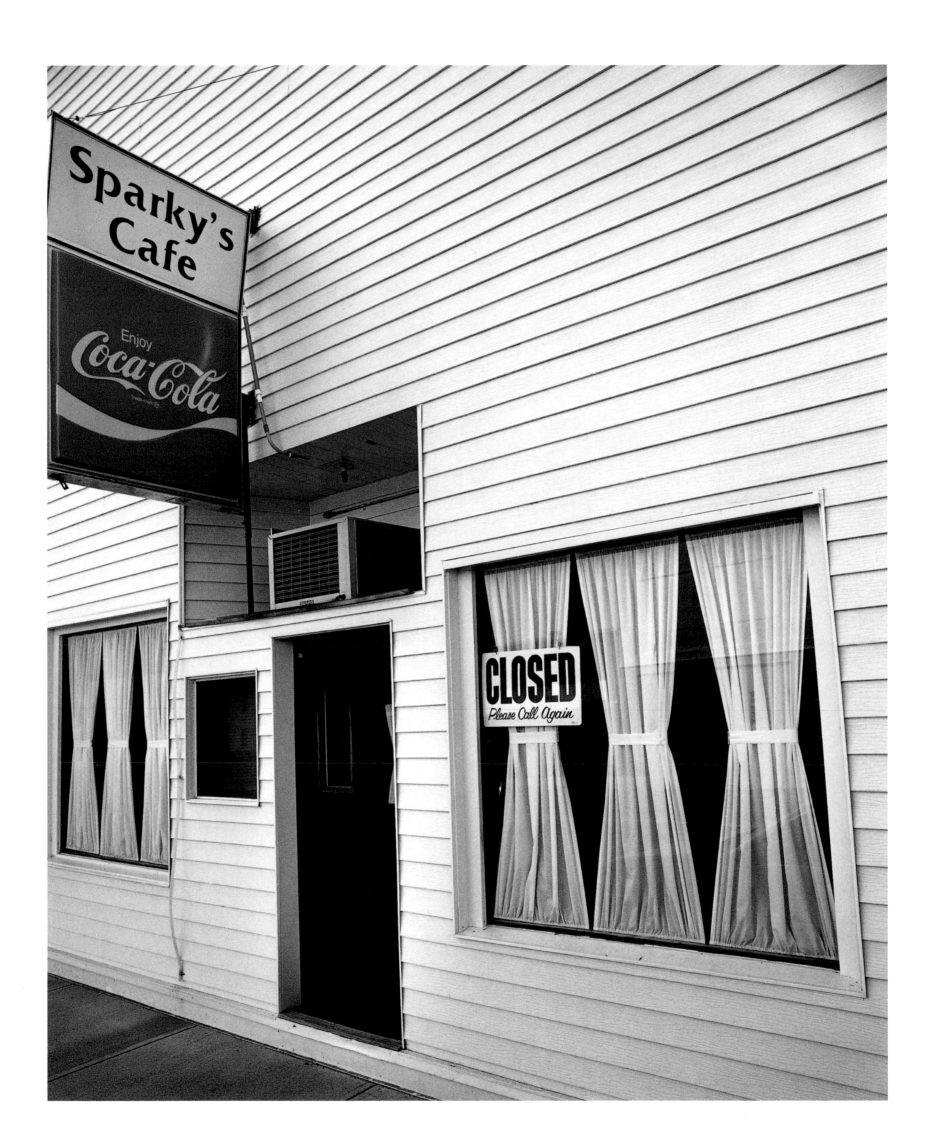

38 EMILY MORGAN IN HER KITCHEN

Pecan Island, Louisiana 1999

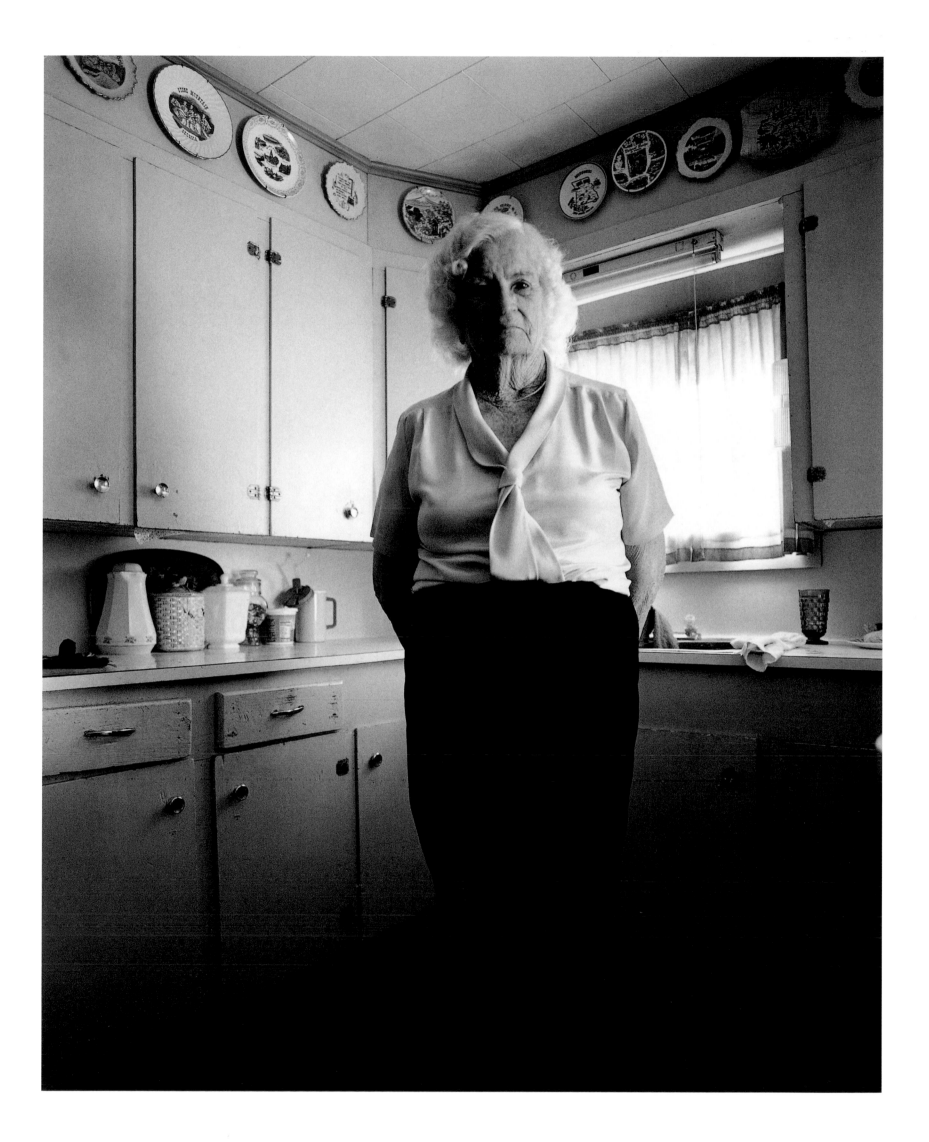

39 UNTITLED

Morgan City, Louisiana 1999

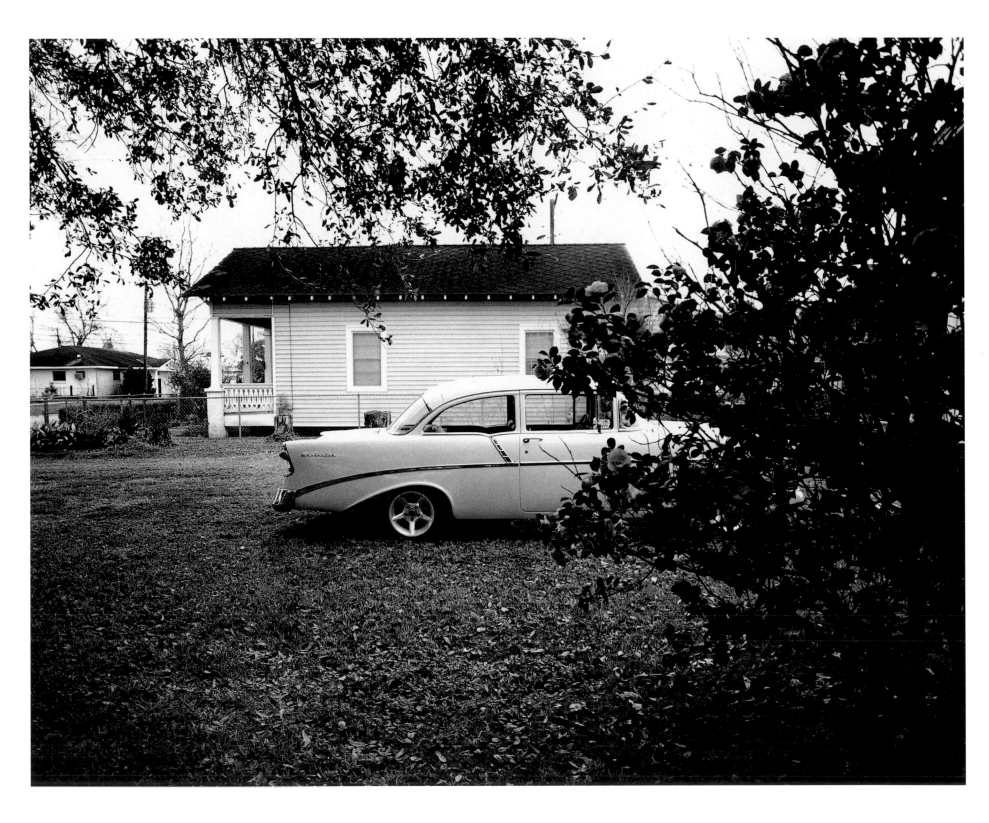

40 HIGHWAY 616

East of Lolita, Texas 1999

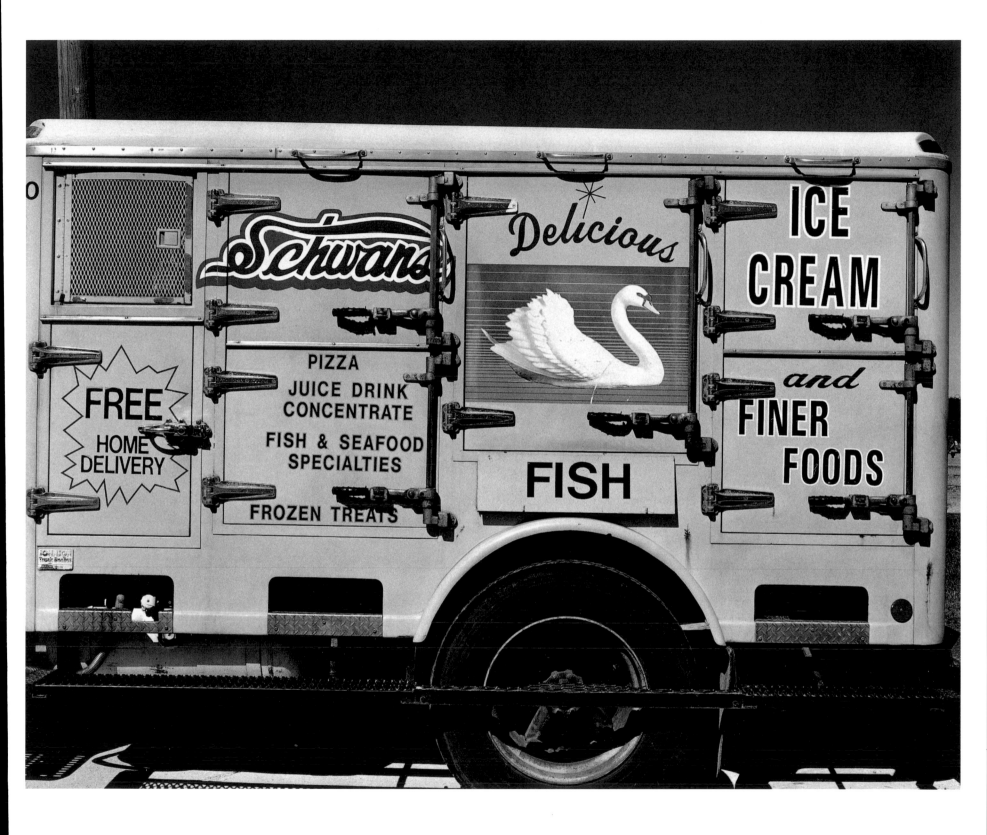

41 DANNY'S FRIED CHICKEN

Galliano, Louisiana 1999

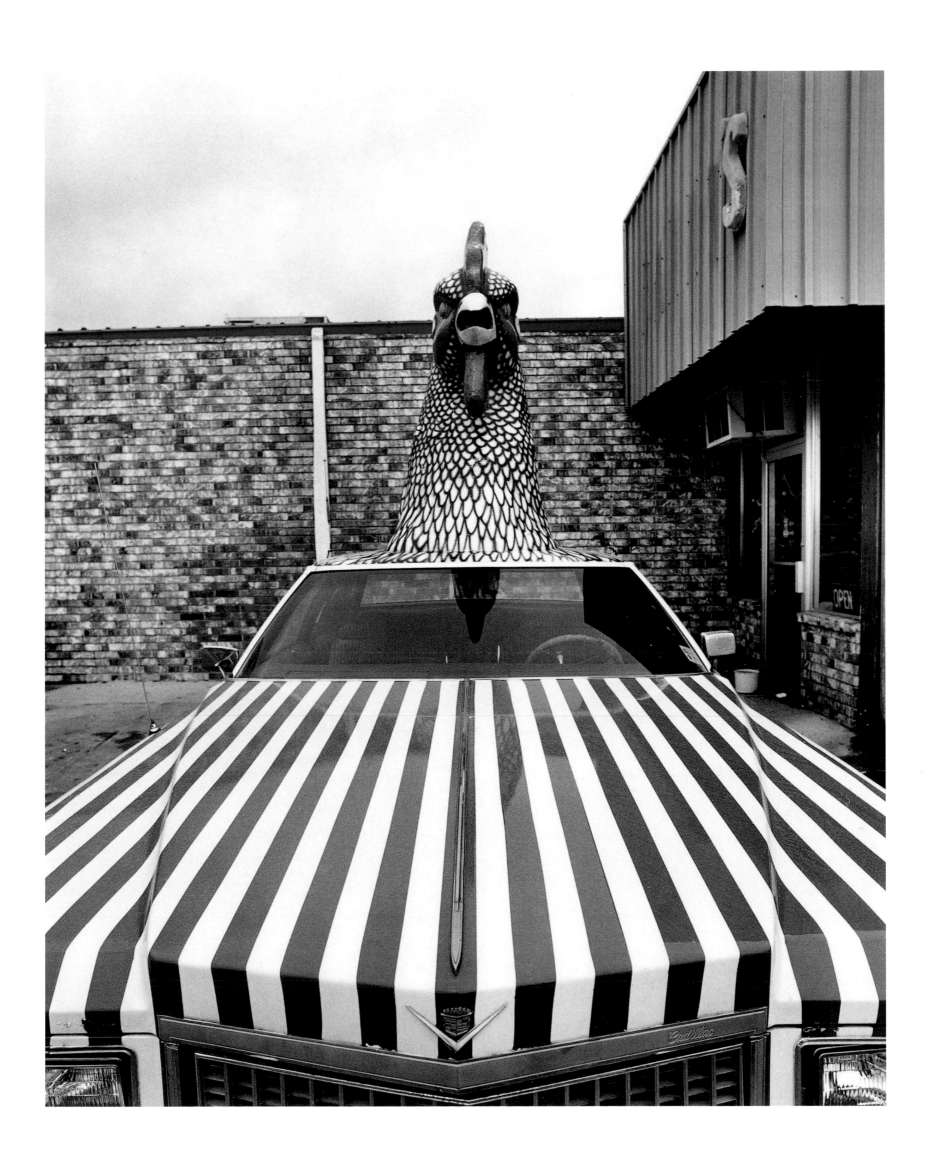

42 UNTITLED

Fort Bridger, Wyoming 1993

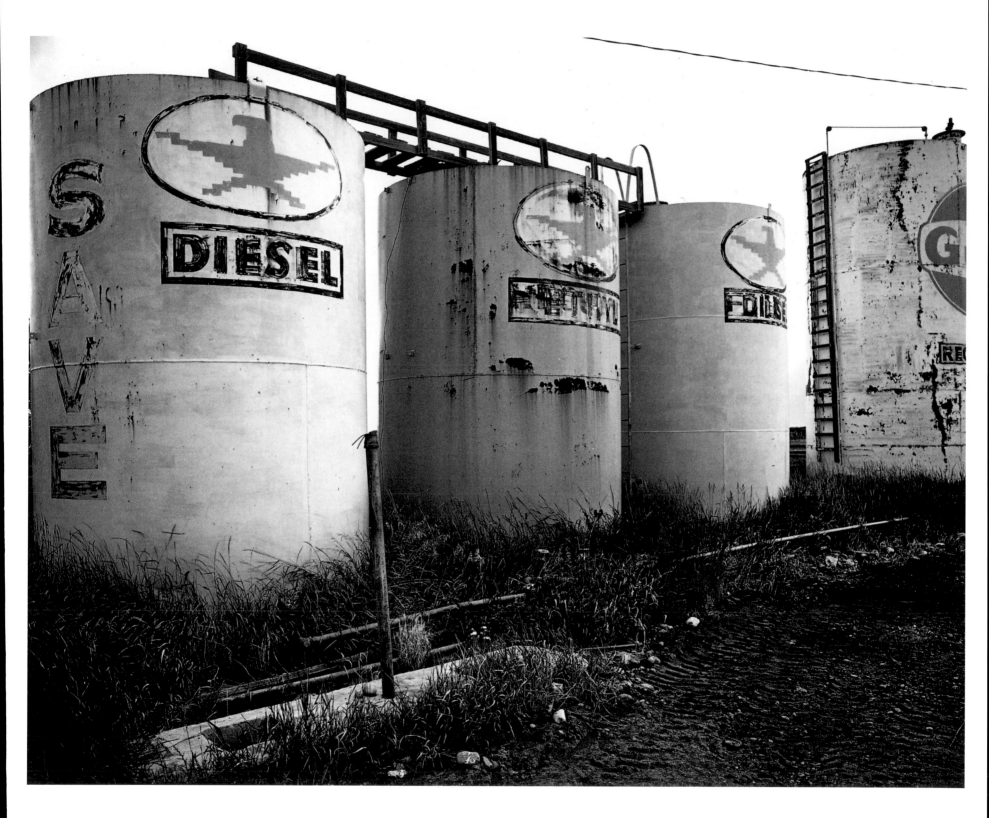

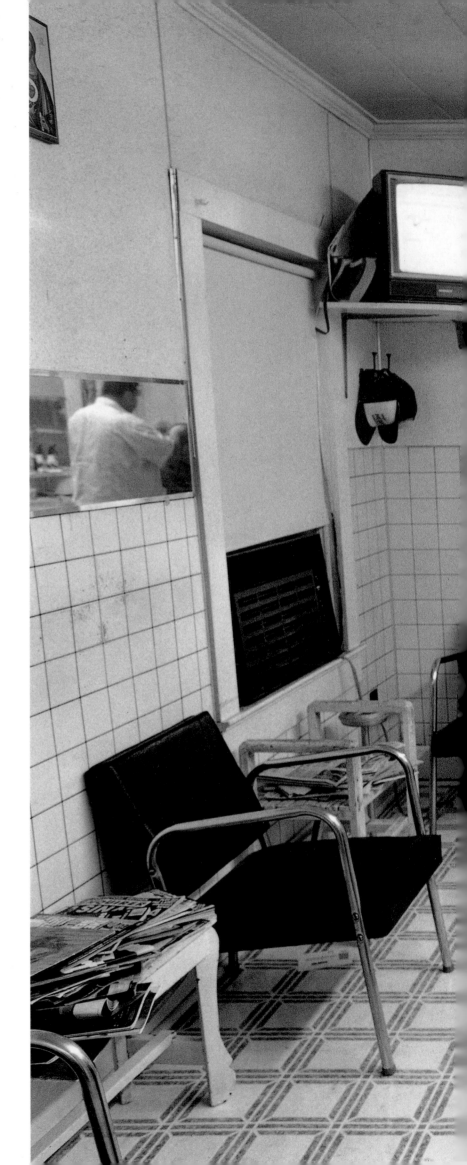

43 NORMAN & MICHAEL BRIGNAC

Franklin, Louisiana 1999

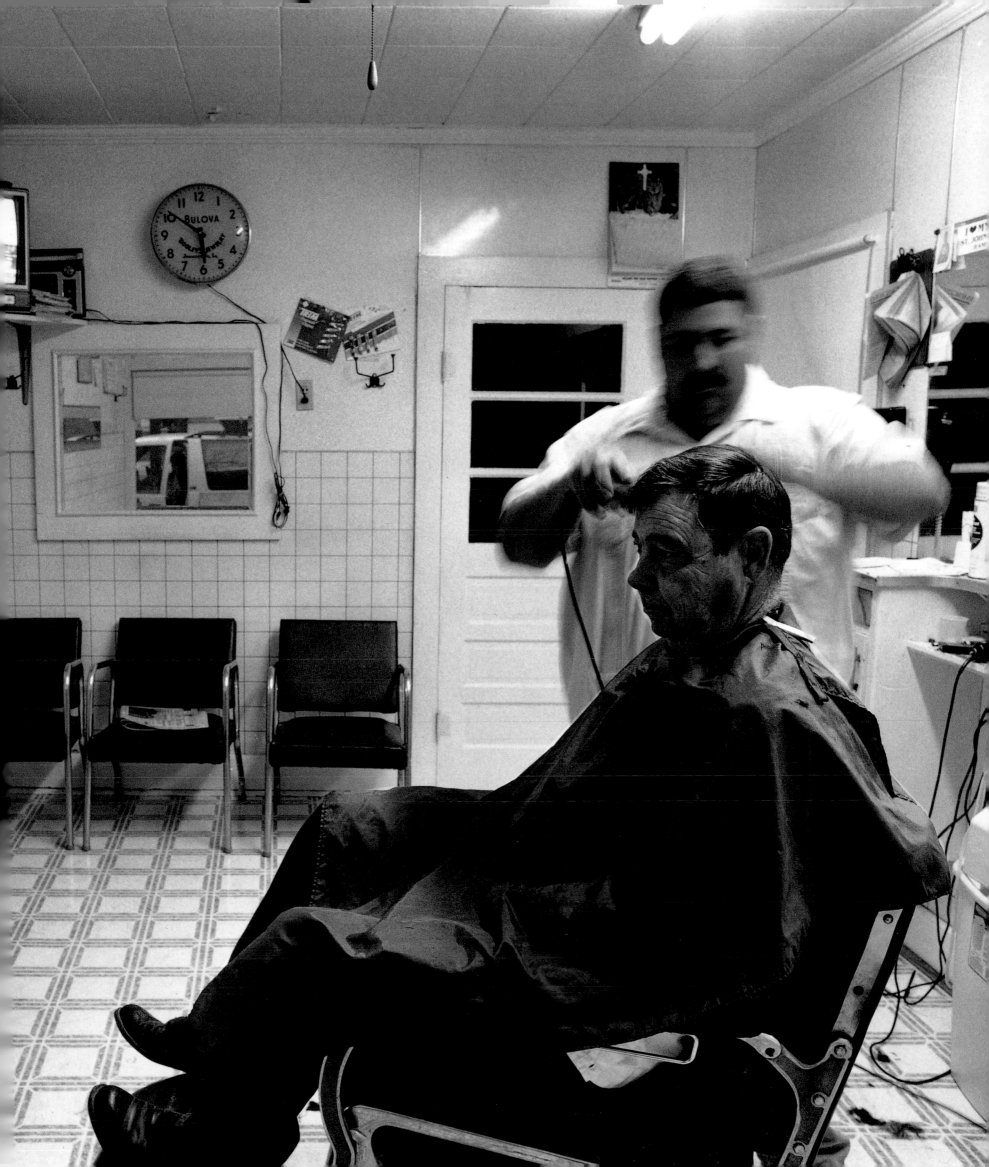

44 SANDY RIDGE ESTATES

Marie Esther, Florida 1999

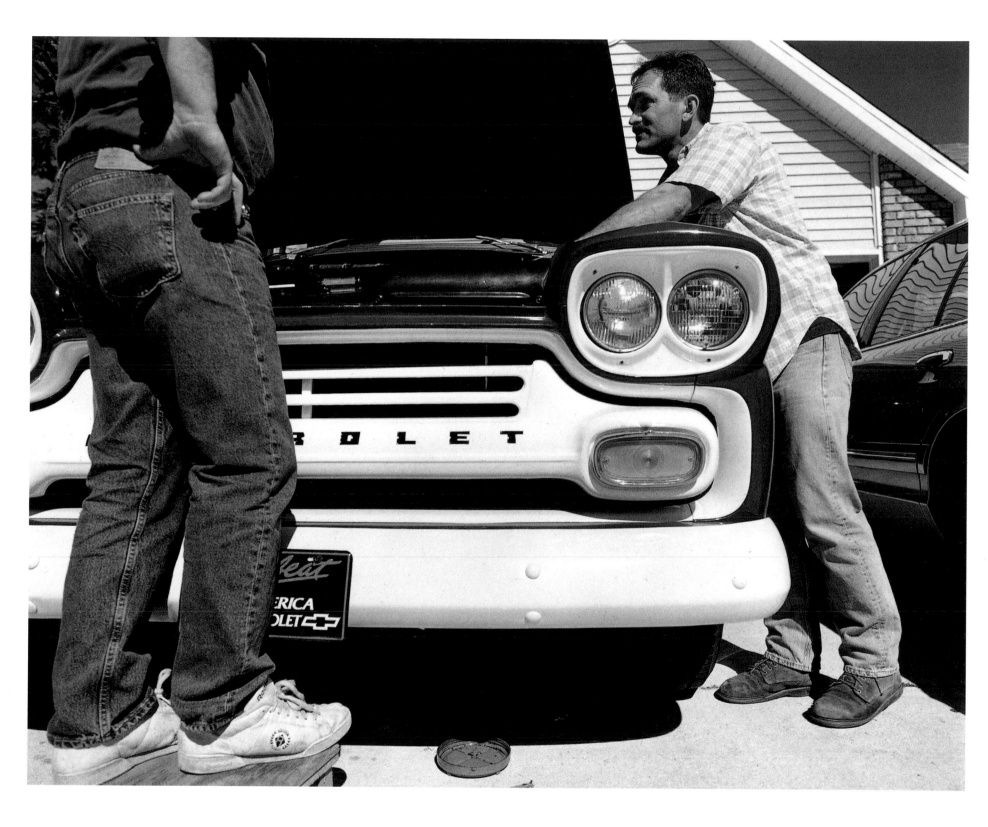

45 UNTITLED

Dobson, Oregon 1993

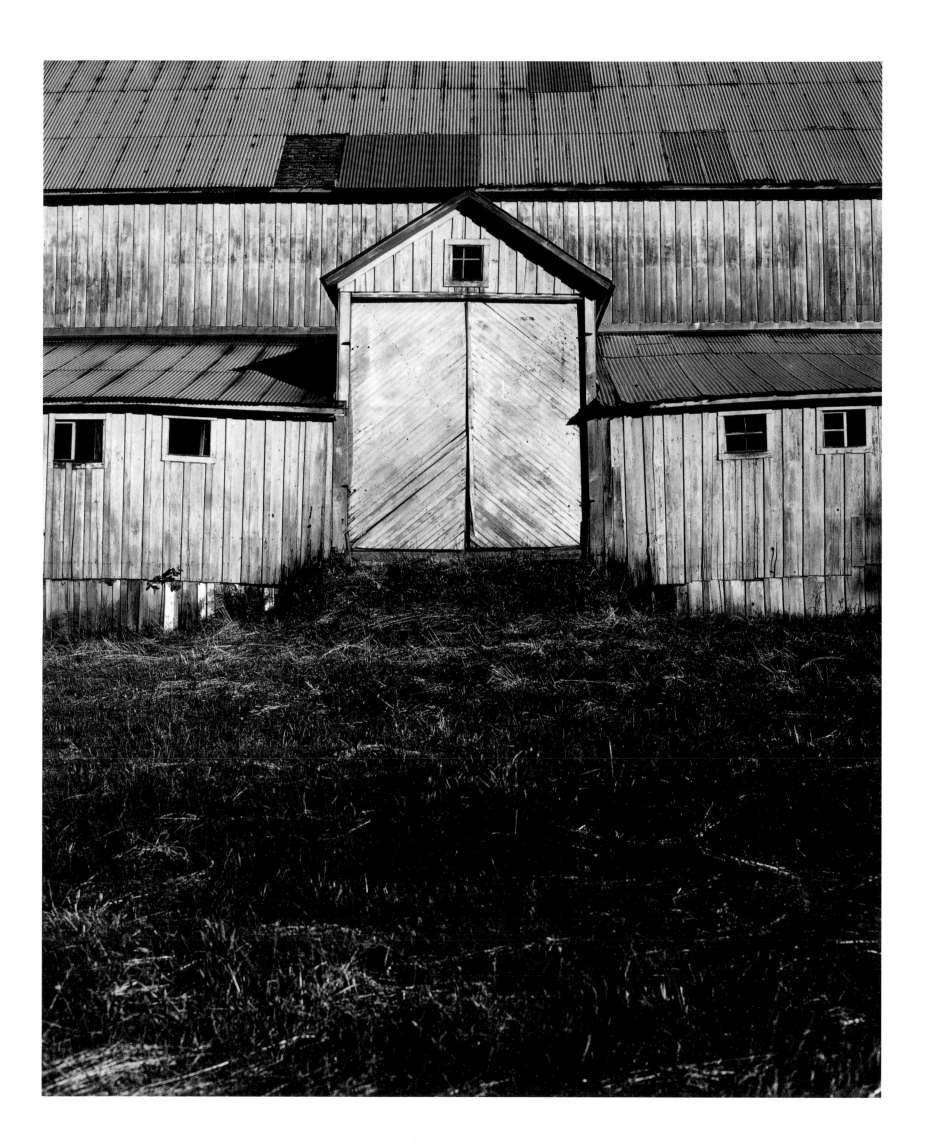

46 SUN 'N' SAND

Carrabelle, Florida 1999

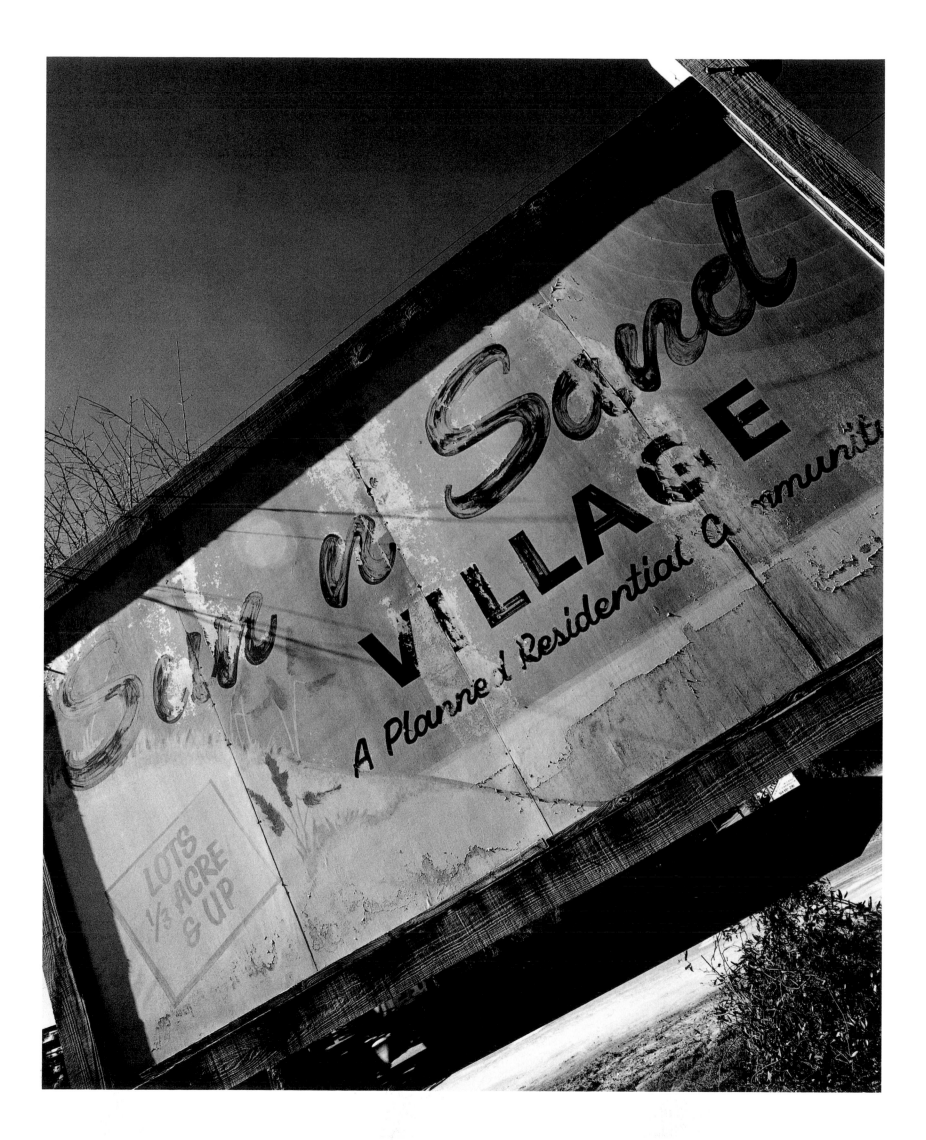

47 FUN IN THE SUN II

Lava Hot Springs, Idaho 1993

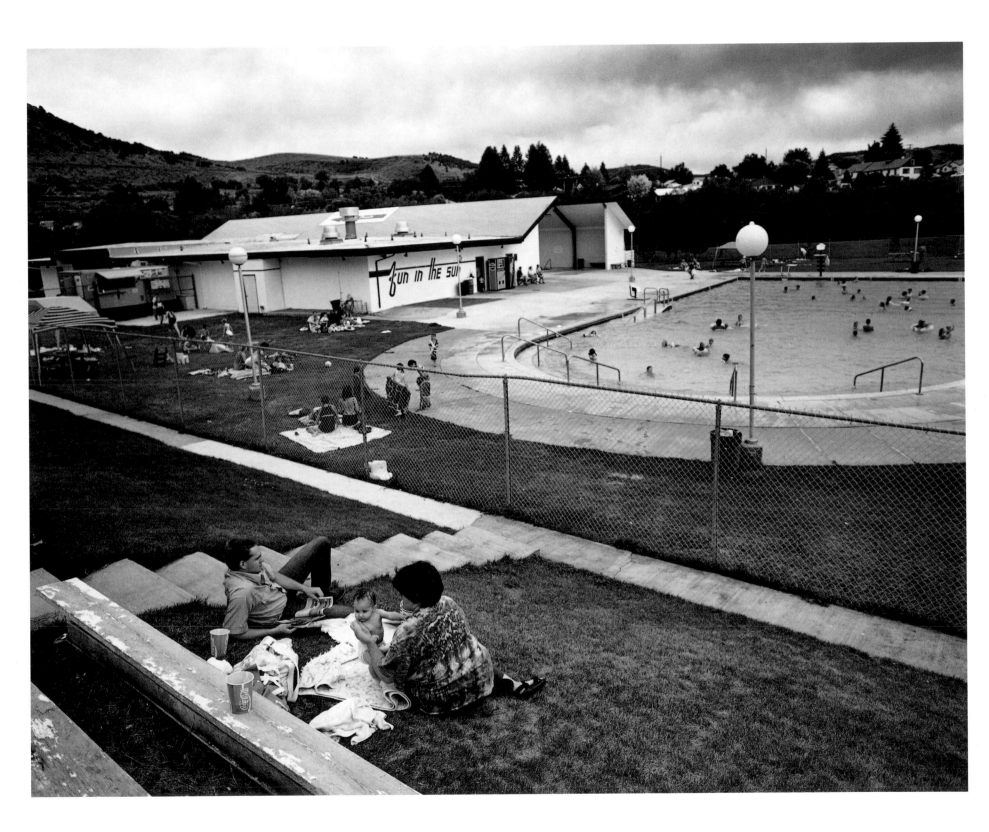

48 WEST 12TH STREET

The Dalles, Oregon 1993

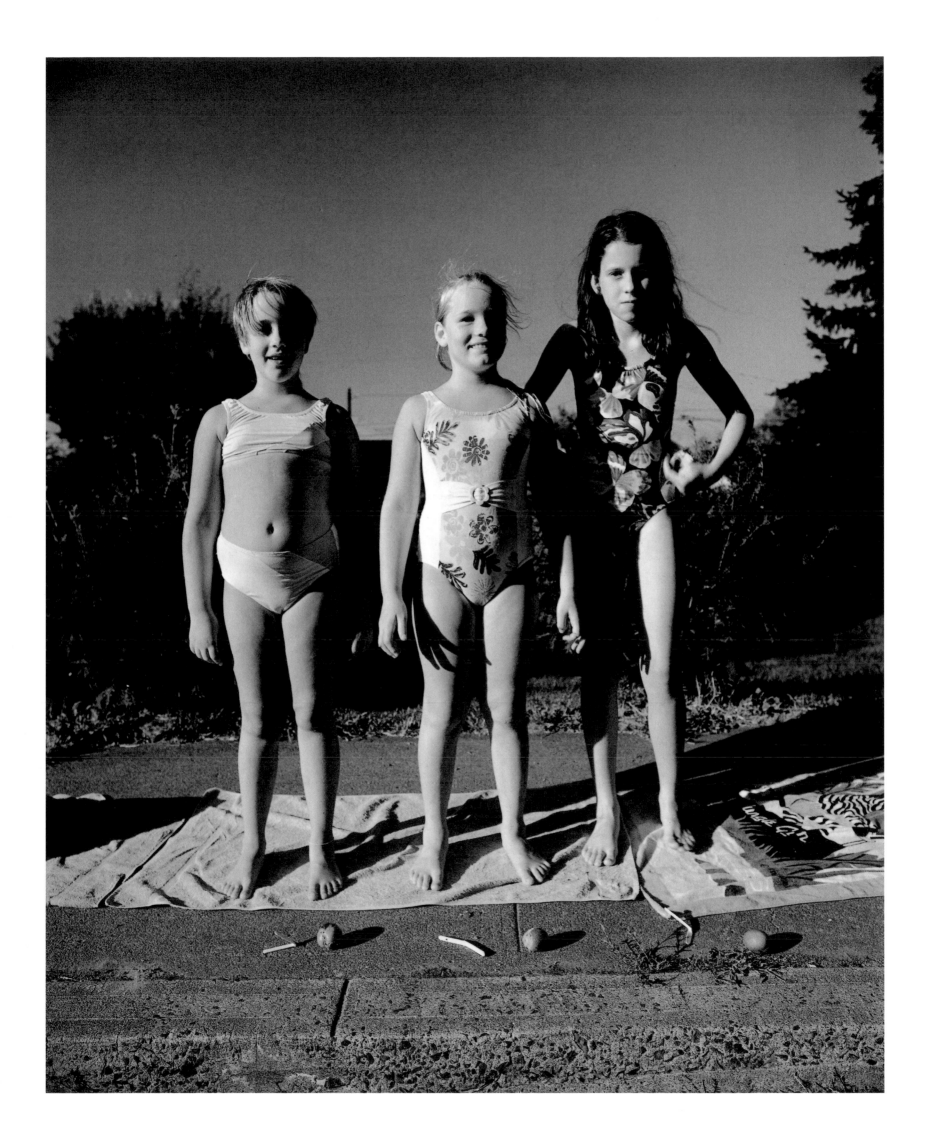

49 UNTITLED
Kaplan, Louisiana 1999

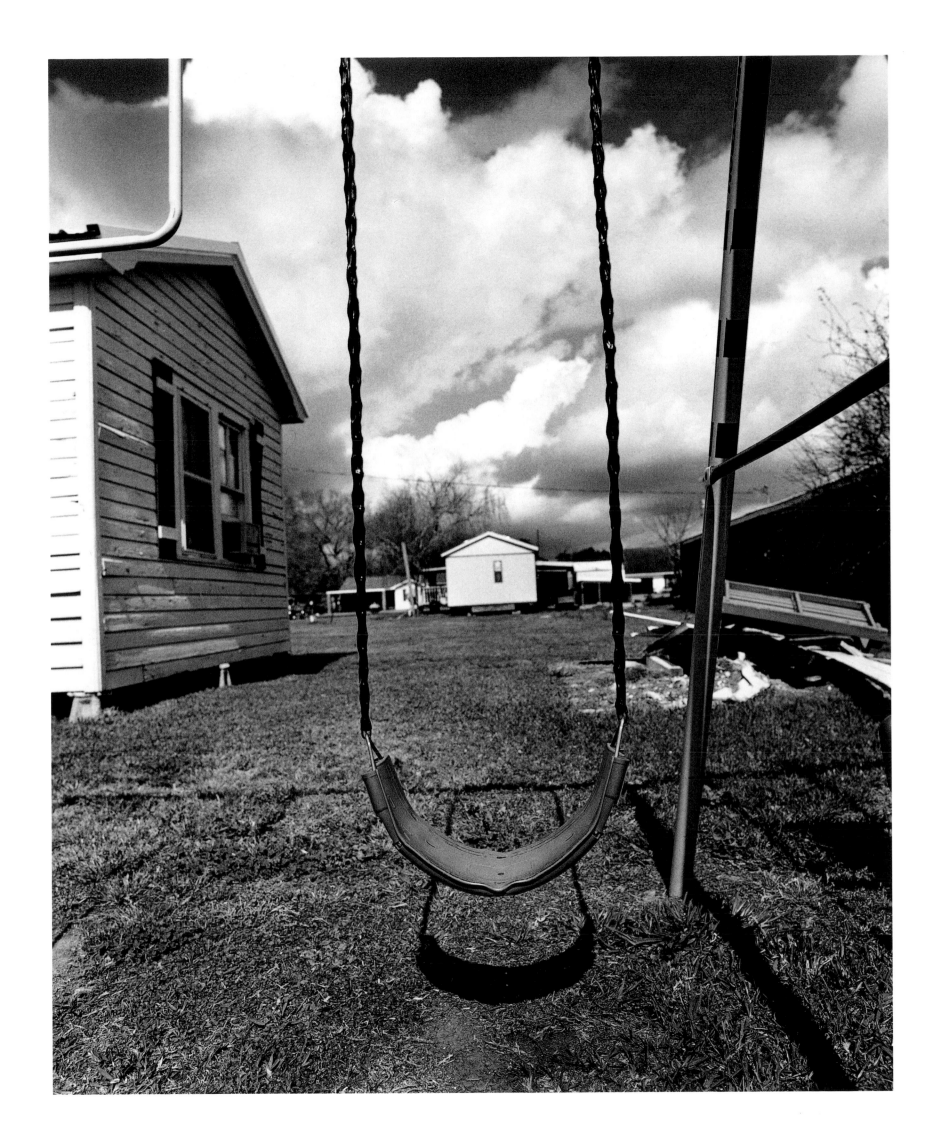

50 FAMILY PORTRAIT

Port Gibson, Mississippi 1996

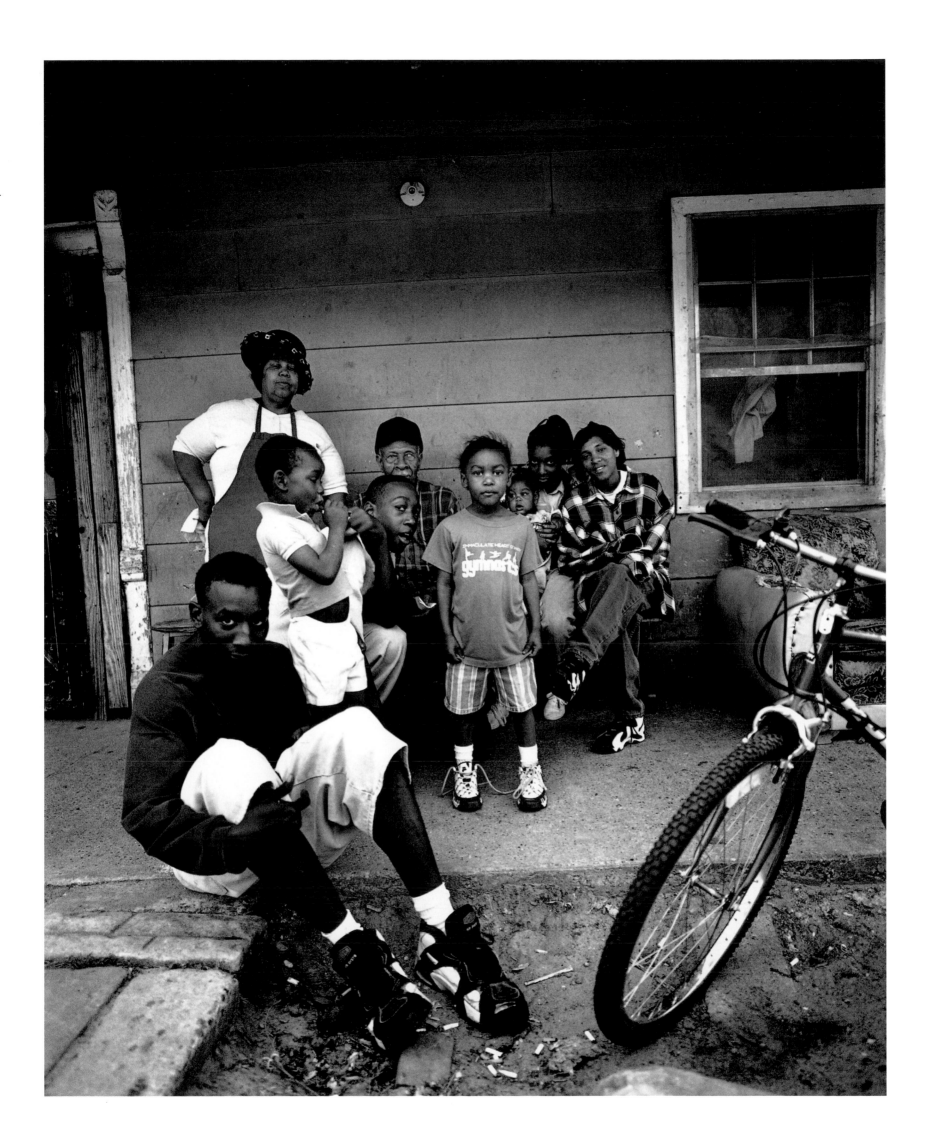

51 KENNETH, BRANDON & KEITH
St. Charles, Louisiana 1999

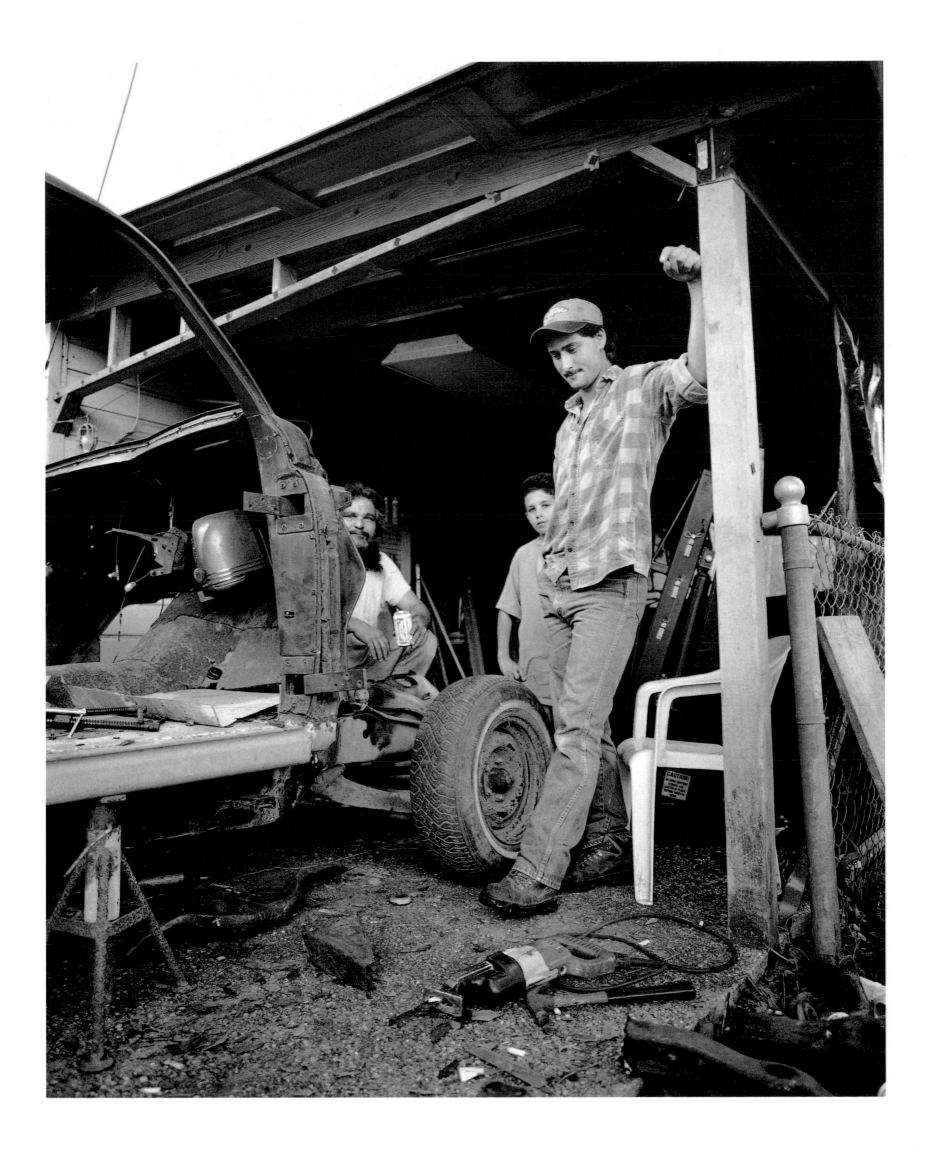

52 PRAY FOR REVIVAL

Pendleton, Oregon 1993

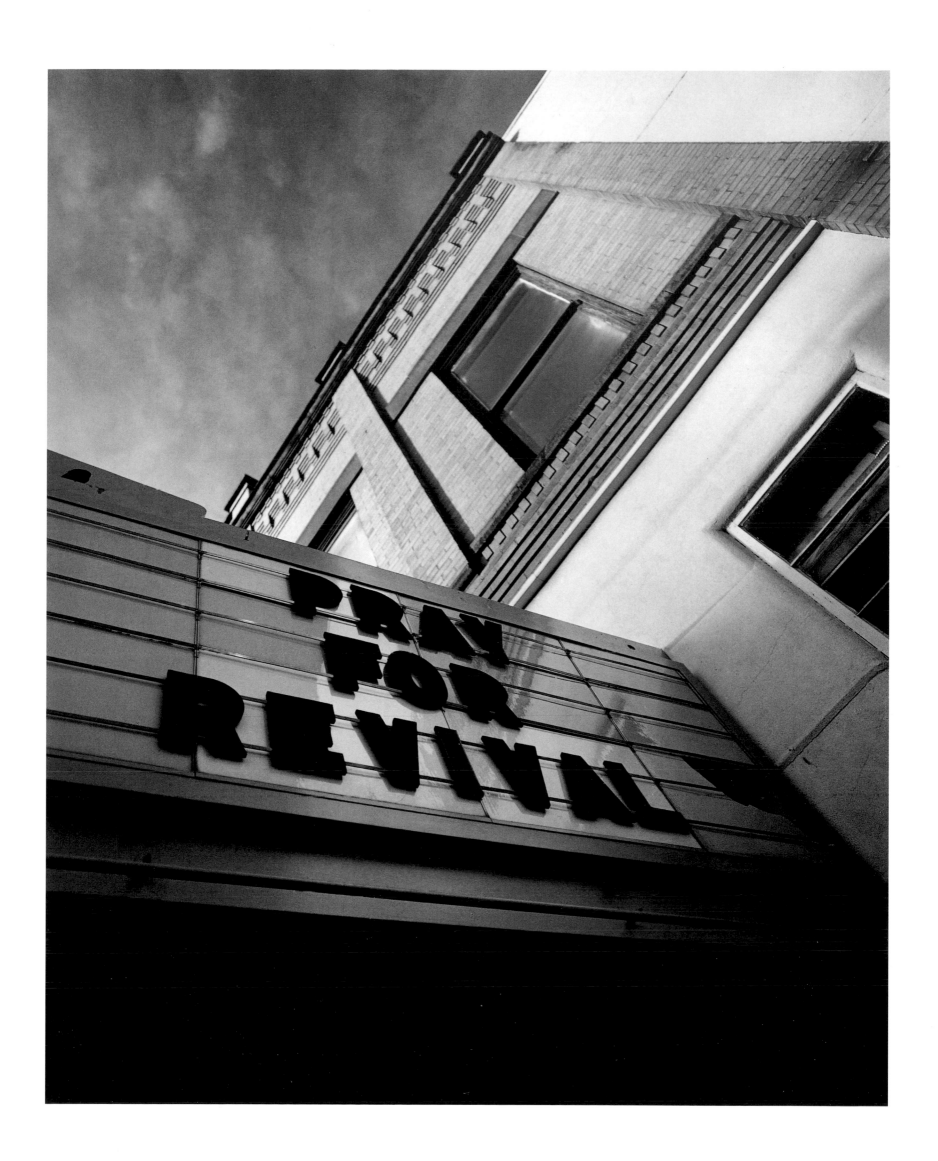

53 UNTITLED

West of Inverness, Mississippi 1996

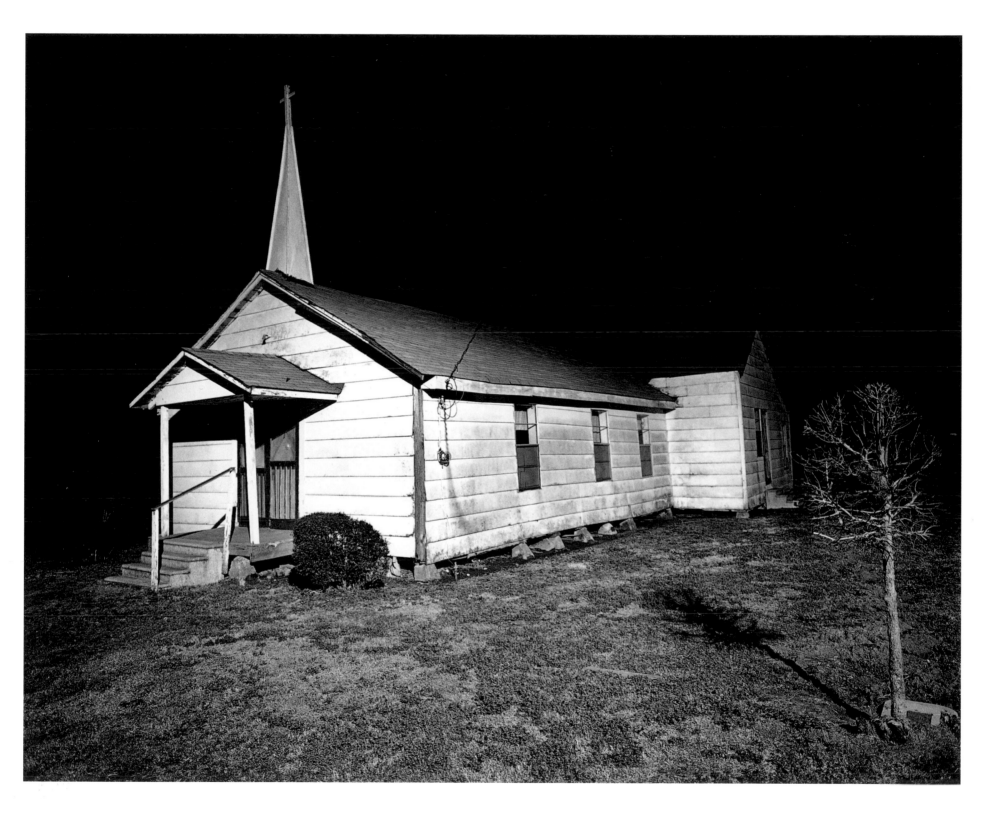

54 UNTITLED

Boise, Idaho 1993

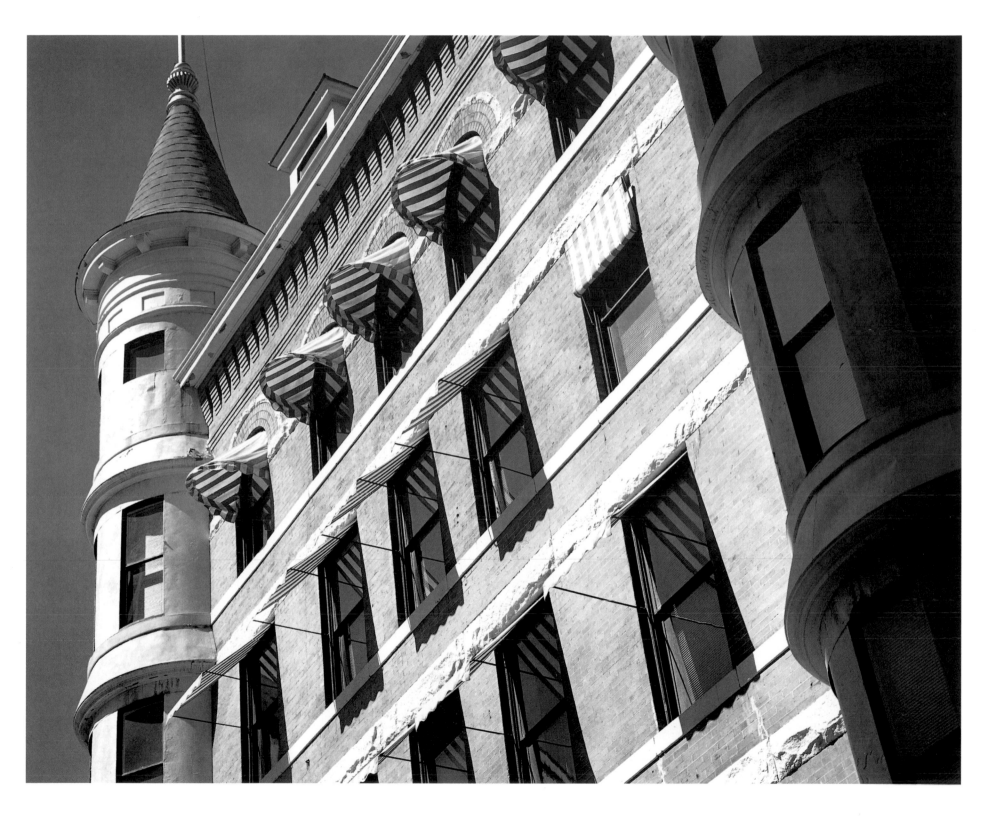

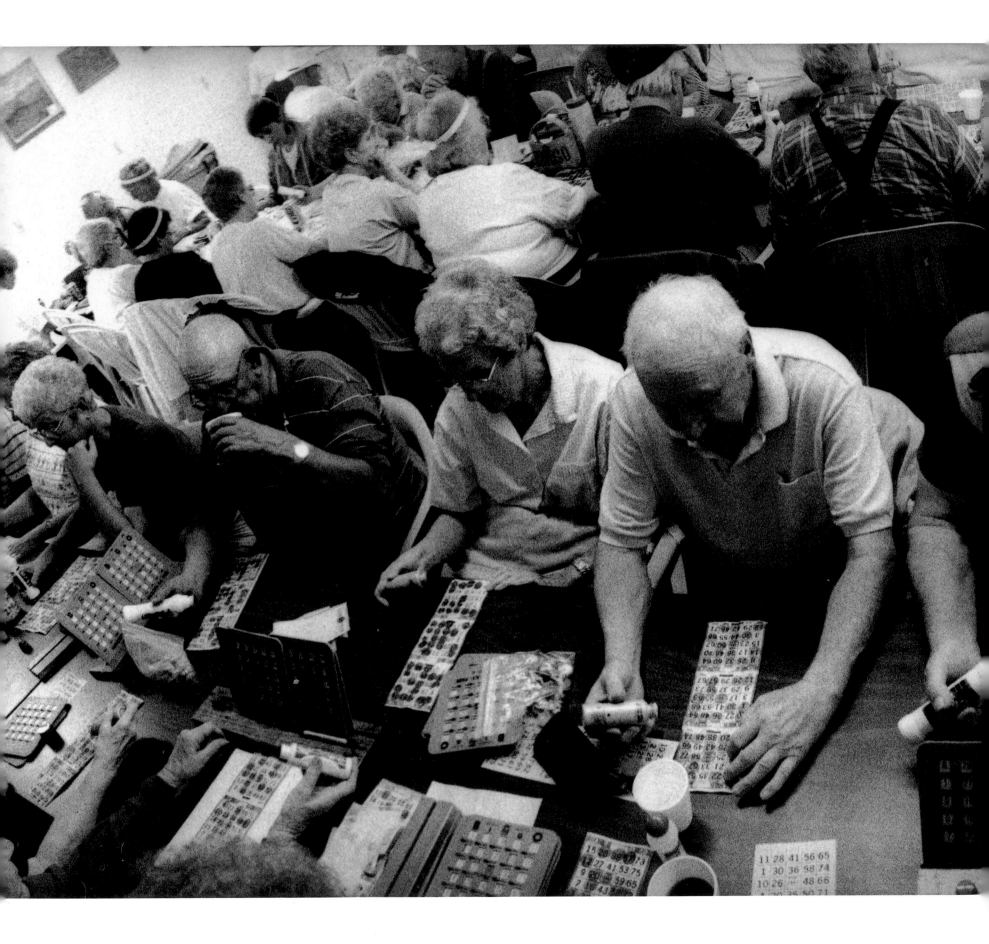

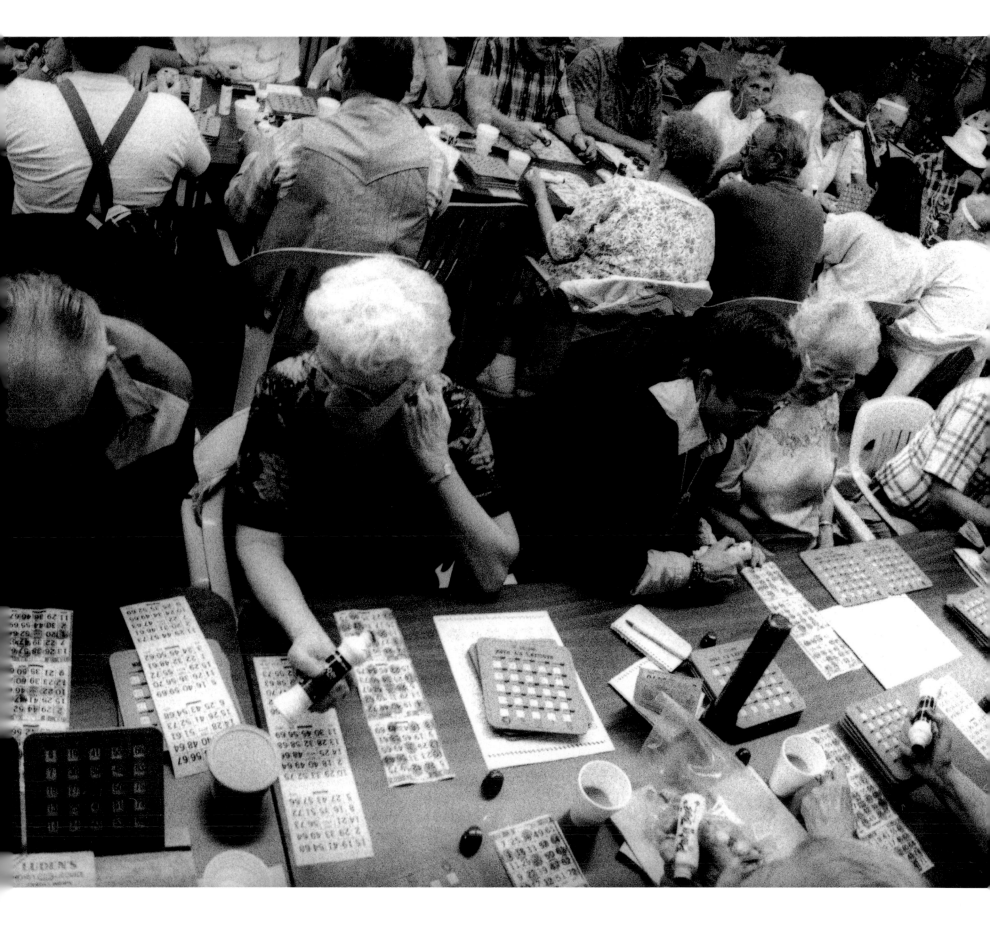

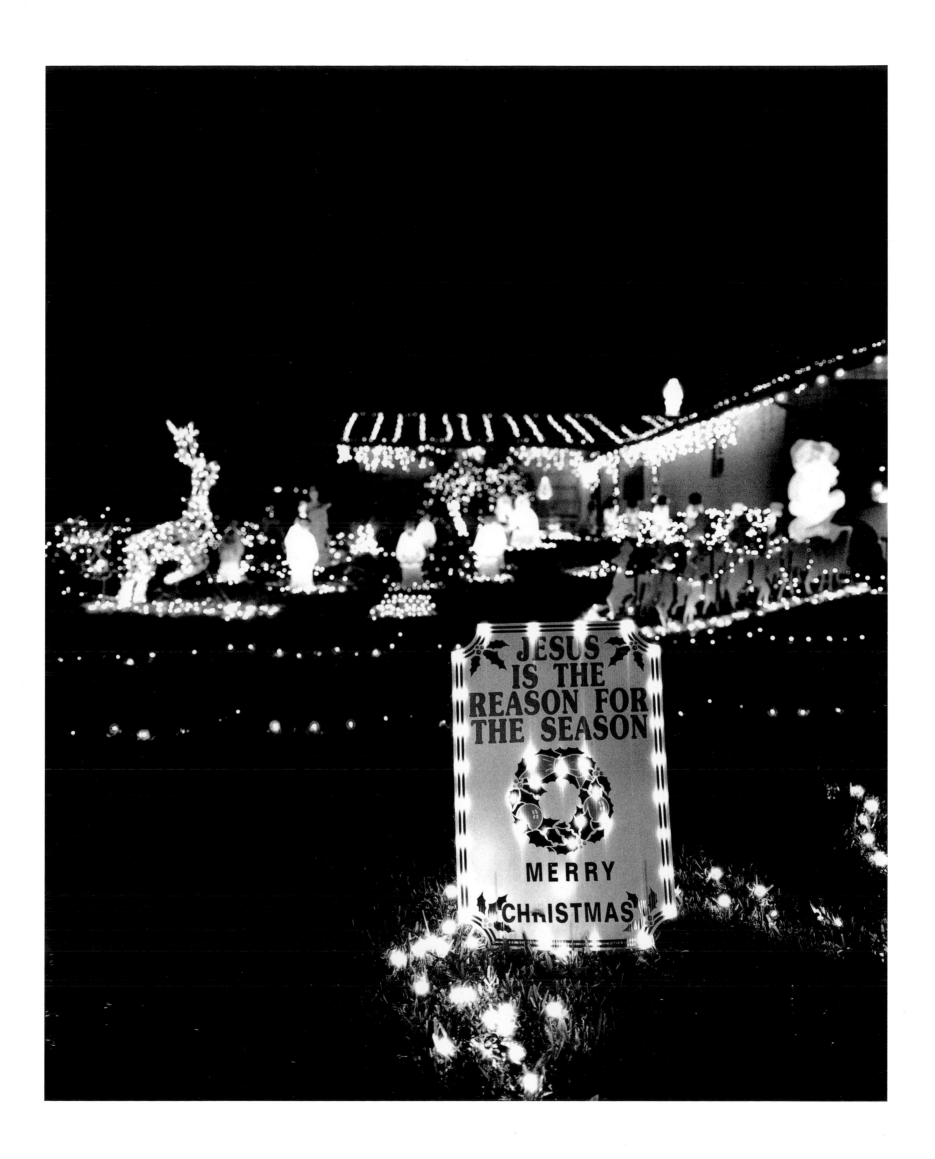

57 THE RAINBOW CAFE

Pendleton, Oregon 1993

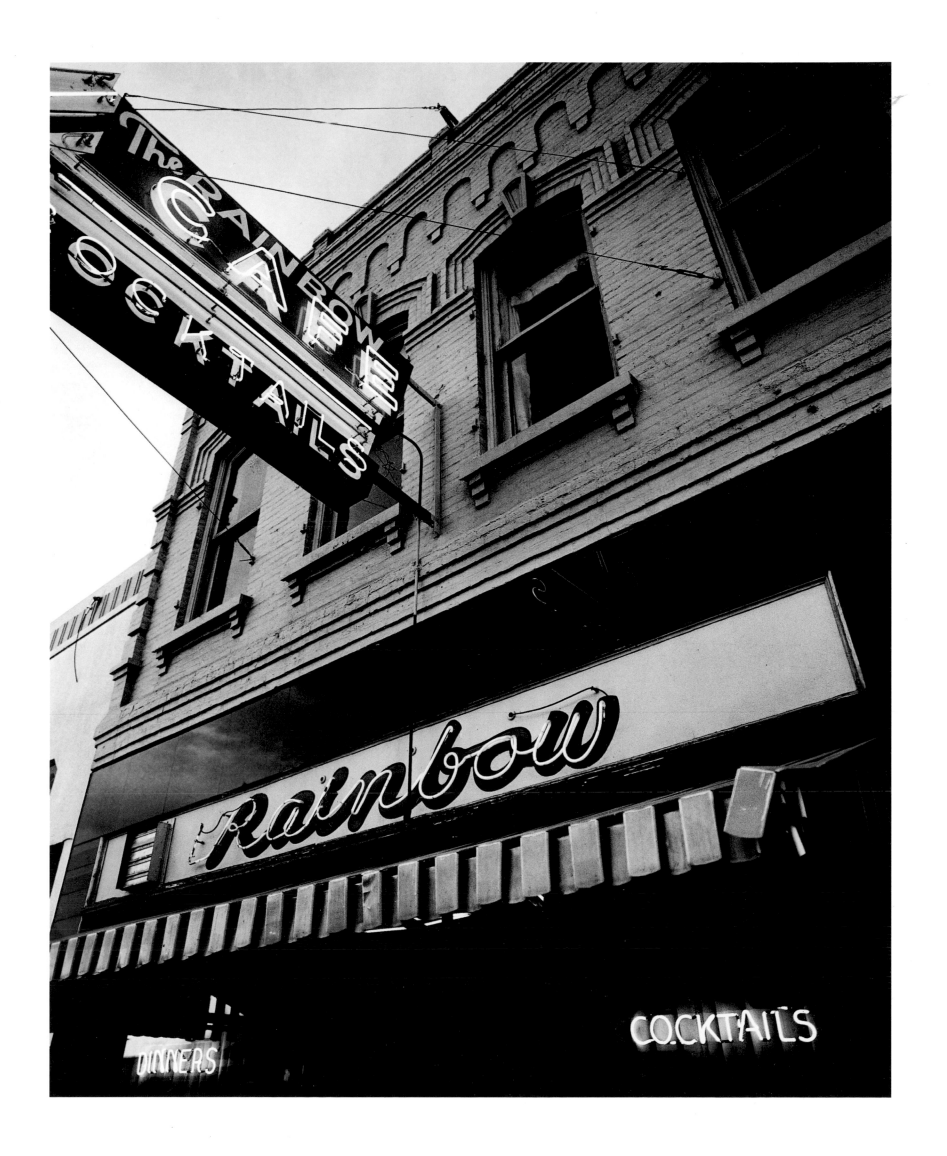

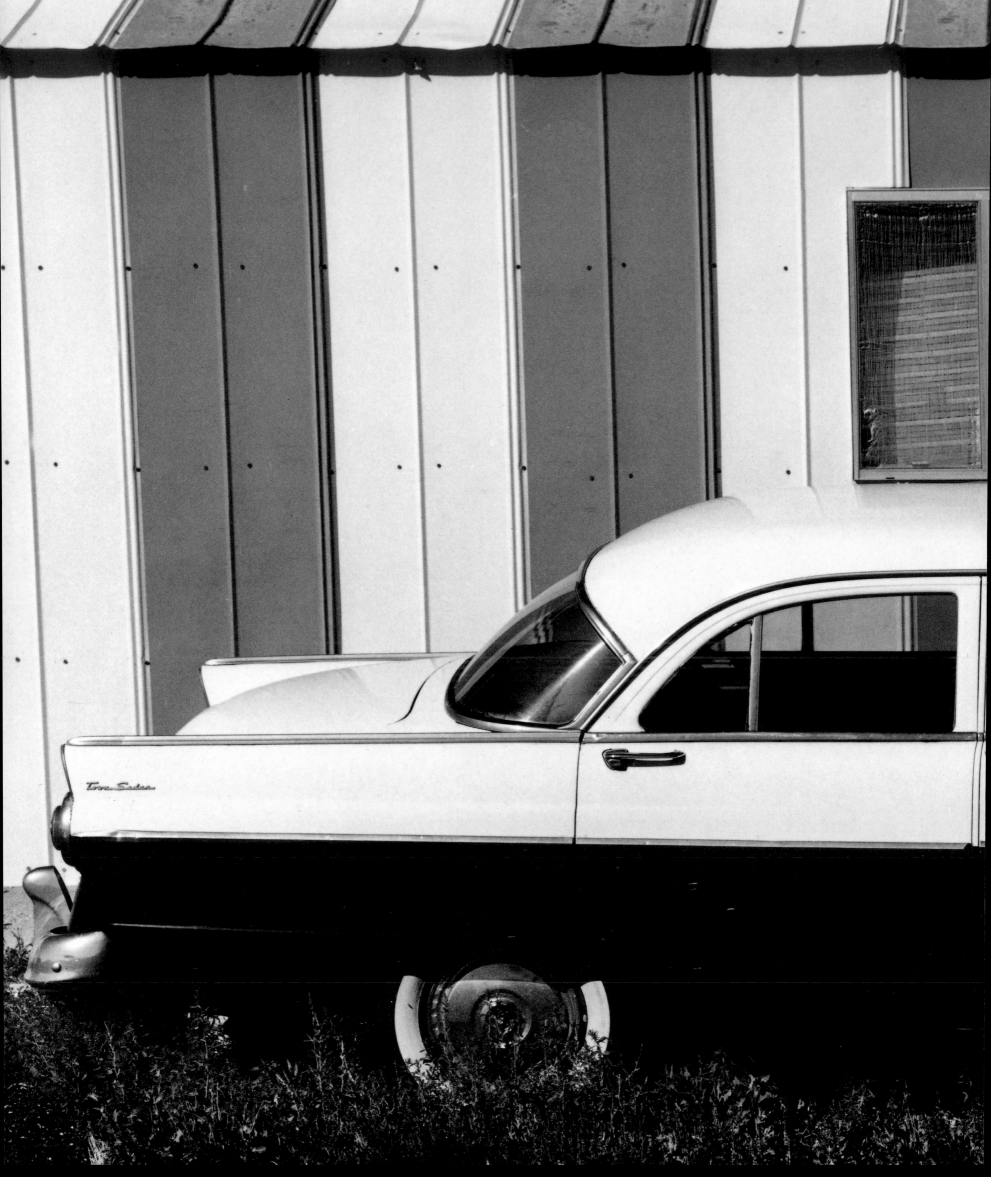

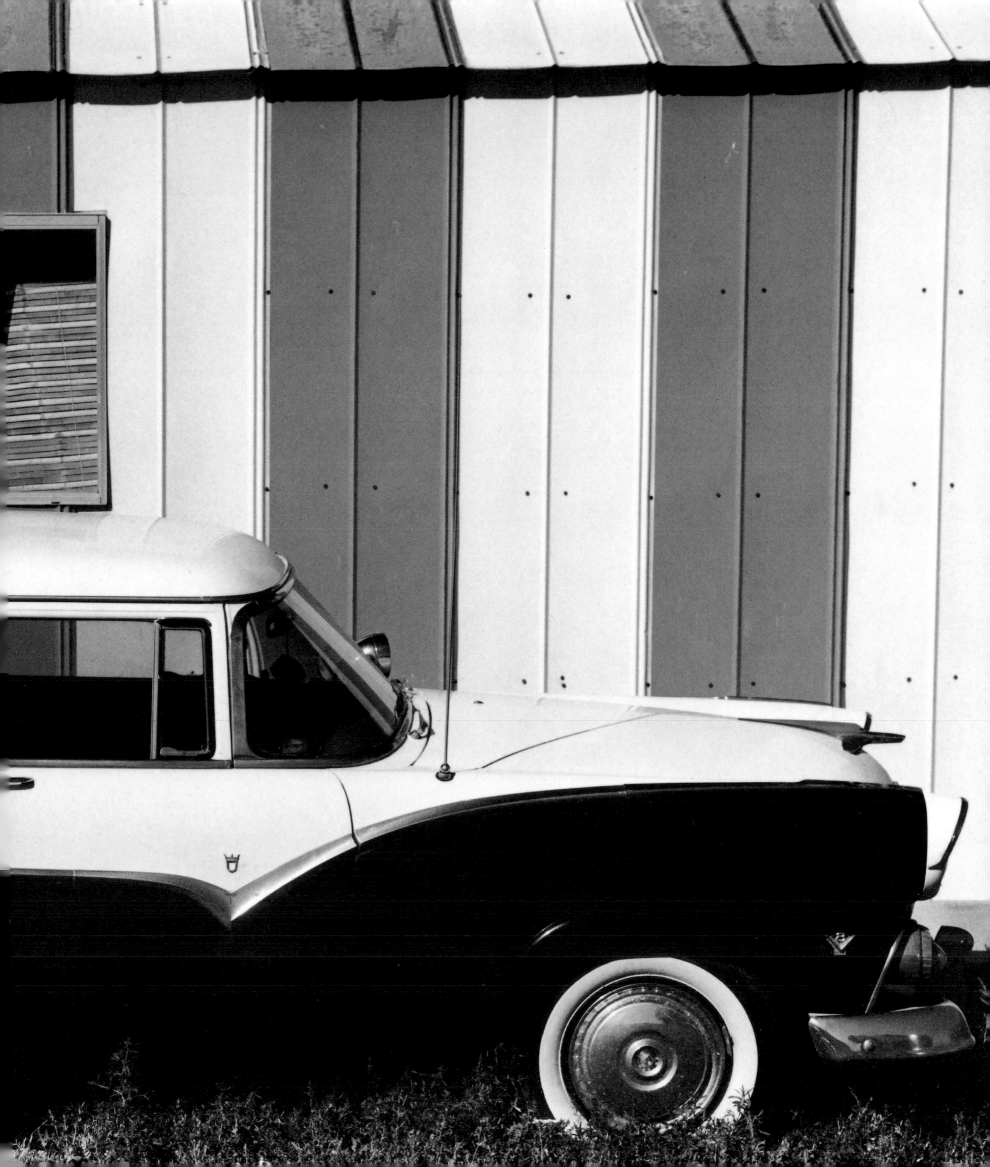

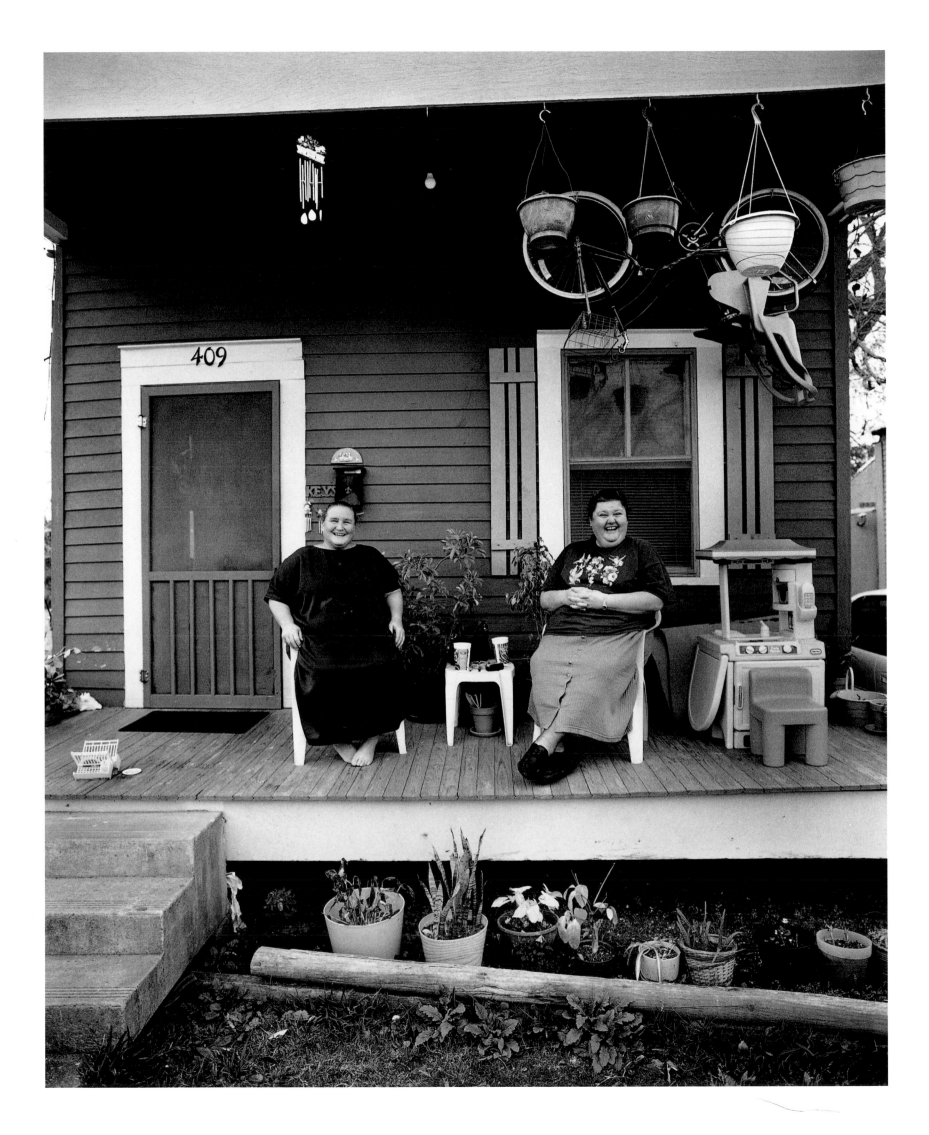

60 BIG JOHN STOKES

Mercey Hot Springs, California 1993

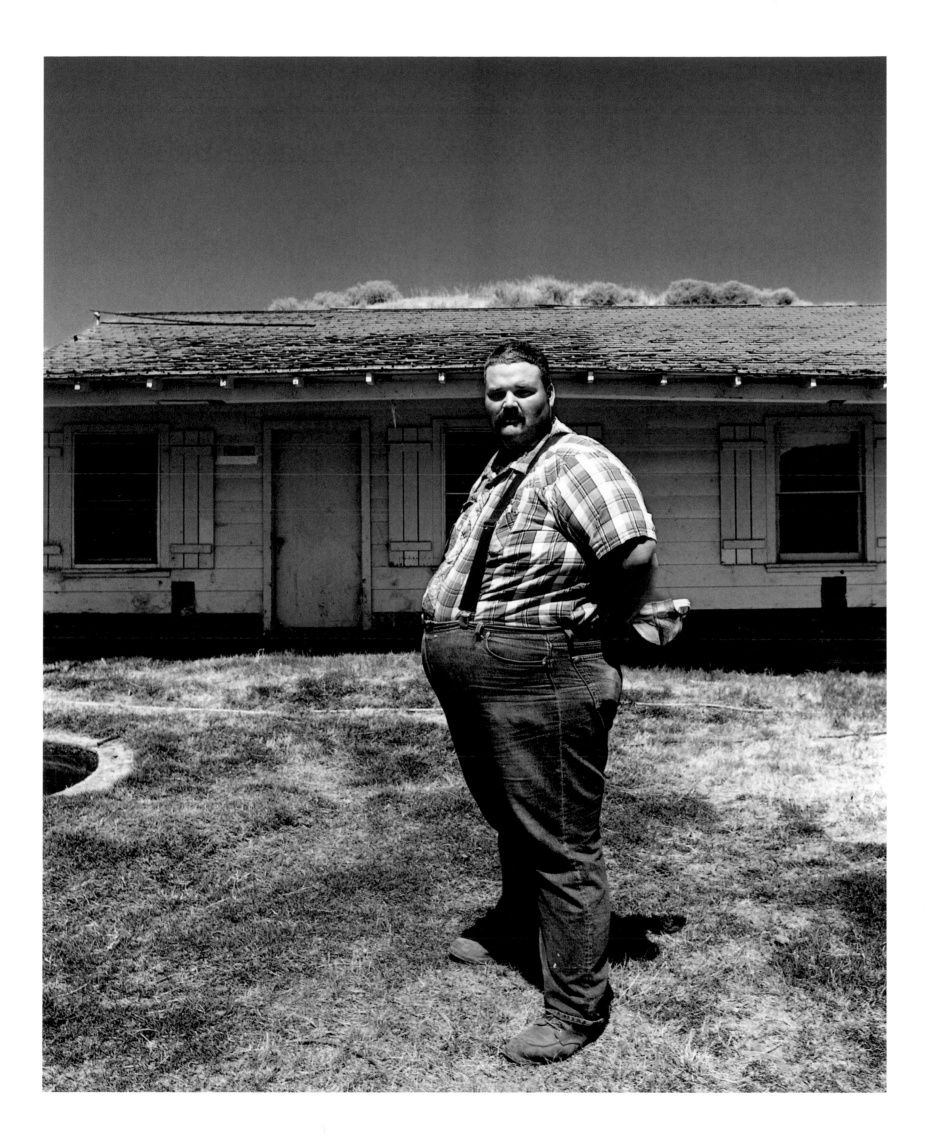

61 I LOVE MY BUD

Highway 1, Golden Meadows, Louisiana 1999

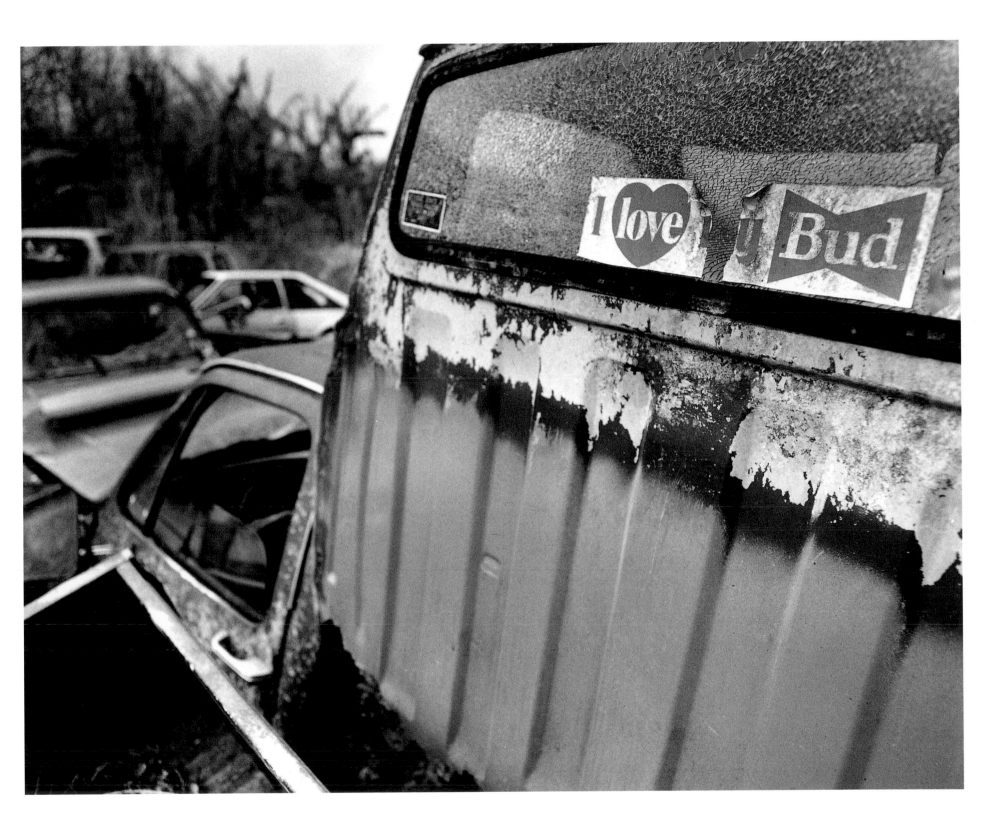

62 HOTEL SAN CARLOS

Yuma, Arizona 1998

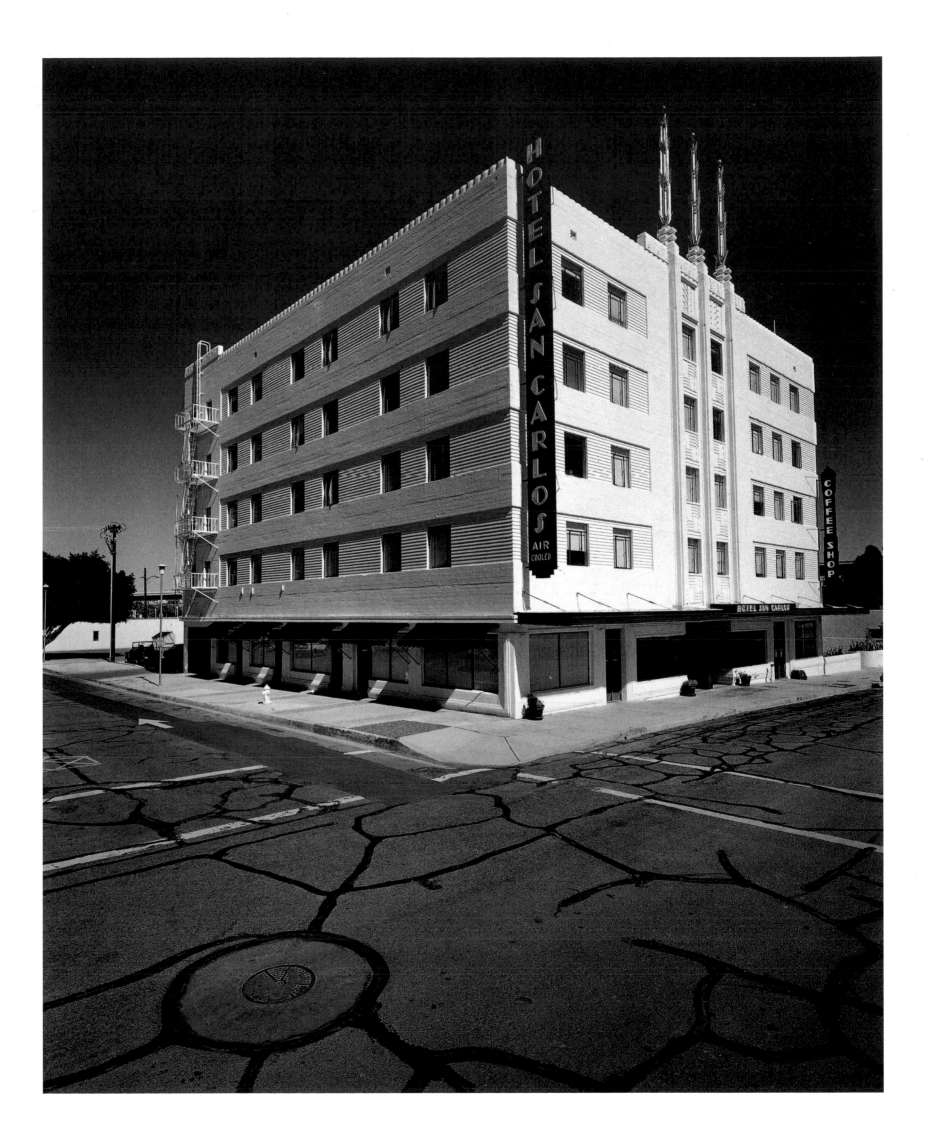

63 LITTLE WALTER'S HOMETOWN

Marksville, Louisiana 1996

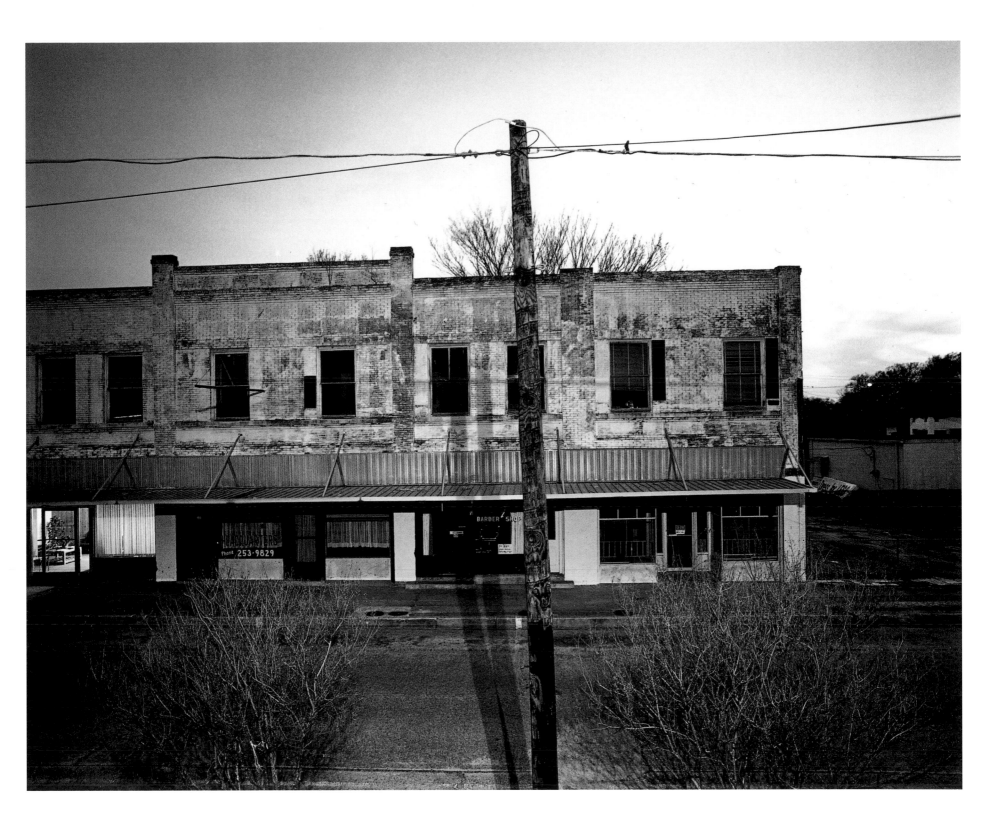

64 TALLY-HO FRIED CHICKEN

Panama City, Florida 1999

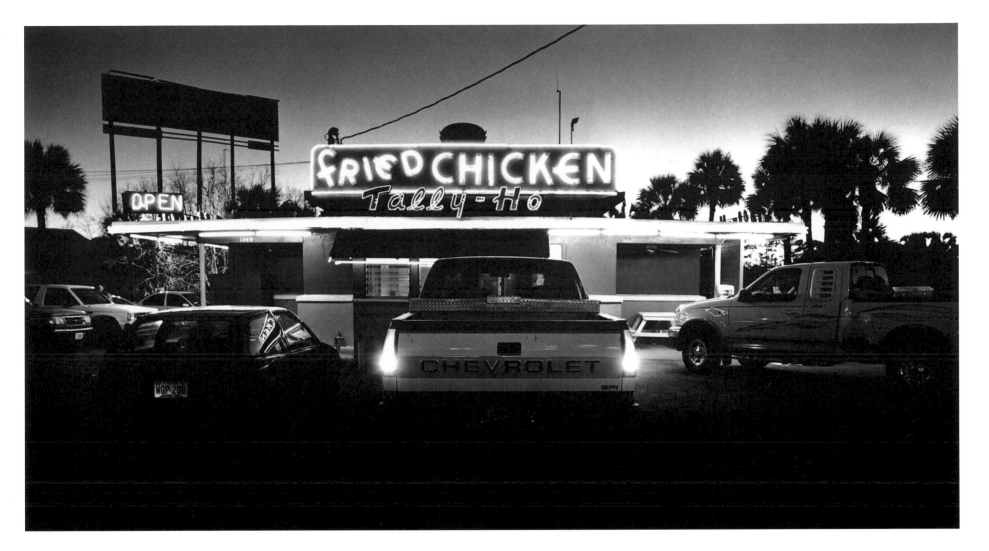

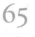 65 HI-WAY SERVICE & GROCERIES

Angora, Nebraska 1993

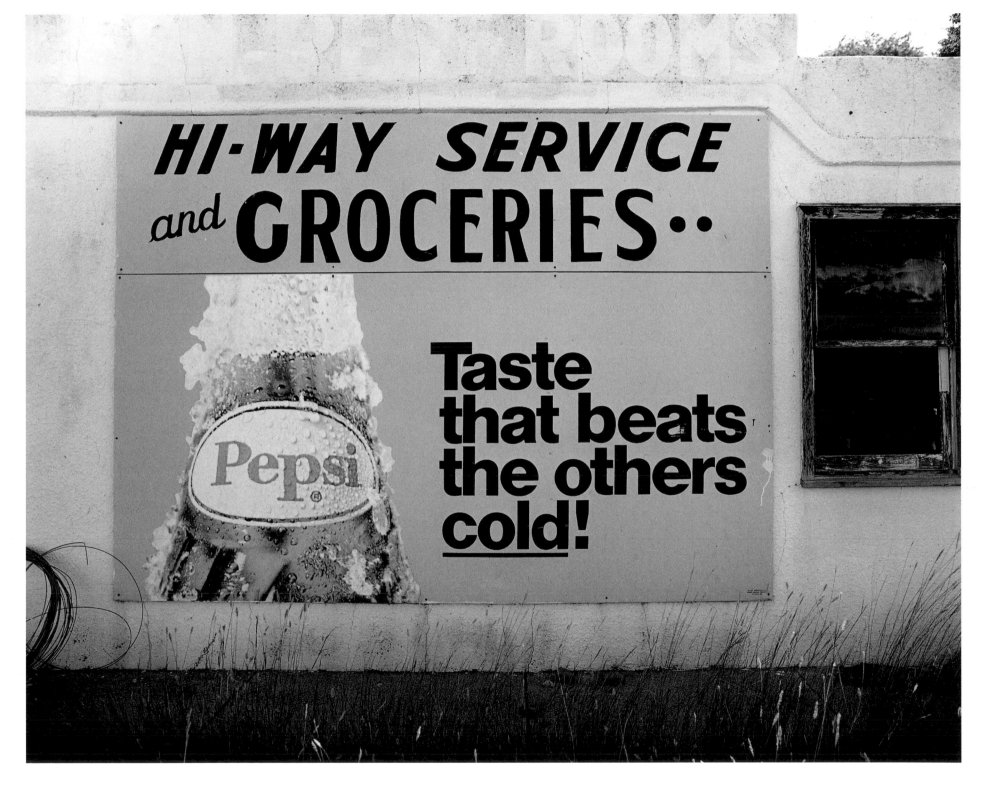

66 AVENUE "K" & 31ST STREET

Galveston, Texas 1999

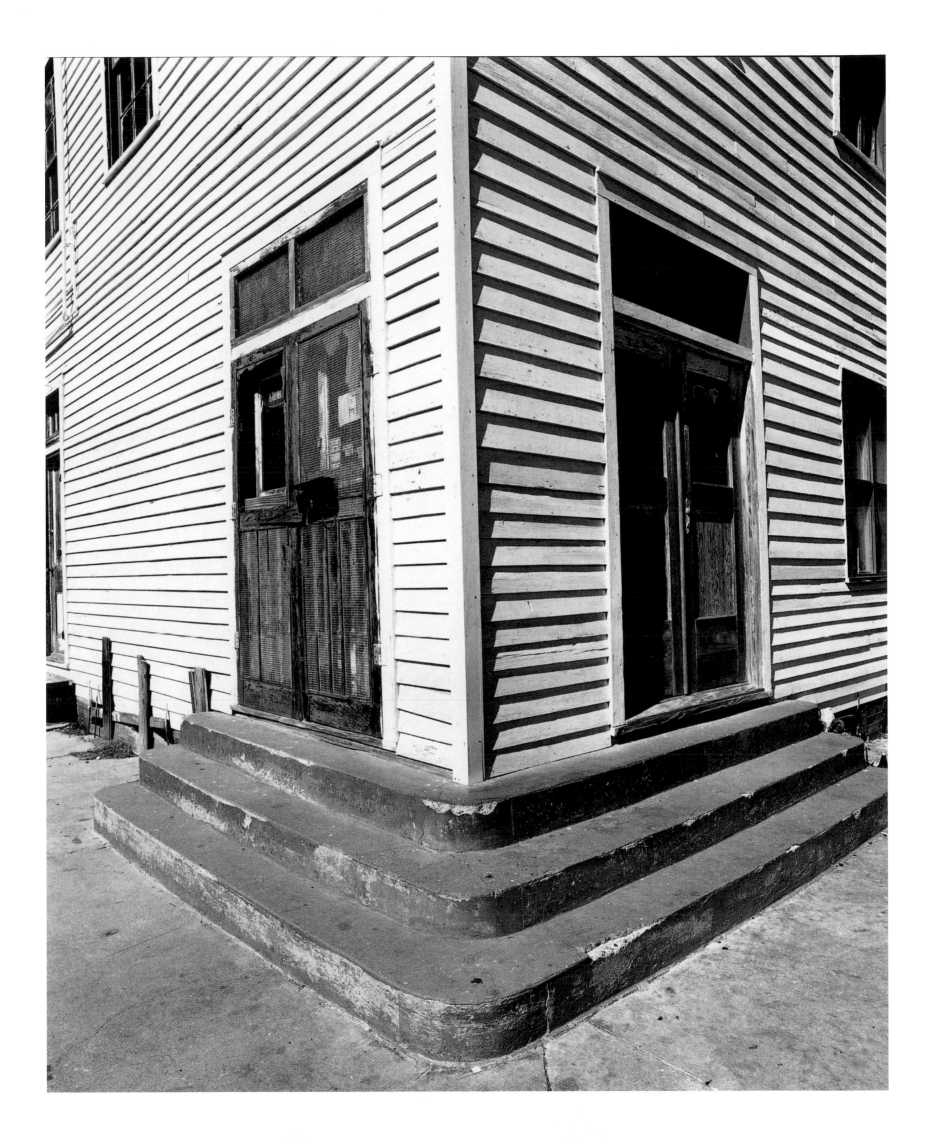

67 CRAWFORD GRAIN COMPANY

Lexington, Nebraska 1993

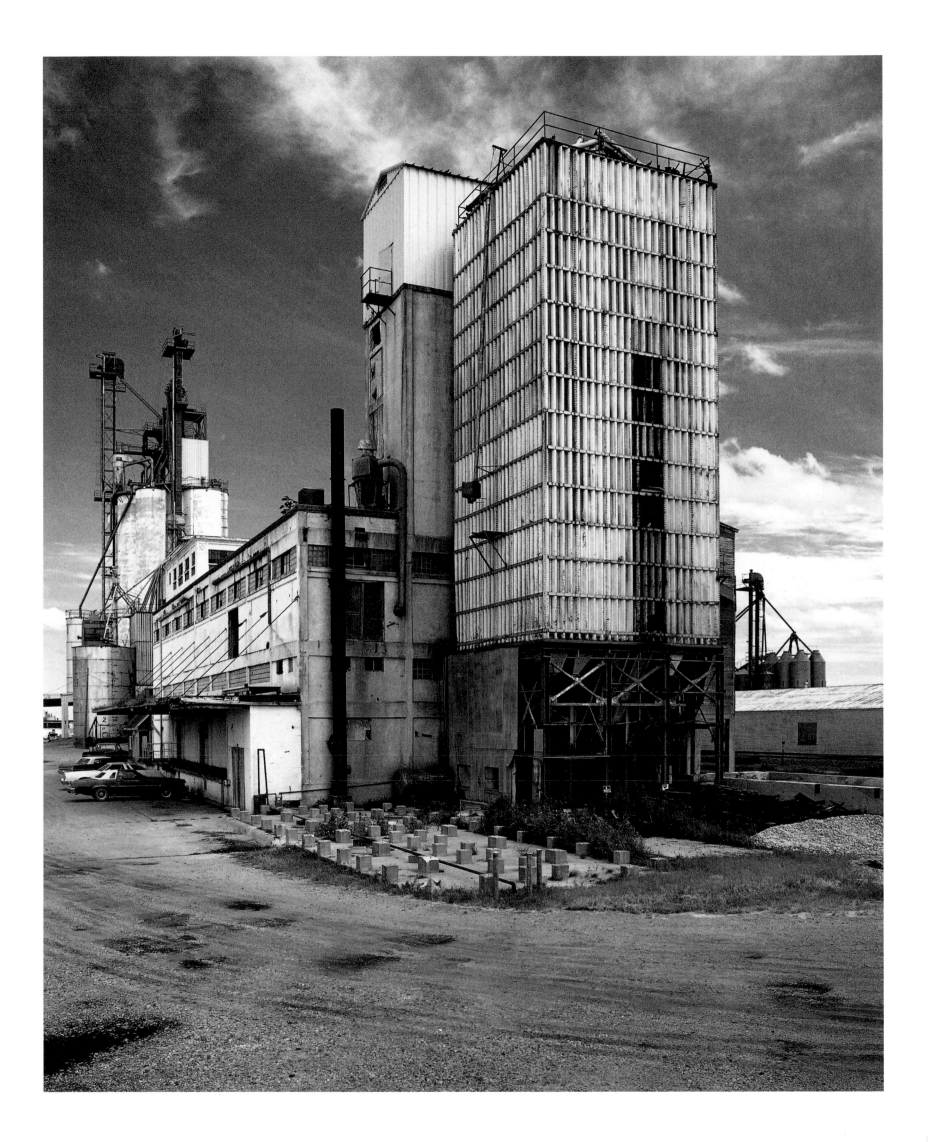

68 MALISSA BALL & FRIEND WITH MEW MEW

Cascade Locks, Oregon 1993

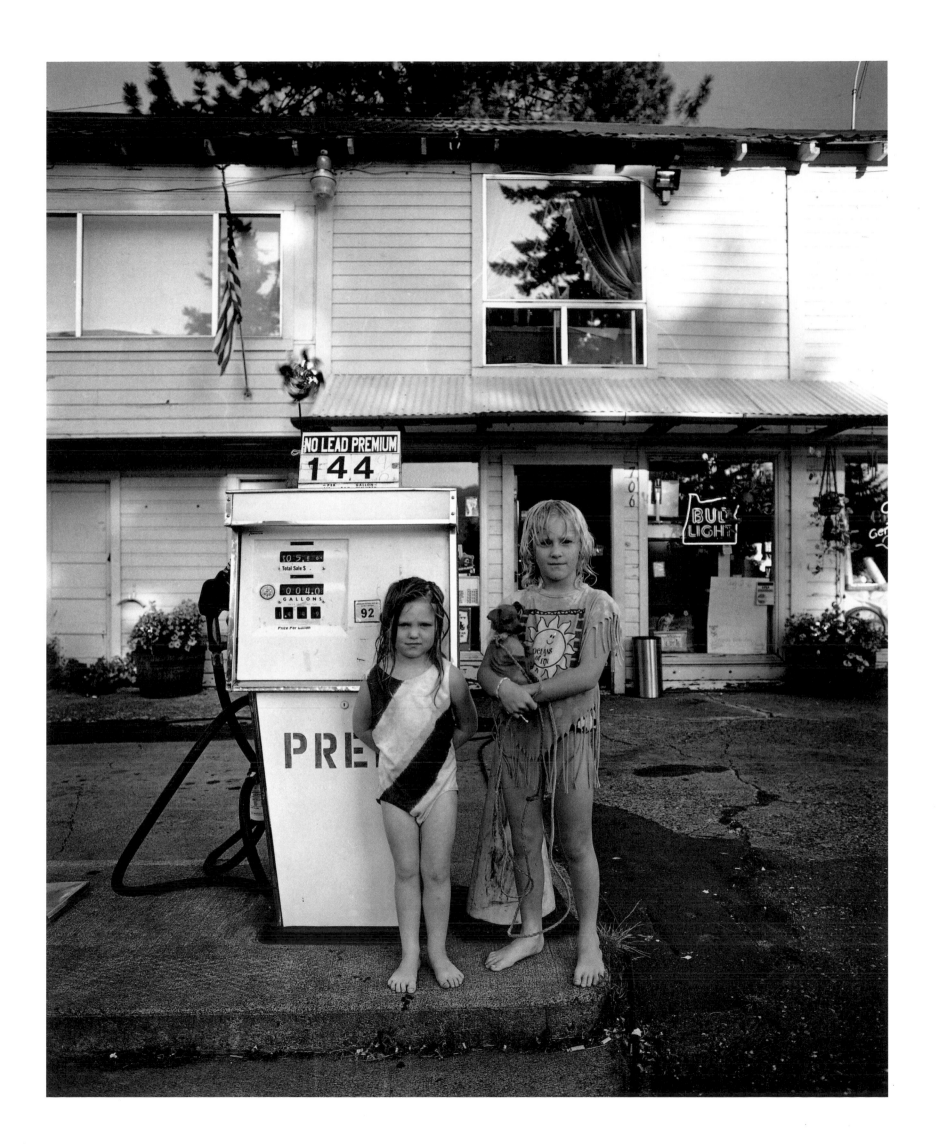

69 UNTITLED

Galveston, Texas 1999

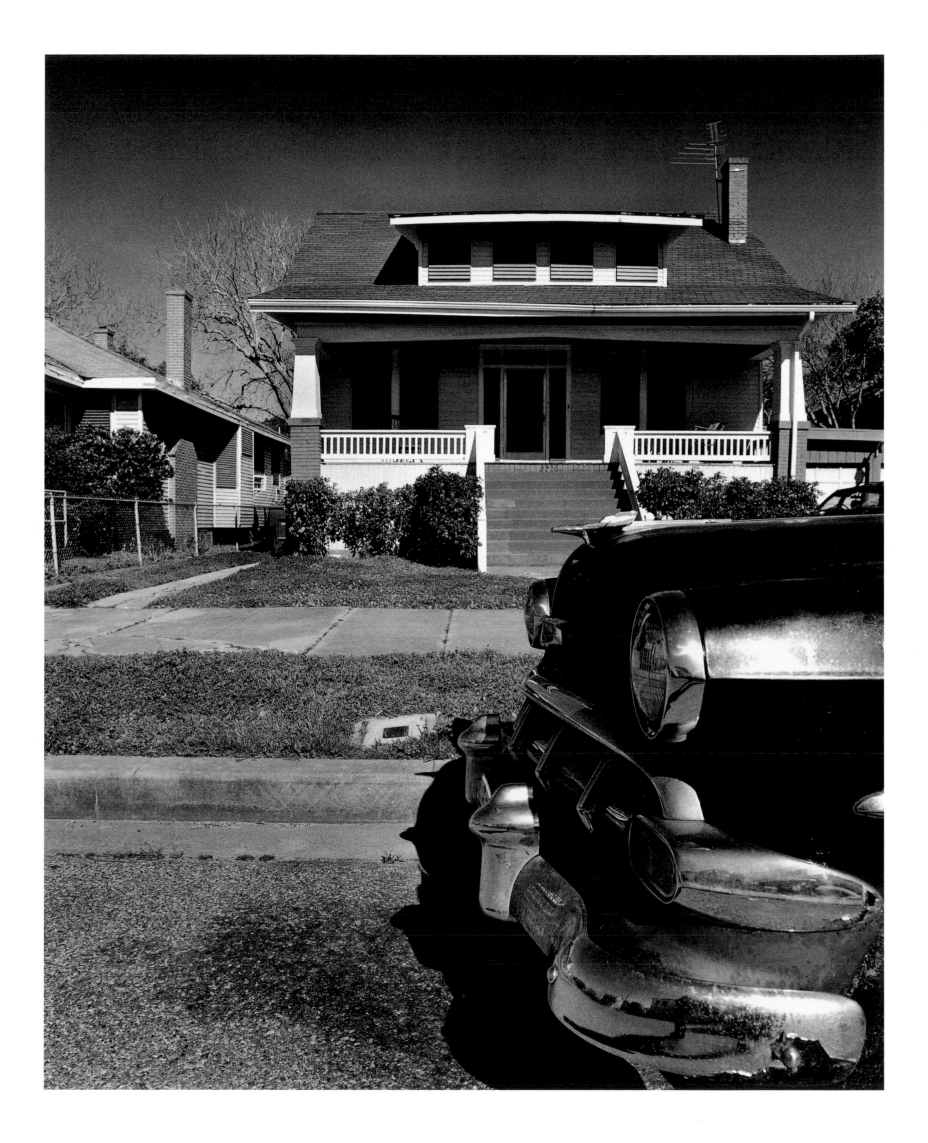

70 JASON SMITH

Kemmerer, Wyoming 1994

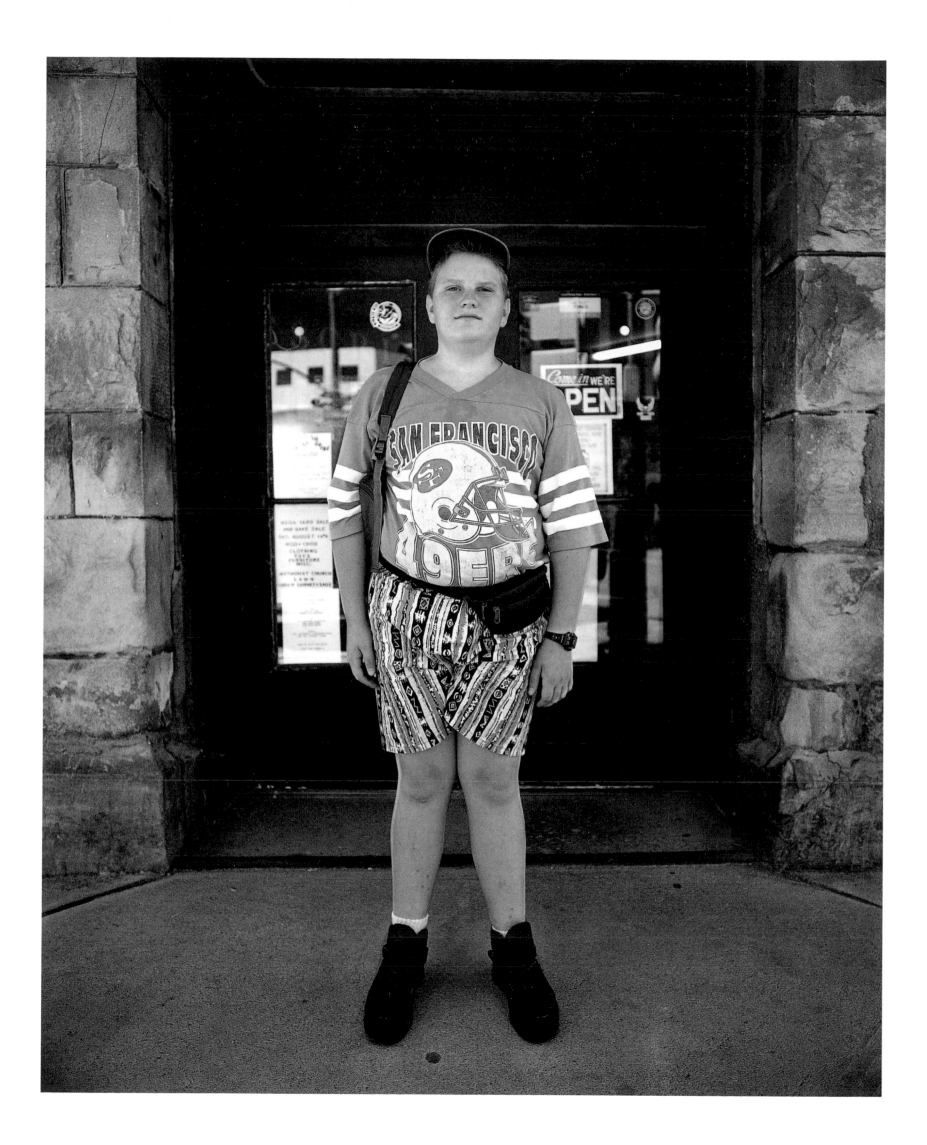

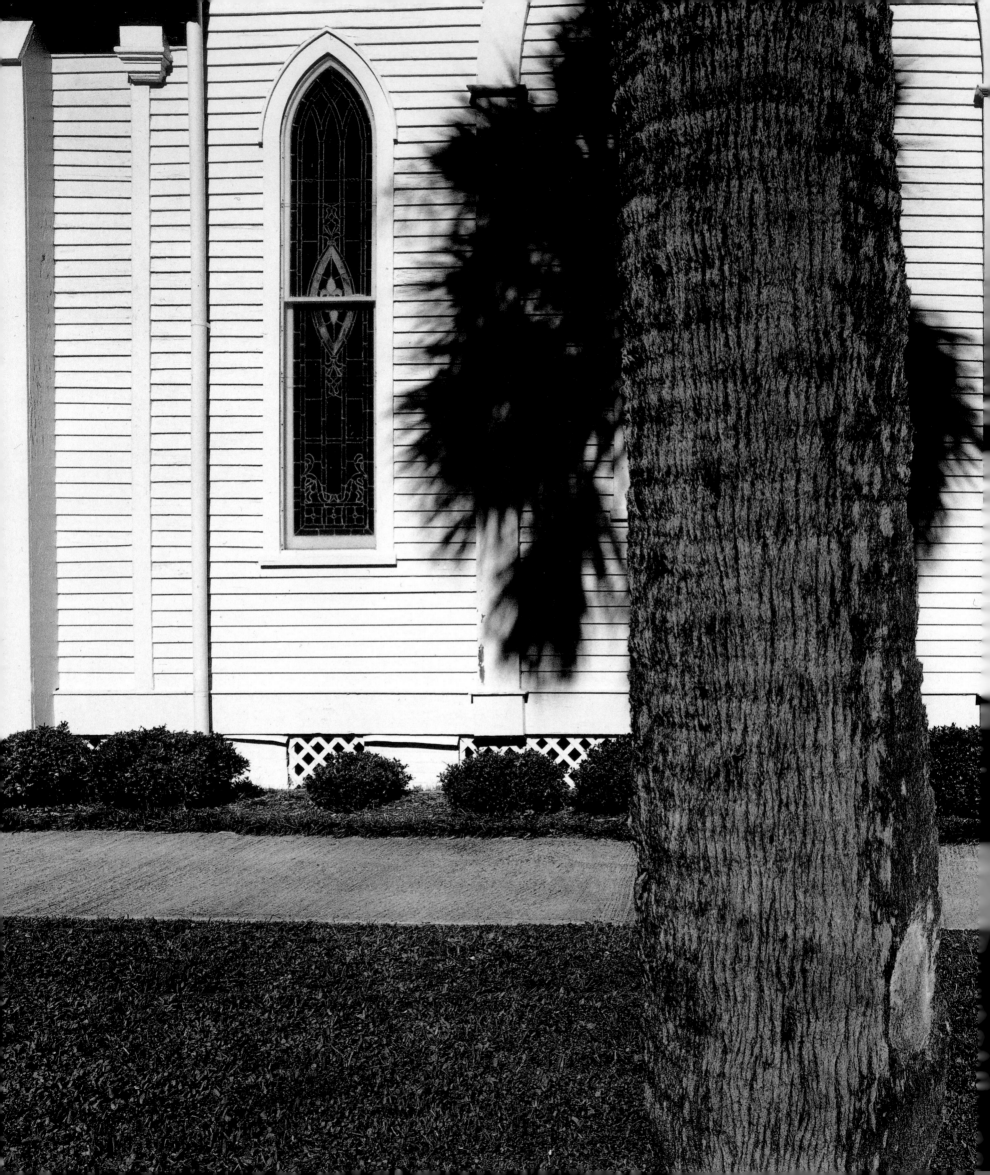

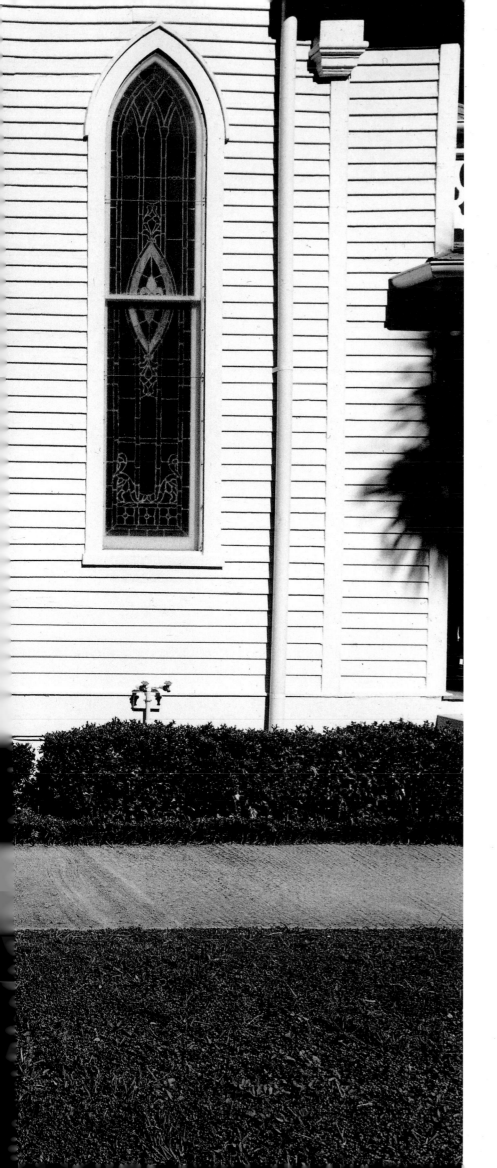

UNTITLED 71
Apalachicola, Florida 1999

72 UNTITLED

Cross City, Florida 1999

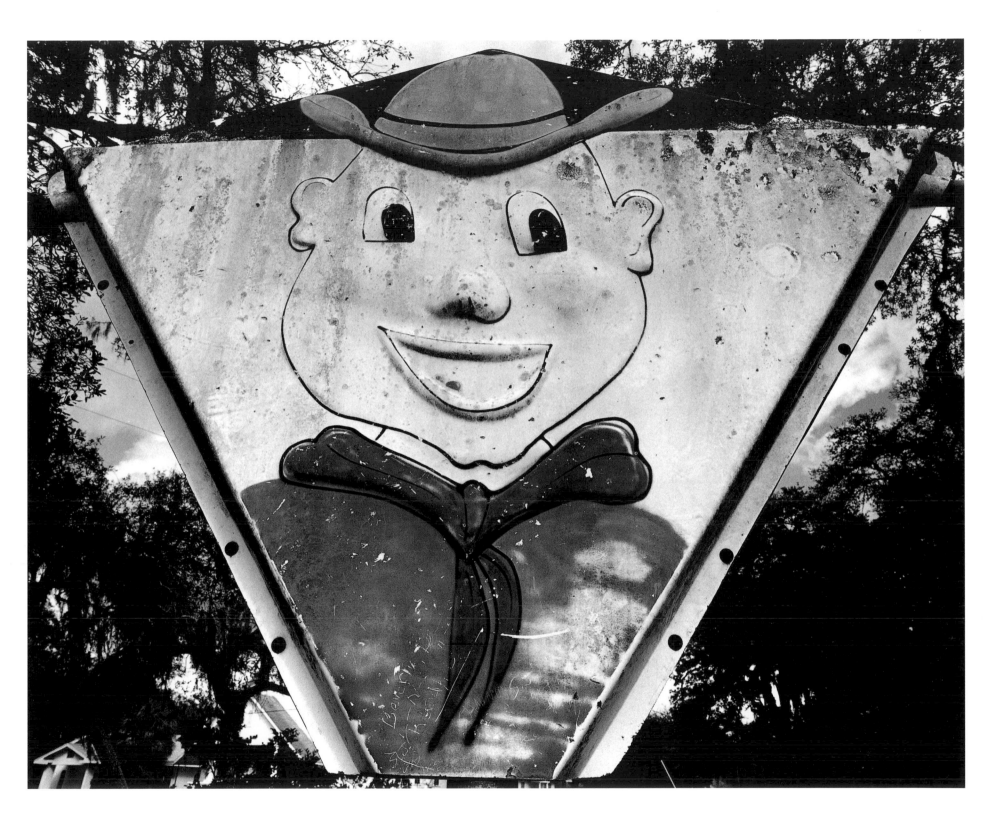

73 HOTEL ENDERS

Soda Springs, Idaho 1993

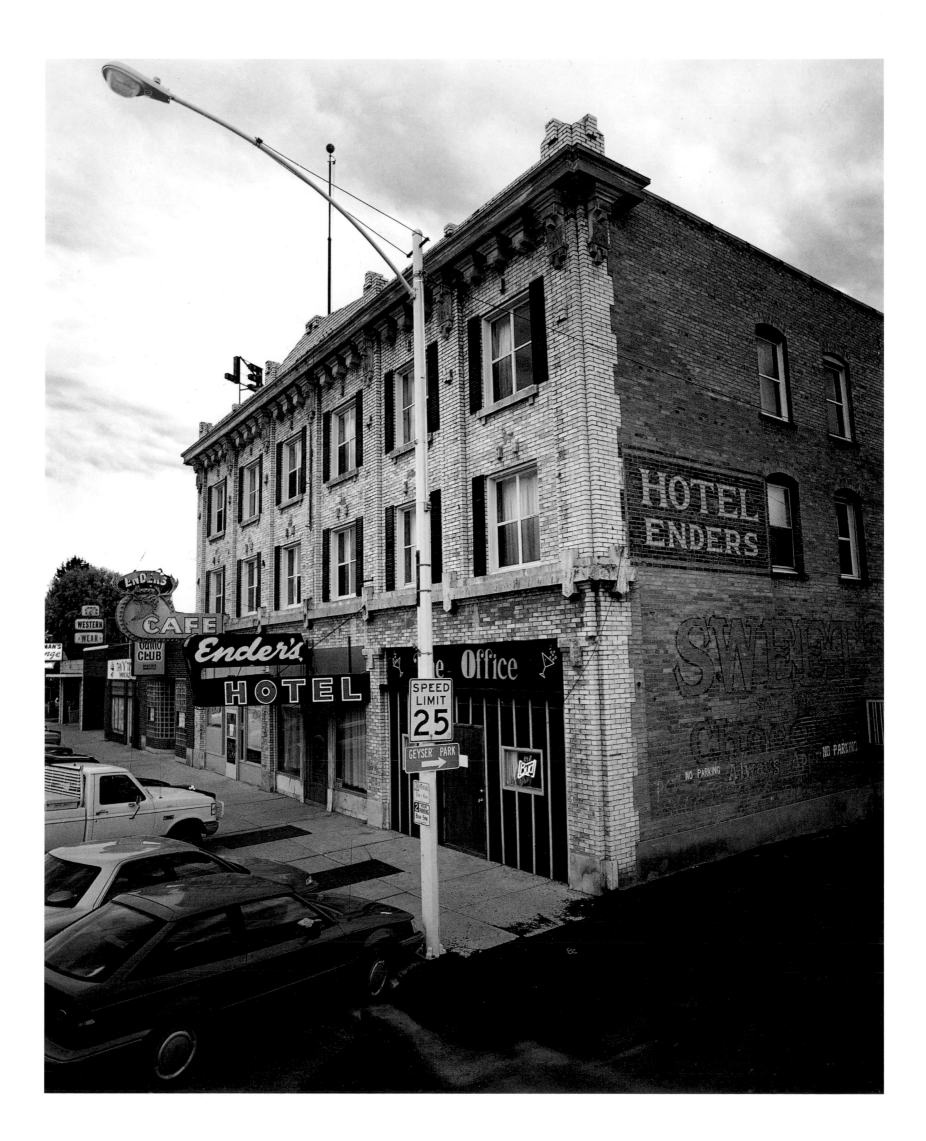

74 MARJORIE GILCHRIEST

Bridgeport, Nebraska 1993

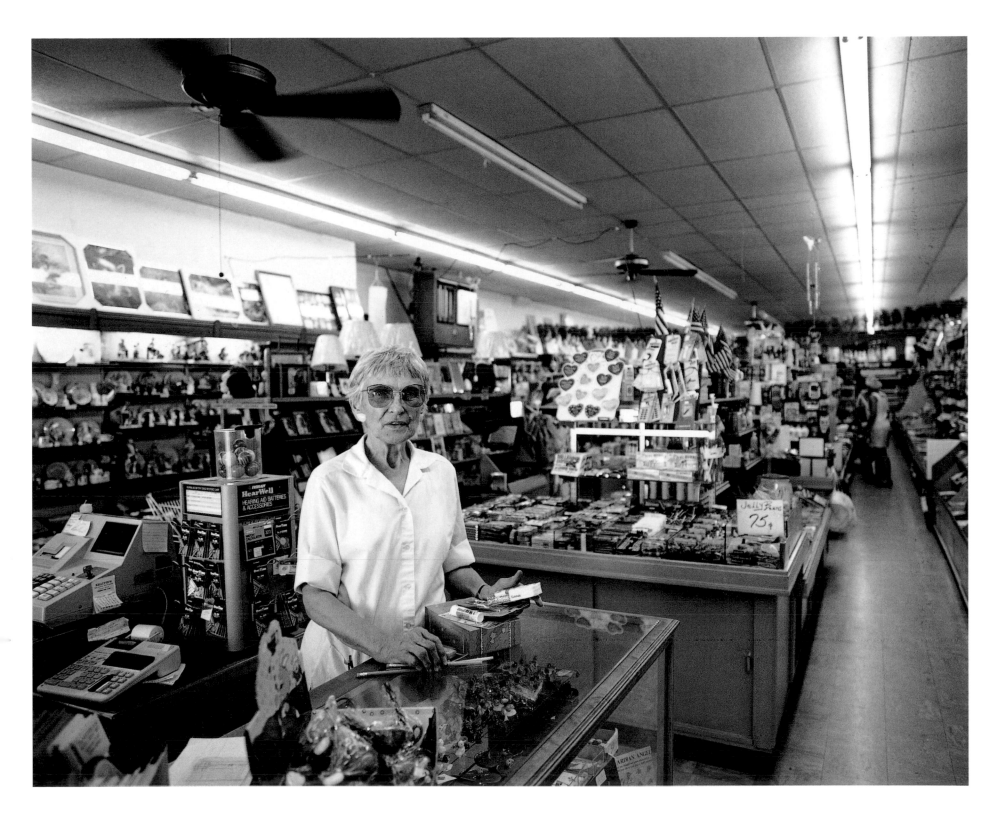

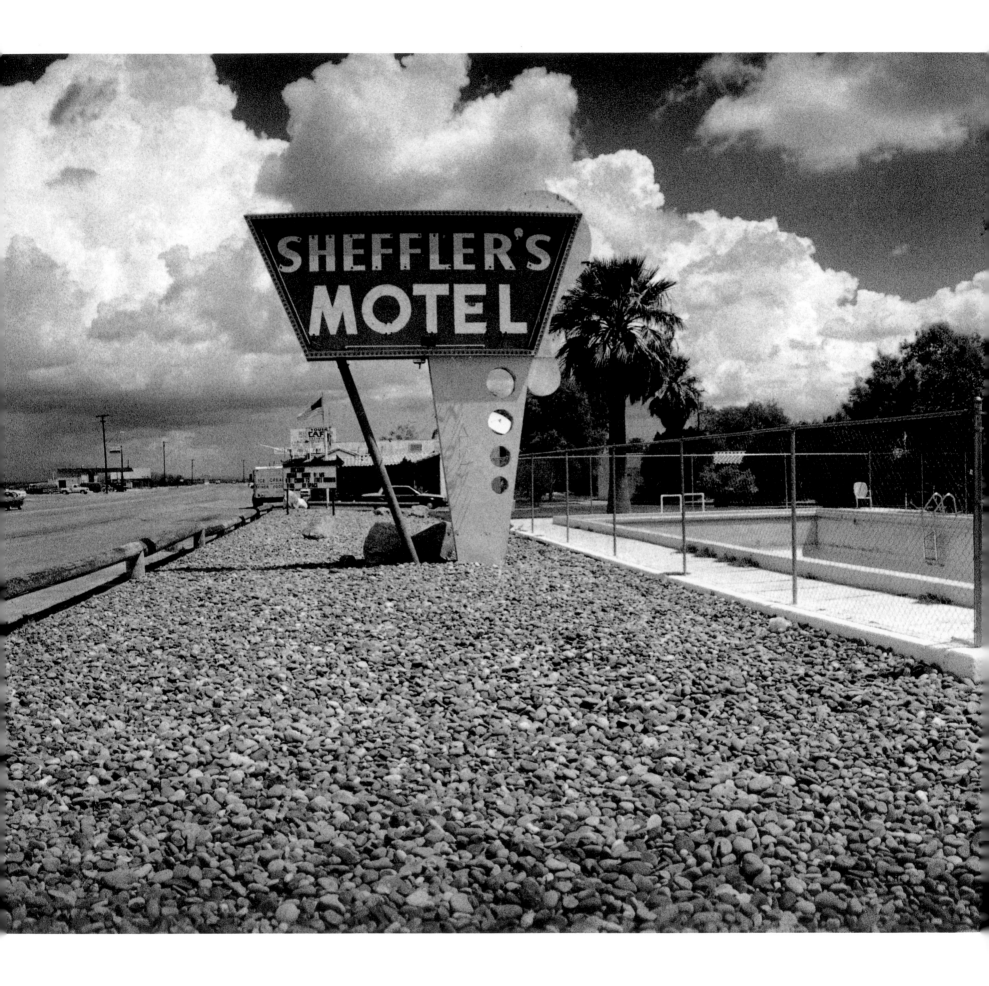

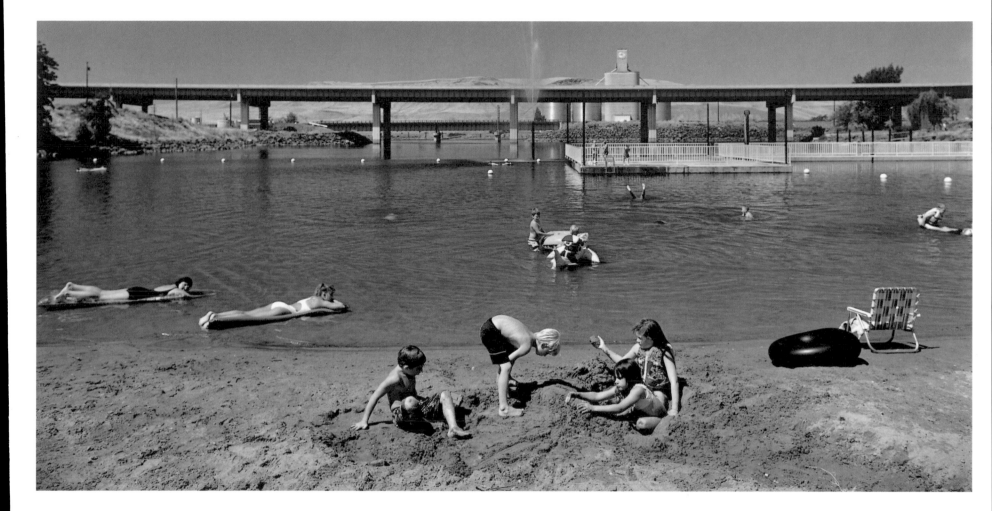

77 LONNY & ETHAN MAYEUX

St. Charles, Louisiana 1999

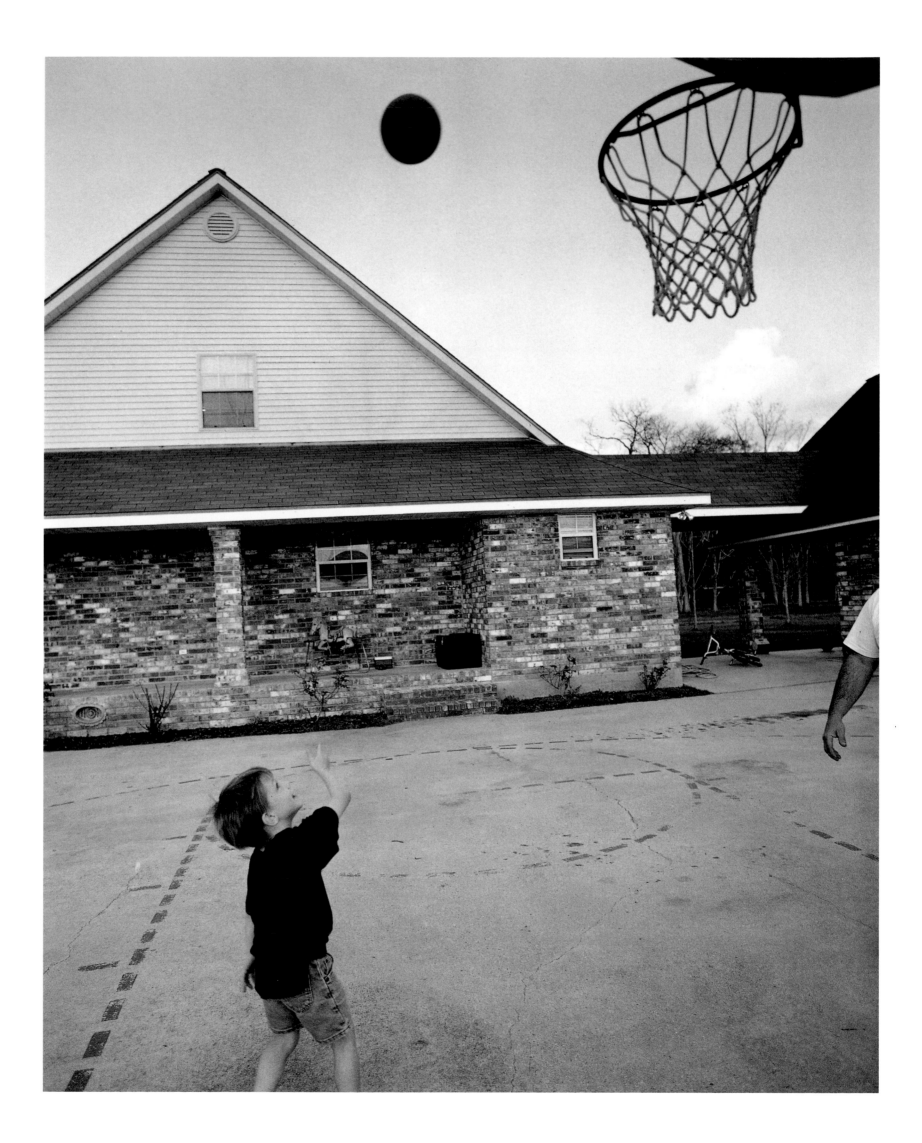

78 BROOKE DEFRENE & FAMILY

St. Charles, Louisiana 1999

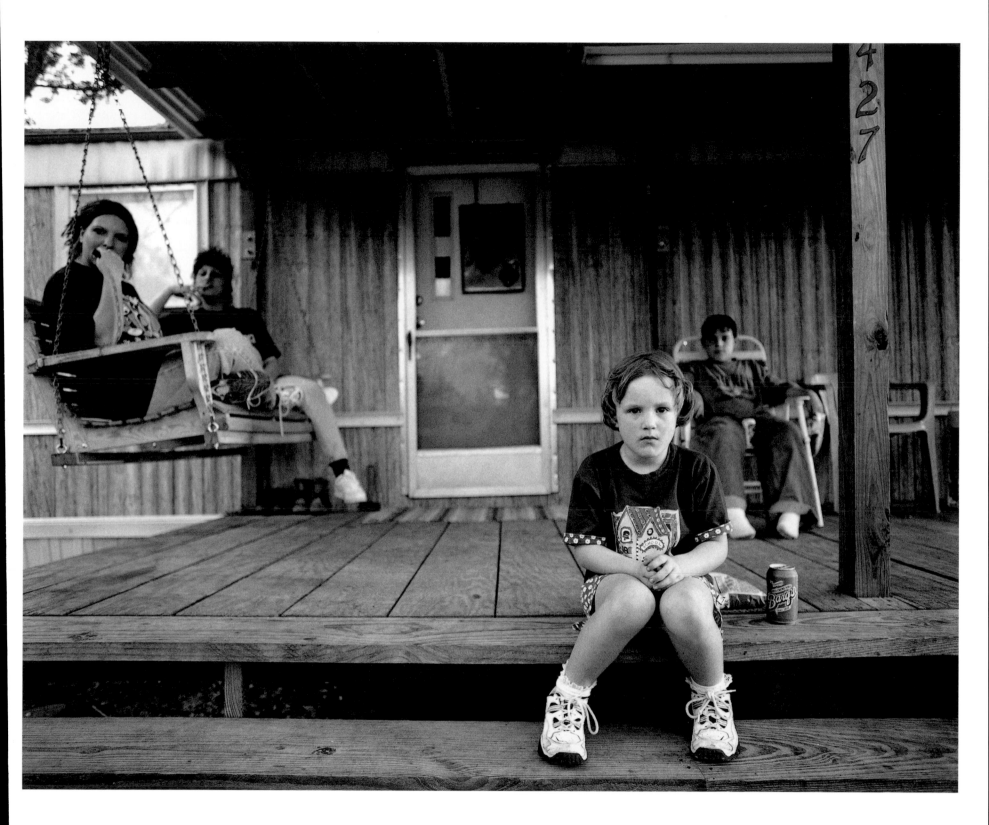

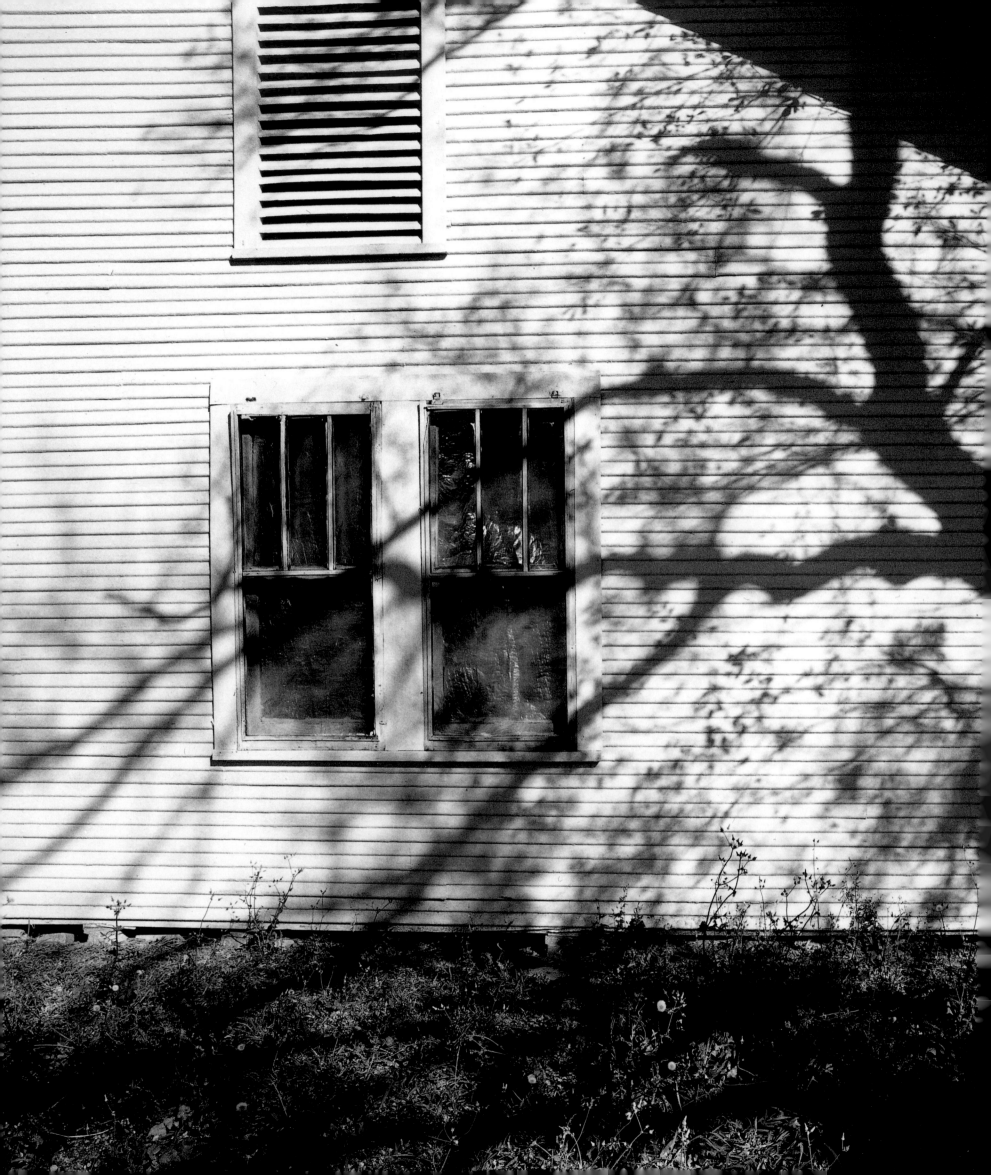

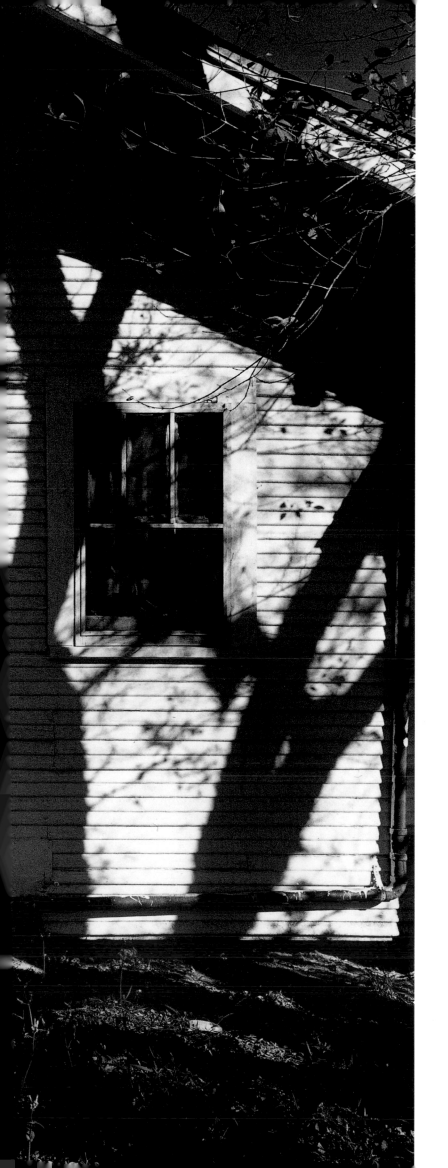

UNTITLED 79
Harlingen, Texas 1999

80 BIENVILLE BISTRO

Mobile, Alabama 1999

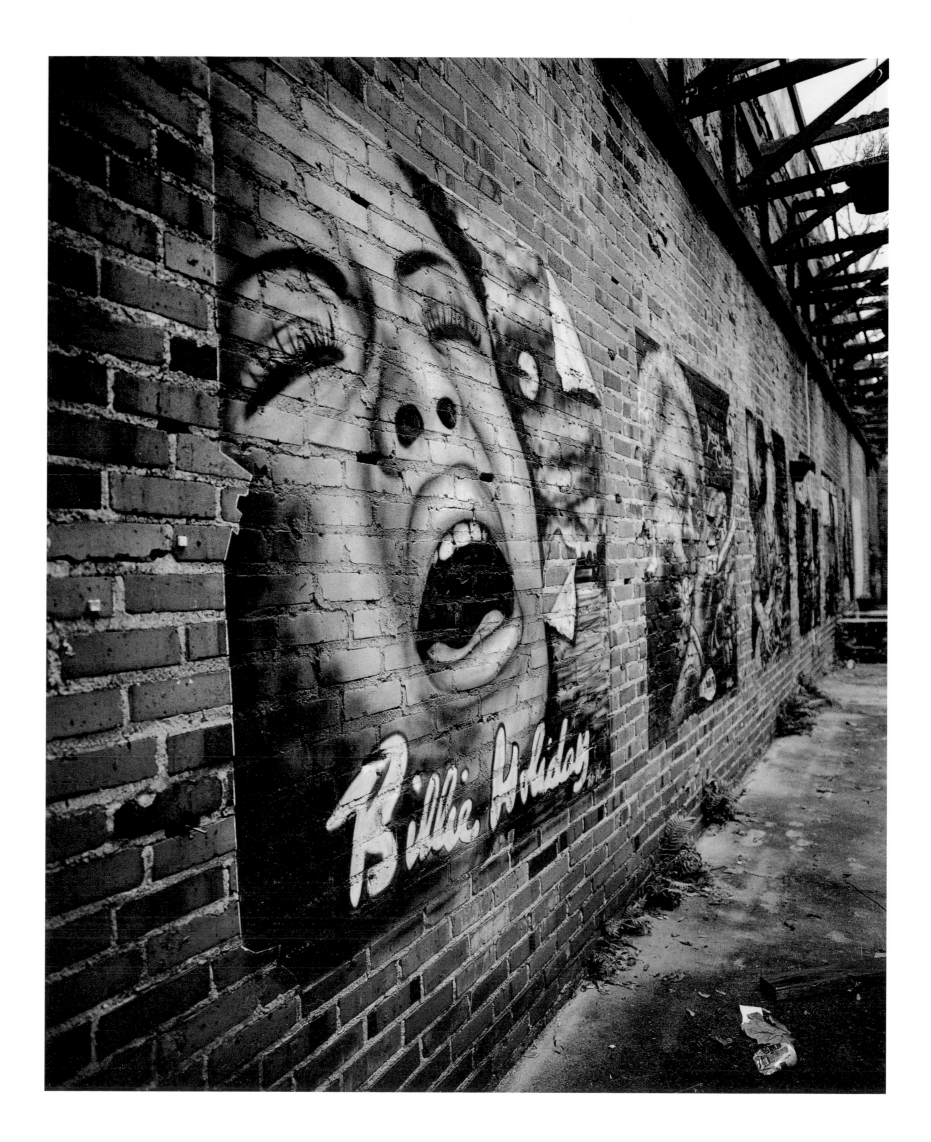

81 DAVID, ANDY & TREVOR

La Grande, Oregon 1993

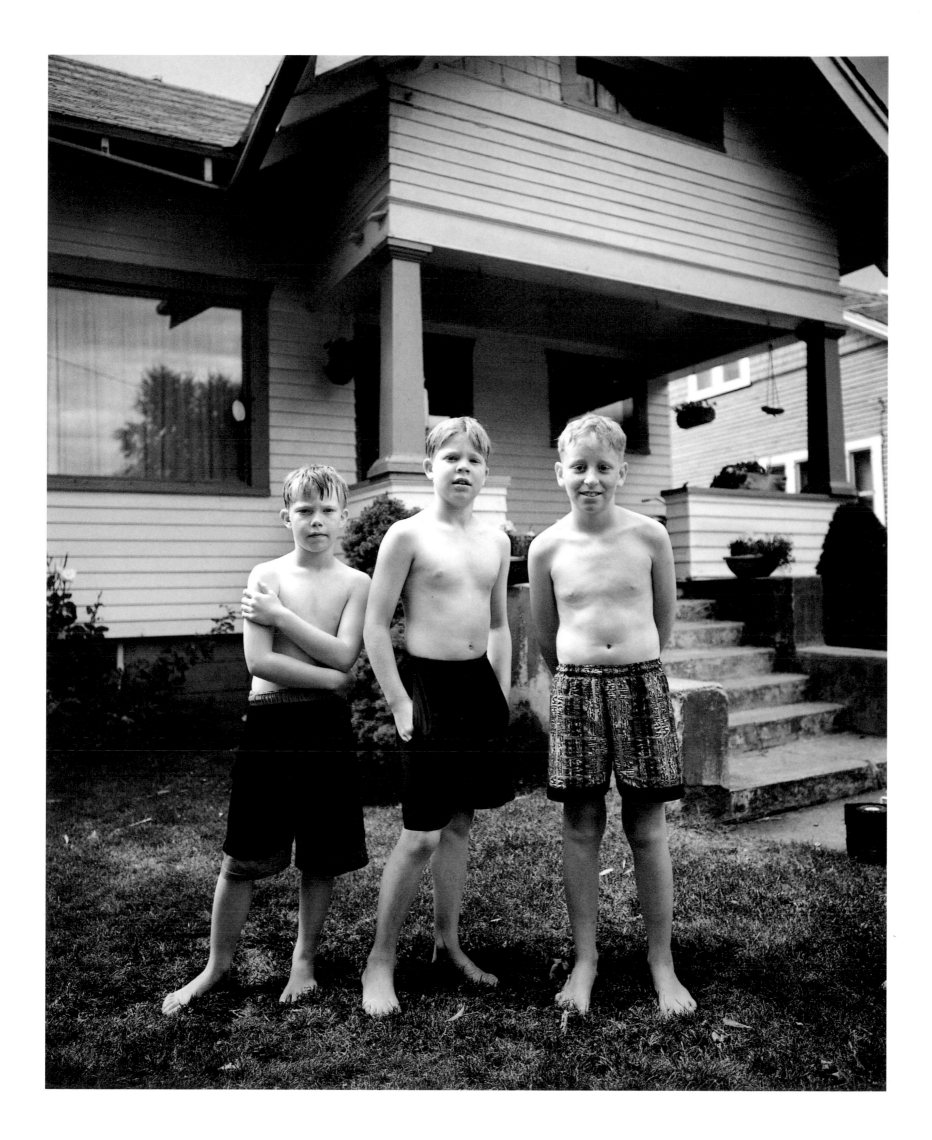

82 BOYCE HOTEL & APARTMENTS
Lava Hot Springs, Idaho 1993

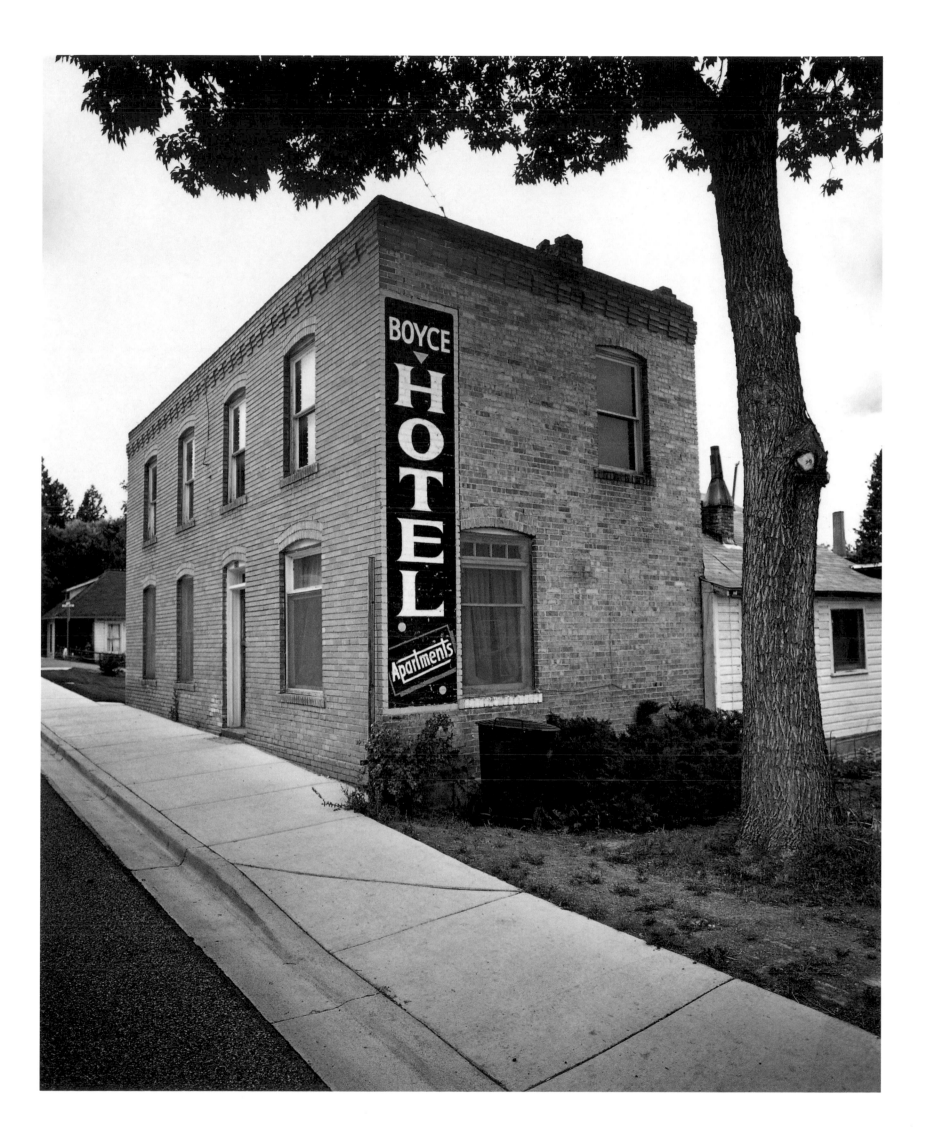

83 DYNA FLOW SPECIAL

Fairview, Oregon 1993

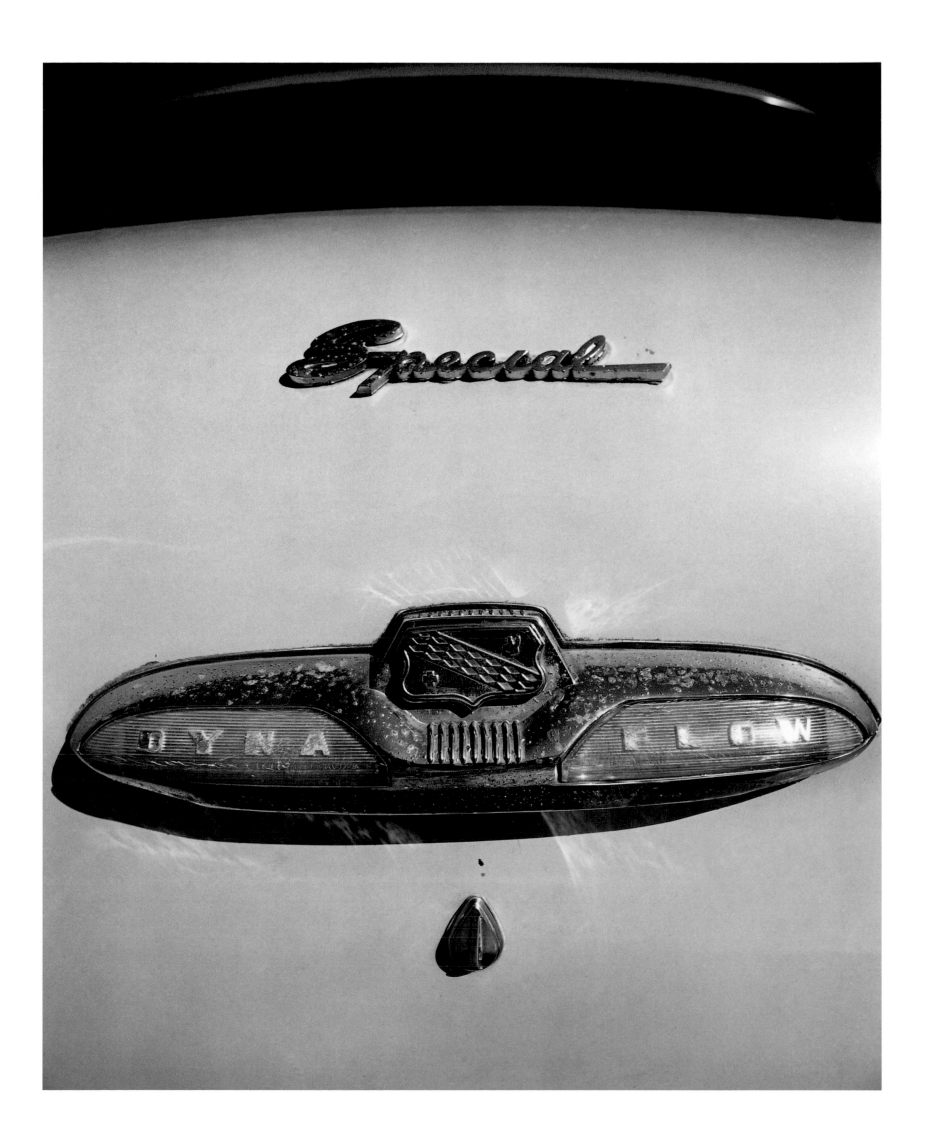

84 OLD HIGHWAY 61
Robinsonville, Mississippi 1997

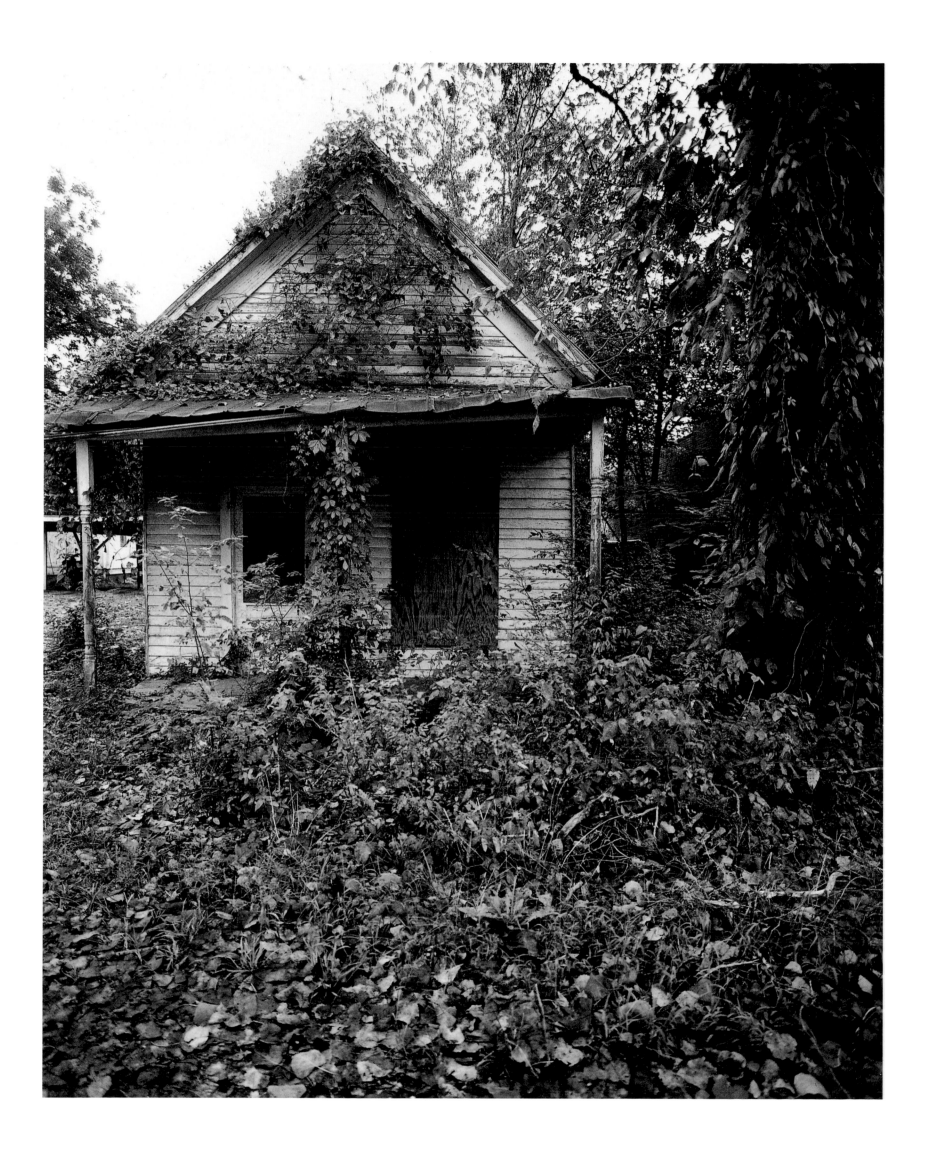

85 JR'S BAR

Cokeville, Wyoming 1993

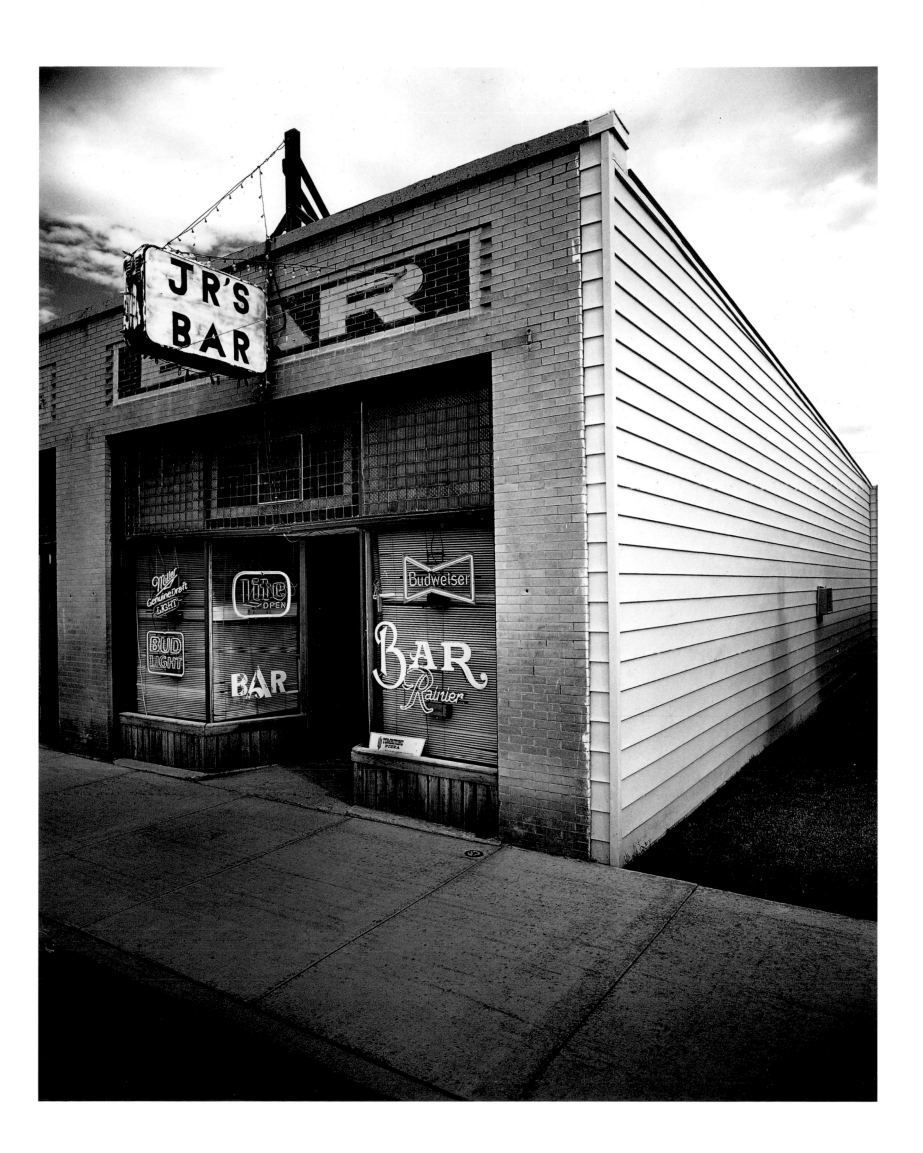

86 VIOLA LASTALA

Quartzside, Arizona 1994

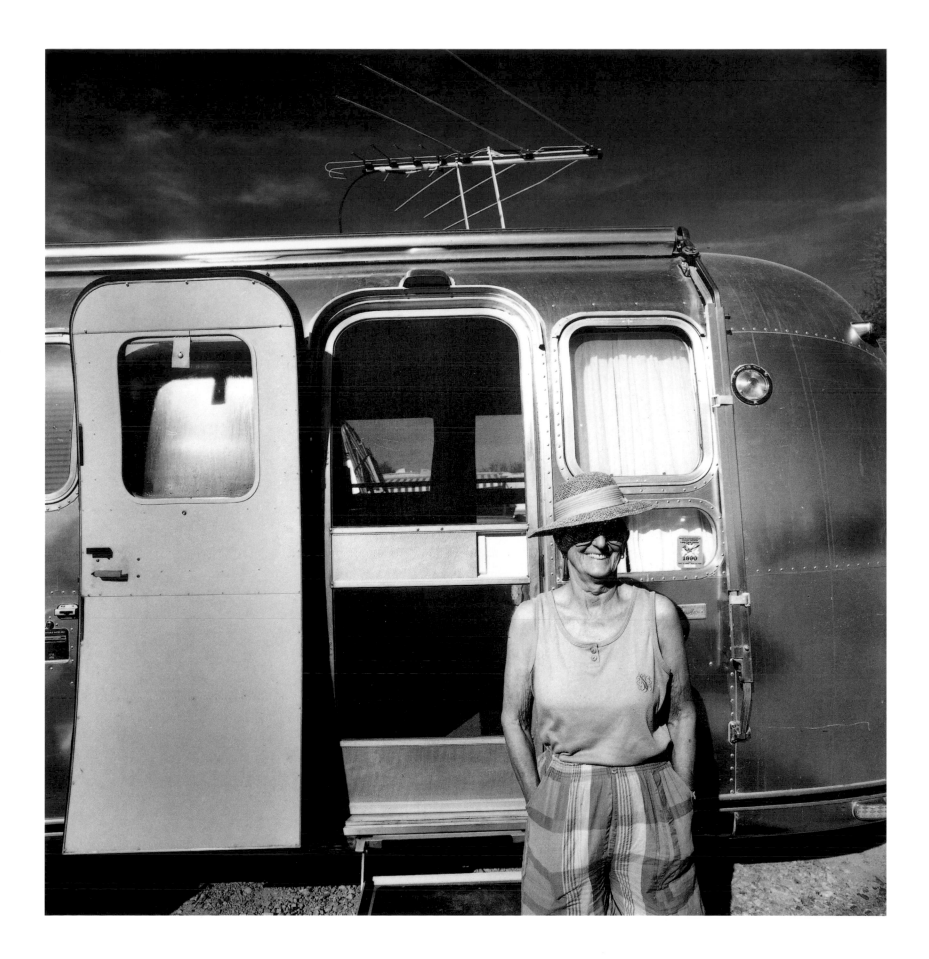

87 WEST VIOLET & NORTH PINE STREETS

Foley, Alabama 1999

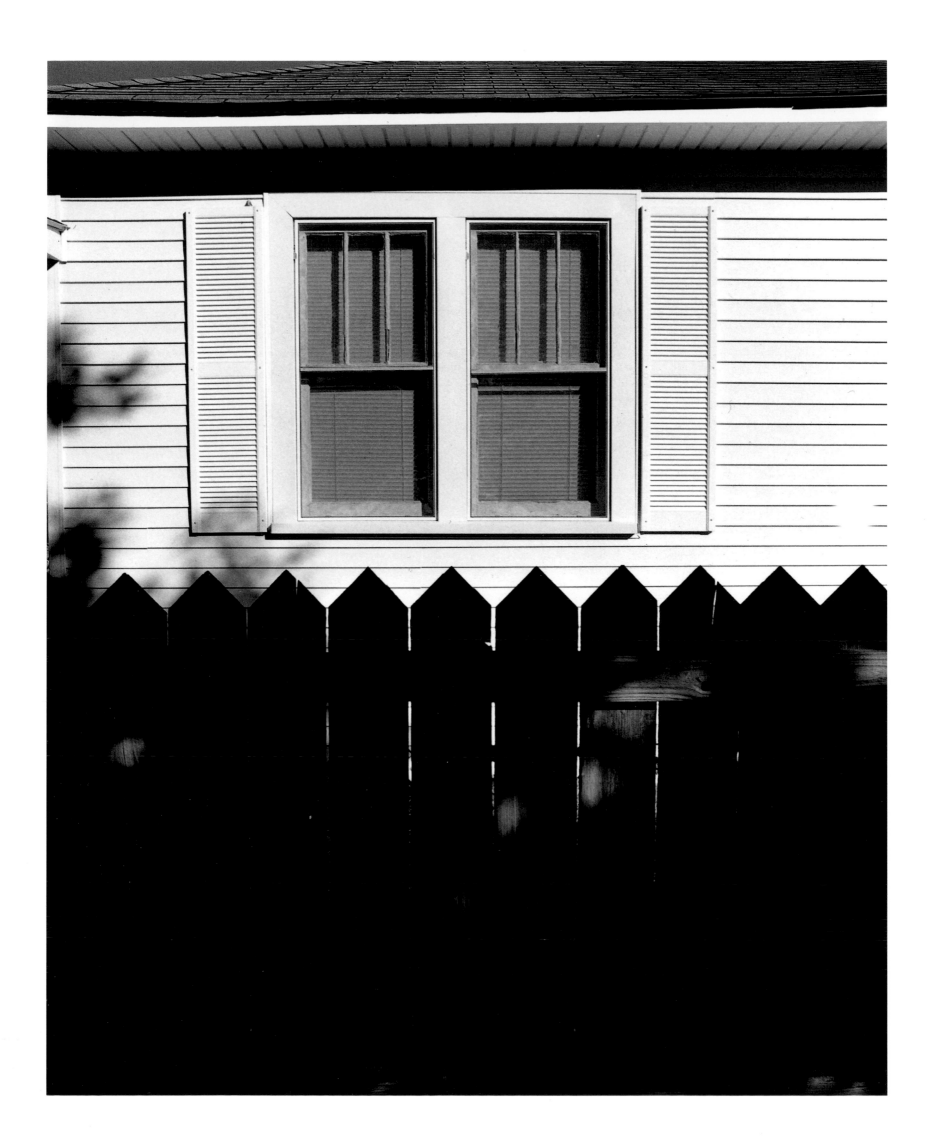

88 UNTITLED

Cokeville, Wyoming 1993

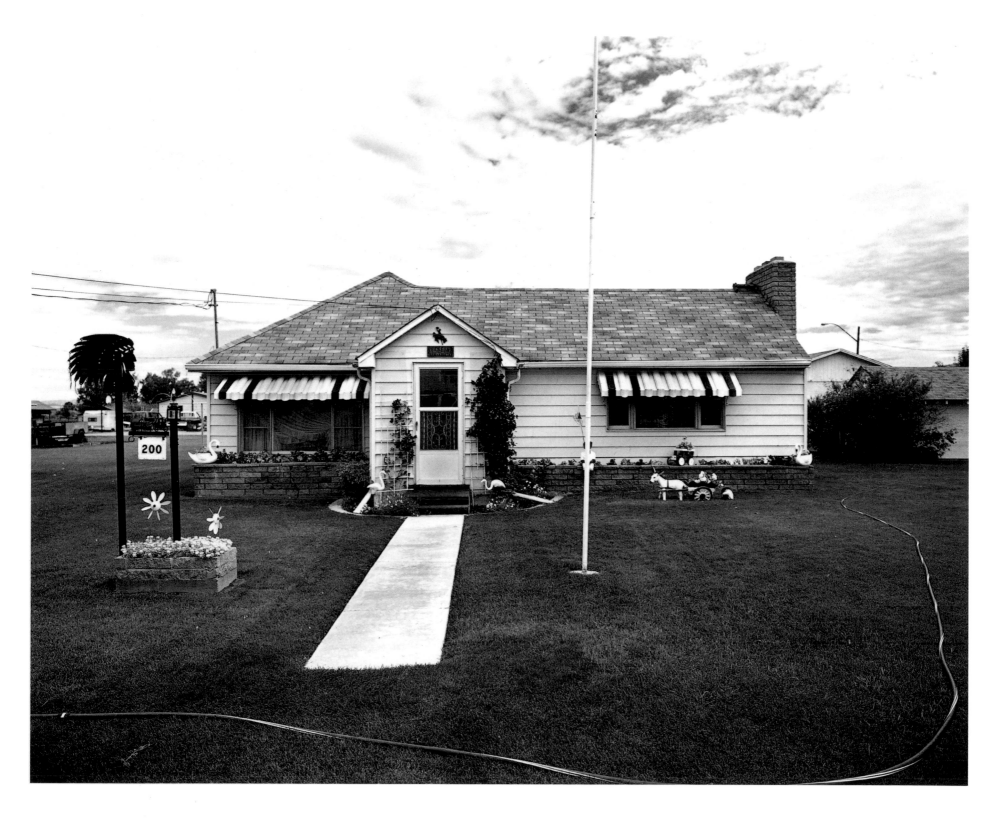

89 UNTITLED

Vinton, Louisiana 1996

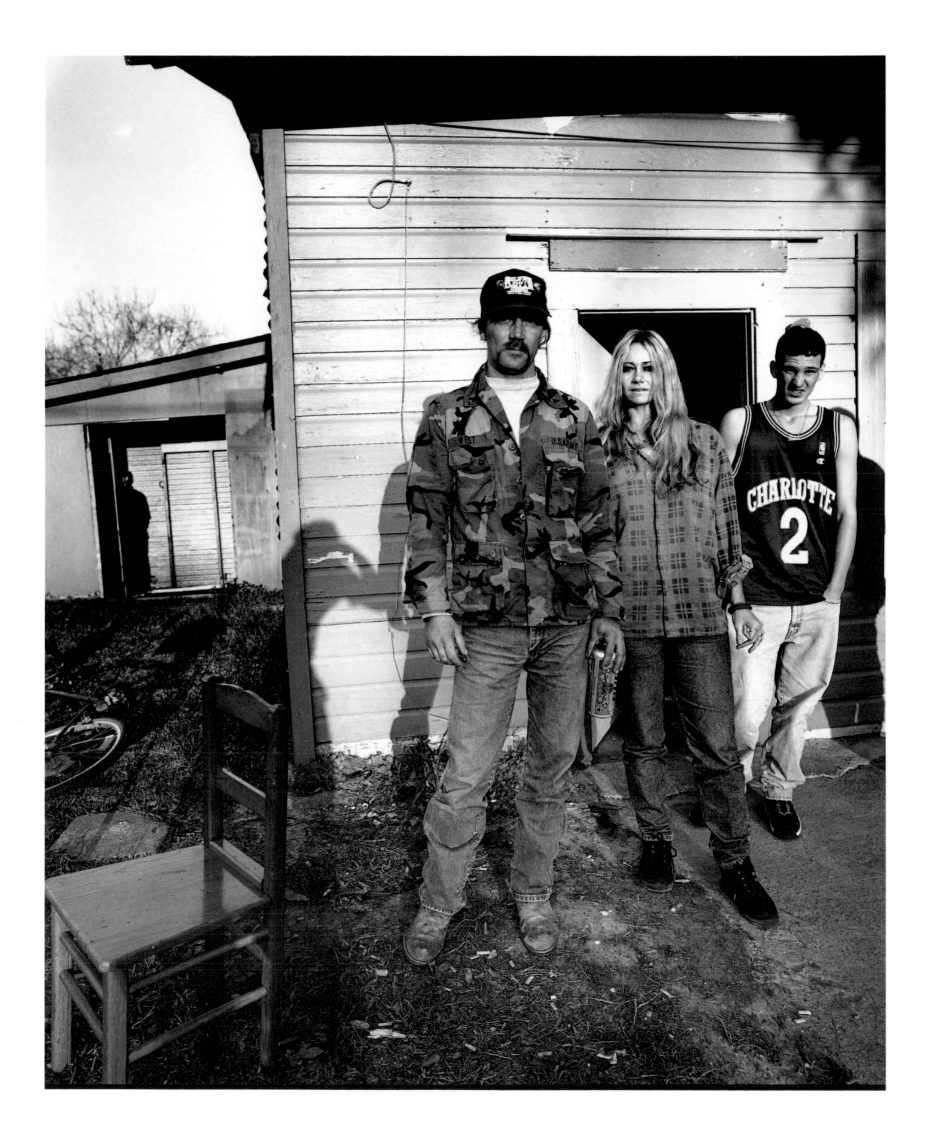

90 JAMIE & TRACY STEVENSON
WITH SARAH, BETHANY & CHARITY
Quartzside, Arizona 1994

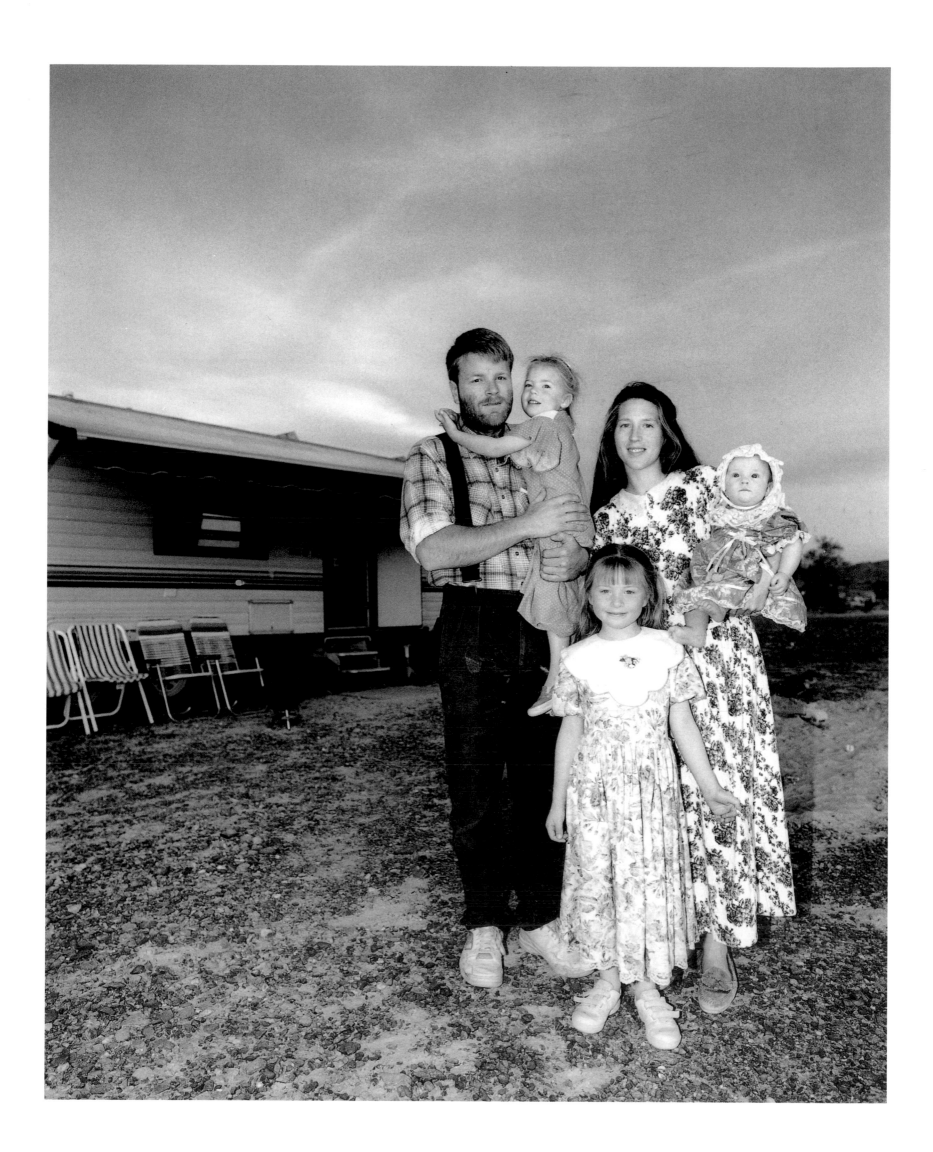

91 UNTITLED

Baker City, Oregon 1993

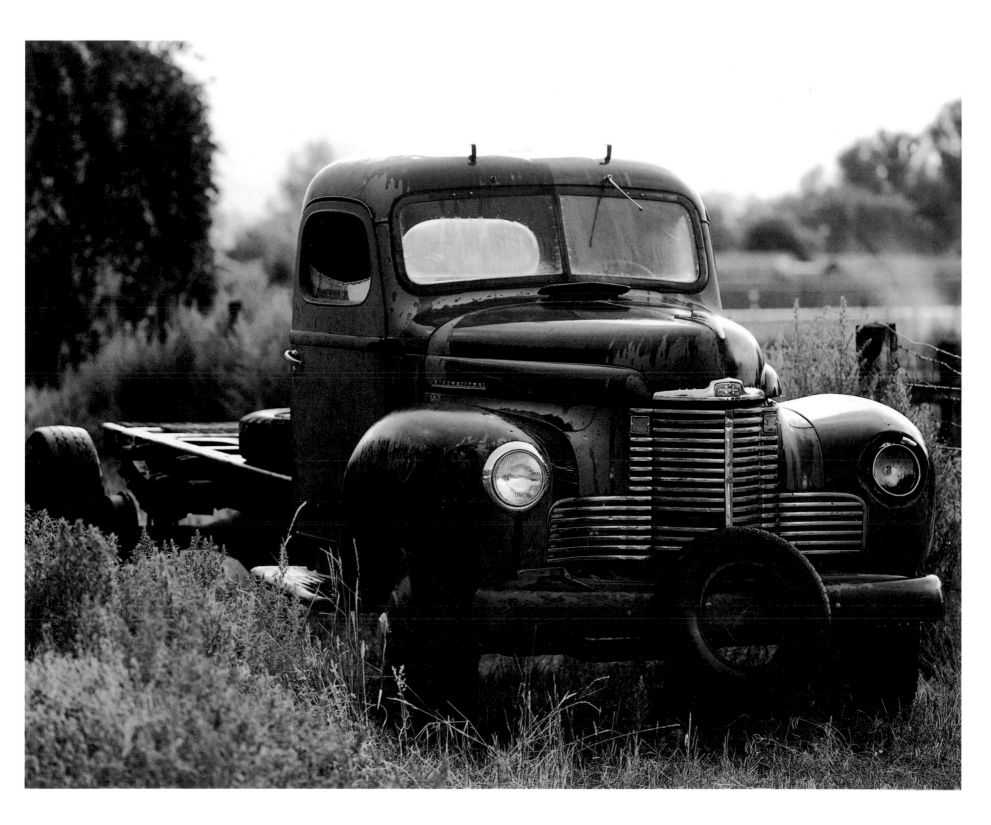

92 BROADWATER LIBRARY

Broadwater, Nebraska 1993

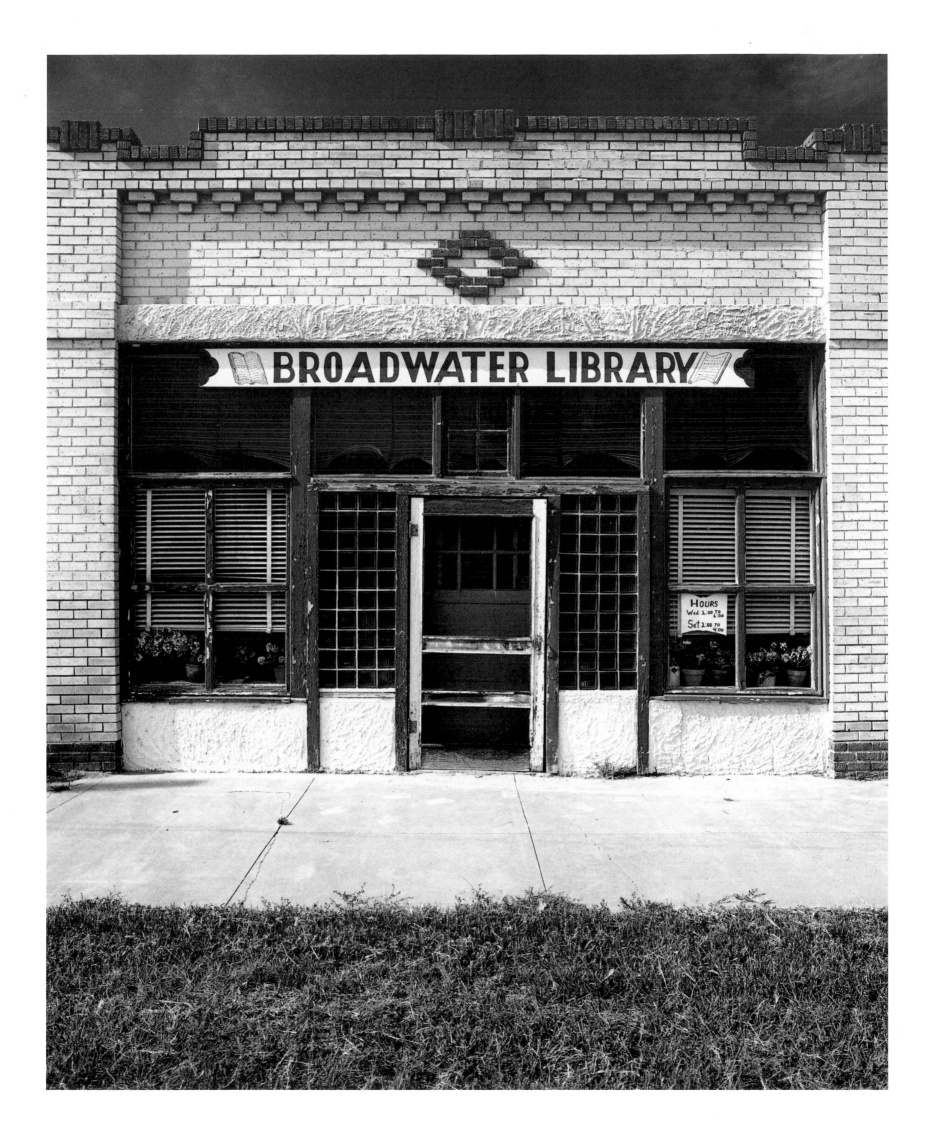

93 JERSEY CREAMERY

Casper, Wyoming 1993

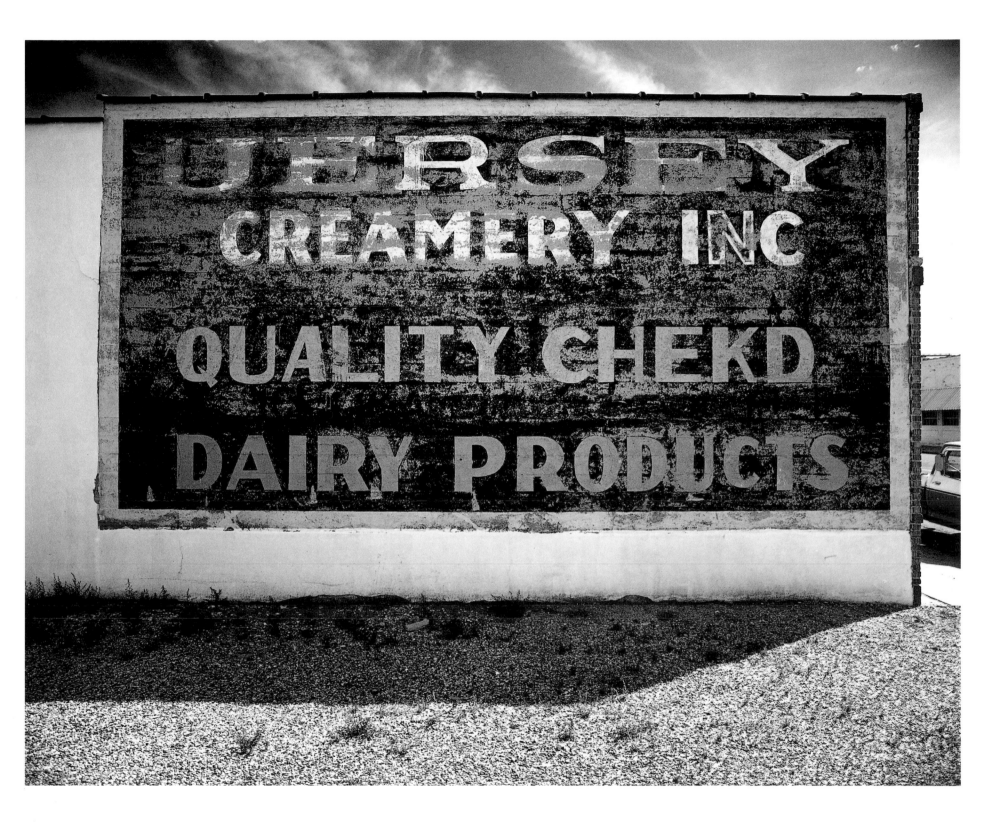

94 THE BEVARD SISTERS

Cozad, Nebraska 1993

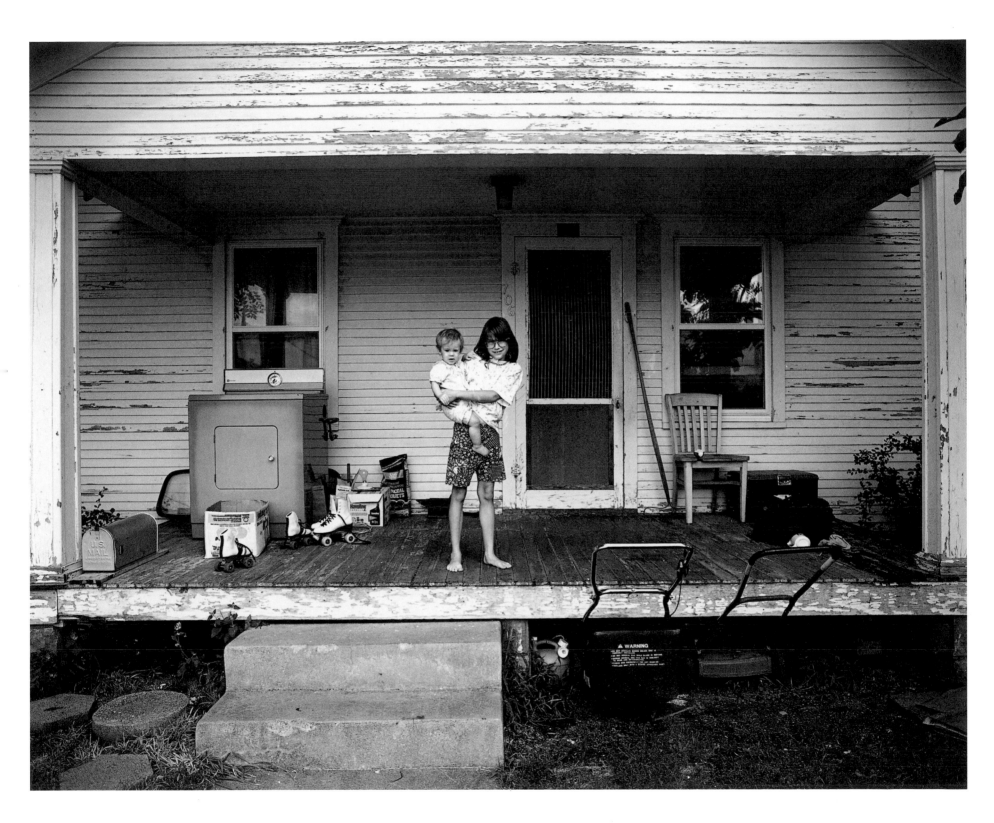

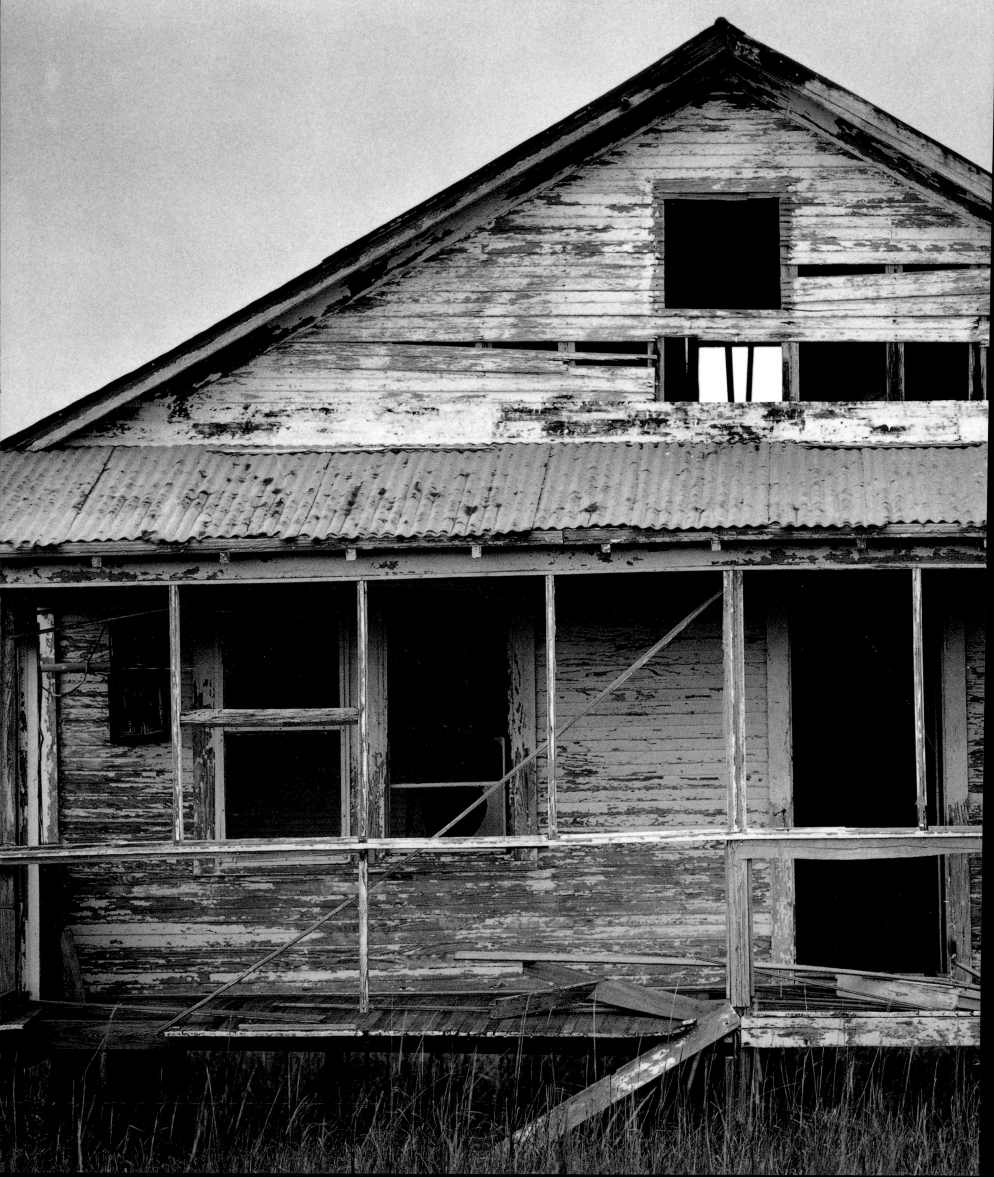

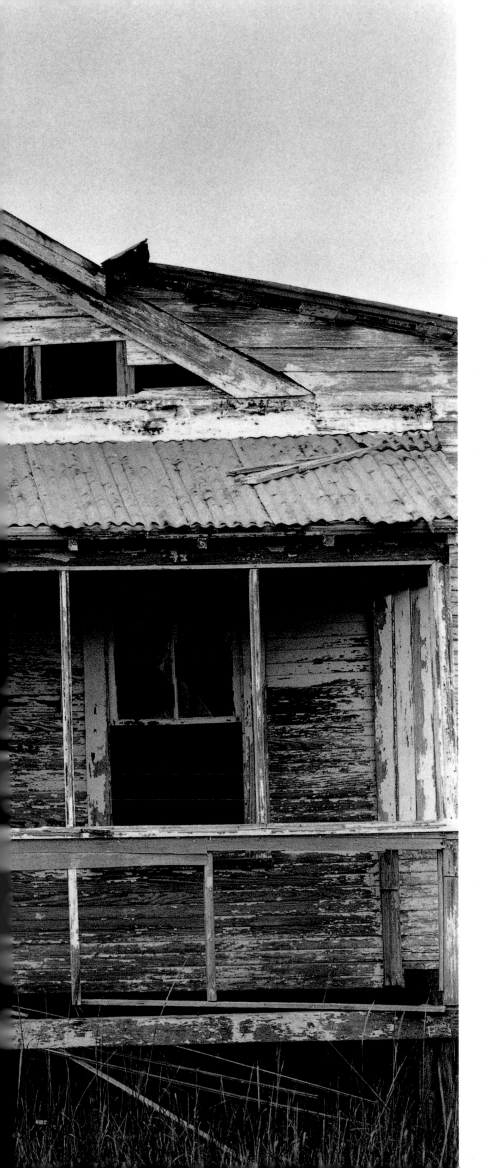

UNTITLED 95

Highway 1, Golden Meadows, Louisiana 1999

96 IRENE & LEO CRABTREE

Ione, Oregon 1993

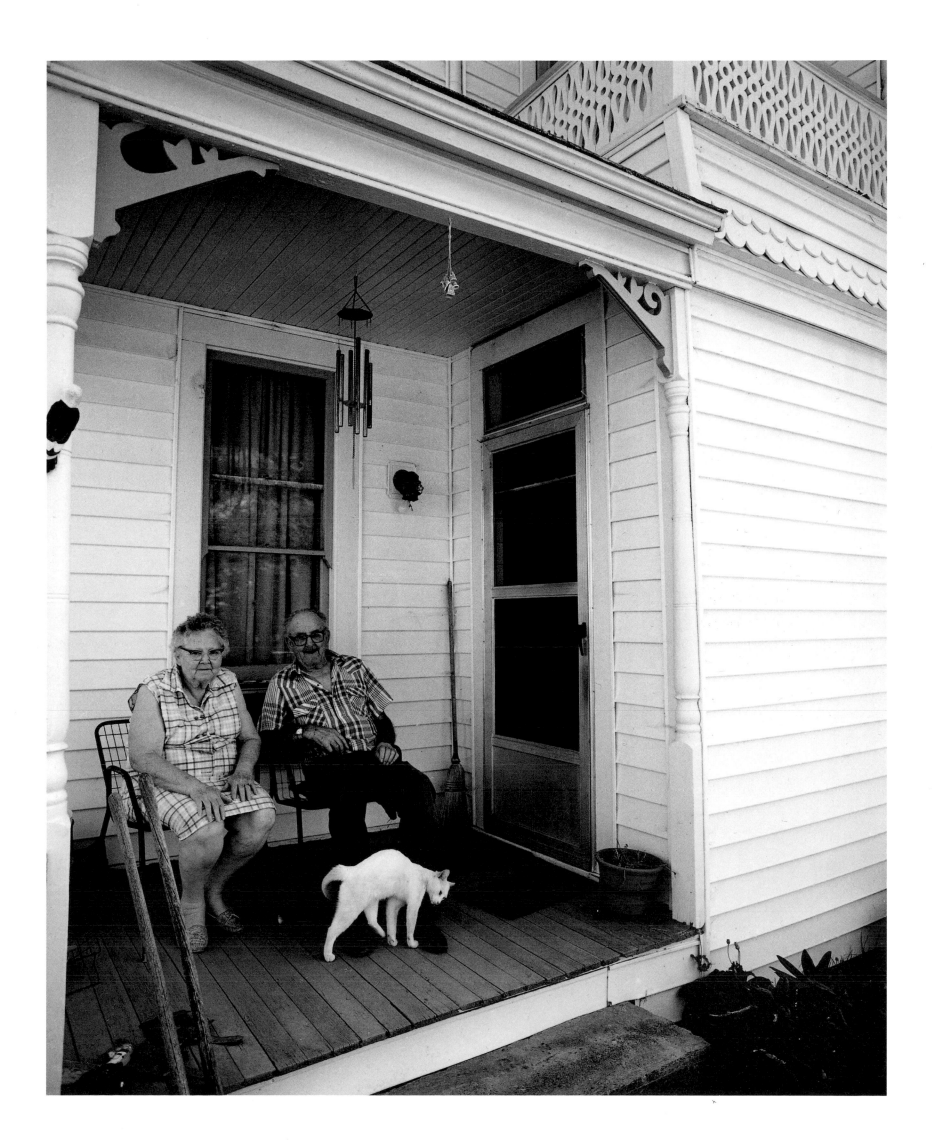

97 UNTITLED
Palacios, Texas 1999

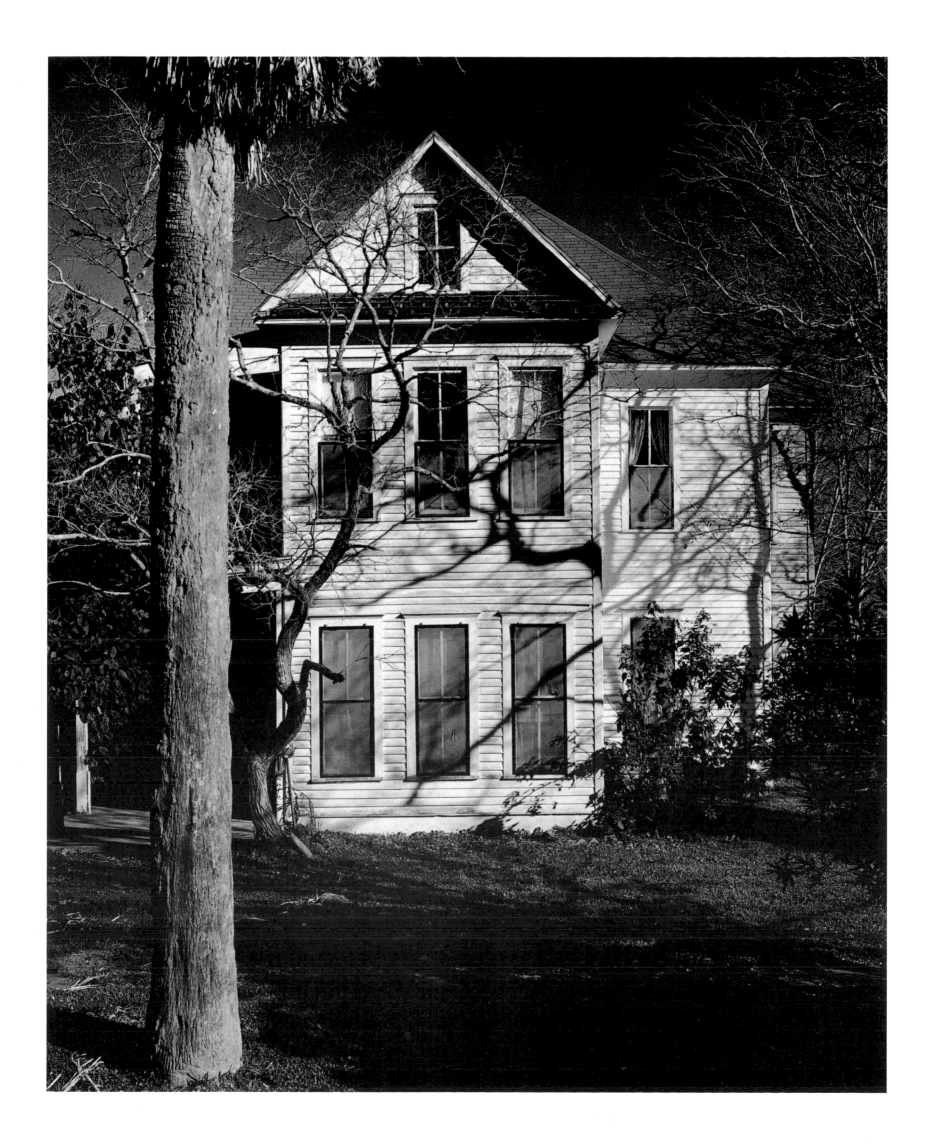

98 LORI HALL & TED DARNELL

Beatty, Nevada 1995

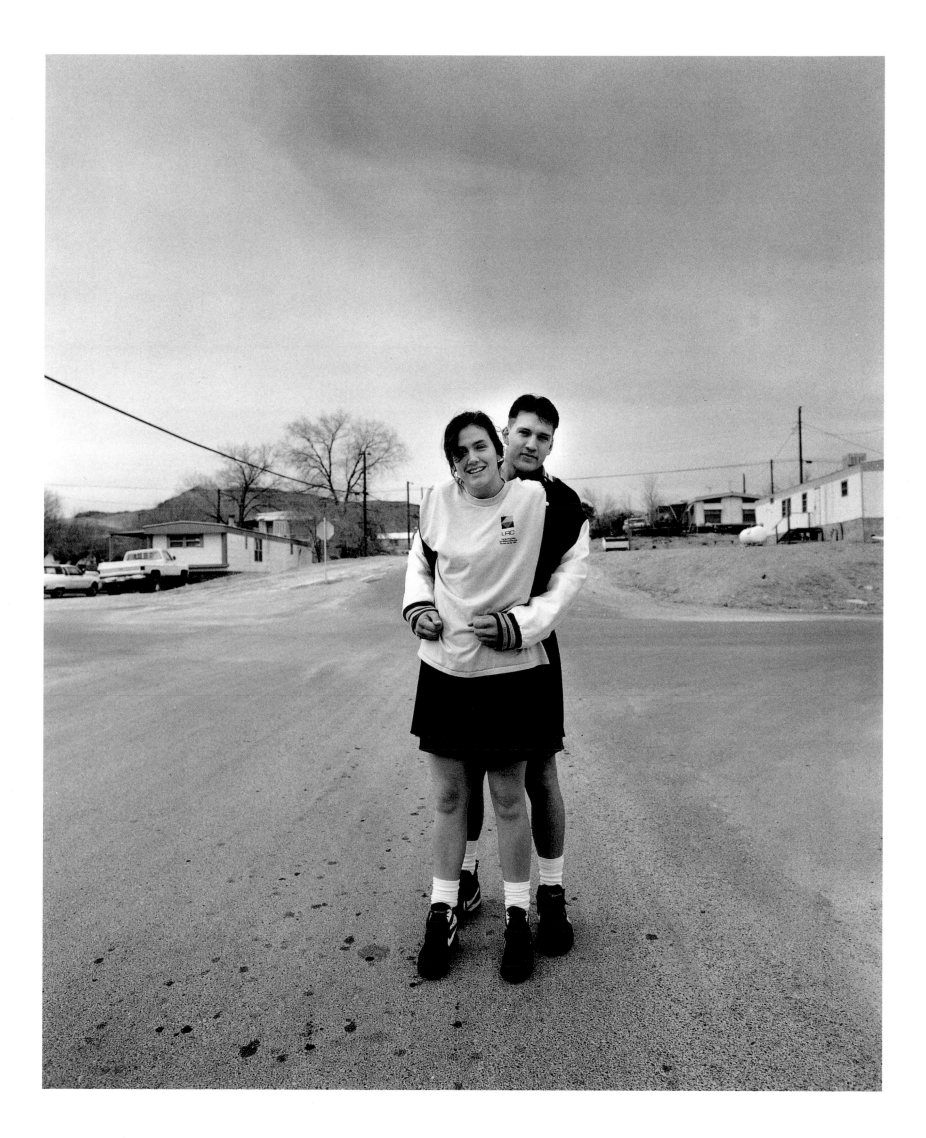

99 QUAIL RUN SUBDIVISION II
Marie Esther, Florida 1999

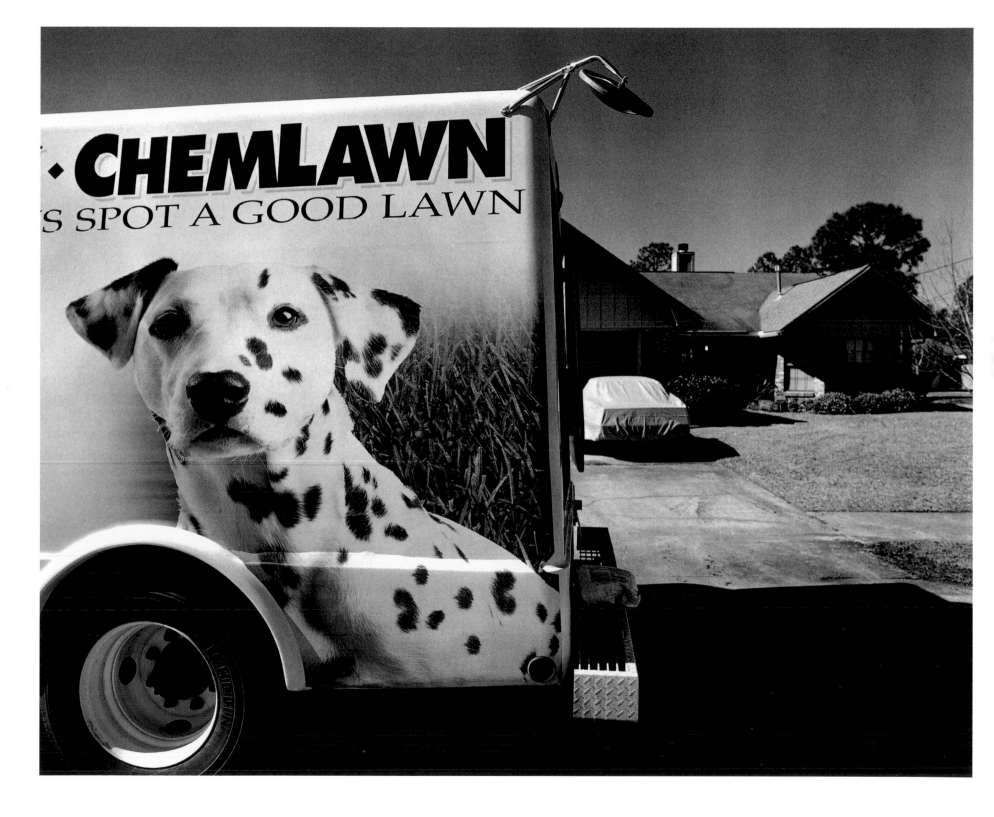

100 ORDER FROM CHAOS

Galveston, Texas 1999

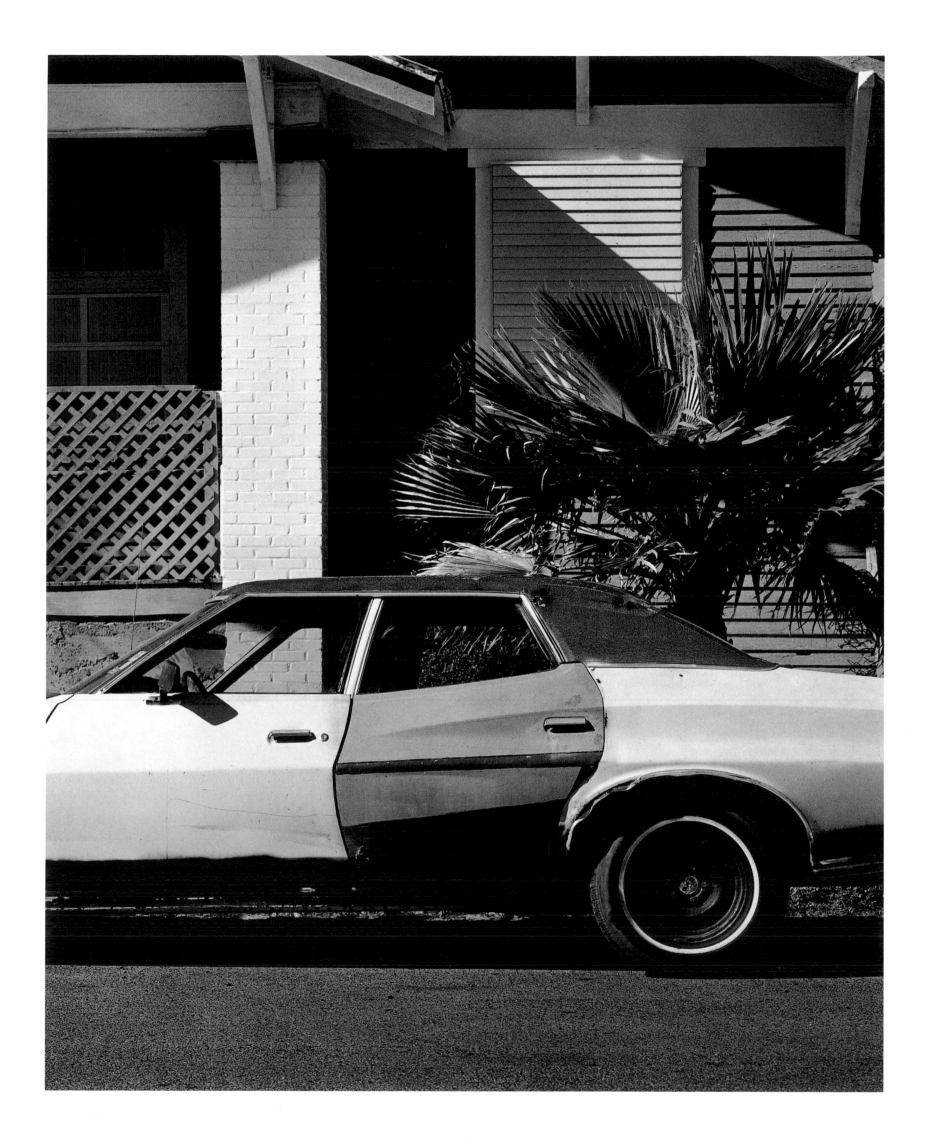

101 LORANG'S

Salome, Arizona 1995

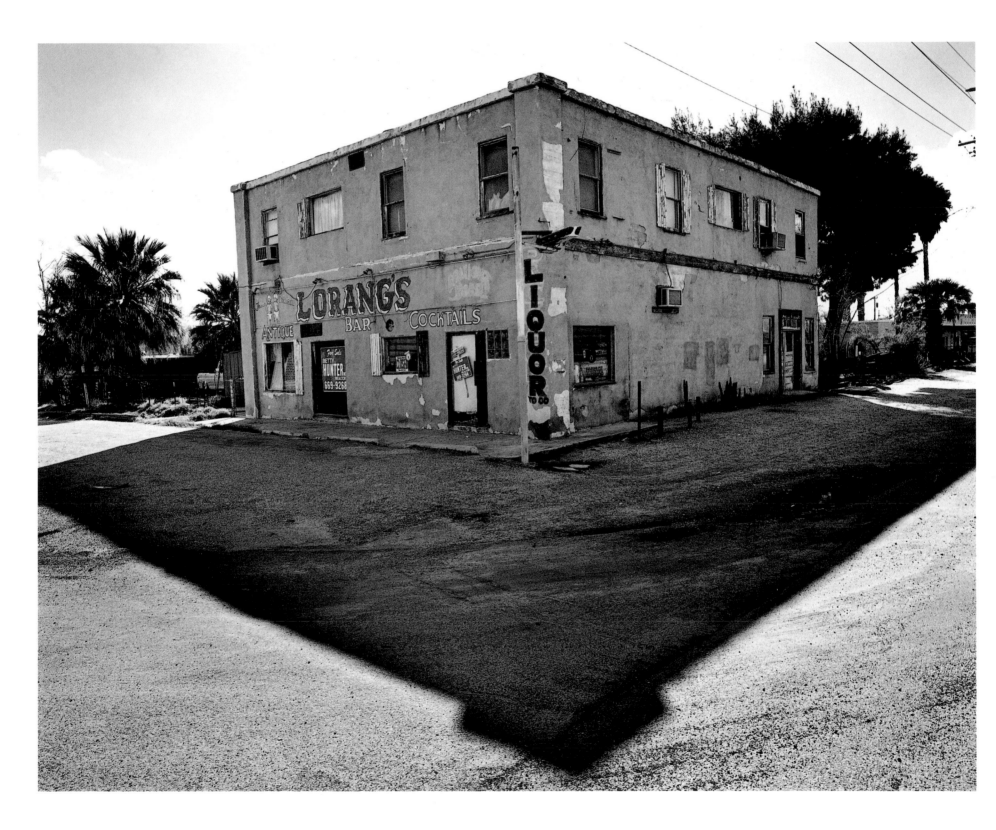

102 UNTITLED

Galveston, Texas 1999

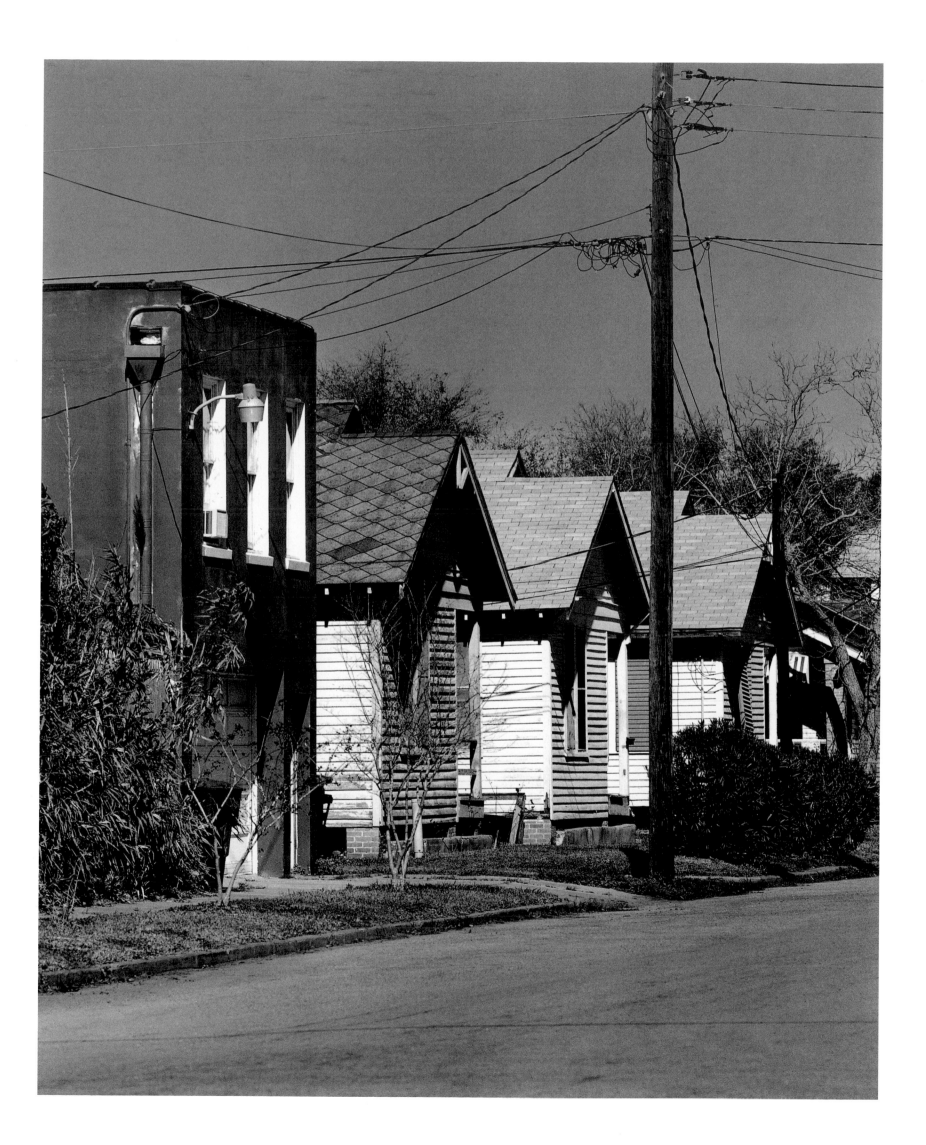

103 CHAMBERLIN'S

Rosco, Nebraska 1993

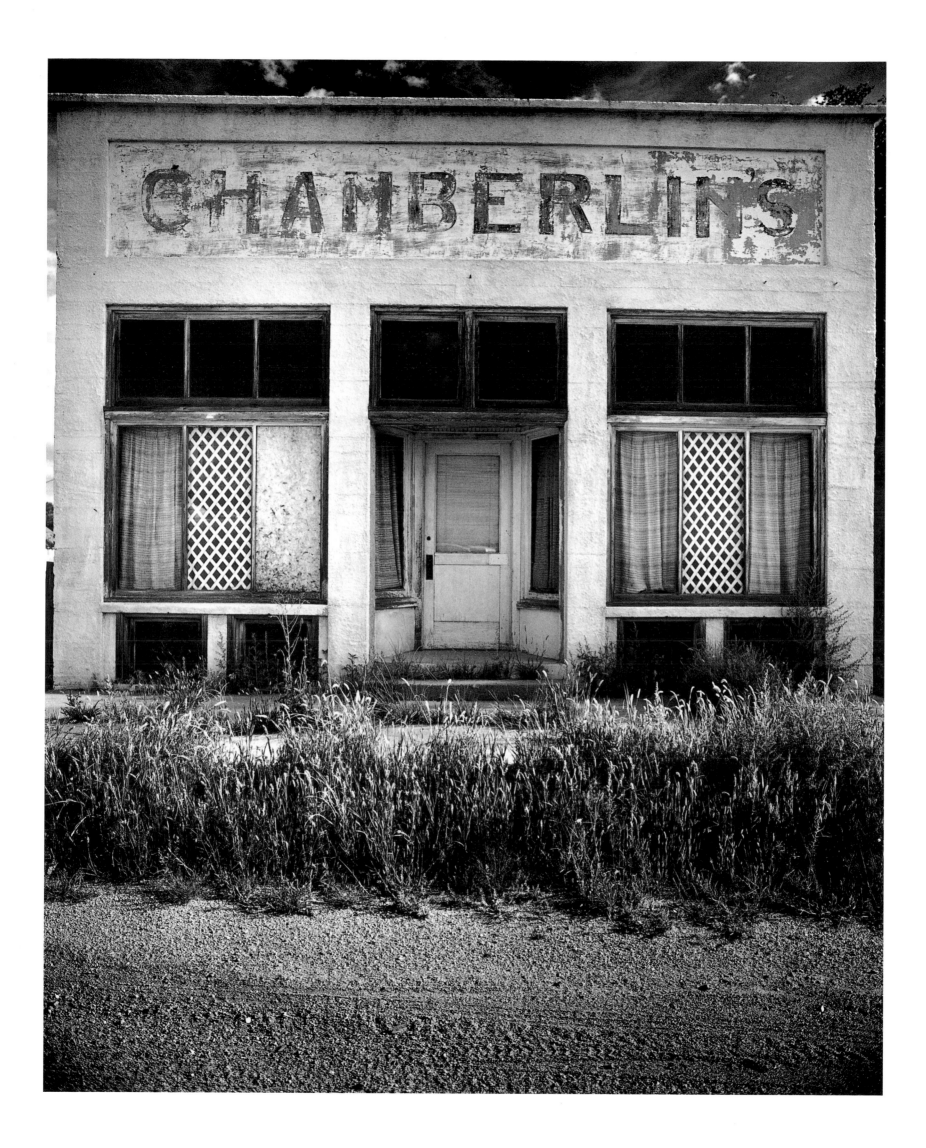

104 SEAN, FISHING

Lolita, Texas 1999

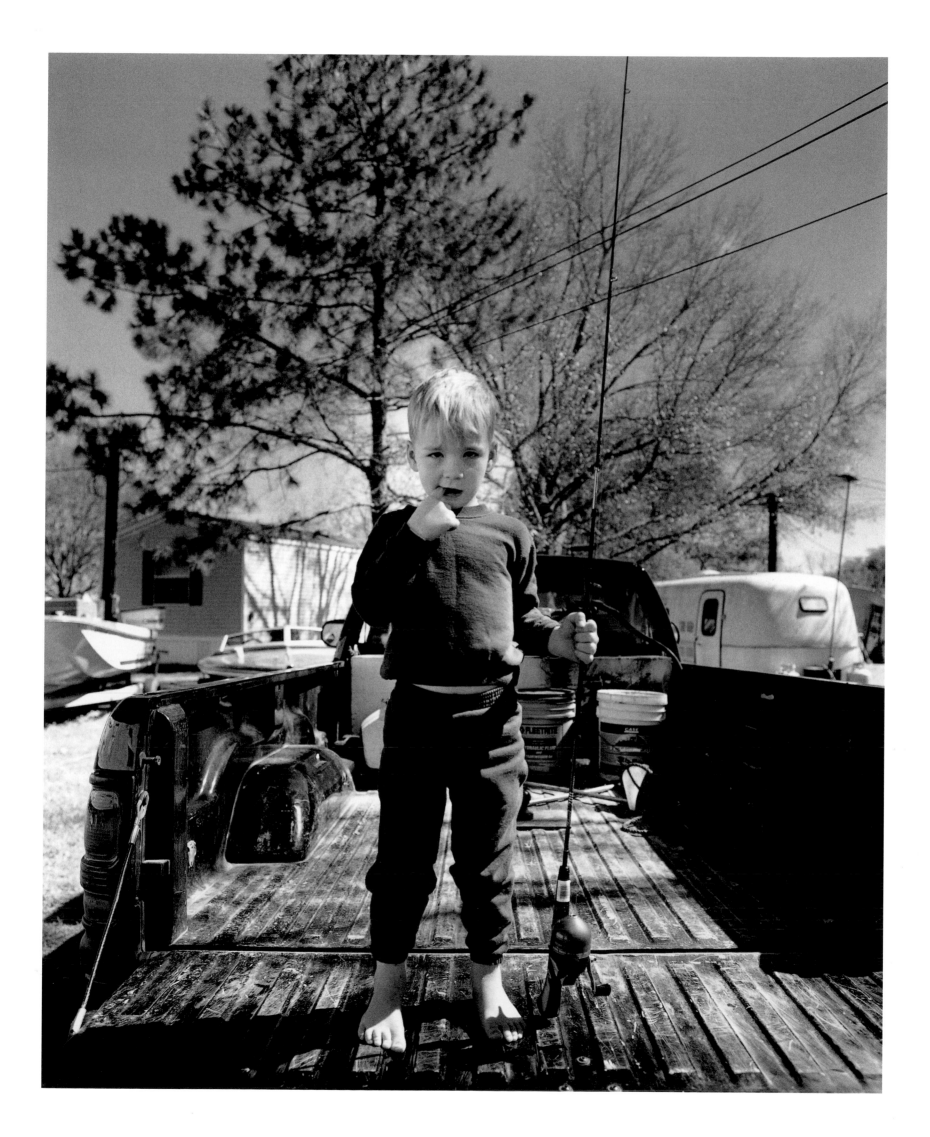

105 CHAPAS GROCERY

St. Charles, Louisiana 1999

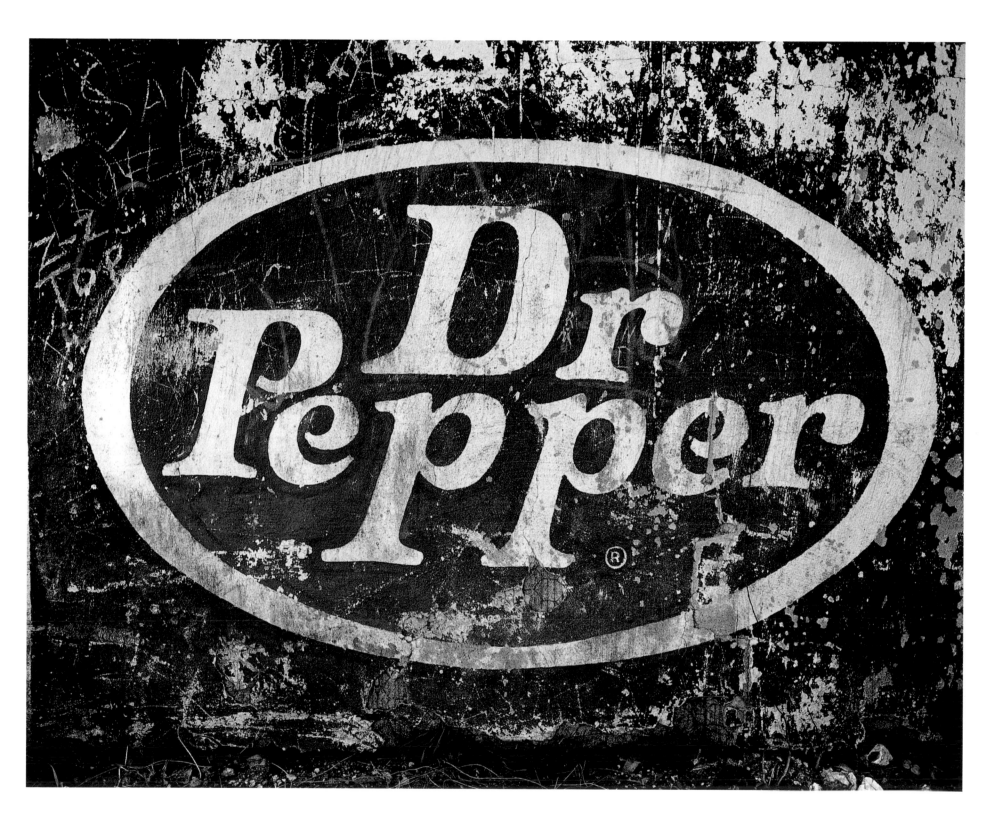

106 WASHINGTON & MAIN STREETS

Baker City, Oregon 1993

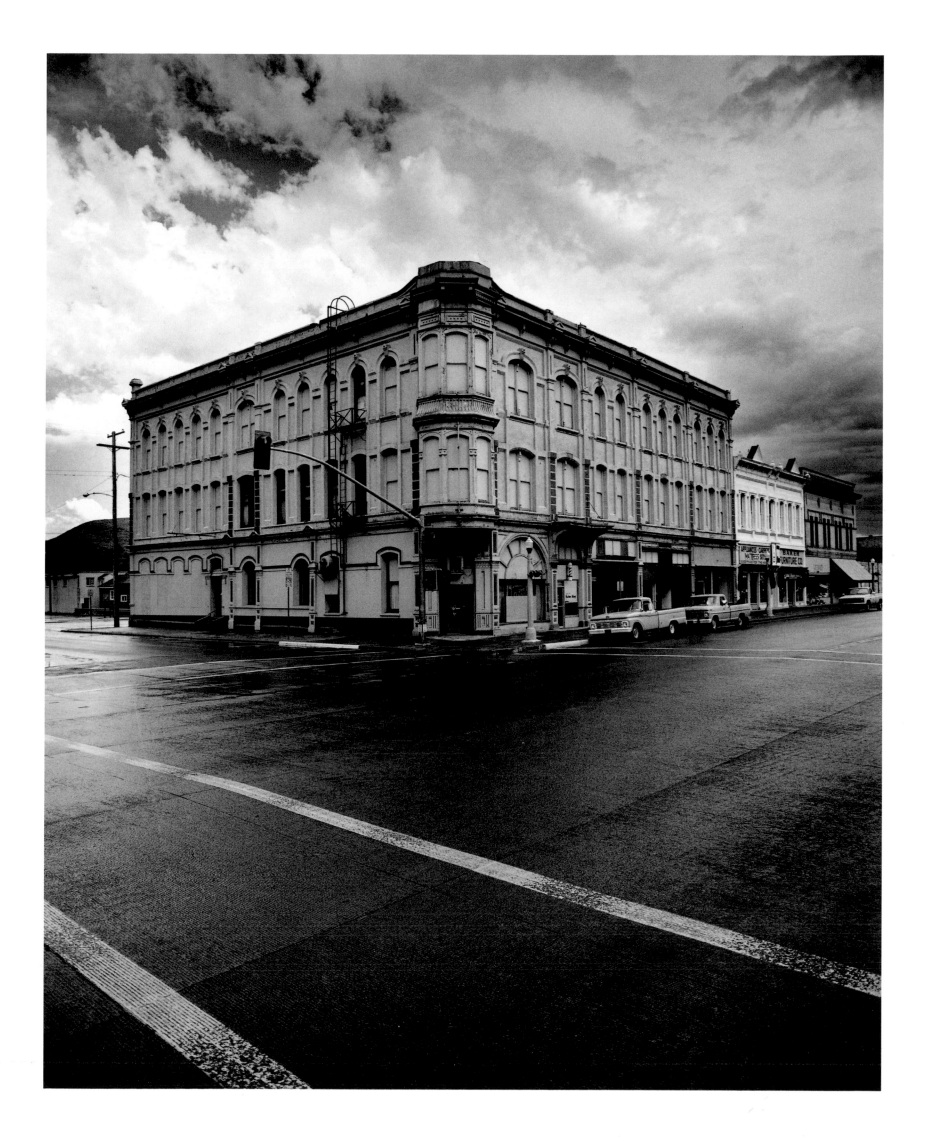

107 BLEDSOE PLANTATION
Sunflower County, Mississippi 1996

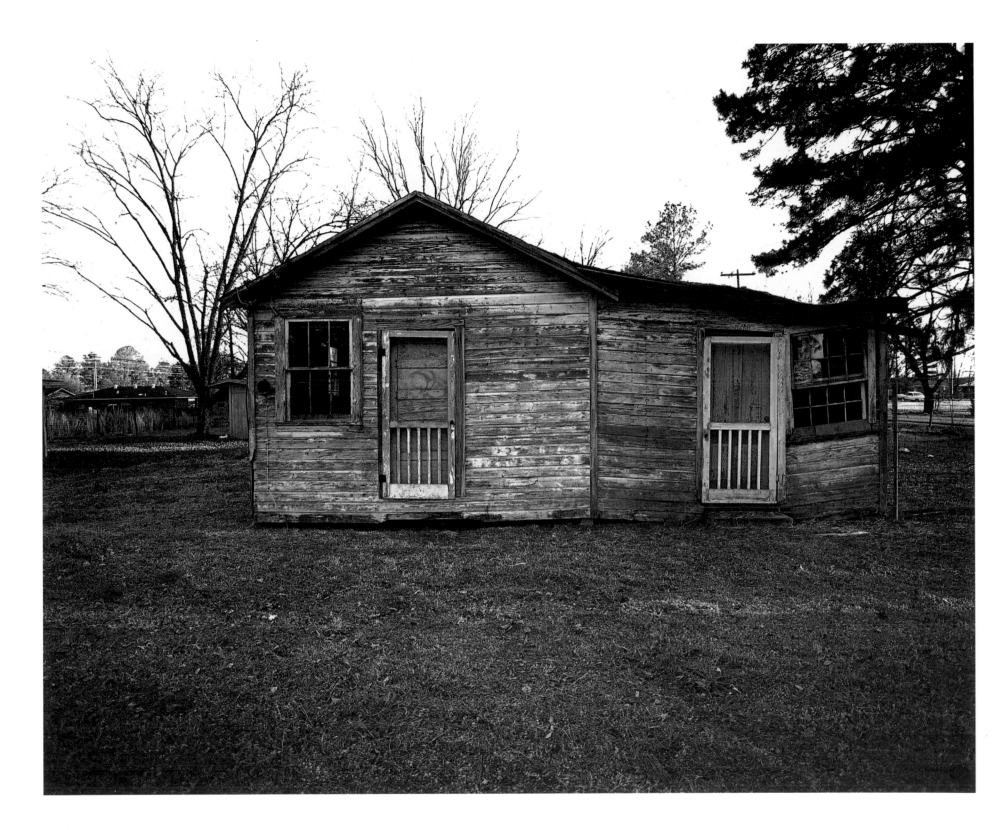

108 WELCOME TO THE DALLES

The Dalles, Oregon 1993

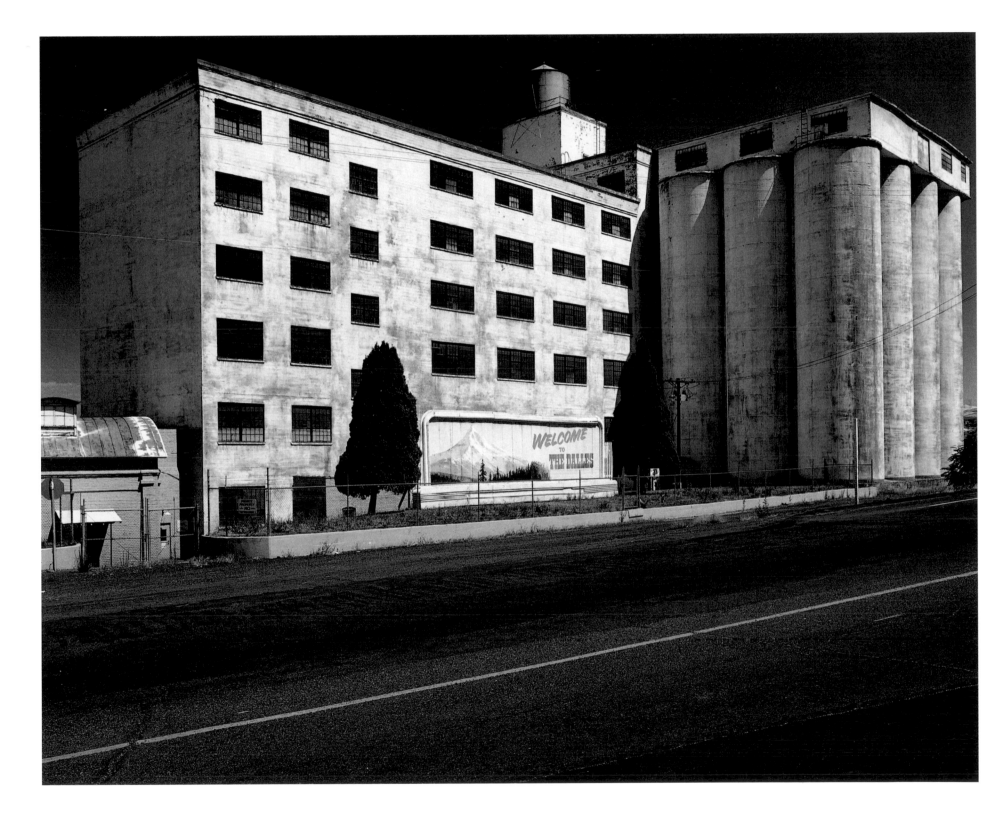

109 THE LONG FAMILY
Morgan City, Louisiana 1999

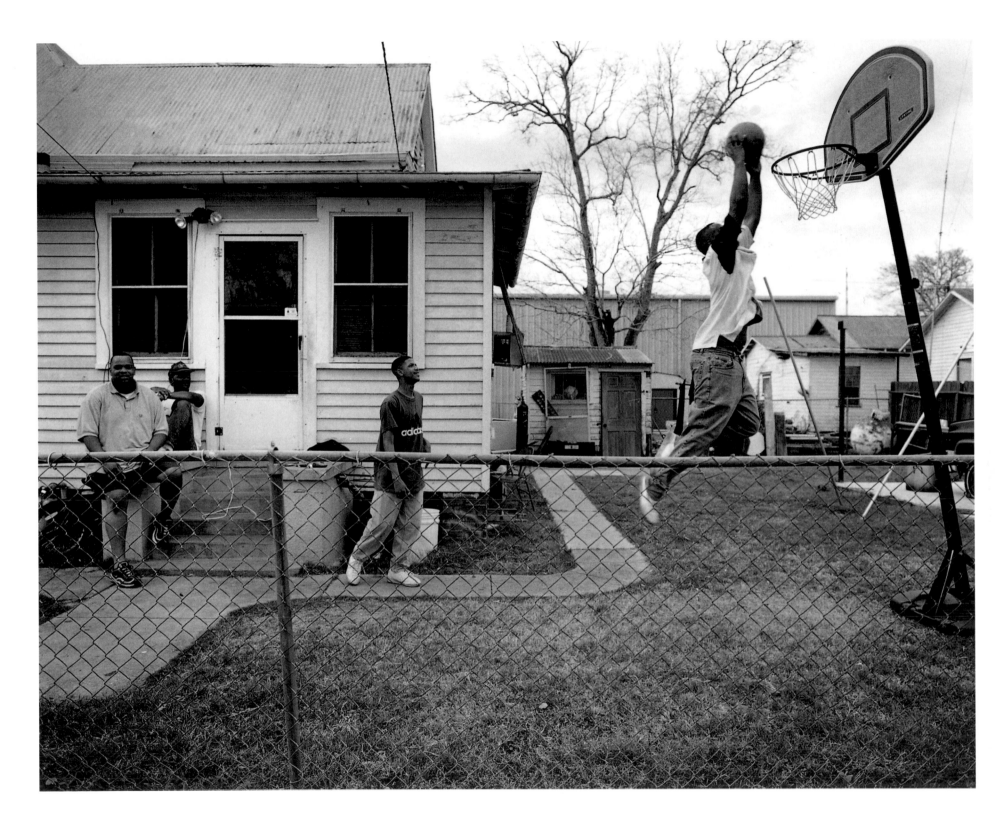

110 TEXAS THEATER

Raymondville, Texas 1999

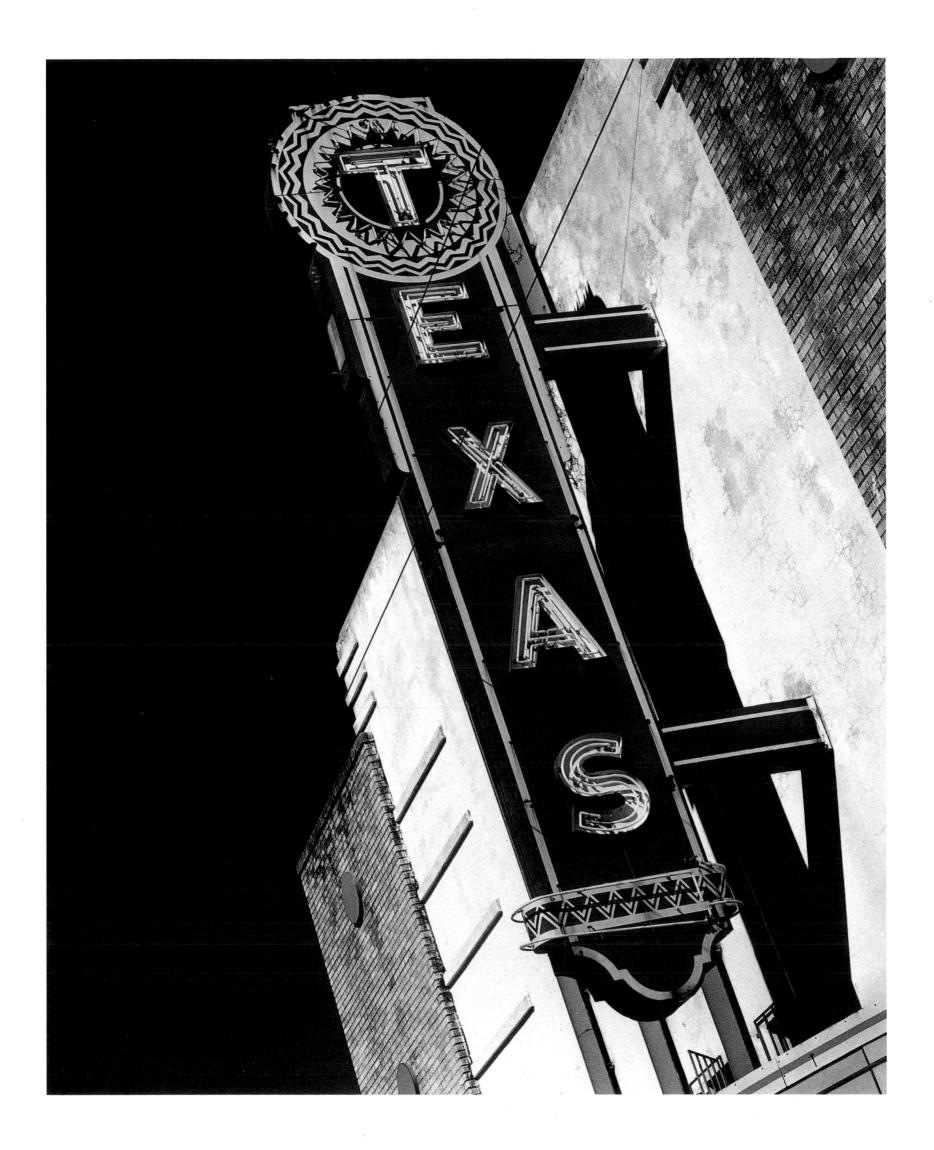

111 MAIN STREET

Pocatello, Idaho 1993

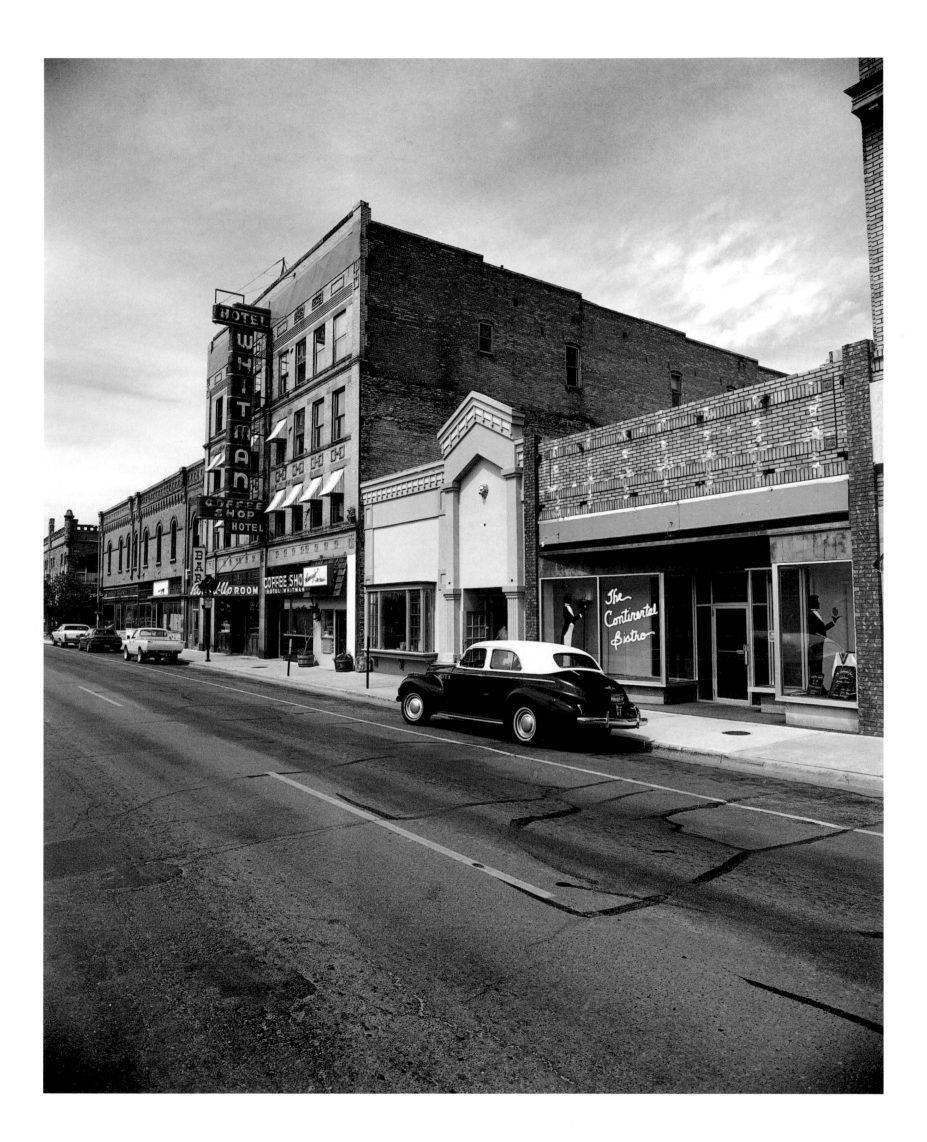

112 AMERICA MY BELOVED

Schreveport, Louisiana 1996

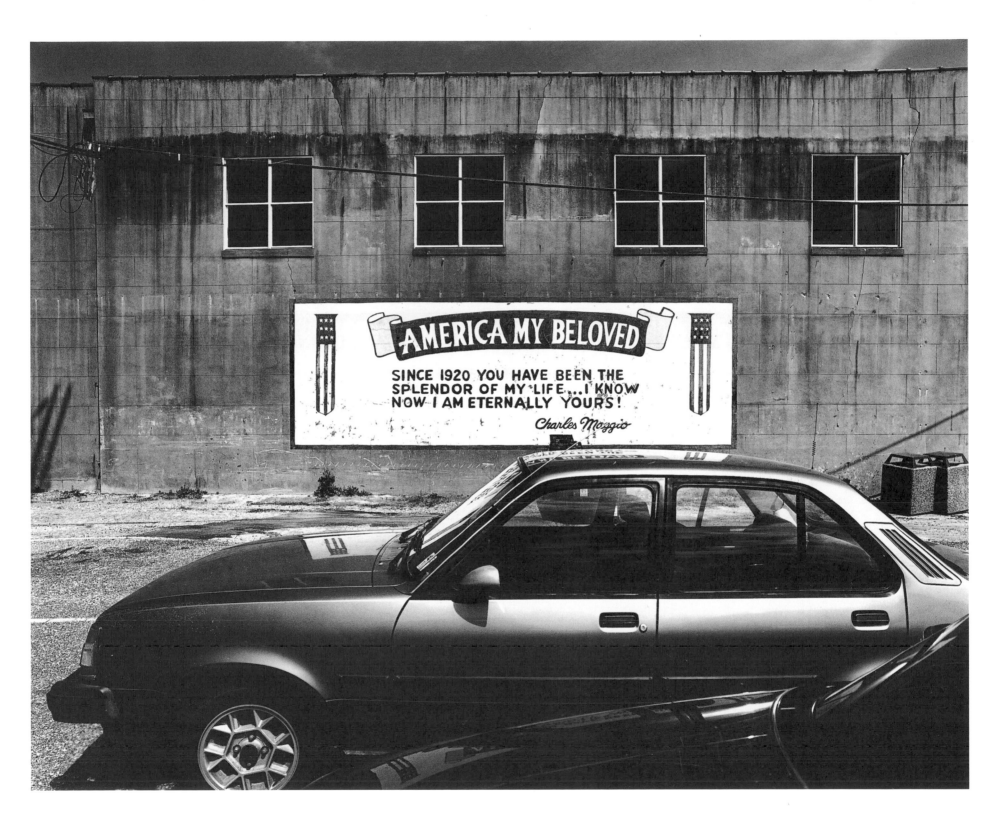

Afterword

Thomas Wolfe wrote, "You can't go home again." I believe that's true in life. In photography, however, it's another matter. This book isn't about going home so much as it is about keeping something alive, if only as a document to remind me of my earliest memories, my life as a child, my friends and family, my vacations and travels; of moments when time didn't matter, when the future was distant and I had my whole life ahead of me. Whenever I looked through *LIFE* magazine and watched the movies and television shows of the time, I saw my America—one I never imagined would one day be different, as I would be.

America is a place that I'm a part of and that is a part of me. Even as I lived abroad for much of my adult life, I always had the comfort of knowing my America was home, waiting for me. My childhood, my teenage years, my early twenties were still there and I could return anytime. This is what helped me through while I lived and worked in London and Paris for so many years. I wasn't leaving anything behind; I still had it anytime I wanted to go there. At that point the year 2000 was so far in the future it was an altogether different dimension. When I finally came home, everything had changed—slowly but methodically. I could no longer recognize the cars. The old neighborhoods still looked the same, but the kids were not. The streets were the same, but the buildings were different. Of course, this is everyone's destiny. You really can't go home again, but you can rediscover the essence of home if you look elsewhere, as I did. I find the places and people I remember everywhere. It doesn't matter that they are not exactly the same—the sense of familiarity is there. The kids are the same, but I'm no longer one of them. At forty-six years old, I'm still a kid. I feel the same, but my friends are older now, no longer willing or free to feel the same as we once did. The excitement seems gone for them in many ways, but not for me. You see, I never grew up and never accepted the idea that I was no longer a kid.

Being a photographer is a great privilege. I still feel the excitement of holding a camera, searching for pictures, driving down a street for the first time in a town I've never been to and, if I'm tuned in, seeing pictures everywhere—people at a barbecue, a cat in a window, a 1949 Studebaker by the side of the road. The houses look familiar even though I've never seen them before. I'm sure I remember where to find the pens and paper at the local five-and-dime. The woman behind the cash register looks the same, but she's not. I come out and think about jumping on my Schwinn racer, but it's my Chevy truck that awaits me.

I see time differently than others do. Photography makes that possible. Sunny days make me realize that nothing has changed inside me; only specific things in the outside world have. I take a picture today of something or someplace I remember from twenty-five years ago, and it's the same as being there again. Driving along those streets in all those towns, I can't help but have my memory jogged. Whenever this happens I know there's a picture there. For every picture there's a subtext. And even though the subtext is what brought about the picture, it has no actual meaning to the picture itself.

This book stands as a collection—a vision of America—yet each picture evokes a particular memory for me. Such is the magic of photography. Everyone can find his or her own meaning in a picture. That's why I never tire of looking at pictures, whether they be found in magazines, books or an old photo album at a flea market. That's what *American Pictures* is about for me: I know the people who see this work will find their own familiarity and comfort in its images. For Americans my age and older, the work will hit home—that place you can never go back to. For others, the book will help them relate to my experience in a way they would never be able to do themselves. They will feel, smell, touch the America I grew up in.

One day in 1993 my wife, Laura, and I were looking at houses when we noticed a "For Sale" sign on a '66 Airstream Caravelle. We laughed about how fun it would be to drive one of those across the country, as we had done three years earlier when we rented an RV to drive from Los Angeles to New York, photographing Laura along the way for a story in a European magazine. We took down the number on the sign. After some discussion, we decided to buy the Airstream. The car I already had wasn't capable of pulling it, so we bought a Chevy Blazer K-5 and learned how to trailer. We took a few small trips to the desert with my daughter and planned to take a longer trip to Canada to visit Laura's sister, who was getting married. I came to realize that the Airstream was perhaps the most important piece of photographic equipment I owned. It brought so many pictures within my grasp that would have not been possible otherwise, just as a certain lens is used to bring home a certain image.

We took off for Canada that summer, camping in trailer parks along the way. A friend of Laura's from Canada was vacationing in Oregon, so we planned to drive first to Mount Hood to see her and do some windsurfing at the Columbia Gorge. I packed the Airstream with camera equipment and cases of film, our two dogs and plenty of food. If I'm photographing, I can find any place interesting and any trip worthwhile. Laura, to her credit, understands this aspect of me. She knows I'm in another zone when we're looking for pictures, and she has other activities she enjoys that we can add to the trip. She also photographs, writes, makes jewelry and studies landscapes.

We photographed all the way up the California coast, stopping in several small towns. There was always something in each place that

was familiar to me. Once we got to the Oregon border, we realized it was the 150th anniversary of the Oregon Trail. We decided to photograph every town on the entire trail—but in reverse. Starting in Oregon City, we drove the entire route all the way through Idaho, Wyoming and Nebraska to St. Louis, Missouri, not far from where the famous trail originated in the fur trade era. From there we drove north through Iowa, Illinois and Michigan, arriving in Canada for the wedding.

To get back home, we figured we could drive eight to ten hours a day if needed, but since we were photographing we tried to do no more than 200 miles a day. We stayed off the main roads for the most part unless we needed to fast forward to the next place before sunset. I would drive up and down every street in every town we passed looking for pictures. I wanted to shoot what I saw when I saw it. Documentary photography is exciting in this respect. Countless pictures weren't taken because the light was wrong, but the pictures I saw were gifts to me—serendipitous events to my alerted eye. I photographed people if I saw people, places if they held memories for me, things if they served as allegories for the way America felt to me while I was growing up. I drew upon everything I had learned shooting reportage stories and portraits for magazines over my twenty-five-year career and applied it to documentary photography.

We charted routes based on finding a thread that made sense to us—the Oregon Trail is one example. The pictures I took had nothing whatever to do with the Trail, but our itinerary helped lead us to them. I look for the same pictures anywhere in any town. It really doesn't matter whether I'm in Pocatello, Idaho, or Lolita, Texas; the pictures I'm looking for are there. Along the way we visited friends, friends of friends, galleries I work with and museums. Sometimes we took a detour to see a place a friend told us about or simply to check out the town a friend's parents were from. It all adds up to pictures.

On another trip Laura wanted to spend a week with her family, who were vacationing in Florida. It took us a little under three days to make it from Los Angeles. A week later we began photographing in every town along the Gulf of Mexico. I've always been interested in that part of the country and although I'd never been there before, I found exactly what I was looking for. We spent my forty-fifth birthday in Palacios, Texas, and I loved it. While Laura baked a birthday cake in an adjoining trailer (our stove was acting up), I ventured up and down the side streets, making several of the photographs in this book. Pictures are everywhere, at every time of day in every town…

On other trips we combed Mississippi, Arkansas, Tennessee, Louisiana and Texas for pictures. We were in Mobile, Alabama, for Mardi Gras but took pictures of a back-alley tribute to Billie Holiday instead. We were in Tarpon Springs, Florida, for Christmas and I went out shooting Santa decorations on the splendid green lawns. We were supposed to be visiting family in Prescott, Arizona, but I was shooting buildings in Salome, south of Prescott, inspired by the perpetual flea markets that exist on the main road in the town. The kids I photographed on a fence in Salome were sitting in for the kids I missed photographing when I was working on another job in Riverside, California, years ago.

The common element in all this picture making is not where it was, who it was or even the fact that it jogged some memory of mine—it is the ensemble look at mid-twentieth-century America that you feel and breathe as you look at the images in *American Pictures*. The faces of the Americans I photographed are honest, the buildings unpretentious. Simple, straightforward people built this country, and I wanted to document what they built as well as what the world of their making looked like. I wanted to take an archive of work from one century into the next. It's like time travel. This book took more than seven years to complete, but the total time to make all these photographs took less than two seconds. Time is relative! The time between the pictures and all that has happened since has no consequence. The work started and stopped while my life continued. Photography all adds up to a vision, a feeling, an emotion I can transmit to others. It's truly a privilege to be a photographer.

Jeff Dunas
Los Angeles, March 2001

Nachwort

Man kann nicht nach Hause zurückkehren«, schrieb Thomas Wolfe. Ich glaube, im Leben stimmt das. In der Fotografie ist das etwas anderes. In diesem Buch geht es nicht so sehr um das Heimkehren als darum, etwas lebendig zu halten, und sei es nur als ein Dokument zum Wachrufen meiner Erinnerungen – mein Leben als Kind, meine Freunde und Familie, meine Ferien und Reisen; Erinnerungen an Momente, in denen Zeit keine Rolle spielte, die Zukunft weit entfernt und das ganze Leben noch vor mir lag. Jedesmal, wenn ich die Zeitschrift *LIFE* durchblätterte und die damaligen Filme oder Fernsehshows anschaute, sah ich mein Amerika – und es war für mich unvorstellbar, dass es sich im Gegensatz zu mir einmal ändern würde.

Amerika ist ein Teil von mir, und ich bin ein Teil von ihm. Sogar während der Jahre, die ich als Erwachsener im Ausland lebte, gab es immer die beruhigende Gewissheit, dass Amerika mein Zuhause war, das auf mich wartete. Meine Kindheit, meine Teenagerzeit und die Jahre, als ich Anfang 20 war, sie waren alle noch da, und ich konnte jederzeit dorthin zurückkehren. Das hat mir durch die vielen Jahre geholfen, in denen ich in Paris und London lebte und arbeitete. Ich hatte nichts für immer hinter mir gelassen; ich konnte jederzeit zurück. Damals lag das Jahr 2000 so weit in der Zukunft, dass es eine komplett andere Dimension war. Als ich schließlich nach Hause kam, hatte sich alles verändert – langsam, aber methodisch. Ich erkannte die Autos nicht mehr auf Anhieb. Die alte Nachbarschaft sah noch genauso aus, aber die Kinder waren nicht mehr dieselben. Es waren die gleichen Straßen, aber mit anderen Gebäuden. Das geht natürlich jedem so. Man kann tatsächlich nicht nach Hause zurückkehren, aber die Essenz von Zuhause wieder finden, wenn man wie ich woanders danach sucht. Ich finde die Orte und Menschen meiner Erinnerung überall. Auch wenn sie nicht dieselben sind – das Gefühl der Vertrautheit ist da. Die Kinder sind die gleichen, ich bin nur nicht mehr einer von ihnen. Mit 46 bin ich immer noch ein Kind. Ich empfinde noch genauso, aber meine Freunde sind heute älter, und sie wollen oder können nicht mehr so fühlen wie wir damals. Das Leben scheint für sie in vielfacher Hinsicht nicht mehr aufregend zu sein. Bei mir ist das anders. Ich bin einfach nie erwachsen geworden und habe nie den Gedanken akzeptiert, dass ich kein Kind mehr bin.

Ein Fotograf zu sein, ist ein großes Privileg. Ich fühle noch immer die Aufregung, eine Kamera in den Händen zu halten, nach Bildern zu suchen, eine Straße in einer Stadt entlangzufahren, in der ich noch nie gewesen bin, und dann, wenn ich richtig eingestimmt bin, überall Bilder zu sehen – Leute auf einer Grillparty, eine Katze im Fenster, einen 1949er Studebaker am Straßenrand. Die Häuser wirken bekannt, obwohl ich sie nie gesehen habe. Ich bin sicher, ich weiß genau, wo im Kramladen um die Ecke Papier und Stifte zu finden sind. Die Frau an der Kasse scheint dieselbe wie damals zu sein, ist sie aber nicht. Ich gehe nach draußen und will mich auf mein Rennrad von Schwinn schwingen, aber dort wartet mein Chevy auf mich.

Ich sehe die Zeit anders als andere. Die Fotografie macht das möglich. An sonnigen Tagen wird mir klar, dass sich in mir nichts geändert hat; nur bestimmte Dinge in der Außenwelt haben sich gewandelt. Ich mache heute ein Foto von Dingen oder Orten, an die ich eine 25 Jahre alte Erinnerung habe, und es ist genauso, als wäre ich wieder dort. Wenn ich all die Straßen in all den Städten entlangfahre, werden unwillkürlich meine Erinnerungen geweckt. Immer, wenn das passiert, weiß ich, dass da ein Bild wartet. Für jedes Bild gibt es einen Untertitel. Und dieser Untertitel ließ zwar das Bild entstehen, hat aber für das Bild selbst keinerlei Bedeutung.

Dieser Bildband ist eine Sammlung – eine Vision von Amerika –, und doch ruft jedes Bild in mir eine ganz spezielle Erinnerung wach. Das ist die Magie der Fotografie. Jeder kann in einem Bild seine eigene Bedeutung finden. Deshalb werde ich nie müde, Bilder anzuschauen, sei es in Zeitschriften, Büchern oder in einem alten Fotoalbum auf dem Flohmarkt. Das macht für mich die Bedeutung von *American Pictures* aus: Ich weiß, dass die Menschen, die diese Arbeit anschauen, ihre eigene Vertrautheit und ihren eigenen Trost in den Bildern finden werden. Amerikaner in meinem Alter und älter wird das Buch an Zuhause erinnern – jenen Ort, an den du nie zurückkehren kannst. Anderen wird das Buch helfen, meine Erfahrung auf eine Art zu erleben, die ihnen allein nie möglich wäre. Sie werden das Amerika fühlen, riechen, berühren können, in dem ich groß wurde.

Als meine Frau Laura und ich uns 1993 Häuser anschauten, entdeckten wir an einem 66er Airstream Caravelle ein Verkaufsschild. Wir lachten darüber, welch ein Spaß das wäre, in einem solchen Wohnwagen quer durchs Land zu ziehen, ähnlich wie drei Jahre zuvor, als wir in einem gemieteten Wohnmobil von Los Angeles nach New York fuhren und unterwegs Fotos von Laura für ein europäisches Magazin machten. Wir notierten uns die Telefonnummer. Nach einigem Hin und Her beschlossen wir, den Airstream zu kaufen. Mein damaliges Auto war nicht in der Lage, ihn zu ziehen, also kauften wir einen Chevy Blazer K-5 und lernten, mit angehängtem Wohnwagen zu fahren. Nach ein paar Ausflügen mit meiner Tochter in die Wüste planten wir eine längere Reise nach Kanada, wo wir Lauras Schwester zu ihrer Hochzeit besuchen wollten. Ich stellte fest, dass der Airstream das vielleicht wichtigste Stück meiner Fotoausrüstung war. Er brachte so viele Bilder in meine Reichweite, die sonst nicht entstanden wären, ganz so, wie man ein bestimmtes Objektiv benutzt, um ein spezielles Bild einzufangen.

Noch im gleichen Sommer brachen wir nach Kanada auf. Unterwegs machten wir Halt auf Campingplätzen. Eine kanadische Freundin von Laura verbrachte ihre Ferien in Oregon; also beschlossen wir, zuerst zum Mount Hood zu fahren, um sie dort zu treffen und in der Columbia Gorge etwas zu windsurfen. Ich packte den Airstream voll mit Kameraausrüstung und Filmen, unseren zwei Hunden und

Lebensmitteln. Wenn ich fotografiere, ist für mich jeder Ort interessant und jeder Ausflug lohnend. Laura hat glücklicherweise dafür Verständnis. Sie weiß, dass ich in einem anderen Bewusstseinszustand bin, wenn wir auf der Jagd nach Bildern sind, und sie hat ihre Aktivitäten, die ihr Spaß machen und die sich in die Reise einbauen lassen. Sie fotografiert ebenfalls, schreibt, macht Schmuckstücke und studiert Landschaften.

Die ganze kalifornische Küste hoch machten wir Fotos. Wir hielten in mehreren Kleinstädten an. In jedem dieser Orte gab es etwas, das mir vertraut war. Bei unserer Ankunft an der Grenze von Oregon stellten wir fest, dass man den 150. Jahrestag des berühmten Oregon Trail feierte. Wir beschlossen, jede Stadt auf der Route dieses alten Pionierweges zu fotografieren – allerdings in umgekehrter Reihenfolge. Von Oregon City aus fuhren wir die komplette Strecke ab: quer durch Idaho, Wyoming und Nebraska bis nach St. Louis, Missouri, wo in der Nähe der berühmte Oregon Trail in der Ära der Pelzhändler seinen Anfang genommen hatte. Von da aus fuhren wir Richtung Norden durch Iowa, Illinois und Michigan nach Kanada zu der Hochzeit.

Wir schätzten, auf dem Rückweg notfalls acht bis zehn Stunden täglich fahren zu können. Da wir aber fotografierten, versuchten wir, nicht mehr als 350 Kilometer am Tag zurückzulegen.Wir hielten uns größtenteils fern von den Hauptstraßen, es sei denn, wir mussten uns beeilen, um den nächsten Ort vor Sonnenuntergang zu erreichen. In jeder Stadt, durch die wir kamen, fuhr ich jede Straße hinauf und hinunter, immer auf der Suche nach Bildern. Ich wollte das fotografieren, was ich sah, und zwar in dem Moment, in dem ich es sah. In dieser Hinsicht ist die Dokumentarfotografie eine aufregende Sache. Unzählige Bilder entstanden nicht, weil das Licht nicht stimmte, aber die Bilder, die ich sah, waren für mich Geschenke – ungeahnte Glücksfälle für mein aufnahmebereites Auge. Ich fotografierte Menschen, wenn ich Menschen sah, Orte, wenn sie für mich erinnerungsträchtig waren, Dinge, wenn sie als Allegorie dienten für die Weise, wie ich Amerika wahrgenommen hatte als ich aufwuchs. Dabei griff ich auf alles zurück, was ich im Laufe meiner 25-jährigen Laufbahn beim Schaffen von Reportagen und Porträts für Zeitschriften gelernt hatte, und wandte es auf die Dokumentarfotografie an.

Unsere Routen planten wir auf der Grundlage eines roten Fadens, der uns sinnvoll erschien – der Oregon Trail ist dafür ein gutes Beispiel. Die Bilder, die ich machte, hatten überhaupt nichts mit dem alten Pionierweg zu tun, aber unsere Reiseroute führte uns zu ihnen. Überall, in jeder Stadt, suche ich nach den gleichen Bildern. Es kommt wirklich nicht darauf an, ob ich in Pocatello, Idaho, oder in Lolita, Texas, bin – die Bilder, nach denen ich suche, sind da. Unterwegs besuchten wir Freunde, Freunde von Freunden, Galerien, mit denen ich zusammenarbeite, und Museen. Manchmal machten wir einen Umweg, um einen Ort zu sehen, weil uns ein Freund von ihm

erzählt hatte, oder einfach, um die Stadt kennen zu lernen, aus der die Eltern eines Freundes stammten. Alles das wird dann zu Bildern.

Auf einer anderen Reise wollte Laura eine Woche mit ihrer Familie verbringen, die in Florida Urlaub machte. Wir brauchten etwas weniger als drei Tage von Los Angeles bis dorthin. Eine Woche später fingen wir an, in jeder Stadt am Golf von Mexiko zu fotografieren. Dieser Teil des Landes hat mich schon immer interessiert, und obwohl ich noch nie dort gewesen war, fand ich genau das, was ich suchte. Meinen 45. Geburtstag verbrachten wir in Palacios, Texas, und ich war begeistert. Während Laura in einem benachbarten Wohnwagen den Geburtstagskuchen backte (unser Backofen spielte verrückt), wagte ich mich in die Seitenstraßen und machte eine Reihe von Fotos, die in diesem Buch zu finden sind. Überall sind Bilder, zu jeder Tageszeit in jeder Stadt ...

Auf anderen Reisen durchkämmten wir Mississippi, Arkansas, Tennessee, Louisiana und Texas auf der Suche nach Bildern. Zum Mardi Gras waren wir in Mobile, Alabama, fotografierten aber stattdessen eine Hinterhof-Hommage für Billie Holiday. Weihnachten waren wir in Tarpon Springs, Florida, und ich fotografierte den Weihnachtsschmuck auf prachtvollen grünen Rasenflächen. In Prescott, Arizona, waren wir eigentlich auf einem Familienbesuch, aber ich fotografierte Gebäude in Salome, südlich von Prescott, inspiriert von den permanenten Flohmärkten auf der Hauptstraße der Stadt. Die Kinder, die ich auf einem Zaun in Salome fotografierte, waren stellvertretend für die Kinder, die ich vor Jahren während einer anderen Arbeit in Riverside, Kalifornien, verpasst hatte zu fotografieren.

Das gemeinsame Element bei der ganzen Fotografiererei ist nicht, wo es war oder wer es war, nicht einmal die Tatsache, dass es Erinnerungen in mir wachrief – es ist der Gesamteindruck vom Amerika Mitte des 20. Jahrhunderts, den man wahrnimmt und einatmet, wenn man die Bilder in *American Pictures* anschaut. Die Gesichter der von mir fotografierten Amerikaner sind ehrlich, die Gebäude schlicht. Dieses Land wurde von einfachen, aufrichtigen Menschen aufgebaut, und ich wollte dokumentieren, was sie erbaut haben, aber auch, wie die von ihnen geschaffene Welt aussieht. Ich wollte ein Arbeitsarchiv von einem Jahrhundert ins nächste bringen. Es ist wie eine Zeitreise. Es hat sieben Jahre gedauert, diesen Bildband fertig zu stellen, dabei brauchte ich für all diese Fotos zusammen insgesamt weniger als zwei Sekunden. Zeit ist relativ! Die Zeit zwischen den Bildern und alles, was seitdem geschah, ist ohne Belang. Die Arbeit begann und hörte auf, während mein Leben weiterging. Das ganze Fotografieren ergibt eine Vision, ein Empfinden, ein Gefühl, das ich anderen vermitteln kann. Es ist tatsächlich ein Privileg, Fotograf zu sein.

Jeff Dunas
Los Angeles, März 2001

Postface

Thomas Wolfe a écrit : « On ne revient pas en arrière », et je pense qu'il a raison. En photographie, toutefois, c'est autre chose. Ce livre ne se veut pas tant un retour en arrière que la préservation de quelque chose de vivant, une sorte de témoignage visuel destiné à me rappeler les plus anciens souvenirs de ma vie d'enfant, de mes amis et de ma famille, de mes vacances et de mes voyages ; de tous ces moments où le temps n'avait pas d'importance, où l'avenir était encore lointain et où j'avais toute la vie devant moi. Lorsque je lisais le magazine *LIFE* et que je regardais les films et les émissions de télévision de l'époque, je voyais mon Amérique — une Amérique que je n'aurais jamais imaginée pouvoir être un jour aussi différente que je le deviendrai.

Je fais partie de l'Amérique et elle fait partie de moi. Même si j'ai vécu à l'étranger pendant longtemps, j'ai toujours eu le réconfort de savoir que l'Amérique était ma demeure, et m'attendait. Mon enfance, mon adolescence, mes vingt ans s'y trouvaient encore, et je pouvais y revenir à n'importe quel moment. C'est ce qui m'a aidé tandis que je vivais et travaillais à Londres et à Paris. Je n'avais rien abandonné que je ne puisse retrouver chaque fois que je le voulais. L'an 2000 était alors bien loin dans l'avenir, comme dans une autre dimension. Et puis, lorsque je suis finalement revenu chez moi, tout avait changé — lentement mais méthodiquement : je ne reconnaissais plus les voitures ; si les anciens quartiers avaient toujours le même air, leurs enfants avaient changé ; les rues étaient les mêmes mais leurs immeubles étaient différents. C'est naturellement la destinée de chacun de se transformer. On ne revient jamais vraiment chez soi mais on peut toutefois en capturer de nouveau l'essence si on regarde ailleurs, comme je l'ai fait. Je retrouve partout des lieux et des gens dont je me souviens. Peu importe qu'ils ne soient pas exactement les mêmes, ils ont tous un même air familier. Les enfants sont les mêmes, mais je ne suis plus l'un d'entre eux. Pourtant, à 46 ans, je me sais encore enfant. Je suis toujours le même mais mes amis sont désormais plus âgés, et ne veulent ou ne peuvent plus s'identifier à ce que nous étions. Ils ont perdu de leur exaltation, mais pas moi. En fait, je n'ai jamais ni grandi ni accepté l'idée que je n'étais plus un enfant.

Être photographe est un grand privilège. Je ressens encore l'excitation que j'ai, l'appareil photo à la main, à chercher des images en parcourant les rues d'une ville que je ne connais pas et, lorsque mon humeur s'y prête, voyant partout un sujet à photographier — des gens auprès d'un barbecue, un chat à la fenêtre, une Studebaker de 1949 au bord de la route. Les maisons me semblent familières même si je ne les ai jamais vues. Je suis sûr que je me souviens où trouver stylo et papier dans le magasin à prix unique du coin. La caissière ressemble à celle de mon souvenir et ce n'est pourtant pas elle. En sortant, je m'apprête à sauter sur mon vélo mais c'est ma Chevrolet qui m'attend.

Je vois le temps différemment des autres grâce à la photographie. Aux beaux jours, je comprends que, contrairement à certaines choses précises du monde extérieur, rien n'a changé en moi. Lorsque je prends aujourd'hui la photo de quelque chose ou de quelque endroit dont j'ai le souvenir d'il y a vingt-cinq ans, c'est comme si je m'y retrouvais. Inconsciemment, ma mémoire s'est rafraîchie à mesure que défilaient les rues de toutes ces villes. Et chaque fois que cela se produit, je sais qu'il y a là une photo à prendre. Dans chaque image se dissimule un motif sous-jacent qui, même s'il en est le déclencheur, n'a aucune signification réelle pour la photo elle-même.

Ce livre se veut être un kaléidoscope — une vision de l'Amérique — dont chaque photo évoque pour moi un souvenir particulier. C'est cela la magie de la photographie. Nous pouvons tous trouver notre propre interprétation d'une image. C'est pourquoi je ne me lasse jamais de regarder des photos, qu'elles soient dans un magazine, un livre ou un vieil album photo découvert aux puces. *American Pictures* vise le même but : permettre à ceux qui découvriront ce travail d'y retrouver une familiarité et un réconfort. Pour les Américains de ma génération ou plus âgés, ce livre va toucher un endroit sensible — ce lieu où l'on ne revient pas. Pour les autres, il va leur permettre d'éprouver ce que j'ai ressenti comme ils n'auraient jamais pu le faire eux-mêmes. Ils apprécieront, sentiront, toucheront l'Amérique dans laquelle j'ai grandi.

Un jour de 1993, ma femme Laura et moi regardions des maisons lorsque nous avons remarqué un panneau À Vendre sur une caravane Caravelle Airstream de 1966. Nous avons plaisanté sur le plaisir qu'il y aurait à en tracter une en parcourant tout le pays, comme je l'avais fait trois ans plus tôt avec notre camping-car de location afin de photographier Laura entre Los Angeles et New York pour un article à paraître dans un magazine européen. Nous avons relevé le numéro de téléphone inscrit sur le panneau puis, après mûre réflexion, nous avons décidé d'acquérir l'Airstream. La voiture que j'avais alors n'étant pas capable de la tracter, nous avons dû acheter une Chevy Blazer K-5 et apprendre à conduire une caravane en faisant quelques petites excursions dans le désert avec ma fille. Nous avons alors envisagé de faire un plus long voyage au Canada pour aller au mariage de la sœur de Laura. Je commençais à réaliser que l'Airstream allait peut-être devenir l'objet le plus important de l'équipement photographique que je possédais. Et il est vrai qu'elle a mis à ma portée beaucoup d'images que je n'aurais pu prendre autrement, un peu comme un type d'objectif particulier permet de faire un certain type de photo.

Nous sommes partis l'été même pour le Canada, nous arrêtant en chemin dans des campings. Comme une amie canadienne de Laura passait ses vacances dans l'Oregon, nous avons décidé d'aller la voir à Mount Hood et de profiter de l'occasion pour faire un peu de windsurf dans les gorges de la Columbia. J'ai chargé mon matériel photo et mes boîtes de films dans l'Airstream, fait monter nos deux chiens et embarqué des tonnes de nourriture. Quand je pars ainsi

en expédition photographique, je peux trouver intéressant n'importe quel endroit. Laura comprend parfaitement mon point de vue ; elle sait que j'entre dans une autre dimension lorsque nous partons en quête d'images. Elle a elle-même d'autres activités qu'elle aime et qu'elle peut pratiquer au cours du voyage : outre un peu de photo, elle écrit, crée des bijoux et étudie les paysages.

Nous n'avons cessé de faire des photos tout en remontant la côte californienne, nous arrêtant presque dans chaque petite ville où, chaque fois, je découvrais quelque chose qui me semblait familier. Comme nous étions parvenus à la frontière de l'Oregon en pleine période de commémoration du 150e anniversaire de l'Oregon Trail, nous avons décidé de photographier toutes les villes situées sur cette piste mythique de l'Ouest – mais que nous allions parcourir à l'envers. Partant de Oregon City, nous avons traversé l'Idaho, le Wyoming et le Nebraska jusqu'à St. Louis (Missouri), pas très loin de l'endroit où la célèbre piste débutait à l'époque du commerce de la fourrure. De là, nous avons ensuite traversé l'Iowa, l'Illinois et le Michigan, et nous sommes arrivés à temps au Canada pour le mariage.

Pour rentrer chez nous, nous avions calculé que nous pourrions conduire huit à dix heures par jour si nécessaire ; mais, comme nous prenions des photos en chemin, nous avons essayé de ne pas rouler plus de 350 km par jour. Nous évitions en général les grandes routes, à moins que nous ne soyons pressés par le temps pour rallier l'étape suivante avant le coucher du soleil. Je parcourais systématiquement toutes les rues de chaque ville que nous traversions. Je voulais prendre en photo ce que je voyais dès que je le voyais – la photographie documentaire n'est excitante que dans cette mesure. J'ai sans doute laissé passer d'innombrables photos parce que la lumière n'était pas bonne, mais ce que je voyais était pour moi comme un cadeau – un événement heureux pour mon œil attentif. Je photographiais des gens si je tombais sur eux, des lieux s'ils évoquaient des souvenirs pour moi, des objets s'ils pouvaient être une allégorie de la manière dont l'Amérique me touchait lorsque j'étais adolescent. J'ai fait appel à toute l'expérience apprise en vingt-cinq ans de photo reportages et de portraits pour des magazines et je l'ai appliquée à la photographie documentaire.

Nous avons étudié une carte en recherchant les routes qui pouvaient avoir un sens pour nous – comme par exemple l'Oregon Trail. Si les photos que j'ai prises n'ont rien à voir avec la piste elle-même, l'itinéraire choisi nous aidait à créer l'occasion de les réaliser. Dans chaque ville, je recherche les mêmes images ; peu importe que je sois à Pocatello dans l'Idaho ou à Lolita au Texas, elles sont là. Nous sommes ainsi passés voir des amis, des amis d'amis, des galeries avec lesquelles je travaille, des musées, parfois nous avons fait un détour pour voir un endroit dont on nous avait parlé ou simplement pour

connaître la ville dont étaient originaires les parents d'un ami. Tout pouvait donner prétexte à une photographie.

À l'occasion d'un autre voyage, Laura a voulu passer une semaine avec sa famille, alors en vacances en Floride. Il nous a fallu un peu moins de trois jours pour y arriver depuis Los Angeles. Une semaine plus tard, nous avons commencé à prendre des photos dans chacune des agglomérations qui bordent le golfe du Mexique. J'avais toujours été intéressé par cette partie du pays et, bien que je n'y sois jamais allé auparavant, j'y ai trouvé exactement ce que je cherchais. Nous avons célébré mon quarante-cinquième anniversaire à Palacios (Texas) et j'ai beaucoup aimé. Pendant que Laura confectionnait un gâteau d'anniversaire surprise dans une caravane voisine (notre four faisait des caprices), je me suis aventuré dans les rues, où j'ai réalisé plusieurs des photos de ce livre. Il y a des images à saisir partout et à n'importe quelle heure du jour dans chacune des villes...

D'autres voyages nous ont permis d'écumer le Mississippi, l'Arkansas, le Tennessee, la Louisiane et le Texas. Nous sommes passés à Mobile (Alabama) le jour du Mardi Gras, mais nous avons préféré prendre en photo un hommage à Billie Holiday affiché dans une ruelle. Nous étions à Tarpon Springs (Floride) à Noël et j'ai photographié les décorations ornant les pelouses. Nous étions censés rendre visite à de la famille à Prescott (Arizona) mais, inspiré par les marchés aux puces permanents qui occupent la rue principale de la ville, j'ai préféré prendre en photo les immeubles de Salome, au sud de Prescott. Les enfants juchés sur une barrière que j'y ai photographiés ont remplacé ceux que je n'avais pas pu prendre plusieurs années auparavant à l'occasion d'un autre projet à Riverside (Californie).

Le dénominateur commun de toutes ces photos n'est ni le lieu, ni le sujet, ni même le fait qu'elles m'évoquaient des souvenirs, mais la vision d'ensemble de cette Amérique du milieu du XXe siècle que l'on sent et que l'on respire en feuilletant American Pictures. Les visages des Américains que j'ai photographiés sont honnêtes, les bâtiments sans prétentions. Ce sont des gens simples et droits qui ont bâti ce pays, et je voulais apporter ainsi mon témoignage de ce qu'ils avaient réalisé et de ce à quoi ressemblait le monde qu'ils avaient créé. Je voulais pouvoir transmettre ces archives d'un siècle à l'autre. Comme pour effectuer un voyage dans le temps, toutes ces photos m'ont pris moins de deux secondes mais il m'a fallu sept ans pour réaliser ce livre. Le temps est relatif ! Mais le temps écoulé entre les images et tout ce qui s'est passé depuis n'a pas d'importance. J'ai entamé et achevé cet ouvrage sans cesser de vivre. La photographie est une vision, une sensation, une émotion que je peux transmettre aux autres. C'est pour cela qu'être photographe est un véritable privilège.

Jeff Dunas
Los Angeles, Mars 2001

Epilogue: The Journey

Having traveled the globe and lived abroad as a fashion model for many years, I really hadn't explored America, or my native country, Canada, for that matter. When Jeff first proposed the idea of a road trip across the United States, I thought it would be like camping. I had lived in New York City and what I had seen of the rest of America seemed rural by comparison.

Our first crossing in 1990 had an exciting purpose: a twenty-eight-page travel assignment about a fashion model crossing the United States for the Italian edition of *Vanity Fair*. It was about the mythic "road" experience. The concept: capture in photographs an American Dream Safari. It was hard work, long days (thirty-two to be exact) and much more exotic than I had expected. Jeff and I made beautiful pictures together and that trip inspired us to further explore the great U.S. of A.

In 1993 we acquired a '66 Airstream Caravelle, fourteen feet of charm that we affectionately refer to as the "Toaster." That same year we headed north from Los Angeles to Oregon and then east, following the Oregon Trail in reverse. It was a fantastic six-week journey. Our little trailer fits two Australian Shepherd-mix dogs, film, camera equipment, food, supplies and ourselves, in that order. Like the original pioneers, we carry all our worldly goods with us. I'm amazed that it's so easy to live this way. Every day is different. It's not always smooth sailing in our land yacht, however. We are rarely apart—it's togetherness 24-7.

Each trip begins with an ultimate destination and an approximate return date. This is frequently determined by family gatherings, reunions, holidays, and so forth. How we get there is the adventure. It's a lot of driving, but we have worked out a system. When we hit the long stretches, we pull off to rest and switch drivers every two and a half hours. That gives us time to stretch our legs and let the dogs run. When we're on the road, Jeff and I share the chores. These include rotating ice packs in the cooler for the film, leveling the Toaster at night, cooking, building campfires, washing clothes, writing in our journals, navigating, and exercising the dogs.

We both love music and have plenty of it to choose from. Johnny Cash is great to listen to while driving down a dusty Texas road. Bruce Springsteen and Patsy Cline never disappoint for the complete American experience. Jeff prefers blues although I have forced him to listen to several operas and soothing classical selections as well. In fact, that's how the two-and-a-half-hour driver-switch came about: whoever is driving selects the music.

On our earlier journeys we pushed the pedal into the night in order to reach a more promising site or to be a few miles closer to a certain location to take advantage of the early morning light. Often this led to frustration. Tired and hungry, we were faced with finding a campsite in the dark, leveling the trailer, calming our agitated dogs and dealing with the general setup-cook-cleanup-charge-the-batteries-and-cell-phones-and-get-to-bed syndrome. Since then, determining how and where we spend each evening has become a priority. One of my favorite tasks is scanning the various resource books we carry for interesting trailer parks or nature reserves, local hot springs and locations of note. Now that we are more seasoned travelers, we have a rule: in camp and set up by dusk. We prefer camping in a national or state park whenever possible. In this way we end the day and start the next in beautiful surroundings: an evening fishing expedition at the lake (I'm the fisherman; Jeff caught an eel once but mostly reels in mosquito bites) or perhaps a swim or soak in warm mineral waters (there are many fabulous natural hot springs across the country). After all, it's not just about the photography (as I keep reminding Jeff); it's also about our quality of life.

A typical day begins early, with the dogs anxious to get out. The inside of our trailer is a sight to behold: equipment stacked on the couches, food stored in crates and coolers, bags creatively over-stuffed. Space is at a premium in an Airstream. We get busy tidying things up. Jeff likes to "roll" before 7:30 in the morning. While he goes for a walk with the dogs, I fire up the espresso maker, then rustle up some breakfast. This is my chance to play June Cleaver for a moment and the only real time Jeff and I are apart. How smoothly this goes determines the character of our day. After breakfast we move fast: I batten down and clean up while Jeff is on plumbing and electrical detail. We do a fluid dance at this point, each of us taking care of business until the leveling blocks are in the trailer, the dogs are in the truck and the camera gear on the back seat. Off we go!

Most days Jeff has an idea of which towns we'll visit. I go with the flow and navigate as best I can. Other days we let our instincts guide us. Our usual approach is to find the town's main street and then drive up and down each side street, observing and drinking it all in. When something catches Jeff's eye, we stop or circle around for a better view. Occasionally I am at the wheel, but Jeff usually prefers to be in the driver's seat, Mamiya camera and accompanying arsenal in his lap, so he can control the angle of the truck if necessary. He has perfected a means of putting the truck in park, opening the door and stepping in one fluid motion from the door's armrest to the roof platform of the truck to take a photograph. It's an immediate-response technique of his. Watching him work is a lesson in one-track-mindedness. He is fully focused on the image and oblivious to the surrounding traffic or annoyance we might have been. He is back inside the truck before anyone realizes what has happened. Later, when we "discuss" my embarrassment, he simply says, "I'm sorry, but they had no memory of the episode a few moments later, while I'll have this picture from exactly the point of view I need forever." Indeed, my embarrassment from those moments is long forgotten whenever I look at the resulting images.

I assist Jeff by loading camera backs of film and carefully recording the names and addresses of the locations and people photographed. Sometimes it's a delicate matter: when children are concerned, I explain to the parents what our mission is while Jeff prepares his picture.

Our trips meet all our needs wonderfully. They also provide opportunities to visit friends we don't often get to see, and make new ones along the way. We've met many interesting and creative individuals while traveling. Some are as eccentric as their personal collections: hubcaps or license plates covering a house, an army of garden gnomes on a front lawn, or so many wind chimes we thought a church was nearby. On one trip we spent an enlightening evening with a young couple, both teachers, and their two children. They were home-schooling their kids while showing them the country. Their life was one long succession of field trips: geology at the Grand Canyon, biology in fields and streams. I have come to realize that the folks who trailer are some of the finest Americans I have ever met. Friendly and straightforward, they are living their dream. Retired perhaps, or just looking for a new experience, they have given up city life and reduced their lives to fit efficiently inside their traveling homes.

One intense night we were on the ferry crossing to Galveston just as the sun had set and a storm was approaching (Jeff captured an amazing moment just prior: houses in the distance, built on stilts with the sun setting behind black clouds on the horizon[Plate 11]). There we were, rocking heavily on the sea. It was so rough we couldn't dock. The dogs were nervous as I watched the barge's bare yellow light bulbs swaying in the wind and rain. Time stood still. After what seemed an eternity, we were able to dock. In Galveston we had reserved a spot on the water in a trailer park for the night but we realized the winds were much too intense to sleep in our assigned place. Jeff decided there was just enough room between two converted Greyhound buses to insert our Airstream and get us out of the howling wind. The next day we emerged from the Toaster and laughed: it looked like a baby elephant standing between its parents!

Jeff has his photography and I enjoy treasure hunting. We are different that way. He brings back photos; I collect plunder from thrift shops and yard sales that will surely inspire some future project. By the time we head for home, our trailer is stuffed to the rivets with old books, a selection of rocks, interesting tree skeletons, blue mason canning jars, old tools, shells and, at one time, even a porch glider! As I browse through these shops and sales, I am continuously fascinated by the things America discards: Jeff often quips that he has no need to buy anything because he has it on film—with the exception of old books. My husband gets lost in old bookshops. I often have found him in deep conversation with the

owner about first-edition photography books, of which Jeff has an enormous collection. He is always hopeful of finding an elusive first edition of Robert Frank's *The Americans*. What a fishing story that would make!

Looking at the pictures in this book, I recall experiencing their subjects, yet I feel differently seeing them now. I see them through Jeff's eyes, and that pleases me. He has a way of crystallizing my emotional response to certain iconographic situations. Many moments from our travels stand out in my mind: an image showing patterns of branches on the side of a house makes me want to lie in the grass and watch the wind dance with the sun. This image is palpable [Plate 15], Jeff has reached into my soul and touched a moment of beauty. I regret I didn't seize that moment when the picture was made.

I am often reminded of conversations Jeff and I shared while crossing America. I remember us lamenting the decaying state of charming old houses, and sharing our joy at discovering simple hand-painted advertisement signs [Plate 93] or faded logos on old brick walls [Plate 105]. I'm beginning to find it quaint when I see price tags instead of bar codes on items in general stores. Jeff and I would often ponder how long it might be before what we knew from our childhoods became truly things of the past.

It's funny how certain things can bring back strong memories of being a kid. Dairy Queens and Sno-Cones dot the main drags of larger towns and offer, for me, deeply satisfying tastes and memories that nurture my inner child. I feel the cool, vanilla-scented air on my face as I order at the sliding window and my mouth waters just thinking of that icy curly-q and that soggy waffle at the base of the cone.

Journeying across America has become an integral part of a lifestyle that we look forward to. We have traveled this country's

highways and back roads, making photographs, visiting the towns and people of the heartland. It has taught me a lot about life and how I want to live it. In fact, I'd say our travels have enriched our love and our lives. Whenever we're away from city stress, we live by the clock of Mother Nature and share a real sense of partnership. It's an intense togetherness that has evoked in us a clearer understanding of each other and how differently we see the world.

An unhurried crossing of America is a fabulous journey that I encourage everyone to take. It is an excellent way to appreciate this country's vastness and beauty. Jeff and I have lived the American Road Trip. In fact, I've always felt a good title for this book might have been "Mythic America: A Journey in Pictures."

I thank Jeff for showing me his country of birth. In our travels there have been many special moments that I'll never forget. What a privilege it has been to have this opportunity to travel and photograph while sharing our lives together.

Laura Morton-Dunas
Los Angeles, June 2001

Laura Morton-Dunas is both a well-known jewelry designer and an experienced residential garden designer living in Los Angeles.

Epilog: Die Reise

Als Model habe ich zwar die ganze Welt bereist und jahrelang im Ausland gelebt, aber weder Amerika noch Kanada, mein Heimatland, richtig kennen gelernt. Als Jeff zum ersten Mal eine Autoreise quer durch die Vereinigten Staaten vorschlug, stellte ich mir eine Campingtour vor. Ich wohnte in New York City und der Rest von Amerika erschien mir vergleichsweise ländlich.

Unsere erste Tour über den Kontinent 1990 hatte einen aufregenden Grund: ein 28 Seiten langer Reisebericht für die italienische Ausgabe von *Vanity Fair* über ein Model, das quer durch die Staaten reist. Es ging um den Mythos der »road experience«. Das Konzept: fotografisches Festhalten einer Safari im Stil des American Dream. Es waren lange, harte Arbeitstage, nahm viel Zeit in Anspruch (32 Tage, um genau zu sein) und war weitaus exotischer, als ich erwartet hatte. Jeff und ich machten zusammen wunderschöne Bilder, und diese Tour inspirierte uns zur weiteren Erforschung der großen Vereinigten Staaten von Amerika.

1993 kauften wir einen 66er Airstream Caravelle, eine 4,20 m lange Schönheit, die wir liebevoll »Toaster« nennen. Noch im gleichen Jahr brachen wir von Los Angeles aus nach Norden bis Oregon auf und folgten von dort in Gegenrichtung dem alten Oregon Trail nach Osten. Es war eine fantastische sechswöchige Reise. In unseren kleinen Wohnwagen passen zwei australische Schäferhundmischlinge, Filmmaterial, Kameraausrüstung, Lebensmittel, Vorräte und wir selbst – in dieser Reihenfolge. Wie die ursprünglichen Pioniere führen wir unsere ganze Habe mit uns. Es erstaunt mich immer wieder, wie einfach es ist, so zu leben. Jeder Tag ist anders. Allerdings geht es auch auf unserem Straßenschiff nicht immer ohne Stürme ab. Wir sind fast die ganze Zeit zusammen – 24 Stunden am Tag, 7 Tage die Woche.

Am Anfang jeder Tour steht ein letztendliches Ziel und ein Termin für die Rückkehr, häufig bestimmt von Familientreffen, Wiedersehen (mit Freunden), Festtagen und dergleichen. Wie wir zum Ziel gelangen, darin liegt das Abenteuer. Man verbringt viele Stunden am Steuer, aber wir haben ein System ausgearbeitet. Auf den langen Strecken halten wir alle zweieinhalb Stunden an, machen eine Pause und wechseln uns mit dem Fahren ab. Dies gibt uns auch die Gelegenheit, uns die Beine zu vertreten und die Hunde laufen zu lassen. Wenn wir unterwegs sind, teilen Jeff und ich uns die täglichen Aufgaben. Dazu gehört auch, die Kühlakkus in der Kühlbox mit Filmmaterial auszutauschen, am Abend den »Toaster« horizontal auszurichten, zu kochen, Feuer zu machen, Kleidung zu waschen, Eintragungen in unsere Tagebüchern zu machen, zu navigieren und den Hunden Bewegung zu verschaffen.

Wir beide lieben Musik und haben immer eine große Auswahl dabei. Johnny Cash ist fantastisch, wenn man eine staubige Landstraße in Texas langfährt. Bruce Springsteen und Patsy Cline enttäuschen nie, wenn man auf die komplette American experience aus ist. Jeff bevorzugt Blues, ich habe ihn allerdings gezwungen, sich auch einige Opern und sanfte Klassikstücke anzuhören. So ist die Idee mit dem Fahrerwechsel alle zweieinhalb Stunden überhaupt entstanden: Wer am Steuer sitzt, wählt die Musik aus.

Auf unseren ersten Reisen brausten wir bis in die Nacht hinein, um noch eine vielversprechendere Stelle zu erreichen, oder um einem bestimmten Ort noch ein paar Meilen näher zu kommen und dann das frühe Morgenlicht ausnutzen zu können. Das brachte aber häufig Frustration mit sich. Müde und hungrig, wie wir waren, mussten wir in der Dunkelheit einen Campingplatz finden, den Wohnwagen aufbocken, unsere aufgeregten Hunde beruhigen und mit dem allgemeinen Aufbau-Kochen-Aufräumen-Batterien-und-Telefonakkus-Aufladen-Schlafengehen-Syndrom fertig werden. Seitdem ist es uns wichtig, festzulegen, wie und wo wir den Abend verbringen wollen. Eine meiner Lieblingsaufgaben ist das Durchforsten der diversen Nachschlagewerke, die wir mitführen, nach interessanten Wohnwagen-Campingplätzen und Naturschutzgebieten, heißen Quellen und bemerkenswerten Orten. Heute, als Reisende mit mehr Erfahrung, befolgen wir eine Regel: bis zum Einbruch der Dunkelheit auf dem Campingplatz zu sein und alles aufgebaut zu haben. Wenn irgend möglich, campen wir am liebsten in einem Nationalpark oder staatlichen Naturreservat. Auf diese Weise verbringen wir das Ende des Tages und den Beginn des neuen in wunderschöner Umgebung – mit einem abendlichen Angelausflug an einen See (ich bin die Anglerin; Jeff hat einmal einen Aal erwischt, fängt sich aber sonst hauptsächlich Mückenstiche ein), oder wir schwimmen und liegen vielleicht in einer warmen Mineralquelle (überall im Land gibt es fabelhafte natürliche heiße Quellen). Schließlich dreht sich nicht nur alles um das Fotografieren (wie ich Jeff immer wieder erkläre), es geht auch um unsere Lebensqualität.

Ein typischer Tag fängt früh an – die Hunde warten schon ungeduldig darauf, nach draußen zu kommen. Das Innere unseres Wohnwagens ist wirklich sehenswert: die Ausrüstung auf den Couchen gestapelt, Lebensmittel in Kisten und Kühlgeräten verstaut, kreativ bis zum Platzen gepackte Taschen. In einem Airstream ist Platz knapp bemessen und wertvoll. Wir machen uns ans Aufräumen. Jeff ist morgens gern schon vor 7:30 Uhr wieder unterwegs. Während er mit den Hunden einen Spaziergang macht, werfe ich die Espressomaschine an und stelle irgendetwas als Frühstück zusammen. Das ist meine Chance, ein wenig June Cleaver zu hören, es sind eigentlich die einzigen Momente, in denen Jeff und ich nicht zusammen sind. Wie reibungslos diese Minuten verlaufen, ist entscheidend für den ganzen restlichen Tag. Nach dem Frühstück beeilen wir uns: Ich räume zusammen und mache die Luken dicht,

während Jeff sich um die Wasser- und Stromdetails kümmert. Wie in einem Tanz bewegen wir uns und bringen alles in Ordnung, bis die Stützblöcke im Wohnwagen liegen, die Hunde im Auto sind und die Kameraausrüstung auf dem Rücksitz liegt. Und los geht's!

Meistens hat Jeff genaue Vorstellungen davon, welche Städte wir an dem Tag besuchen und wo wir anhalten wollen. Ich schwimme mit dem Strom und navigiere, so gut ich kann. An anderen Tagen lassen wir uns vom Instinkt leiten. Gewöhnlich halten wir Ausschau nach der Hauptstraße des Städtchens, dann fahren wir jede einzelne Seitenstraße auf und ab, beobachten und saugen alles in uns ein. Wenn Jeff ein Motiv ins Auge springt, halten wir an, oder wir umkreisen es, um einen besseren Blickwinkel zu finden. Gelegentlich fahre ich, aber normalerweise zieht Jeff es vor, selbst am Steuer zu sitzen, die Mamiya-Kamera mit zugehörigem Arsenal im Schoß, so dass er, falls nötig, den Winkel des Wagens verändern kann. Er hat eine perfekte Methode entwickelt, ihn zu parken, die Tür zu öffnen und sich in einer fließenden Bewegung von der Armstütze auf den Dachgepäckträger des Wagens zu schwingen, um von da aus zu fotografieren. Das ist bei ihm eine unmittelbare Reiz-Reaktions-Technik. Ihm bei der Arbeit zuzuschauen ist eine Lektion in Konzentration auf eine einzige Sache. Er ist vollkommen auf das Bild konzentriert und bemerkt weder den Verkehr ringsum, noch das Ärgernis, das wir möglicherweise erregen. Bevor irgendjemand erkennt, was geschehen ist, sitzt er schon wieder im Auto. Wenn wir später darüber »diskutieren«, wie peinlich mir die Situation war, sagt er einfach: »Das tut mir leid, aber schon ein paar Minuten später erinnern sie sich nicht mehr an den Vorfall. Ich dagegen habe für alle Zeiten dieses Bild aus genau dem Blickwinkel, den ich brauchte.« Und tatsächlich habe ich die Peinlichkeit solcher Momente längst vergessen, wenn ich später die fotografischen Ergebnisse anschaue.

Ich assistiere Jeff, indem ich neue Filme in die Kamera einlege und sorgfältig die Namen und Adressen der fotografierten Orte und Menschen notiere. Das ist manchmal eine heikle Angelegenheit: Wenn es um Kinder geht, erkläre ich den Eltern unser Vorhaben, während Jeff sein Bild vorbereitet.

Unsere Reisen werden all unseren Bedürfnissen wunderbar gerecht. Außerdem verschaffen sie uns die Gelegenheit, Freunde zu besuchen, die wir nicht häufig zu sehen bekommen, und unterwegs neue Freundschaften zu schließen. Auf unseren Reisen haben wir viele interessante und kreative Menschen getroffen. Manche sind ebenso exzentrisch wie ihre persönlichen Sammlungen: Radkappen oder Nummernschilder, die ein ganzes Haus bedecken, eine Armee von Gartenzwergen auf einem Vorgartenrasen, oder so viele Windspiele, dass wir dachten, ganz in der Nähe einer Kirche zu sein. Auf einer Reise verbrachten wir einen hochinteressanten Abend mit einem jungen Paar, beide Lehrer, und ihren zwei Kindern. Sie unterrichteten ihre Kinder selbst und zeigten ihnen das Land. Ihr Leben bestand aus einer langen Reihe von Feldstudien: Geologie am Grand Canyon, Biologie in Wald und Flur. Ich habe festgestellt, dass unter dem »fahrenden Volk« mit ihren Wohnwagen die besten Amerikaner zu finden sind, denen ich je begegnet bin. Freundlich und geradeheraus leben sie ihren Traum. Als Rentner vielleicht oder weil sie auf der Suche nach einer neuen Erfahrung sind, haben sie ihr Stadtleben aufgegeben und ihre Existenz so reduziert, dass sie reibungslos in ihr mobiles Zuhause passt.

An einem besonders stimmungsvollen Abend befanden wir uns auf einer Fähre nach Galveston. Die Sonne war gerade untergegangen, als ein Sturm aufzog (Jeff fing den atemberaubenden Moment ein, direkt bevor der Sturm losbrach: Häuser auf Stelzen mit dem aufziehenden Sturm und der untergehenden Sonne hinter schwarzen Wolken am Horizont, Bild 11). Da waren wir nun auf See in dem heftig schaukelnden Kahn. Es war so stürmisch, dass wir nicht anlegen konnten. Die Hunde waren nervös, und ich beobachtete wie die nackten gelben Glühbirnen im Wind und im Regen hin und her schaukelten. Die Zeit stand still. Es schien eine Ewigkeit, bis wir endlich andocken konnten. In Galveston hatten wir für die Nacht auf einem Wohnwagen-Campingplatz einen Stellplatz am Wasser reserviert. Wir mussten feststellen, dass es viel zu stürmisch war, um an dem uns zugewiesenen Fleck zu schlafen. Jeff entschied, zwischen zwei umgebauten Greyhound-Bussen sei gerade genug Platz für unseren Airstream, außerdem würde so auch der heulende Wind von uns abgehalten. Als wir am nächsten Tag aus unserem Wohnwagen kletterten, mussten wir lachen: Unser Toaster sah aus wie ein Baby-Elefant zwischen seinen beiden Eltern!

Jeff hat seine Fotografie, und ich begebe mich auf die Schatzsuche. In dieser Hinsicht sind wir verschieden. Er bringt Fotos nach Hause; ich jage in Ramschläden und Hinterhof-Verkäufen nach Plunder, der mit Sicherheit den Anstoß zu irgendeinem zukünftigen Projekt geben wird. Wenn wir die Rückreise antreten, ist unser Anhänger zum Bersten vollgestopft mit alten Büchern, einer Ansammlung von Steinen, interessanten Baumskeletten, Blue Mason Einmachkrügen, alten Werkzeugen, Muscheln und einmal sogar einer Hollywoodschaukel. Wenn ich diese Läden und Märkte durchstöbere, bin ich immer wieder fasziniert von den Dingen, die Amerika ausrangiert. Jeff witzelt oft herum, er brauche nichts zu kaufen, weil er es auf Film habe – mit einer Ausnahme: alte Bücher. Mein Ehemann geht in alten Buchläden verloren. Dort habe ich ihn schon oft wiedergefunden, mit dem Ladenbesitzer in ein Gespräch über Erstausgaben von Fotobänden vertieft, von denen Jeff bereits eine unglaubliche Sammlung besitzt. Er hofft immer, eines Tages eine seltene Erstausgabe von Robert Franks *The Americans* zu finden. Das wäre ein Fischzug!

Wenn ich die Bilder in diesem Buch anschaue, erinnere ich mich, ihre Motive erlebt zu haben, und doch empfinde ich anders, wenn ich sie jetzt sehe. Ich sehe sie durch Jeffs Augen, und das gefällt mir. Er schafft es, meine emotionale Reaktion auf bestimmte Bildsituationen herauszukristallisieren. Viele Augenblicke unserer Reisen treten in meinem Geist deutlich hervor: Ein Bild mit dem Muster von Zweigen auf einer Häuserwand lässt in mir den Wunsch aufkommen, im Gras zu liegen und dem Tanz des Windes mit der Sonne zuzuschauen. Dieses Bild ist vollkommen [Bild 15], Jeff hat meine Seele erreicht und einen Moment von Schönheit berührt. Ich bedaure, dass ich den Augenblick nicht zu fassen bekam, als das Foto entstand.

Ich denke oft an Gespräche, die ich mit Jeff führte, als wir Amerika durchquerten. Ich erinnere mich, wie wir den verfallenen Zustand bezaubernder alter Häuser beklagten und wie wir uns gemeinsam freuten, wenn wir einfache, handgemalte Schilder [Bild 93] oder verblichene Logos an alten Backsteinmauern [Bild 105] entdeckten. Ich finde es reizend, in Tante-Emma-Läden auf den Waren Preisschilder an Stelle von Strichkodes zu finden. Jeff und ich haben oft darüber nachgedacht, wie lange es wohl noch dauert, bis das, was wir aus unserer Kindheit kennen, tatsächlich der Vergangenheit angehört.

Es ist merkwürdig, wie stark einen bestimmte Dinge an die eigene Kindheit erinnern. Eisdielen wie Dairy Queens und Sno-Cones hier und da auf den eintönigen Hauptstraßen größerer Städte verheißen für mich noch immer höchst angenehme Geschmackserlebnisse – und Erinnerungen, die dem inneren Kind in mir gut tun. Ich fühle die kühle, nach Vanille duftende Luft in meinem Gesicht, während ich am Schiebefenster meine Bestellung aufgebe, und mir läuft das Wasser im Mund zusammen, wenn ich nur an das kalte süße Eis und die aufgeweichte Waffel unten an der Eistüte denke.

Kreuz und quer durch Amerika zu reisen ist zu einem wesentlichen Bestandteil eines Lebensstils geworden, auf den wir uns immer wieder freuen. Wir haben die Highways und Landstraßen dieses Landes befahren, dabei fotografiert und die Städte und Menschen im Herzen des Landes besucht. Ich habe dabei eine Menge über das Leben gelernt und darüber, wie ich es führen will. Ich möchte sogar sagen, unsere Reisen haben unsere Liebe und unser Leben bereichert. Immer, wenn wir aus dem Stress der Großstadt heraus sind, leben wir nach der Uhr von Mutter Natur und erleben gemeinsam ein wahres Gefühl von Partnerschaft. Es ist ein intensives Zusammensein, das in uns ein klareres Verständnis füreinander geweckt hat und dafür, wie unterschiedlich wir die Welt sehen.

Ohne Eile quer durch Amerika zu fahren ist eine fabelhafte Reise, die ich jedem empfehlen möchte. Es ist eine ausgezeichnete Art, die Weite und Schönheit dieses Landes zu würdigen. Jeff und ich sind auf Amerikas Straßen gereist. In meinen Augen hätte dieser Band auch den Titel »Amerikanischer Mythos: Eine Reise in Bildern« tragen können. Ich danke Jeff dafür, dass er mir sein Geburtsland gezeigt hat. Auf unseren Reisen gab es viele besondere Augenblicke, die ich nie vergessen werde. Was für ein Privileg, die Möglichkeit zu haben, zu reisen, zu fotografieren und unser Leben gemeinsam zu leben.

Laura Morton-Dunas
Los Angeles, Juni 2001

Laura Morton-Dunas ist sowohl eine bekannte Schmuckdesignerin als auch eine erfahrene Gestalterin von Gärten in Wohnanlagen; sie lebt in Los Angeles.

Épilogue : Le voyage

Ayant travaillé de nombreuses années comme mannequin, j'ai longtemps parcouru le monde entier et souvent vécu à l'étranger mais je n'avais jamais eu le loisir de vraiment explorer les États-Unis ou mon pays natal, le Canada. Lorsque Jeff m'a proposé son idée d'un circuit itinérant à travers les États-Unis, j'ai pensé qu'il s'agirait simplement de faire un peu de camping. Ayant habité quelque temps New York, ce que je connaissais du reste de l'Amérique me paraissait plutôt rural et frustre en comparaison.

Une commande de *Vanity Fair* Italie pour illustrer, en vingt-huit pages, la traversée des États-Unis par un mannequin, nous a donné l'occasion de faire, en 1990, notre premier grand voyage ensemble. Ce thème passionnant, une sorte de safari photographique du Rêve américain, permettait d'évoquer et de faire revivre la mythique aventure de la « route ». Les photos réalisées par Jeff étaient superbes mais la réalisation de ce travail difficile, et qui nous prit beaucoup de temps (trente-deux jours exactement), nous entraîna dans un monde bien plus exotique que je ne l'aurais jamais imaginé. C'est cette première expérience qui nous incita alors à explorer plus à fond les États-Unis d'Amérique.

En 1993, après avoir acheté une Caravelle Airstream modèle 1966, une charmante caravane de quatre mètres que nous avons affectueusement baptisée « Toaster », nous sommes partis de Los Angeles en direction du Nord et de l'Oregon, où nous avons bifurqué à l'est en suivant à l'envers l'Oregon Trail. Ce furent six semaines d'un fantastique voyage. Notre petite caravane était pleine, avec nos deux chiens – des bergers australiens, des pellicules, le matériel photo, nos provisions … et nous-mêmes, dans cet ordre. À l'instar des premiers pionniers, nous emportions tous nos objets de valeur avec nous. Je suis encore toute étonnée qu'il soit si facile de vivre ainsi. Pas une journée ne se ressemble. Mais la navigation n'est pas toujours paisible à bord de notre yacht terrestre car nous sommes rarement séparés – nous devons en effet vivre ensemble 24 heures sur 24 et 7 jours sur 7 !

Nos voyages ne sont définis que par une destination finale et une date approximative de retour, fixées en fonction des réunions de famille, des rendez-vous donnés à nos amis, des vacances, etc. L'aventure, c'est simplement la manière dont nous parvenons au but fixé. Nous parcourons énormément de kilomètres en voiture mais nous avons mis au point un système de roulement : lorsque nous devons parcourir un long trajet, nous échangeons nos places toutes les deux heures et demie. Cet arrêt nous permet de nous détendre un peu et de faire courir les chiens. Jeff et moi nous partageons toutes les corvées : changer les packs de glace de la glacière pour les pellicules, mettre le Toaster à l'horizontale pour la nuit, faire la cuisine, préparer le feu, laver nos vêtements, écrire notre journal, préparer l'étape du lendemain et promener les chiens.

Nous aimons tous deux écouter de la musique en conduisant et nous emportons largement de quoi nous distraire pendant tout le voyage. Si Johnny Cash est parfait sur les routes poussiéreuses du Texas, Bruce Springsteen et Patsy Cline ajoutent ce petit plus indispensable pour goûter vraiment l'aventure américaine. Bien que Jeff ait une préférence pour le blues, j'ai réussi à le convaincre d'écouter des opéras et une sélection de morceaux de musique classique. En fait, c'est généralement à cause de la musique que l'on échange nos places : celui qui conduit a le droit de choisir ce qu'il veut entendre.

Au cours de nos premiers voyages, nous conduisions souvent jusqu'à la nuit pour atteindre un endroit prometteur ou nous rapprocher de quelques kilomètres d'un lieu particulier afin de tirer parti de la lumière du petit matin. Cette solution nous a rarement satisfait ; affamés, fatigués, nous devions dénicher le terrain de camping dans l'obscurité, puis garer et stabiliser la caravane, calmer nos chiens et gérer enfin le syndrome quotidien du campeur : installation, cuisine, nettoyage, recharge des batteries et des téléphones portables, puis couchage. Depuis lors, notre priorité est désormais de décider comment et où nous passerons la nuit. L'une de mes tâches favorites est de chercher dans les différents guides dont nous disposons quels sont les campings ou les réserves naturelles intéressants, s'il y a des sources d'eau chaude ou des sites remarquables. Maintenant que nous sommes des voyageurs plus chevronnés, notre règle est simple : nous arrêter dans un camping et avoir tout préparé avant la nuit. Lorsque c'est possible, nous préférons toujours camper dans un parc national car cela nous permet non seulement de finir la journée et de commencer la suivante dans un cadre magnifique mais aussi d'aller faire une petite partie de pêche sur le lac à la tombée de la nuit (c'est moi qui pêche ; si Jeff a pris une fois une anguille, il attrape bien plus souvent des piqûres de moustiques !), ou de nous plonger dans des sources d'eau minérale chaudes (il en existe plusieurs qui sont fabuleuses). Après tout, il ne s'agit pas non plus que la passion de la photographie (comme je ne cesse de le répéter à Jeff) s'exerce au détriment de notre qualité de vie.

Une journée normale commence tôt, les chiens étant pressés de sortir. Il faut voir alors l'intérieur de notre caravane, avec tout le matériel entassé sur les couchettes, la nourriture en vrac dans les cartons et les glacières, les sacs pleins jusqu'à ras bord. L'essentiel, dans une Airstream, est de bien gérer l'espace sinon on passe tout son temps à ranger. Jeff aime « tourner » avant 7 h 30 du matin, il part promener les chiens tandis que j'allume la machine à café et que je prépare un petit déjeuner. C'est l'heure où je joue à super woman (façon June Cleaver) et pratiquement le seul moment où Jeff et moi sommes séparés. La manière dont se déroule cette première heure détermine l'ambiance de toute la journée. Nous repartons vite après le petit déjeuner : je remets tout en ordre pendant

que Jeff s'occupe des détails de la plomberie et de l'électricité. C'est ensuite une sorte de ballet tout de fluidité, où chacun d'entre nous s'occupe dans son coin des tâches à accomplir jusqu'à ce que nous soyons prêts à partir, les cales rangées dans la caravane, les chiens dans la voiture et le matériel photo sur le siège arrière.

Jeff a généralement déjà une petite idée des villes qu'il veut voir et des endroits où il veut s'arrêter. Je l'aide du mieux que je peux dans sa navigation. Parfois, nous nous laissons simplement guider par notre instinct. Notre « tactique » habituelle consiste à trouver la rue principale de la ville puis à parcourir les rues latérales en observant tout sans en perdre une miette. Dès que quelque sujet possible attire l'attention de Jeff, nous nous arrêtons ou nous en faisons le tour pour mieux l'étudier en détail. Il arrive que je conduise mais Jeff préfère habituellement être au volant, son Mamiya et son matériel sur les genoux. Il exécute ainsi plus librement les manœuvres qu'il désire pour avoir l'angle de vue souhaité. Dès qu'il a repéré ce qui l'intéresse, il déclenche une séquence d'actions rapide et bien rodée qui lui permet, en un seul mouvement continu, d'enclencher la position Park, d'ouvrir la porte et de grimper depuis l'accoudoir jusqu'au toit du camion pour prendre sa photo. Le regarder travailler est une parfaite illustration de l'état dans lequel peut mettre une idée fixe. Jeff est en effet totalement absorbé par l'image à saisir et, oublieux du trafic qui l'entoure, ne songe même pas aux perturbations qu'il peut créer. D'ailleurs, il est en général entré à l'intérieur du véhicule avant que quiconque ait pu vraiment réaliser ce qui s'est passé. Si nous « discutons » ensuite de la gêne causée aux autres et de l'embarras dans lequel j'ai été quelques instants, il dit simplement : « Je suis désolé, mais ils ne se souviennent déjà plus de l'incident quelques minutes plus tard alors que je dispose à jamais de l'image que je voulais et sous l'angle exact dont j'avais besoin. » Il est vrai que j'oublie moi aussi la gêne éprouvée à ces moments-là dès que je revois ces photos.

J'assiste Jeff en rechargeant ses appareils et en notant soigneusement les coordonnées des gens et des lieux. Ma tâche est parfois un peu délicate, notamment lorsque je dois expliquer en quoi consiste notre travail aux parents des enfants que Jeff s'apprête à photographier.

Nos voyages répondent à merveille à tous nos besoins. Ils nous offrent l'occasion de rendre visite à des amis que nous ne voyons pas souvent et de nous en faire de nouveaux en cours de route. Ils nous permettent ainsi de rencontrer beaucoup de gens intéressants et créatifs. Certains sont aussi excentriques que les collections qu'ils possèdent et exposent : enjoliveurs ou plaques d'immatriculation recouvrant les murs de leur maison, armée de nains de jardin plantée sur la pelouse, ou orchestre de carillons tintant si fort que nous avions alors cru qu'il y avait une église à proximité. Nous avons également passé une merveilleuse soirée avec un jeune couple d'instituteurs et leurs deux enfants, auxquels ils faisaient l'école tout en sillonnant le pays. Leurs voyages étaient une succession de travaux pratiques sur le terrain : leçons de géologie dans le Grand Canyon, de biologie dans les champs et les torrents. J'ai commencé à comprendre que les adeptes de la caravane sont parmi les meilleurs Américains que j'ai jamais rencontrés. De caractère amical et direct, qu'ils soient à la retraite ou qu'ils aient cherché à connaître une nouvelle expérience, ils ont souvent abandonné la grande ville et vivent paisiblement leur rêve, à leur rythme, en simplifiant leur mode et leur train de vie pour mieux s'adapter à leur nouvelle demeure itinérante.

De tous ces voyages, je me souviens d'un soir en particulier où nous traversions la baie en ferry pour arriver à Galveston. Jeff venait de saisir ce moment extraordinaire où des maisons sur pilotis, enflammées par le soleil couchant, se détachaient, au loin, sur le ciel noir et encombré de nuages d'un orage menaçant [illustration 11]. La mer était mauvaise et le bateau tanguait si violemment qu'on ne pouvait approcher du quai. Les chiens étaient nerveux et je fixais les ampoules nues qui balançaient des lueurs jaunâtres dans le vent et la pluie. Soudain, le temps s'arrêta et, après ce qui me parut durer une éternité, nous pûmes enfin accoster. Nous avions réservé pour la nuit un emplacement en bord de mer au camping de Galveston. Nous avons cependant rapidement compris que le vent était beaucoup trop fort pour dormir à l'endroit qui nous avait été attribué. Découvrant deux anciens autocars Greyhound transformés en camping-car, Jeff décida qu'il y avait juste assez de place pour glisser notre Airstream entre les deux et échapper ainsi aux bourrasques. En sortant du Toaster, le lendemain matin, nous avons éclaté de rire : la caravane ressemblait à un bébé éléphant entre ses parents !

Si Jeff est passionné par la photographie, je préfère quant à moi la « chasse au trésor » dans les brocantes de charité et les vide-greniers. Les objets que j'y découvre inspirent parfois quelques-unes de mes créations. Lorsque nous rentrons à la maison, notre caravane est pleine à ras bord de vieux livres, de pierres, de souches d'arbre intéressantes, de bocaux à conserves, de vieux outils, de coquillages … et même, une fois, d'une balancelle ! Lorsque je chine dans ces échoppes, je suis toujours étonnée de ce que les Américains peuvent jeter. Jeff se moque souvent de moi en disant qu'il n'a nul besoin d'acheter quoique ce soit de tout cela car il en conserve le souvenir sur la pellicule – à l'exception des vieux livres. Mon mari aime en effet à se perdre dans les librairies d'occasion. Il m'est souvent arrivé de le retrouver en grande conversation avec le libraire au sujet de la première édition d'un album de photographie – dont Jeff possède d'ailleurs déjà une impressionnante collection. Il espère toujours découvrir la première édition, rare, de *The Americans,* de Robert Frank.

En parcourant les pages de ce livre, de nombreux moments de nos voyages me reviennent alors en mémoire. Mais, si je me souviens bien des lieux et des circonstances dans lesquelles ces photos ont été prises, j'éprouve une impression très différente car je les vois maintenant à travers le regard de Jeff. Et cette manière qu'il a de réussir à cristalliser ma réponse émotionnelle à certaines situations iconographiques me plaît beaucoup ; comme cette photo d'une maison encadrée de branches d'arbres qui me donne soudain l'envie de m'allonger dans l'herbe pour regarder danser le vent, les arbres et le soleil. Jeff touche mon âme au point que cette image devient réelle [illustration 15] et que je regrette presque, rétrospectivement, de n'avoir su apprécier ce pur moment de beauté à l'instant où il a pris sa photo.

Je me rappelle très souvent les conversations que j'ai eues avec Jeff lorsque nous avons traversé l'Amérique. Je me souviens de nos réflexions attristées sur l'état décrépit de charmantes vieilles maisons, notre joie de découvrir de simples enseignes peintes à la main [illustration 93] ou des réclames à demi effacées sur un vieux mur de briques [illustration 105]. Je commence à trouver pittoresque de voir aujourd'hui chez les vieux commerçants des étiquettes rédigées à la main au lieu de vulgaires codes barre. Jeff et moi nous nous sommes souvent demandés combien de temps il faudrait avant que ce que nous avons connu dans notre enfance appartienne vraiment au passé.

Il est amusant de voir comment certaines choses peuvent faire renaître des souvenirs d'enfant. Les Dairy Queens et les Sno-Cones qui s'alignent dans la rue principale des plus grosses bourgades m'offrent des parfums de souvenirs qui entretiennent mon enfant intérieur. Je sens un air frais et vanillé sur mon visage lorsque je passe commande au guichet et je salive déjà à la pensée de cette boule de glace fraîche et de cette pointe de gaufre humide à la base du cône.

Ces voyages en Amérique, dont la perspective nous réjouit chaque fois, font désormais partie intégrante de notre mode de vie. Nous avons parcouru les autoroutes et les routes secondaires de presque tout le pays pour voir et connaître mieux les villes et les habitants de l'Amérique profonde. Cela m'a beaucoup appris sur la vie en général et la manière dont je veux vivre. En fait, je crois bien que ces aventures enrichissent notre amour et nos deux existences. Chaque fois que nous pouvons nous libérer du stress urbain et partir vivre au rythme de Mère Nature, nous retrouvons un véritable sentiment de complicité et de communion intense, qui suscite en nous une meilleure compréhension de l'autre et de la manière très différente dont il voit le monde.

J'encourage tout le monde à entreprendre cette fabuleuse promenade que représente une traversée buissonnière des États-Unis. C'est en vivant comme nous ce légendaire « American Road Trip » – j'ai toujours pensé que ce livre aurait pu s'intituler : « Une Amérique mythique : Un Voyage en images » – que l'on peut certainement apprécier à sa juste valeur la grandeur et la beauté de ce pays. Je remercie Jeff de m'avoir présenté son pays d'origine. Je n'ai jamais oublié ces nombreux moments particuliers de nos voyages. Ce fut un privilège d'avoir eu la possibilité de partager avec lui ces voyages et ces photographies.

Laura Morton-Dunas
Los Angeles, Juin 2001

Laura Morton-Dunas est à la fois une célèbre créatrice de bijoux et une paysagiste confirmée vivant à Los Angeles.

Acknowledgements

This book would not have been possible without the constant help and support of my wife, Laura. It's a long and lonely road out there, and on all of the journeys that this work required she accompanied me, sharing the adventure. She showed great patience as I worked endlessly in my darkroom. I don't know if I would have attempted to produce a body of work such as *American Pictures* had she not been willing to share the journeys. Naturally, this book is dedicated to her.

Ludwig Könemann, whom I have known for many years, immediately agreed to publish this book and gave me the exceptional freedom to design and edit it. His support throughout the process has been remarkable. I appreciate the opportunity to work with his fine company. I'd also like to thank Könemann's publishing director, Peter Feierabend. Sally Bald functioned as my editor on the project and was patient and supportive of my ideas. I value the experience of working with her. Of course, the entire Könemann staff was a pleasure to work with and I thank them for their professionalism and dedication.

My friend Larry Vigon of Vigon/Ellis designed the dust jacket, for which I'm very grateful. His creativity is legendary and his eye remarkable. I'd also like to acknowledge the invaluable help of David Fahey for his thoughtful guidance on sequencing the photographs.

I'm honored that Anthony Vidler and Graham Howe contributed texts to this book. Both are talented, intelligent and vibrant people whom I am privileged to know and count among my friends.

Others who were instrumental in making this project a reality include Clémence Ajzner, Thomas Bertotti, Nancy Bishop, Ken Browar, Wally Byam, Gary Chiachi, Stephen Cohen, Giuseppe Damiani, Ken Damy, Alexa Kate Dunas, Dorian Dunas, R.S. Dunas, David Fahey, Beverly Feldman, Hans Figge, Anthony Friedkin, Michel Gaillard, Sabine Gerber, Bill Goldberg, Petra Grimm, Randy Haessig, Frédéric Huijbregts, James Ishihara, Kyla Jakovickas, Hannah Jarvis, Samy and Heddy Kamienowicz, Don Kelly, Alain Labbé, Jean-Claude Lemagny, Joel D. Levinson, Modesto Lopez, Ken Marcus, Galen Metz, Alia Mohsenin, Astor Morgan, Linda Morton, Phillip Nardulli, Agnes Reynaud, Willy Ronis, Phillip Schreckenberger, Keith Selle, Laura Serani, Samir Silbaei, Dino Spadavecchia, Beatrice Wachsberger-Thomas, Mark Voges, Gary Wagner, Conan Wang, Barry S. Weingart, Koleen White, Dianne Woo, Marc Yeh and H. G. von Zydowitz.

For many years I have enjoyed the support of Mamiya France. I've used their cameras since 1982 and consider the RZ-67 to be the best medium-format camera in existence. For this book I used primarily 50-, 65- and 300-millimeter lenses. I also used the Widelux and Noblex panoramic cameras. I worked primarily with Agfapan 400 film. I thank Agfa France and Agfa GmbH for their enduring support of my personal work. All my Agfa film is developed in Rodinal 1:50. Agfa's excellent warm-tone developers and papers complete the process. I live part of each year in Europe and thank Air France for their assistance. I'd like to mention Epson America for providing the excellent scanners and ink-jet printers that enabled me to art design this book.

An exhibition of the work from *American Pictures* will tour museums in the United States and abroad. Please contact the author at jrdphoto@dunas.com for further information.

Jeff Dunas' *American Pictures* photographs are represented by the Stephen Cohen Gallery in Los Angeles.

Additional work by Jeff Dunas can be seen at http://www.dunas.com.

Danksagung

Dieser Bildband hätte nicht entstehen können ohne die ständige Hilfe und Unterstützung meiner Frau Laura. Dort draußen sind die Straßen lang und einsam, und sie hat mich auf allen Reisen für dieses Buch begleitet und an dem Abenteuer teilgenommen. Wenn ich endlose Stunden in meiner Dunkelkammer arbeitete, hat sie große Geduld gezeigt. Ich weiß nicht, ob ich ein solches Werk wie *American Pictures* begonnen hätte, wenn sie nicht bereit gewesen wäre, mit mir zu reisen. Selbstverständlich ist ihr dieses Buch gewidmet.

Ludwig Könemann, den ich schon seit Jahren kenne, erklärte sich auf der Stelle bereit, dieses Buch zu publizieren, und er räumte mir die ungewöhnliche Freiheit ein, es selbst zu gestalten und herauszugeben. Seine Unterstützung während des gesamten Herstellungsprozesses war bemerkenswert. Ich weiß die Gelegenheit zu schätzen, mit seinem hervorragenden Verlag zu kooperieren. Auch Peter Feierabend, dem Verlagsleiter der Könemann Verlagsgesellschaft mbH, möchte ich meinen Dank aussprechen. Sally Bald, meine Lektorin bei diesem Projekt, hat viel Geduld bewiesen und meine Ideen unterstützt. Die Erfahrung, mit ihr arbeiten zu dürfen, war für mich von großem Wert. Natürlich war die Arbeit mit dem gesamten Mitarbeiterstab der Könemann Verlagsgesellschaft mbH eine Freude, und ich danke ihnen allen für ihre Professionalität und ihr aufrichtiges Interesse.

Mein Freund Larry Vigon von Vigon/Ellis entwarf den Schutzumschlag, wofür ich ihm sehr dankbar bin. Seine Kreativität ist legendär und sein Blick bemerkenswert. Ich möchte aber auch David Fahey für seine unschätzbare Hilfe und seinen wohl überlegten Rat bei der Auswahl der Fotos danken.

Ich fühle mich geehrt, dass Anthony Vidler und Graham Howe Texte zu diesem Buch beigetragen haben. Sie sind beide talentiert, intelligent und mitreißend, und ich habe das Privileg, sie zu kennen und meine Freunde nennen zu dürfen.

Zu all denen, die halfen, dieses Projekt zu realisieren, gehören Clémence Ajzner, Thomas Bertotti, Nancy Bishop, Ken Browar, Wally Byam, Gary Chiachi, Stephen Cohen, Giuseppe Damiani, Ken Damy, Alexa Kate Dunas, Dorian Dunas, R.S. Dunas, David Fahey, Beverly Feldman, Hans Figge, Anthony Friedkin, Michel Gaillard, Sabine Gerber, Bill Goldberg, Petra Grimm, Randy Haessig, Frédéric Huijbregts, James Ishihara, Kyla Jakovickas, Hannah Jarvis, Samy and Heddy Kamienowicz, Don Kelly, Alain Labbé, Jean-Claude Lemagny, Joel D. Levinson, Modesto Lopez, Ken Marcus, Galen Metz, Alia Mohsenin, Astor Morgan, Linda Morton, Phillip Nardulli, Agnes Reynaud, Willy Ronis, Phillip Schreckenberger, Keith Selle, Laura Serani, Samir Silbaei, Dino Spadavecchia, Beatrice Wachsberger-Thomas, Mark Voges, Gary Wagner, Conan Wang, Barry S. Weingart, Koleen White, Dianne Woo, Marc Yeh und H. G. von Zydowitz.

Seit vielen Jahren erfreue ich mich nun schon der Unterstützung durch Mamiya France. Ich benutze die Kameras dieser Firma seit 1982 und halte die RZ-67 für die beste Mittelformat-Kamera, die es gibt. Für dieses Buch habe ich vorrangig 50-, 65- und 300-Millimeter-Objektive benutzt. Ich habe auch die Widelux und Noblex Panorama-Kameras verwendet. Hauptsächlich arbeitete ich mit Agfapan 400 Film. Mein Dank gilt Agfa France und Agfa GmbH für ihre andauernde Unterstützung meiner persönlichen Arbeit. All meine Agfa-Filme werden in Rodinal 1:50 entwickelt. Agfas ausgezeichnete Warmton-Entwickler und -Papiere vollenden den Herstellungsprozess. Einen Teil des Jahres verbringe ich immer in Europa, und ich danke der Air France für ihre Assistenz. Außerdem möchte ich Epson America nicht unerwähnt lassen, die mir ihre exzellenten Scanner und Tintenstrahldrucker zur Verfügung stellten, mit denen mir die Gestaltung dieses Buches ermöglicht wurde.

Eine Ausstellung mit Arbeiten aus *American Pictures* wird in diversen Museen der Vereinigten Staaten und in anderen Ländern zu sehen sein. Für weitere Informationen erreichen sie den Autor unter jrdphoto@dunas.com.

Jeff Dunas' Fotografien aus *American Pictures* werden vertreten durch die Stephen Cohen Gallery, Los Angeles.

Weitere Arbeiten von Jeff Dunas finden Sie unter http://www.dunas.com.

Remerciements

Ce livre n'aurait pas pu voir le jour sans l'aide et le soutien constants de mon épouse, Laura. La route aurait été longue et solitaire mais elle m'a heureusement accompagné, partageant l'aventure de tous les voyages entrepris pour cet ouvrage. Elle a fait preuve aussi d'une grande patience tandis que je travaillais infatigablement dans ma chambre noire. Je ne suis pas sûr que j'aurais osé entreprendre la réalisation d'une œuvre telle que *American Pictures* si elle n'avait pas souhaité partager cette aventure avec moi. Cet ouvrage lui est donc naturellement dédié.

Ludwig Könemann, que je connais depuis de nombreuses années, a immédiatement accepté de publier ce livre et m'a laissé l'exceptionnelle liberté de le concevoir et de l'éditer. Son soutien m'a été précieux et j'ai été ravi de travailler pour son excellente maison d'édition. Je dois également remercier Peter Feierabend, directeur éditorial de Könemann Verlag, qui m'a généreusement accordé de son temps en m'aidant à parachever la direction artistique et la production de ce livre. Sally Bald, responsable de l'édition de ce projet, s'est montrée patiente et d'un grand secours. J'ai particulièrement apprécié sa collaboration. Ce fut naturellement aussi un plaisir que de rencontrer les membres du personnel Könemann et je les remercie tous pour le professionnalisme et le dévouement dont ils ont fait preuve.

Je dois beaucoup à mon ami Larry Vigon, de Vigon/Ellis, qui a conçu la jaquette. Sa créativité est légendaire et son œil remarquable. Je remercie également David Fahey pour l'aide inestimable et attentionnée qu'il m'a apportée en me guidant dans le choix de l'enchaînement des photographies.

Je suis honoré qu'Anthony Vidler et Graham Howe aient contribué à la rédaction des textes de cet ouvrage. Tous deux sont des êtres talentueux, intelligents et vibrants que j'ai le privilège de connaître et de compter parmi mes amis.

Je veux également remercier tous ceux qui ont permis de faire de ce projet une réalité : Clémence Ajzner, Thomas Bertotti, Nancy Bishop, Ken Browar, Wally Byam, Gary Chiachi, Stephen Cohen, Giuseppe Damiani, Ken Damy, Alexa Kate Dunas, Dorian Dunas, R.S. Dunas, David Fahey, Beverly Feldman, Hans Figge, Anthony Friedkin, Michel Gaillard, Sabine Gerber, Bill Goldberg, Petra Grimm, Randy Haessig, Frédéric Huijbregts, James Ishihara, Kyla Jakovickas, Hannah Jarvis, Samy and Heddy Kamienowicz, Don Kelly, Alain Labbé, Jean-Claude Lemagny, Joel D. Levinson, Modesto Lopez, Ken Marcus, Galen Metz, Alia Mohsenin, Astor Morgan, Linda Morton, Phillip Nardulli, Agnes Reynaud, Willy Ronis, Phillip Schreckenberger, Keith Selle, Laura Serani, Samir Silbaei, Dino Spadavecchia, Beatrice Wachsberger-Thomas, Mark Voges, Gary Wagner, Conan Wang, Barry S. Weingart, Koleen White, Dianne Woo, Marc Yeh et H. G. von Zydowitz.

Je bénéficie depuis de nombreuses années du soutien de Mamiya France. J'utilise les appareils de cette marque depuis 1982 et j'estime que leur modèle RZ-67 est le meilleur appareil photographique de format intermédiaire qui puisse exister. Les photos de cet ouvrage ont été réalisées essentiellement avec des objectifs de 50, 65 et 300 mm. J'ai également employé les appareils panoramiques Widelux et Noblex. J'ai utilisé principalement un film Agfapan 400 Asa. Je remercie Agfa France et Agfa GmbH pour leur soutien constant à l'égard de mon travail personnel. Tous mes films Agfa ont été développés avec un Rodinal 1:50 et les excellents produits de développement et papiers Agfa. Passant une partie de l'année en Europe, je remercie Air France pour son assistance. Je veux également mentionner Epson America et les remercier pour la qualité de leurs scanners et imprimantes à jet d'encre, qui m'ont permis de mieux gérer la direction artistique de cet ouvrage.

Une exposition itinérante des œuvres présentées dans *American Pictures* doit être organisée dans différents musées des États-Unis et à l'étranger. Pour plus d'informations, veuillez contacter l'auteur à l'adresse jrdphoto@dunas.com.

Les photographies de *American Pictures* par Jeff Dunas sont représentées par la Stephen Cohen Gallery de Los Angeles.

Vous pouvez également découvrir d'autres œuvres de Jeff Dunas à l'adresse http://www.dunas.com.

© 2001 Könemann Verlagsgesellschaft mbH
Bonner Straße 126, D–50968 Köln

© 2001 Jeff Dunas for the photographs, foreword and afterword
© 2001 Graham Howe for the introduction
© 2001 Anthony Vidler for the preface
© 2001 Laura Morton-Dunas for the epilogue

For the Adorno quote *Minima Moralia* on page 12
© New Left Books, 1974, translated by E.F.N. Jephcott
Für das Adorno-Zitat aus *Minima Moralia* auf Seite 15
© Suhrkamp Verlag, Neuauflage 1973
Pour la citation de Theodor Adorno de *Minima Moralia* sur le page 18
© Éditions Payot, 1980, traduit par Eliane Kaufholz et Jean-René Ladmiral

Project manager: Sally Bald
Project editors: Sabine Gerber, Hannah Jarvis
Design and typography: Vigon/Ellis
Translation into German: Brigitte Wünnenberg
Translation into French: Arnaud Dupin de Beyssat
Production: Petra Grimm, Mark Voges
Color separation: C.D.N. Pressing, Caselle di Sommacampagna, Italy
Printing and binding: Grafedit, Azzano, Italy

Printed in Italy

ISBN 3-8290-6080-7

10 9 8 7 6 5 4 3 2 1